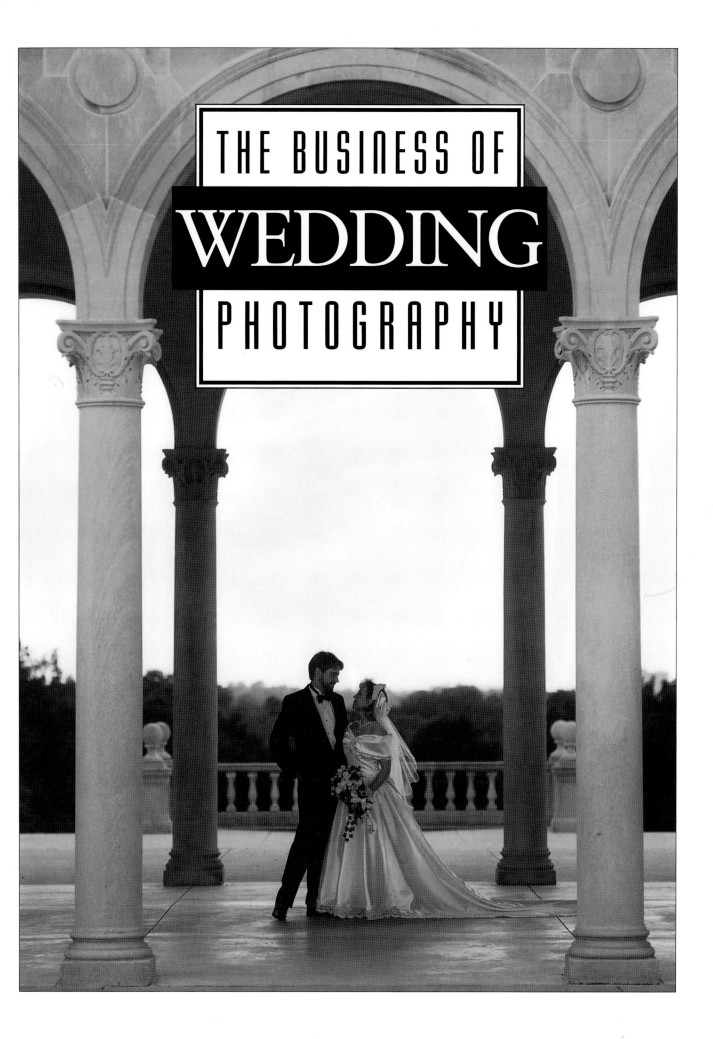

THE BUSINESS OF
WEDDING
PHOTOGRAPHY

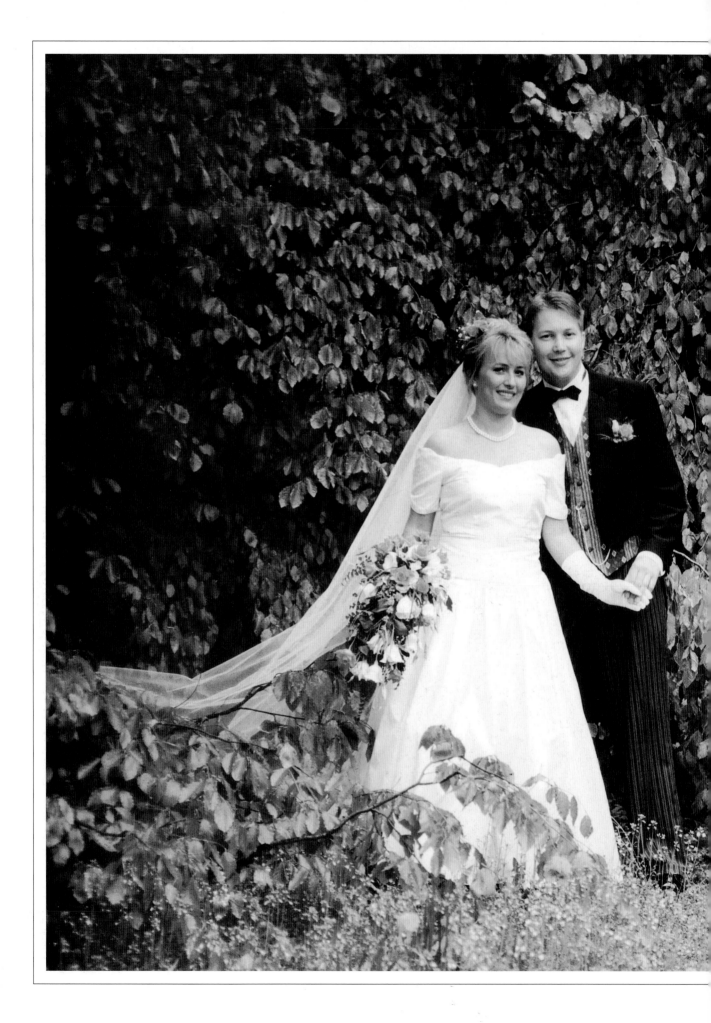

THE BUSINESS OF

WEDDING

PHOTOGRAPHY

ANN MONTEITH

AMPHOTO BOOKS
an imprint of
Watson-Guptill Publications/New York

Ann K. Monteith, a portrait-studio owner and a consultant to studio owners and industry suppliers, is a frequent instructor at and a former chairman of the Board of Trustees of the Winona International School of Photography. She resides with her husband, James, in Annville, Pennsylvania, and Deep Creek Lake, Maryland.

Picture information:
Half-title page © John Howard
Title page © Trine Melhüüs

Senior Editor: Robin Simmen
Editor: Liz Harvey
Designer: Bob Fillie, Graphiti Graphics
Graphic Production: Hector Campbell

Copyright © 1996 by Ann K. Monteith
First published 1996 in New York by Amphoto Books,
an imprint of Watson-Guptill Publications,
a division of BPI Communications,
1515 Broadway, New York, NY 10036

Library of Congress Cataloging-in-Publication Data
Monteith, Ann.
 The business of wedding photography : a professional's guide to
 marketing and managing a successful studio, with profiles of 30 top
 wedding photographers / by Ann Monteith.
 p. cm.
 Includes index.
 ISBN 0-8174-3617-0 (hc)
 1. Wedding photography. 2. Photography—business methods.
 3. Photographers—Biography. I. Title.
 TR819.M66 1996 96-32919
 778.9'93925'068—dc20 CIP

Manufactured in Hong Kong

1 2 3 4 5 6 7 8 9 /04 03 02 01 00 99 98 97 96

With appreciation to my daughter, Julie Monteith,

and son-in-law, Christopher Frum,

whose adroit sense of timing enabled me

to assume the surprisingly agreeable role of

"Mother of the Bride" during the production of this book.

With my love and best wishes for a marriage as long-lasting

and fulfilling as I've been lucky enough to enjoy.

CONTENTS

THE BUSINESS

PROFILES

INTRODUCTION

Of the many life-cycle events that constitute a family's history, the wedding ceremony has captured the interest and imagination of photographers, both amateur and professional, like no other—for both its beauty and its significance to generations past, present, and future. From culture to culture, across religious and racial lines, and within all economic classes, the desire persists for photographs that preserve the history and sentiment of this most important family occasion.

The earliest examples of wedding photography reflect the constraints that the cumbersome equipment of the day imposed. Most wedding photography was limited to formal studio portraiture and usually included only the bride and groom or the bride alone. Wedding portraits of this era were of necessity somber in character due to the long exposure that the large-format portrait cameras required in order to create properly exposed negative material.

By the turn of the century, a few adventuresome photographers began hauling their equipment to the location of the wedding ceremony. This afforded more possibilities for including in the photographs additional participants in the wedding ritual, such as members of the wedding party and family members of the bride and groom. Only occasionally, however, was the live action of the ceremony recorded.

During the 1930s and 1940s, some portrait studios began to send photographers to the wedding and reception to record a few highlights. The photographers were usually equipped with a 4 x 5 Speed Graphic camera and a flash-bulb attachment; this was the "portable" equipment of its day. While most of the images were stiffly posed, a few photographers began experimenting with more candid "action" pictures.

It wasn't until the development of medium-format cameras in the early 1950s, and the subsequent manufacture of portable electronic strobes, that professional photographers began to recognize the potential of recording the story of the wedding event. By the mid-1950s, full-service portrait studios began offering "candid wedding coverage" as a studio product line. By the late 1950s, some studios began to offer a few "experimental" portraits created with the newly introduced Kodak color negative film. By the mid-1960s, color albums had become the industry standard.

During the late 1960s and early 1970s, a few pioneering individuals began to extend the artistic and technical dimensions of the medium in a bold and revolutionary manner. In fact, they forever altered the landscape of professional wedding photography. Among them were the late Bill Stockwell of Oklahoma City, Oklahoma; Monte Zucker of Silver Spring, Maryland; and the late Rocky Gunn of Los Angeles, California.

Still active as a portrait and wedding photographer, as well as an internationally acclaimed lecturer and writer, Zucker is the father of the modern wedding-photography industry. Like most portrait and candid photographers of the 1950s, Zucker began photographing weddings and bar mitzvahs using a hand-held 4 x 5 Speed Graphic camera mounted to a flash.

During a two-day Stockwell class in 1965, Zucker was exposed to the classical studio portraiture of Joe Zeltsman, the best-known American portraitist/teacher of his day. Zucker was so impressed by Zeltsman's candids and portraits that he immediately started to take a series of once-a-month classes at Zeltsman's New Jersey studio. Shortly thereafter, in addition to his ever-expanding repertoire of candid photographs bearing the Stockwell influence ("mistys," candlelight poses, and double exposures), Zucker began to create classical portraits of the bride and groom using a painted background brought to the church or reception. The strategy paid off, and soon Zucker was the most sought-after wedding photographer in the Baltimore/Washington, DC metroplex. He also became the mentor to thousands who flocked to his seminars throughout the country, and later throughout the world. One eager student of the "Monte method," Rocky Gunn was a young actor-turned-photographer who informed the instructor that he could create portrait lighting on subjects posed in dramatic outdoor locations. In July, 1982, Gunn's startling approach of photographing brides and grooms in the most dramatic settings—on mountainsides, in fields, and on beaches —was featured in a *Life* magazine article that touted the emergence of contemporary wedding photography.

Suddenly, wedding photography began to take center stage as a photographic specialty that could command high fees because of its ability to interpret and preserve the romance and excitement of the wedding day. The 24-page wedding album gave way to thicker, library-bound volumes in which presentation became an art in itself. Enterprising marketers offered "spreads" of smaller, related images opposing a dominant 8 x 10 print. The photographers also added parents' albums and gift folios for relatives and members of the wedding party; some photographers even began to feature enlarged, wall-decor images. Choosing the "right" wedding photographer became as important to the bridal ritual as choosing the wedding gown.

From this crucible of currents and crosscurrents of styles, the modern profession of wedding photography emerged. The vision of these pioneers has nourished, informed, and inspired both the artistic and business practices of a legion of talented entrepreneurs, including those who are profiled in this volume.

THE BUSINESS

GETTING STARTED

One of the unusual aspects of the wedding-photography business is that only rarely does anyone decide overnight to enter it as a full-time profession. Most established wedding photographers began their careers as weekend warriors. Few entered the adult world that follows high school or college with a burning desire to become a professional wedding photographer.

In fact, the resumés of well-known and not-so-famous wedding photographers alike reveal that their former jobs or professions were completely unrelated to photography as a business. Most began with a hobbyist's interest in photography that developed into a way to make a little extra money. This evolution ultimately tapped into a deeply rooted yearning that nearly all successful wedding photographers recognize as the motivation behind their career change. This was the desire, or perhaps even the compulsion, to create images of beauty that the public holds in high esteem.

Few portrait or wedding photographers would readily acknowledge the need for public recognition as the primary motivating factor in their quest for professional success. But most would admit to this truth if pressed about the subject. Understanding this creative compulsion is significant for those considering wedding photography as a profession.

PHOTOGRAPHY: A PASSION BUSINESS

Photography, like many professions in the arts, tends to be a "passion business," one in which the owner is motivated by the passion of creating photographs, and not by the mundane business of earning a living. Any business is likely to be more successful when its principal focus is "how many widgets can I make per hour at how much profit per widget?" rather than "my most important concern is creating images that please my artistic sensibilities and inspire my clients to shower me with praise for my abilities." Far too often, wedding photographers become concerned about the marketing and management aspects of their business only when they run out of money. Unfortunately, it is quite difficult to rebound from this position.

Business experts agree that passion businesses are more failure prone than businesses in which the profit motive is the impetus for going into business. Success in the wedding-photography business requires a long-term dedication to learning not only the technical and artistic principles that govern the production of wedding photography, but also the principles of operating a small business. Without this dual commitment, a wedding-photography business is doomed to the unpleasant fate that befalls most passion businesses.

WEDDING PHOTOGRAPHY AS A SIDELINE

Unlike most professions, there is no clear-cut career path to success in wedding photography. Most professionals, however, begin by "understudying." This involves working part-time at a studio or for an experienced, freelance wedding photographer. Some professional wedding photographers choose to make it on their own from the very beginning. They get started by reading instructional books, attending wedding-photography seminars, and shooting friends' weddings to receive some on-the-job training.

The fact that you can develop wedding photography as a sideline business while receiving a full-time paycheck from a "real job" has both positive and negative implications. On the positive side, it costs very little to start up a part-time wedding business. Samples of your work and photographic equipment are the only essential "capital expenses," or initial expenses. The minimum equipment requirements for photographing a wedding are a medium-format camera, a standard-focal-length lens, and an on-camera flash. In the hands of a talented photographer, even a 35mm camera can produce satisfactory images. Keep in mind, though, that the public sometimes perceives a 35mm shooter to be less professional than a photographer who uses a medium-format camera.

In recent years, film companies have developed 35mm films that produce images whose grain structure holds together when enlarged. Camera companies

have introduced automatic cameras that produce properly exposed negatives under a variety of circumstances, thereby enabling amateurs with little training to produce acceptable candid photographs. The proverbial "Uncle Harry," with his omnipresent amateur camera, now takes photographs that professionals can no longer easily dismiss because of their quality. (This was possible with Uncle Harry's camera-enthusiast predecessors.)

On the other hand, operating a wedding-photography business as a sideline does have pitfalls. Part-timers raising families must handle the inevitable pressure that arises when the spare-time business consumes family time and when a couple's social life becomes a thing of the past. Such pressure is lessened considerably when the photographer's spouse or significant other is directly involved in the new undertaking. This reduces the tension that is a natural byproduct of using "free" time to support a business. Having divided loyalties between a full-time job and a part-time wedding business also creates its own kind of stress. It is quite common to have your mind on wedding matters while working at the real job, and vice versa.

But the most serious pitfall associated with operating a part-time wedding-photography business is the tendency to treat it as a diversionary sideline, not as a business that conforms to principles of good management. As long as the business is "making a few bucks," some owners are satisfied. This can have devastating consequences if a part-timer decides to "go full-time." Now the business must stand on its own, and the bad business habits developed when the enterprise was nothing more than a profitable hobby are hard to shake.

WORKING FULL-TIME VERSUS PART-TIME

Once bitten by the wedding-photography bug, the part-time wedding photographer inevitably faces a question: "Should I make the transition from a sideline business to a full-time profession, and if so, how should I go about doing this?" Just because anyone can start a part-time wedding business without much difficulty doesn't mean that a full-time business operates quite so smoothly. Sincere, career-oriented wedding photographers soon discover that many weekend shooters, who have very few overhead expenses, view wedding photography only as a way to earn easy part-time income. All they have to do is undercut the prices of established professionals.

Full-time pros must make a serious commitment to a marketing program. This plan is designed to make potential clients aware of what distinguishes the products and services of serious professionals from those of amateurs and part-timers. Another goal of the marketing program is to explain why the professionals' higher fees translate into increased benefits for clients.

Most wedding professionals agree that working part-time until you've achieved some name recognition in the community and a clientele that is enthusiastic about your work is the most reasonable strategy to pursue. Realistically, it can take as long as three to five years to master the technical and management aspects of a wedding business, as well as the marketing expertise required to create an awareness of your business in the community. Therefore, it makes sense to take advantage of the fact that wedding photography is one of the few professions that you can run as a weekend sideline until the time is right to strike out on your own. Before you do, however, you should be honest with yourself about your prospects as you evaluate the major factors that enhance the probability of business success.

BECOMING A BUSINESS OWNER

For many people, the pride of ownership and the desire for independence are powerful motivating factors for starting a full-time or part-time business. There is a certain prestige that comes from being recognized in the community as a business owner. However, because ownership involves risk, you should ask yourself some important questions before making this commitment. Affirmative answers to the questions posed below increase your chances of succeeding in the competitive world of wedding photography.

- Do you possess the fundamental technical knowledge required to light and pose subjects in formal wedding photographs, as well as to capture candid images of the wedding story?
- Do you understand the business of photography?
- Are you a leader?
- Are you a self-starter?
- Do you like people?
- Do you have a strong sense of commitment?
- Are you good at organization?
- Are you in good health?
- Does your family approve of your decision?
- Do you know financial and business advisors who can help you make business decisions?
- Do you have adequate financing?
- Do you have a suitable place of business where you can meet with prospects and clients?

Even if you can answer all of these questions affirmatively, you still must have a business plan in order to maximize your chances of success.

ELEMENTS OF A BUSINESS PLAN

Whether you want to sell pencils, ball bearings, or wedding photography, the elements of a business plan are essentially the same. Its purpose is to provide structure for your business. It does this by identifying the various functions that must be managed.

Product. What do you plan to sell? To whom do you plan to sell it? Who else competes for the same customers, selling the same or similar products?

Promotion. List the promotional media that will comprise your marketing effort, and estimate the cost of these promotional enterprises.

Price. Determine the wholesale costs of your wedding-photography products. Decide on an appropriate markup percentage, which is a cost-of-sales factor, according to a realistic appraisal of your overhead, or general expenses. Then, using your cost-of-sales factor, calculate your retail prices.

Presentation. What sales tools will you need to sell your product? What method or methods of sales presentation will you employ? Will you do the sales presentation yourself, or will you hire someone to do it for you?

Place. Where and when do you intend to conduct your business? List any modifications required to conduct business at the desired location.

Personnel. What key functions of the business must be staffed? Can you handle these functions yourself, or will you have to hire full- or part-time staff members? Calculate wages, taxes, and benefits that you plan to pay any personnel on your payroll or payments to anyone you might purchase freelance services from.

Productivity. List factors, both technological and personal, that can enhance the productivity of your business. Next, write down factors that can have a negative impact on productivity.

Projections. How many wedding pictures and/or other types of photographs, such as studio portraits, do you project your business will photograph and sell within an annual time frame? Jot down both the projected amount of your total sales first and the cost of sales of these projected sales. Next, list the annual overhead amount, including such general expenses as your salary and benefits and those of your employees. Devise a capital-expense budget that includes equipment, furnishing, fixtures, automobile(s), the building (if you intend to purchase an office building), and any other "assets" that you'll buy for the business. From these data, create a projected, annual income-and-expense budget for your proposed business. These two budgets, capital-expense and income-and-expense, are vital because they'll spell out the financial reality of your proposed business venture.

As you can see from the business plan outlined above, operating a photography business involves a great deal more than just taking pictures. The chapters that follow will provide you with the basic marketing and management tools you need to operate a successful wedding-photography business. In addition, you'll have the opportunity to learn from the experience of the successful professional wedding photographers who are profiled. If you're willing to commit the time, resources, and energy necessary to master the technical, artistic, and management skills required to become a professional photographer, then owning a wedding-photography business will be a realistic objective for you.

WHERE TO TURN FOR HELP

Professional associations offer a host of educational resources and activities to assist aspiring and working professional photographers. In addition, these organizations offer insurance plans, the most important of which is "indemnification" insurance that protects you and your business from "errors and omissions." In today's litigious society, it is foolhardy to operate a business without this type of insurance. These professional associations include:

Professional Photographers of America
57 Forsyth Street, NW—Suite 1600
Atlanta, GA 30303-2205
800-786-6277
404-614-6400 fax

Professional Photographers of America (PPA) is the oldest and largest association of professional image makers in the world. It is made up of a network of more than 200 state, local, regional, and national affiliates. It also includes the PPA/Winona Continuing Education System that operates classes ranging from one day to a full week at affiliate schools throughout the United States and abroad. Professional active members receive indemnification insurance as a benefit of membership. PPA is the publisher of *Professional Photographer* magazine, the most widely read magazine in the industry. Each year, PPA sponsors an international convention, trade show, and print competition/exhibition.

Wedding and Portrait Photographers International
1312 Lincoln Boulevard
Santa Monica, CA 90406-2003
310-451-0090
310-395-9058 fax

Wedding and Portrait Photographers International (WPPI) sponsors an annual convention, trade show, and print competition and publishes *Rangefinder* magazine.

ESTABLISHING A REAL BUSINESS

Whether you're operating a part-time wedding-photography business that you intend to keep as a sideline, or one that you plan to expand gradually until you are ready to go full-time, it is wise to employ sound management practices from the very beginning, otherwise the business will evolve with no direction and function like an overgrown hobby. Just as you would never begin a cross-country trip without advance planning and a road map to tell you where you're going, show you how to get there, and measure your progress along the way, you must both consider certain factors and take specific actions in order to operate your wedding-photography enterprise in a business-like manner.

GET SOUND BUSINESS ADVICE

First, check with your local chamber of commerce to see what kinds of business licenses and tax numbers (federal, state, and local) are required to start a business in your area. If you intend to operate your business out of your home, determine what zoning restrictions cover the conduct of a home business. As your plans progress, you'll need to select professional advisors in the following areas: banking, insurance, legal, and accounting.

A banker generally is the first professional whose help you'll require should you need to borrow start-up capital. It also is important to establish a line of credit that you can use during periods when your cash flow isn't sufficient to pay your day-to-day bills. A line-of-credit loan is a short-term loan, intended to be repaid within 12 months.

An insurance agent can give you advice about policies that protect your business assets and operations and retirement-fund options. Professional Photographers of America (PPA) also offers group coverage in some of these areas, including cost-effective equipment insurance. As a benefit of membership, PPA provides professional active members with malpractice or "errors and omissions" indemnification. In today's litigious society, it is vital for you to carry such indemnification, particularly if you're photographing weddings.

It is a smart idea to get to know a lawyer who can handle both your personal matters, such as drafting a will, and any business matters that might arise, such as advice on the best kind of business structure. Ask other businesspersons in your community to recommend a good lawyer, and make certain that you are aware of all applicable fees before entering into any transaction with the lawyer you choose.

An accountant or an accounting service can help you to complete various business tax filings. These include sales tax, FICA (Social Security), and withholding taxes on any employees you might hire. The accountant also will file your annual personal and business income-tax forms. When hiring an accountant, don't make the mistake that is common to most photography businesses, which is to let the accountant set up your reporting system without your direction as to what managerial data you'll need in order to run your business. Otherwise, your accounting system is likely to satisfy government requirements only, and not provide you with the essential data you need to make daily business decisions (Chapter 12 will help you to direct your accountant as to the information you require).

Should the Internal Revenue Service (IRS) or state or local taxing authorities audit you or your business, your accountant should be willing to represent you at little, if any, additional charge. Before hiring a certified

public accountant (CPA), make certain that the individual is willing to work with you on these terms, and that you clearly understand all the costs involved. If you have trouble locating such an accountant, contact Comprehensive Business Services (see Resources on page 190). This nationally based firm sells franchises to CPAs who specialize in helping small businesses obtain vital managerial data about their businesses; it also provides any necessary tax-accounting assistance.

TYPES OF BUSINESS STRUCTURES

A good accountant can advise you about the kind of structure that will be best for your business. The possibilities include a sole proprietorship, partnership, corporation, or subchapter S corporation. Naturally, each option has advantages and disadvantages. Because governmental requirements and corporate tax rates vary from state to state, after having received advice from your accountant, it is best to consult an attorney before deciding upon a business structure.

SOLE PROPRIETORSHIPS

Most wedding photographers initially become sole proprietors because this is the easiest way to start a business. This structure involves few, if any, legalities; you simply have to obtain a business license and tax numbers. As a sole proprietor, you can conduct business as you wish, without the restrictions imposed by corporate legalities, and without having to please or share profits with a partner. A sole proprietorship also can be quite demanding since the buck starts and stops with you. When things go wrong, you are responsible. Also, when the time comes to retire, a sole proprietorship can be difficult to sell because in many cases, the proprietor is the most valuable asset of the business.

PARTNERSHIPS

Partnerships among wedding photographers are rare, although not unheard of. Issues concerning ego ("My work is better than your work"), responsibility ("I do more work than you do"), spousal jealousies ("His spouse doesn't like me and never lets him forget it"), and liabilities ("I'm tired of cleaning up after your mistakes") inevitably intrude into most partnerships. Many friendships have been ruined by the formation of a business partnership.

The best partnerships are those in which each partner is responsible for a specific aspect of the business, and in which a legally binding agreement clearly spells out each partner's interests and liabilities. Each partner should retain an attorney to offer advice in crafting the agreement. When a well-thought-out partnership agreement is in place, the arrangement will have a much better chance of realizing the advantages of this business structure. These benefits include increased access to capital and credit and having someone who possesses complementary skills with whom to share the workload.

CORPORATIONS

At one time corporations were considered the "safest" business entity because they shielded the business owner(s) from liability in the event of a lawsuit or bankruptcy. The reality of the current legal system and the tight borrowing policies of lending institutions have diminished these advantages. Today, lawyers sue not only the corporation, but all of its principals. Furthermore, banks require that you pledge personal assets, as well as those of your business, against the loans they grant. Corporations do create some tax benefits, such as pension and profit-sharing options that provide stockholders with a way to accumulate tax-free income. But you must measure these advantages against the double-taxation aspect of corporations in which corporate dividends are taxed before they're distributed.

In states with unusually high corporate-net-income and capital-stock franchise taxes, a corporation isn't a good idea. A corporation requires a "filing," which your attorney can do and which necessitates a filing fee. Corporate status also requires that the business hold regular stockholders' meetings and conduct an annual audit.

SUBCHAPTER S CORPORATIONS

The same legal requirements that exist for regular corporations apply to subchapter S corporations. But this type of business structure has the advantage of treating business profits as personal income that isn't taxed until it is taken out of the business. Photography businesses easily meet most of the requirements for subchapter S corporations. Incorporation doesn't become much of an issue until the business begins to show a profit. Depending on the amount of money you invest in the business, Social Security taxes can be minimized under a subchapter S, as compared to a sole proprietorship, and capital can be accumulated for future expansion without the profit or dividend taxation of sole proprietorships or corporations.

As to liability issues, the subchapter S entity no longer provides much protection from liability or bankruptcy. Therefore, it is best to rely on "errors and omissions" insurance (available from PPA), as well as on business insurance that carries a liability component to protect you from "trip and fall" lawsuits.

As is the case with partnerships, don't choose either form of incorporation without having your accountant and attorney determine the best kind of structure for you. They'll base their decision on investment, salary, net profit, and liability considerations, and on the various issues that concern the future of the business, including your retirement from it.

INVESTING IN YOUR BUSINESS

Deciding where you'll locate your business and how much you'll spend on business assets should be governed by the amount of your business investment in relation to the amount of return that you estimate your business can realize from that investment. As the chart below shows, the only true measure of profit is how it relates to capital investment. To understand this principle, compare the figures for Business A and Business B.

CAPITAL INVESTMENT VERSUS PROFIT

BUSINESS A

Investment	$200,000
Sales	$250,000
10% profit	$25,000
Percentage of profit returned on investment	–12.5%

BUSINESS B

Investment	$50,000
Sales	$125,000
10% profit	$12,500
Percentage of profit returned on investment	–25.0%

* The formula for calculating the return on investment (ROI) is to divide the dollar amount of the investment into the dollar amount of the profit.

Consider the following example. Owner A invests $200,000 in her business, while owner B puts $50,000 in his. Business A does a total sales of $250,000 while Business B has sales of $125,000. Both businesses realize a net profit of 10 percent, or $25,000 for Business A and $12,500 for Business B. Business A appears to be twice as profitable as Business B.

However, if you compare those profits of $25,000 and $12,500 to the amounts of money invested by each owner, you'll see that $25,000 as a return on the investment of $200,000 is only 12.5 percent as compared to the 25 percent return generated by Business B. This company's investment of only $50,000 yielded a profit of $12,500. So, Business B's ROI rate is twice as large as the Business A's rate of return.

As you examine your investment options, keep in mind that the larger your investment, the more sales you must generate in order to realize a profit that will justify the size of your investment. Remember, too, that the cost of fixed assets continues whether or not you meet your sales goals. Make your commitments to capital expenditures with enough leeway so that you can survive if early sales don't live up to projections.

FINANCING YOUR INVESTMENT

Most new business owners seriously underestimate the cost of opening a business; however, realistic budgeting should enable you to accurately project financial requirements, within a 10-percent margin of error. Once you know what your start-up costs will be, you must determine how to finance this capital investment. The most conservative method, of course, is to use your own money to finance all or part of the investment. Shrewd business owners, however, rarely like to tie up their own capital because they want that money to be working for them. Therefore, they'll borrow the funds needed for new business ventures.

This form of leverage presupposes two things: first, that you have sufficient assets to use as collateral to secure the loan; and second, that there is a high degree of certainty that your business won't fail, causing you to foreclose on the loan. You should be aware that the cost of borrowing increases in relation to the lessening of capital equity. In other words, as a business loses value on paper or has fewer assets standing behind it, the more it will cost to borrow funds to invest or for use in financing cash flow.

Because of the high failure rate of banks and savings-and-loan companies during the late 1980s and early 1990s, capital loans for small businesses have become very difficult to obtain without substantial collateral to secure them. Consequently many small business owners are forced to borrow from private individuals, family members, and even credit-card companies to provide start-up capital. Because of the high rates of interest frequently demanded from lenders, it is vital for you to establish a capital budget that is plausible—not only in terms of your initial business investment, but also according to how much monthly overhead is required to operate the business.

The cost of capital varies widely. Different types of loans have different interest rates. Check with a variety of lending institutions, including banks, insurance companies, credit unions, and such government agencies as the Small Business Administration. Make certain that you understand the characteristics, costs, and risks associated with each loan option.

When approaching any lender, you must have a business plan that includes the following:

- The desired loan amount
- What security, if any, you can offer
- A financial plan that shows projected profit and loss (see Chapter 12)
- The length of time over which you expect to repay the loan
- A capital expense budget that shows what you intend to purchase with the borrowed funds
- Your personal net-worth statement

XYZ STUDIO CAPITAL-EXPENSE BUDGET	
LEASEHOLD IMPROVEMENTS	
Contractor (addition to home)	$21,700
Heating system	$1,000
Carpet	$2,300
TOTAL	$25,000
FURNISHINGS AND FIXTURES	
Wing chair	$715
Love seat	$440
End tables	$245
Desk	$625
Desk chair	$290
Table	$285
Miscellaneous	$1,000
TOTAL	$3,600
EQUIPMENT AND PROPS	
Background rollers	$400
Dark background	$800
Medium background	$800
Two posing stools	$200
Posing table	$100
Two elegant chairs	$800
Leather chair	$700
Victorian chair	$225
Camera, back, viewfinder	$3,000
Lenses: standard, wide angle, medium telephoto	$4,000
Back-up body and lens (used)	$3,000
Two portable strobes @ $300	$600
Four strobes @ $450	$1,800
Camera stand	$500
Radio release	$200
Barndoors, slaves, reflectors	$239
Miscellaneous	$1,000
TOTAL	$18,364
MISCELLANEOUS	
Vacuum cleaner	$200
Coffee maker, small refrigerator	$800
Plants and accents	$1,000
Mini-blinds	$400
Signs	$2,000
TOTAL	$4,400
DISPLAY PRINTS AND SAMPLES	
Twenty display prints (@ an average price of $125)	$2,500
Twenty frames (@ an average price of $60)	$1,200
Four display albums @ $400	$1,600
Miscellaneous album covers, leaves, etc.	$1,000
TOTAL	$6,300
GRAND TOTAL	$57,664

CAPITAL EXPENSES

Whenever you purchase an item that fits into a capital-expense category, you must keep a record of the date of purchase, a description of the item purchased, and the amount paid for the item. Your accountant will need this capital-expense record to calculate the studio depreciation expense when it is time to prepare your income taxes. Capital expenses include the following categories:

Business Buildings. Real estate that you purchase for business purposes.

Leasehold Improvements. Improvements you make (with the landlord's permission) to a leased or rented property.

Furnishings. As its name suggests, this expense category refers to all furnishings and fixtures used to improve both the working and the decorative environment of your business.

Equipment and Props. This grouping includes all major equipment and prop items that have a useful life of more than one year. Like all of the items listed here, their cost will be expensed through depreciation. Less expensive props and equipment (under $200) may be expensed immediately, as may more expensive items that you can prove will be used up within a year.

Business Vehicles. Any vehicle used exclusively for

CAPITAL-EXPENSE BUDGET FOR PART-TIME WEDDING PHOTOGRAPHER*	
Camera, back, viewfinder	$3,000
Lenses: standard, wide angle, medium telephoto	$4,000
Back-up body and lens (used)	$3,000
Two flash units with external battery packs (one for back-up) @ $300	$600
Miscellaneous brackets, cases, meters, etc.	$1,000
Twenty display prints (@ an average price of $125)	$2,500
Twenty frames (@ an average price of $60)	$1,200
Four display albums @ $400	$1,600
Miscellaneous album covers, leaves, etc.	$1,000
TOTAL	$17,900

*This photographer shoots all the photographs at the wedding and meets prospects in their own home.

business purposes. If you use your own automobile for work purposes, you must keep a record in accordance with IRS rules in order to deduct an allowable amount from your business income.

The charts on page 16 show two capital-expense budgets. The first pertains to a hypothetical studio portrait/wedding business that involves the construction of an office/camera-room addition to a home. The second budget summarizes the capital expenses for a part-time business that involves no studio building.

DEPRECIATION

Undoubtedly the most difficult concepts for any businessperson to understand are how to expense capital purchases through depreciation and what effect depreciation has on both the net worth and cash flow of the business. Many people, including some accountants, dwell on the capacity of depreciation to generate tax savings. The danger with this kind of thinking is that for every tax savings you acquire through depreciation that isn't offset by income, you can lose part of your original capital investment. This can be tragic for individuals who invest their life savings in a business only to find, several years later, that most of the investment has "depreciated" away.

The object of any investment, whether in the form of a business, securities, or savings accounts, is twofold. You want to earn interest or a "return" on your investment, and you want to have the original sum invested remain intact for the duration of the investment. So it is crucial that as you plan your investment in capital assets, you understand how to manage depreciation.

Strictly speaking, depreciation is the federal government's method of allowing you to deduct as a "general expense" the cost of a capital asset over a period of time that is designated as the life expectancy of that item. The government does this in lieu of permitting you to deduct the entire cost of certain capital items as a general expense against income for the year in which you purchased them. These include such items as buildings, improvements, vehicles, equipment, furniture, and fixtures.

Bankers also use depreciation as a way to calculate the value of your business. The more accumulated depreciation that shows on your balance sheet, the less paper value, or equity, the bank will assign to your business. This becomes important when you apply for a bank loan or seek a buyer for your business. Three types of depreciation methods are available to business owners.

Straight-line Depreciation. This system is the most conservative method. Here, the cost of a capital item is divided evenly for the duration of the recovery period. For example, a $15,000 automobile, which can be expensed over a three-year period, will be depreciated at a rate of $5,000 per year in non-cash expenses that offset studio income.

Modified Accelerated Depreciation. Through this system, an asset depreciates by a variable amount each year over the lifetime of the item, according to a rate that the IRS establishes for that particular type of asset.

Accelerated Depreciation. Recent changes in the federal tax code have enabled business owners to expense a stipulated dollar amount of capital expense each year. This amount, which is referred to as accelerated depreciation, can change as tax codes are revised. At present, this figure is $17,000. When you file your income tax, your accountant is likely to ask if you wish to take advantage of accelerated depreciation as a means of lowering your taxable income, or as a way of creating a business loss to offset other income. The best rule of thumb regarding this issue is to accelerate your depreciation if your business is showing a profit, but to elect straight-line depreciation if your business is showing a loss.

A prudent way to safeguard the money you've invested in your business is simply to write a check to yourself each month for 1/12 of the amount of depreciation you're entitled to expense during the fiscal year. Your accountant can provide this figure for you, although you should be familiar with your depreciation schedule. Then take this monthly check, and deposit it in a money-market account in your business name. Be aware, though, that this practice effectively places an additional strain on your checkbook. And this, in turn, places a subtle, psychological pressure on you to drum up additional business to cover the depreciation check. What you're doing, in essence, is creating sufficient business to reimburse yourself for the money you spent making capital purchases for your business. This is exactly what you would face if you were paying back a bank loan for the start-up money you borrowed from that institution. You're simply paying yourself back instead of paying the bank.

CHAPTER 3

DETERMINING YOUR MARKETING OBJECTIVES

Every new photography-business owner faces the same dilemmas: What do I do first? Do I devote myself to improving my photography so that clients will want to use my services? Do I concentrate on promoting my photography so that I can afford to stay in business? When will I find the time to plan management strategies that will ensure my profitability?

To operate a successful business, owners must continually juggle all of these important business functions, making progress simultaneously in each vital area. This is particularly difficult for photographers who start out on their own, which many aspiring wedding photographers do, frequently on a part-time basis. To have a successful career in wedding photography, independent business owners must assume three vital roles. They must serve as technicians who create photographs, entrepreneurs who recognize and capitalize on business opportunities, and managers who bring structure and discipline to the business.

Often, however, what is good for one function of the business conflicts with the best interests of one or both of the other two functions. For example, the entrepreneur wants to go to school to learn a new style of photography that will increase business. At the same time, the technician already feels overworked with the current client volume, and the manager complains that there isn't enough money in the budget to cover the tuition. While a clearly defined marketing strategy isn't a cure-all for this complex situation, it will help to prevent wasted effort. Good marketing begins with an understanding of its fundamentals.

UNDERSTANDING THE MARKETING MIX

Marketing is an ongoing process that involves several steps. These include:

- Identifying who you want for customers
- Determining the needs and wants of these customers
- Creating products and services that will fulfill the customers' needs and wants
- Finding ways to create a demand for these products and services
- Selling and servicing the customers in a way that makes them want to use your services again and/or refer your business to other potential consumers

The components involved in implementing an effective marketing strategy are referred to as the "marketing mix" or the "4 Ps of Marketing": product, promotion, place, and price.

PRODUCT

The most important questions any new business owner must answer are: What do you plan to sell? Who do you plan to sell it to? What is your experience (or the experience of others) in successfully selling this product to your targeted market? Who is your competition? The answers to these questions will help you define the market segment you want to reach: low-income, middle-income, or high-income clients, or a mixture of income levels. This decision will dictate the type of product you sell, from economy coverage and inexpensive albums to full-coverage service that includes top-quality bound albums and a full line of wedding-photography accessories.

PROMOTION

Promotion, which is central to effective marketing, involves a variety of methods of communication between a seller and prospective buyers. Effective promotion informs buyers that the seller has the right product at the right price at the right time in the right place. The message to be communicated is intended to inform potential buyers how the seller's products and services meet their requirements. Promotion succeeds when, during the communication process, it leads buyers

to want to know more about how to obtain the seller's goods or services.

PLACE

The place in which you do business is an important part of the marketing mix. You must choose an appropriate business environment, in terms of both location and atmosphere, to support the products and services you intend to sell, as well as the clients you expect to purchase them.

PRICE

Within the marketing mix, price is a critical component because of its ability to communicate information that is of interest to potential clients. As an important indicator of value, price can be expressed through the following equation: Benefit divided by price equals value. Consumers continually weigh the benefits of a product or service in relation to its price. If the value they assign to a product's benefits outweighs its price, they'll buy it.

Price also serves as an attention-getting device. You can attract clients away from your competitors when you use price to advertise an especially good value. The manipulation of price—downward or upward—can generate or control business volume.

TARGETING YOUR IDEAL CLIENT

One indicator of a successful business is the management's ability to define the demographic characteristics of the clients the business is designed to serve. This classification forms the basis of both operational and marketing plans for the business. First, it establishes how the business will position itself in terms of its volume-pricing structure. This, in turn, affects the way the management will market the business to the public. Photography studios that offer wedding photography—either as the sole product line or as one of several product lines—generally fall into one of three volume-price categories.

HIGH VOLUME, LOW PRICE

For clients who patronize this type of low-end business, price alone is likely to be enough of a reason to book their wedding coverage. The marketing plan that supports this segment of the wedding market features cost most prominently in relation to the benefits the business offers. While a claim of quality might be mentioned, it is only incidental to the attribute of price. Newcomers to wedding photography often use low prices to establish a customer base that helps to put their business on the map. When their abilities and reputations improve, many raise their prices as a means of controlling volume.

LOW VOLUME, HIGH PRICE

Consumers who want "something different" or "the best money can buy" are willing to pay the price. Affluent clients are easy to identify through mailing lists that target income levels, geographical areas that feature upscale housing, and client lists of such upscale businesses as country clubs and fashion boutiques. The marketing package that supports this target conveys a sense of quality, service, and even snob appeal. The design and copy quality of marketing materials must convey these values. The drawback to servicing this market segment is that small and midsize communities might not have a population base large enough to support an upscale business.

MEDIUM VOLUME, MEDIUM PRICE

Most photographic businesses, including wedding studios, fall into this volume-price category. Unfortunately, customer profiles in this vast segment are far more difficult to define because perceptions of quality and value vary widely from prospect to prospect. Some wedding couples are more price-oriented than others who are willing to spend more—provided they perceive the higher price to be indicative of better quality and service.

The marketing challenge involving this segment is twofold. You must create a promotional presence geared toward an ideal client for whom quality is the most essential attribute. At the same time, you must promise value to the middle-class couple for whom both quality and value are important considerations. To such clients, quality is worth more, but the critical question is: How much more? Compounding this challenge is the fact that competition is, by definition, greatest in this middle- to upper-middle-class segment. A good marketing strategy for a business catering to this segment is to stress why and how its product and service are better than or different from those of the competition.

STRESS BENEFITS NOT FEATURES

Regardless of the market segment a business targets, the foundation of a successful marketing program rests on the firm's ability to identify and translate each of its product or service features into a discernible customer benefit. The following contrasts should help you understand the difference between benefits and features.

Feature. A wedding album containing 36 8 x 10 color photographs.

Benefit. Your wedding album will capture the emotion, excitement, and beauty of the most romantic day of your life.

Feature. A 16 x 20 wall portrait from your prenuptial session.

Benefit. An artistic piece of wall decor that you'll treasure today and hand down to future generations as a valuable family heirloom. The importance of differentiating between features and benefits is that the more benefits the consumer can identify as having personal meaning, the more likely it is that the consumer will patronize your business.

DISTINGUISHING YOUR PRODUCTS AND SERVICES

The goal of any marketing program is to create a line of products that will meet the needs of an ideal market population. An essential part of this strategy is to develop products with discernible differences. And when a studio distinguishes its services from those of competitors, it effectively positions itself against that competition. This position is strengthened every time the studio successfully assigns added value to its products and services, and/or introduces products and services that the competition doesn't offer.

WEDDING-PHOTOGRAPHY PRODUCTS

Most wedding photographers offer a similar range of wedding-photography goods and services, although some of the photographers profiled in this volume have improved their profitability by introducing innovative products. Never before have aspiring wedding photographers had such a variety of products to choose from. Profitable studios recognize a vast extended market, beyond the bride and groom, who are logical clients for certain wedding-photography products.

ALBUMS

The bride and groom's album is the traditional centerpiece of any collection of wedding photography. Most couples keep their album on display for many months, sometimes even years, after the wedding day. It is the means by which they fondly recall the events of their wedding day, and it provides them with an opportunity to relive the day when shared with family and friends. Sales of additional smaller albums for family members also are an important way to build profits.

Bride and Groom's Album. The usual options for the couple's album are: a single album containing 8 x 10 or 10 x 10 enlargements; a single album presented as a "storybook" that includes a variety of image sizes; and multiple-album (two or more albums) sets, which can consist of a volume of portraits and a volume that provides photojournalistic coverage of the wedding day's events. Increasingly, photographers are enhancing the presentation of the bride and groom's

album through a variety of photographic media. These include black-and-white, handtinted, infrared, and special-effect images, as well as custom matting of individual pages and two-page, panoramic spreads. The couple's album remains the primary focus for the studio when it comes to booking the wedding; however, this album is merely the tip of the wedding iceberg for enterprising wedding photographers.

Parent Albums. For many years, studios commonly offered two kinds of parent albums. One type matched the couple's album exactly. The other was a less expensive, alternative album filled with a limited selection of 4 x 5 or 5 x 5 images or proofs left over from the initial preview set. Many successful studios now offer much more extravagant parent albums. These albums are sold in many different sizes and configurations, ranging from 4 x 5 through 8 x 10 and containing a variety of image sizes.

Albums for Other Family Members. The recent marketing trend of maximizing wedding-event sales by offering wedding products to an ever-expanding market has resulted in some studios selling albums specifically for grandparents and other special family members, such as siblings. Album companies now routinely provide album inscriptions that read, for example, "My Grandson's Wedding" and "My Sister's Wedding."

WALL PORTRAITS AND INDIVIDUAL PRINTS

One of the most exciting aspects of wedding photography is creating images that ultimately become decorative focal points in the home of the bride and groom. Most couples also choose smaller, individual images to use as decorative table or bookcase accents, and many create groupings of images that serve as wall accents.

For the Bride and Groom. Many photographers strive to create artistically conceived images of the bride and groom as a means of increasing profits through sales of decorative wall decor for the bridal couple's new home. Subject matter includes interpretive, romantic poses of the couple; pictorial images that present the couple in an attractive outdoor or architectural environment; and casual, romantic, "engagement-session" portraits of the bride and groom in a variety of poses and locations.

For Parents. For many families, the bridal portrait remains an honored family tradition for the bride's parents; however, as more photographers understand the importance of catering to the groom and his family, they discover that the groom's parents are eager to purchase wall portraits of the groom or of the bride and groom.

For Family Members. Family portraits created on the wedding day also facilitate sales of wall portraits and multiple-print sets to family members. Some photography studios offer a complimentary, pre-wedding, family-portrait session for the families of the bride and groom as part of their wedding-photography service. These images represent excellent opportunities for wall-portrait sales.

For Bridal-Party Members and Wedding Guests. Members of the wedding party—alone or with their spouses, significant others, and even siblings—provide additional opportunities for wall-portrait and print sales for photographers willing to predetermine the possibilities that exist among the wedding participants and attendees.

GIFT FOLIOS

Gift folios that include two or more photographs serve as appropriate thank-you gifts for wedding-party members, family members, and the bridal couple's special friends.

HOLIDAY CARDS AND THANK-YOU CARDS

Holiday cards featuring a wedding portrait appeal to both the bride and groom and their families. Often the bridal couple will purchase notecards that feature a wedding portrait to send as thank-you notes for wedding gifts.

ALBUM UPGRADES AND FRAMES

Offering a top-of-the-line, library-bound album as an upgrade can add to wedding revenues, as can a line of wall portrait and desk-size frames. In a library-bound album, the photographs are bound directly into the spine by the album manufacturer, as opposed to the photographer placing the photograph into a page that is inserted into the album.

MISCELLANEOUS BRIDAL MERCHANDISE AND SERVICES

Because studios become the focal point for so many prenuptial plans, it is both logical and profitable to carry photography-related wedding products. These include engagement-announcement cards, wedding announcements, "photo sculptures," and even bridal specialty merchandise and wedding-planning services. Photo sculptures are photographs bonded to a foam-core material and then jigsaw-cut around the primary subject matter of the image to create a three-dimensional presentation. A bridal registry enables studios to target wedding guests who wish to purchase wedding photography as a gift for the bride and groom.

ESTABLISHING A UNIQUE SELLING PROPOSITION

If you are a prospective wedding photographer and have defined your intended market and the products you plan to sell, the next step toward creating a cohesive marketing strategy is to establish your "Unique Selling Proposition" (USP). This is a concise statement that declares what you do best and why you stand above your competition. A USP represents what should come to mind when a prospect thinks about purchasing wedding photography. If you serve more than one market, you'll have to develop a USP for each market segment.

Among the attributes to consider in creating this expanded statement of purpose include:

• What you do
• Who you serve
• Why you are unique
• The advantages of doing business with your studio
• Your quality
• What you do best
• Areas in which you specialize
• Your distinctive style
• Your dedication and commitment
• Why you should be trusted
• The pride you take in your work
• Your competitive prices
• The range of options you offer
• Your location
• Your reputation

The following is an example of a USP that can form the basis of a dynamic marketing plan:

> Our studio serves discriminating wedding couples who value creative portrait artistry and emotion-filled candids that capture the love, emotion, and excitement of your wedding day. Our handcrafted albums and distinctive wall portraits are decorative focal points in fine homes throughout the East Coast. We take pride in the fact that the high degree of service we provide to our customers results in ongoing client referrals and recognition from other wedding professionals who consider our studio to be the leader in artistic innovation and quality customer service.

Keep in mind that as your wedding-photography business grows and changes, so will your USP.

CHOOSING A BUSINESS LOCATION

Among the many elements that affect where wedding photographers choose to establish a business location are: the characteristics of the desired target market; the proximity to this ideal clientele; and the photographers' financial position, level of experience, and family lifestyle. If you are an aspiring photographer or one who is ready to relocate your business, these and other factors will dictate where you'll decide to open your business.

You might opt to work in your home or at a commercial location; to establish your business in an inner city or closer to an area that supports recreational activities you and you family enjoy; or to select a suburban location that is pleasant for family living and convenient to adjacent suburban populations. An inexperienced photographer might be wise to gain experience while working in a home studio that requires little capital investment or overhead expense. Of course, these various business-location possibilities have both advantages and disadvantages.

OPERATING A BUSINESS AT HOME

Since the majority of wedding photographers start out by working part-time, most begin by working at home. Many continue to do so throughout their careers. There are numerous advantages to operating a business at home. Not the least of these is significant savings in both start-up investment and general expenses that help to lessen the risk of going into business. In addition to enabling photographers to gain experience while earning a regular paycheck, a home business can, in some cases, eliminate the problems associated with finding reputable child care.

There are, however, some disadvantages to this business arrangement. A home business can encroach physically on family space. It is also difficult to enforce regular business hours, which sometimes leaves the owner with a feeling of being on call at all hours. Furthermore, a home location can hinder business development if it is hard for prospective clients to find or if the home itself doesn't present an image that is compatible with the target clientele.

If you choose the option of a home studio, you must define what percentage of your home will be living space and what percentage the business will use. This division will become important when you calculate business expenses when you file income taxes. You're entitled to deduct as business expenses the established percentage of utility, property-tax, and insurance payments for the portion of your home used exclusively for business. You must also remember to calculate depreciation on any business improvements made to your property, as well as have your business make monthly rental payments to you as the landlord.

Paying rent to yourself is one of the most important steps you can take to establish yourself as a bona-fide business entity. Without having to cover rental payments, you can charge less for your product, but your prices won't reflect the true cost of doing business. In fact, they'll be unrealistically low. What would happen, for example, if you had to vacate your home studio because of property damage? You would be forced to find another location and pay rent to a landlord other than yourself. As a result, you would have to raise your prices immediately in order to reflect the cost of doing business at the new location.

Another way to look at paying rent to yourself is to consider the space you use in your home as a commercial asset. If you didn't occupy the space yourself, you could rent it to another businessperson. So when you don't pay rent for the space you no longer use for yourself and your family, you're just cheating yourself. Also, keep in mind that all moneys paid to you as rent aren't classified as earned income, so they are free of Social-Security and unemployment-compensation taxes.

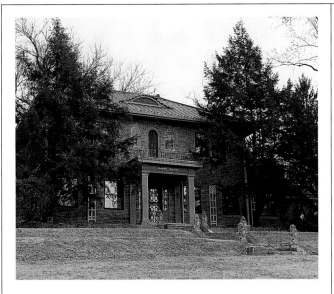

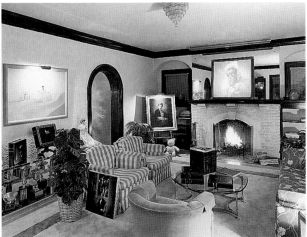

David Ziser succeeds in creating a cozy atmosphere in his consultation room (bottom). Both his studio and home are located in a stately, residential facility in Edgewood, Kentucky (top).

CHOOSING A COMMERCIAL LOCATION

Operating a studio at a commercial location provides increased visibility in the market and gives owners more choices in terms of business growth and community image. The options for operating at a commercial location include leasing a commercial property, purchasing a commercial property, buying an existing studio, or building a new studio from scratch. The investment capital needed for each of these possibilities varies considerably, and each choice has inherent advantages and risks.

Most wedding photographers who make the move to a commercial location discover that they can't sustain the higher overhead by wedding-photography income alone; consequently, they must expand their business to include various portraiture product lines. These new product lines, in turn, usually mean adding one or more additional staff members, which, of course, increases overhead expense.

Before making any part-time or full-time business move that will involve commitment of capital, you should consult several financial management experts who are well versed on the subject of small businesses. Local business owners of good standing, particularly those who operate businesses that sell discretionary merchandise, such as gift boutiques, fine home-furnishings shops, and jewelry stores, can be helpful. A small-business consultant is another possibility, but your best bet is to hire a photographer with a long-standing track record of financial success to advise you on all aspects of your business plan. Don't sign anything that commits you to a building lease or purchase arrangement until a lawyer studies the agreement and makes certain that you can fulfill the legal obligations of business ownership. These include license fees, occupancy permits, and zoning variances.

It bears repeating that when home-studio photographers make the move to a purchased or leased business facility, they're making a serious commitment that nearly always results in lifestyle changes. The additional expense of the new facility requires more sales in order to support the studio, and this fact inevitably means more hours on the job. Before you make your move, make sure that you not only have the potential to increase your earnings, but also that you can handle the additional stress of managing a bigger business. If not, you could fall victim to financial calamity or business burn-out.

CHOOSING A NONTRADITIONAL LOCATION

Photographers who have few prospects for raising start-up capital should consider a nontraditional business location that reduces overhead costs. Such an arrangement also can shield novice photographers from the financial risk of investing large amounts of capital in a fledgling business that may take several years to develop a profitable client base. For example, other professionals who deal with the wedding trade, such as florists and bridal-shop owners, may have excess floor space that they would be willing to rent to you as a location where you can meet with prospective clients and even photograph formal wedding portraits. This kind of arrangement would be mutually beneficial. The store owner receives income to offset overhead expenses, and you gain the prestige of associating with an allied professional—in a professional setting—without the risk of a lease or ownership situation. You might even consider sharing facilities with another photographer, provided that your businesses are compatible. This type of nonpartnership pairing is on the rise because of the high overhead of commercial business locations.

Another possibility is setting up shop in a "business incubator." This type of facility is usually supported either by a local or regional business-development

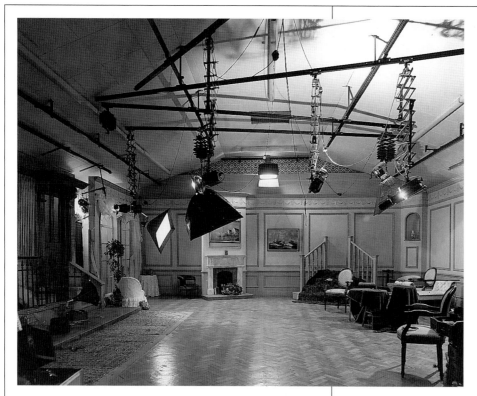

consortium or by independent entrepreneurs. The purpose of the incubator is to provide start-up businesses with low-rent office facilities in a building that houses such centralized services as a conference room, a reception area, copy and fax machines, and kitchen facilities that all the tenants share. Thus, the incubator provides new businesses with a professional facility without the usual start-up costs in a more "sheltered" situation that can nurture the business until its trade can sustain an independent location.

The ultimate low-overhead situation is to operate the business from your home while conducting all meetings with prospective and current clients at their homes. This enables you to reduce overhead expenses substantially. In addition, you can promote this way of doing business as a customer-service feature that responds to the busy lifestyle of brides, grooms, and their parents. Operating a business in this manner requires that you carry appropriate samples, and that you conduct yourself in a business-like manner, from how you dress to how you create your sales presentation. You also must be prepared to work with portable backgrounds and lighting equipment so that you can make portraits of the bride at her home, should this service be part of your wedding-photography plans.

MINIMAL FACILITY REQUIREMENTS

Whether you decide to run your business out of your home or at a commercial location, you should be aware of the space requirements needed to operate it efficiently. A work area should enhance or facilitate your business image, merchandising and sales, and

work flow. To accomplish this end, a studio generally must be large enough to support the following:

- Reception/waiting/display area
- Camera room (assuming that your wedding business includes shooting formal portraits of the bride and/or bride and groom)
- Projection/sales/conference area (in some cases, the camera room can double as a sales area)
- Dressing room/restroom
- Workroom/production area
- Storage area for props and miscellaneous equipment

It would be difficult to meet these requirements in an area smaller than 1,000 square feet in size. The image of your business is directly related to what clients observe when they visit your studio. Furnishings need not be lavish, but they must be tasteful, functional, in good repair, and part of a coordinated design. You'll probably save money in the long run if you use the services of an interior designer who can suggest floor plans and furnishings and coordinate a color scheme. You might look for a designer who is willing to do your planning in exchange for photographs of some interiors that the designer has created.

Plan your studio to expedite both merchandising and sales. This means providing areas where prospective customers can readily view all of the products you sell and where you can meet privately with clients during planning or sales sessions. You must also give some thought to work flow when planning your facilities. A workroom needs plenty of counters for assembling orders and framing, as well as storage shelves and cabinet space. Work flow is equally important

when planning your camera room. This space must be large enough to permit you to work efficiently.

As a general rule, a camera room is large enough when it can accommodate props, lighting equipment, cameras, and subjects without infringing on the area needed to light and photograph the given subject or subjects. This space, of course, varies according to the subject matter the photographer intends to shoot. In order for you to shoot full-length bridal portraits with a 127mm lens on a Mamiya RB or RZ67 camera, your camera room must be a minimum of 20 to 25 feet long. If your work area is limited, you can create full-length portraits in a smaller amount of space with a 90mm lens. You can shoot a full-length group portrait of as many as 12 adults with a 127mm lens in a camera room measuring 30 feet long and 15 feet wide. Ceilings that are 10 feet high are ideal, but 8-foot ceilings are workable.

THE IDEAL ENVIRONMENT

Accomplished wedding photographers agree that a vital component of their success flows from a commitment to create an environment that not only presents an image of competence and professionalism, but also raises the comfort level of prospective clients when they visit the studio to inquire about wedding-photography services. These photographers agree that achieving an atmosphere that inspires trust and confidence is paramount when it comes to booking the wedding. Customers must believe in the studio photographer's ability to live up to the promise of artfully recording the most important day in their lives.

For example, California photographer Gary Fong believes that his choice of location is perfect for the upscale clientele he serves. His studio is located in a 16-story office complex near the Los Angeles Airport, between the Los Angeles Hilton and the Los Angeles Airport Marriott. Fong explains:

There are many reasons I selected this particular building. As we derive all of our work from referrals, it didn't make sense to have a retail or storefront location. I believe that wedding photography is more of a professional service than a retail one; therefore, a professional photographer's office should have a similar atmosphere as, for example, a law firm. Professional competence and appearance are critical, and that is why the impression your place of business makes is so important.

The reason why a couple books a photographer is directly related to how comfortable they feel with the photographer. Clients look to their wedding photographer for more than just photographs. They deserve to have an entertaining experience while being with us.

Therefore, when I designed my studio, I had in mind an office that embodied the characteristics of a living room as well as a gallery. Bearing in mind that the strongest impression on a prospective client is achieved when he or she walks through the door, we designed the studio to have an impressive entry. It is important that the client be impressed, but also feel at home. So we brew fresh, imported Swedish and Hawaiian coffees in the morning, and fresh flowers are delivered by our wedding florist once a week. For album-design sessions that go into the dinner hour, the nearby Hilton Hotel offers room service to our suite. For colors, I selected a combination of muted gray, warm gray, royal purple, and mauve. This color combination reflects the way the studio is organized to combine the look of a gallery and an opulent residence.

Similarly, Texas photographer Alvin Gee established his studio in an office complex in a west Houston business district. The studio is positioned to take advantage of the traffic generated from his proximity to the career professionals he targets for his wedding and portraiture business. Gee reveals his thinking:

This is our tenth year in the office building. There are many high-powered men and women working in the downtown area, and many come in for business portraits. This opens the door to long-term client relationships through family portraits and wedding photography. There are a lot of home studios and studios in shopping centers in Houston, but the business-office situation works nicely for me. It is really helpful not to worry about janitorial services and trash hauling because this is provided by the business center. It is also comforting to know that if the neighborhood starts to go bad, you can simply move your business to a better part of town.

Monte Clay & Associates is truly "The House That Weddings Built." A 1991 fire in the studio's spray booth necessitated a complete renovation of the interior. The restored facility consists of six levels and is a showcase for the firm's wedding and portrait photography. According to Clay:

People are very impressed when they come in. I think the message they get helps to confirm that they're working with a first-class organization. For the clientele we serve, we must be able to cater to them and pamper them, and our studio facility must reflect this attitude.

An important aspect of our studio organization is the network of computers. We couldn't do without our computers, which we expect to become even more important as we move into the age of digital photography. Eventually, we

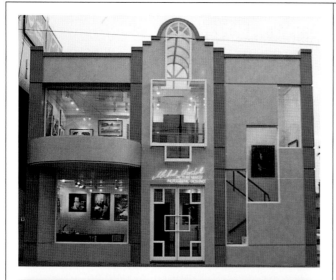

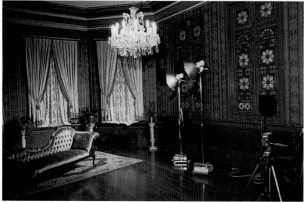

Australian photographer Michael Warshall operates two distinctly different studio facilities in the suburbs of Melbourne. One is high-tech and ultramodern (top), while the other is located in a century-old Victorian mansion (bottom).

expect to have an "event station" composed of a digital camera and the hardware and software required to produce high-quality, dye-sublimation prints. We look forward to adding this equipment to our facilities.

When Bruce and Sue Hudson built their dream studio in Renton, Washington, a suburb of Seattle, their goal was to create what Sue describes as "a professional-looking building that has an 'expensive-but-worth-it' image." They realized their goal in November 1986, when they purchased a run-down, 50-year-old house on 1.3 acres of commercially zoned land. In February 1988, the newly renovated studio opened. Sue describes their studio:

The building itself is approximately 4,000 square feet, and we've turned the land into our own personal "back lot," which we market as "Hudson's exclusive 1-acre portrait park."

Australian photographer Michael Warshall operates two studios with vastly different designs, which he describes:

At our Elsternwick studio, you will find the latest in facilities, architecturally designed as a photographic studio. It was specially created to provide the ultimate in service and quality for the discerning portrait/wedding client and includes the latest in high-tech video production facilities. The studio, which is designed in shades of black, white, and gray, in an ultra-modern style, complements our 100-year-old Victorian mansion, Broadhinton, which provides an old-world setting for those who prefer classic and outdoor photography.

Maryland photographer Calvin Hayes is similarly proud of his innovative studio, which is centrally located in a busy section of Baltimore, Maryland. He explains:

I think I've got the best-looking studio in town. It is a great location. You can't miss it because it sits right at the "gateway" to the Baltimore Inner Harbor, and there is plenty of parking. Originally, the building was a vinegar plant, then a warehouse. Ships were repaired 50 feet from the studio. The building has a marble entrance with fine, beautifully finished handles on the door. It is constructed of brick, with 16-foot ceilings. It has lots of glass and wooden beams, and we've stuccoed the walls.

My goal was to create an artistic environment in which clients could relax. I meet with clients in "the entertainment room." It has a bar, a stereo system, and a television hooked to a satellite system. There are no photographs on the wall because I want to promote myself and not the photography. One of the "Guerrilla Marketing" ideas I've adopted is a "Cafe Calvin Menu" that clients can pick up in the entertainment room. I offer light snacks and Famous Amos cookies that I give to them as a parting gift, thanking them for stopping by. This is a diversion that helps to relax the prospective clients and something that helps to keep my name in front of the public.

The 800-square-foot shooting area is a cyclorama that we call the "fashion booth." It is a curved white wall that is set up for high key. Nearby is a 700-square-foot dressing room and makeup area. We're now building a second cyclorama that will be large enough to photograph an automobile.

DESIGNING THE ALBUM

Gone are the days when a wedding album consisted of a series of stiffly posed 8 x 10 "candids" mounted in the windows of an inexpensive, white-vinyl album. Today, the layout, design, and construction of the album or album set have evolved into an art unto itself. Smart marketers have learned to exploit their innovative design skills as a powerful means of establishing a promotional advantage over their competitors.

Creative album design has become part of the marketing mix because it influences the function of three of marketing's fundamental precepts: product, promotion, and price. Artistically conceived albums become "new" products that many prospective clients will value for their uniqueness when properly promoted. When studios succeed in creating a demand for this specialized product, it is possible for them to charge a premium price. In this chapter, studio owners who have gained a reputation for album-design innovation reveal how they approach this artistic and profit-enhancing aspect of their wedding photography businesses.

CREATING A CLIENT ALBUM

Stewart and Susan Powers of Gainesville, Florida, have earned an impressive list of awards for their eye-catching wedding albums in national, regional, and statewide competitions, including a 1995 entry that received the first perfect score of 100 to be awarded in the state of Florida. The same album went on to score 100 in 1996 in the international wedding-album competitions of both Professional Photographers of America (PPA) and Wedding and Portrait Photographers International (WPPI). According to Susan, their commitment to creative album design affects every aspect of their business, from promotion and customer service through photographic sessions and product sales.

EXPLAINING PRODUCT OPTIONS

According to the Powers, creative album design can be accomplished only by way of understanding the couple's vision of the wedding, arriving at a concept or vision for the album, and planning how each image will be approached on the day of the wedding. Susan explains how she and her husband approach the design of their storytelling albums:

In most cases, we actually have a concept of the size of the album before we create the images. This is a byproduct of our "menu system" of pricing, which allows clients to choose a wedding coverage that exactly fits their needs and desires. When meeting with the couples, I explain every single product we offer through our menu system, and I ask them what their thoughts are about such features as enlargements and panorama spreads, as they must be planned. In addition to the 5 x 5 prints, couples can choose anywhere between 20 and 140 enlargements for one album or a two-album set.

For example, if a couple chooses two panoramas—an illustrative image of the bridal party and an illustration of the bride and groom together—I would explain that we must plan these images ahead of time because the panorama is shot as an extreme horizontal or vertical format. We must make certain that the subject matter in the panorama never fills more than half the width or height of the frame. Even though these are wide shots, Stewart prefers to use the longest lens he can because we like the effect of the background compression. Then we just take a slice out of the negative to create the panorama.

EXPLAINING THE STORYTELLING CONCEPT

According to Susan Powers, it is smart to explain to the couple how important storytelling is to the success

of a wedding album. This concept becomes the standard by which the couple will measure how well the album communicates the unique story of their wedding day. She explains:

> I tell the couple that what we intend to do is to create a story that is expressed in the album. I tell them that we'll be "writing a book." But we'll create visual images instead of word images. For example, the first image in the album will set the stage for where the events of the wedding take place. Usually this means that we'll present the wedding invitation arranged among wedding flowers because you can read the names of the couple and the location of the wedding.

Next, we introduce the key players through enlargements. How "in depth" we go with these enlargements is a function of how much the couple wishes to invest. In our area, we don't have very many affluent clients, and the most that some of them can afford is a maximum of 20 enlargements. But that is enough to tell the highlights of the wedding story when they're blended with smaller images. Early on, I inform the couple that in my opinion the most important album enlargements occur in the following order of priority: portraits of the bride and groom together; individuals of the bride and groom, the family members, and the bridal party; and, finally, the candid images.

A good way to choose the enlargements, I tell them, is to think in terms of how they would feel if they'd discovered an album of their grandparents' wedding in an old trunk in the attic. I ask them, "Which of the portraits would have the most meaning to you?" These, then, are the images they should choose for their enlargements. Candids are fine, but from the point of view of lasting value, the couple's children and grandchildren are more likely to preserve the really beautiful images of their family members.

ARRANGING THE PREVIEW ALBUM

Susan Powers maintains that the arrangement of the preview album is critical to the success of creating an album that ultimately will portray the essence of the wedding-day events in a storytelling sequence. She explains:

> We arrange the preview album in a chronological order, in a storytelling sequence, so that it becomes evident that we photograph in matching

This series of images is typical of the storytelling style of Stewart and Susan Powers. They achieve this by carefully planning how they'll shoot the wedding-day events. The photographers strive to make each set of facing pages reveal a completed thought. As Susan explains, "Each set of pages is a 'paragraph' in the wedding story. Taken as a whole, you should be able to walk through the events of the day without having to ask questions. Wedding storybooks designed this way are personal, historical documents and priceless heirlooms."

This wedding-album spread shows off Cindy Faust's skill at combining multiple images to create panoramic collages and custom-designed mats.

pages, with the bride facing toward the right and the groom facing to the left, etc. When we have only one direction of light, that means we sometimes have to flop the negative. As we photograph, we also are making a series of images, so we can enlarge a dominant image, with three or four companion images to compose a two-page spread. I look at a two-page spread as being a "paragraph" or as a completed thought.

The design process itself takes place during a preview return appointment that usually runs about an hour and a half. Susan prefers to keep the process simple:

> I draw an imaginary line on the floor of our gallery and tell the couple to think of the line as the spine of the album. Then we use the previews to lay out the book in facing pages, so that the couple can see exactly how their album will be organized.

According to Susan, some brides will choose a theme for the wedding. She explains:

> This is a natural part of the bride wanting to have a dream come true. That, after all, is the number-one job of photographers. Making pictures isn't the issue. The successful photographer is a storyteller. I tell brides that our mission statement is "to create a body of work that is so rich in imagery and so complete in its storytelling that anyone who looks at the album—your children someday, or friends or relatives who weren't at the wedding—they'll know not only what happened this day—who you were with and what you did—they also will know about your dreams."

CREATING A SALON ALBUM

When Stewart and Susan Powers's salon album scored a perfect 100 in 1995 and 1996 album competitions, it set a standard for wedding-album-design excellence. Susan explains how she and Stewart approached the design of this album:

> Like some of our more elaborate albums that have received exceptional salon scores, this album included segments photographed before the wedding to tell a story of the courtship and pre-wedding preparations. The album begins with poetry and presents the groom's proposal to the bride in several pages that also include poetry, then it makes a transition to the mother sewing banners for the church, the bride having her hair done, the events of the wedding day, and finally the dawn of the next morning. All of the preliminary photographs appear in black and white. The poetry is done by calligraphy on drafting vellum.
>
> The vellum is transparent and appears as fly sheets between the album pages. When you open the book, you see the poetry appearing over the pages. I wrote the poetry from the story they told me about how they met. This album has 24 hours of shooting in it, at eight different location sessions, on four different days. The bride had seen several of our previous PPA loan-collection albums, and she said she wanted her wedding album to look like they did.

Susan is quick to point out the difference between laying out a client's album and a salon album:

> A competition album must have no repetition,

whereas in the bride's album, she may want different expressions in the same view of the face. That is fine because you're presenting the album for maximum sales, whereas in a salon album, every spread should be a "Wow!"

Although a salon album for competition takes time and money to create, Susan and Stewart Powers believe that scoring well in professional competition has had a marked effect on their business. As Susan says:

Salon albums function on a lot of levels. Our very first album entry scored a third place in the state competition, and for the entire year we advertised that we had one of the top three albums in the state of Florida. This great publicity definitely helped our business to grow. At our next competition, the judges had many criticisms of our work, and we were quite disappointed. But we learned something important about creating effective storytelling albums from a judge's critique: You want your locations to be consistent as you view the double-page spreads. You must be able to "walk" from location to location, not jump around, for example, from an indoor portrait of the bride to an outdoor por-

trait of the groom. The location progression must make visual sense.

We took everything we learned from having our album critiqued, and when we entered the next year we won first place, and have now won first prize for six consecutive years. And as we got better at album design, it became a personal challenge for us to keep improving. Now our goal is to extend the limits of our wedding photography through an emphasis on elegance and romance, without resorting to silly special effects.

The effect on our business has been that couples say they've never seen anything like our albums before—and they want them! What we've found is that when you're showing the finest product you can produce, you'll create the desire of prospective clients to own this level of quality. When we have a high-scoring salon album, you better believe that the bride shows the album to everyone she knows! This reinforces the wisdom of the purchase to that bride as well as other customers who have done business with us.

The Fifth Generation album company has been willing to create the special matting and covers that we need for creative salon competition, and sometimes we'll create special graphic

configurations, such as a diamond shape, where the camera is turned on the diagonal to record the overview of the wedding ceremony. We mount that print on a piece of gold mylar and mount the diamond on a single leaf. However, we don't rely on gimmicks.

I think that is the key to our success: good, solid photography; good, solid layouts; and beautiful images that tell a story. I still consider the photography to be the most important aspect of the album. Creative matting doesn't make up for mediocre photography.

Album design also is an important issue for New Orleans-area photographer Robert Faust, who relies on the artistic talent of his wife, Cindy, to create customized album pages that add originality and drama to each album for the bride and groom. Cindy says that she perfected her album-design skills by attending programs given by other wedding photographers and going to print judgings where she could observe what she liked best about album presentation. Then she added her own original twist to the designs.

According to Cindy, her album-design task is made easier because of Robert's ability to create photographs in series that are easily expressed in a story-telling manner. She explains:

I begin with a series of images that would look nice together on a double-page spread. In most cases, the images shown on the spread are made in the same location, and I choose the most important picture of the series to be the domi-

nant image in the spread. We use Art Leather albums because of the variety of standard mats that are available, but when a series of images suggests a design that can't be accomplished with one of the mats, I must create my own.

First, I decide what the shape of the pictures will be, cut that shape, then use spray glue to affix it to an underlay. To enhance the story-telling theme, I always choose an enlargement of the place where the activity is taking place, such as the church or the reception hall, to use as a transitional photograph. Sometimes we order a few images in several different sizes so that I have some options during the construction process.

In order to help couples understand the design potential of their wedding photographs, Robert and Cindy Faust present the bride and groom with a preview book that is arranged according to the order in which they suggest that the album be arranged. For specially designed pages—those for which special cutting and mounting are involved—Cindy creates a rough sketch to present to the couple for their reaction.

Los Angeles wedding photographer Gary Fong is well known throughout the industry for his innovations in album design and for having created the Art Leather album company's Montage album-design software. Fong and his studio manager/photographer Lisa Coplen are credited with developing a concept of album design that presents the formal portraits of the bride and groom, the wedding party, and family members in one volume, and the complete, uninterrupted

"Family Tree Collage" is one of Bruce and Diane Fleischer's most popular designs. It combines the wedding photographs of the parents of both the bride and groom with a contemporary portrait of the bridal couple.

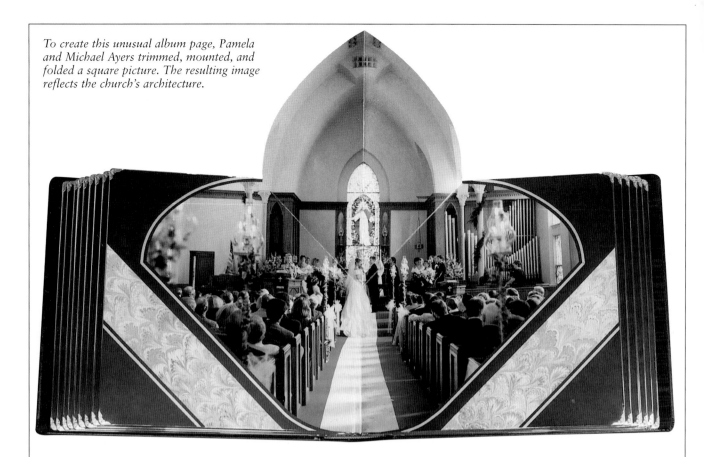

To create this unusual album page, Pamela and Michael Ayers trimmed, mounted, and folded a square picture. The resulting image reflects the church's architecture.

candid story of the wedding day events in a second volume. Fong describes their rationale:

> In designing the "Storybook Album" set, our strategy is to break the wedding day into "Montages." These Montages are best presented in a double-page spread, with the left and right facing pages relating to each other, maintaining a continuous flow. Each Montage contains the elements of a sophisticated publication. When the couple begins to see the wedding day consisting of a series of interconnecting vignettes, the concept of story line and flow begin to fall into place. For the photographer, it becomes much easier to think like a creative storyteller: concentrating on previsualizing and designing each scene.

The benefits of the Storybook Album set are easy for couples to understand. Separating the photojournalism enables them to have two totally different perspectives of the wedding day, in two volumes that have a defined focus. Instead of an album with posed portraiture and unposed candids, awkwardly mixed together in a way that interrupts story flow and continuity, they receive two albums that preserve the intent of each separate style. Therefore, the candid wedding day is presented from start to finish, much like a wedding video, while the portrait album beautifully accomplishes what it says on the spine: a volume dedicated to portraiture.

One of the industry's most innovative wedding photographers, Stephen Rudd of Toronto, has added another dimension to wedding-album design through his creation of "techniqued" photographs that he makes via the use of filters, lens accessories, and screens that can be sandwiched with negatives during the printing process.

The key to designing an album using these techniques is to strike an artistic balance. He explains:

> Don't overdo any single technique. Always leave the viewer with the feeling of "Wow! I wish the photographer had done more like these." If you overdo any technique, you'll risk having the images become ordinary. One thing you can count on is that you won't waste your time or your money on manipulated photographs. The only additional cost is for the filters, lens accessories, and screens. From there, you can order straight machine prints. And you'll find that couples never leave the manipulated images out of their album because they perceive them to be truly the "unique" part of their wedding coverage.

Bruce and Diane Fleischer, whose business, Picture This by Bruce Fleischer, is located in the Washington, DC, metroplex, are making use of rapidly emerging, digital-imaging technology to create imaginatively designed, computer-generated images appropriate for inclusion in the wedding album or as refreshing wall decor.

At the most exotic end of the album-design spectrum is the work of Lima, Ohio, photographer Michael Ayers, the developer of a design discipline that he calls "Album Architecture." Ayers, who studied civil engineering as well as photography in college, has applied his engineering skills to break out of the design limitations imposed by standard album inserts.

As inspiration for their novel designs, Michael and his wife, Pamela, often use the architecture of the church or other locations and elements that are part of the wedding or reception environment to provide an underlying structure or frame for the specially designed pages. These elements include stained-glass windows, church bells, and floral arrangements. Take a look at the pop-up page opposite. Here, a 16-inch-square photograph was trimmed, mounted, and folded into a shape that echoes the architecture of the church. Marbled paper accents the edges and the back side of the exposed print.

Obviously, such unusual treatments require a great deal of planning to implement. Michael describes his approach to each wedding as something of a chess game in which once a move has been made or an event has taken place, it can't be repeated. He clarifies his purpose:

> My design goal is that as each page is turned, the viewer will witness a little story of what happened at the moment the images were recorded. As each of these "sub-stories" is played out, the result is an extremely memorable wedding scenario.

To craft their albums, Michael and Pamela Ayers use Art Leather Futura albums and inserts, Fuji photographic paper, and pressure-sensitive adhesive made by Coda, Inc. According to Michael, the design work is greatly facilitated through the use of Art Leather's Montage software:

> In addition to keeping track of everything having to do with the wedding order, it shows couples exactly how their album will appear. In order to show our Designer Pages, we simply display a Panorama Page insert and provide a description of what photographs will go on the page and a bit about the special design.

Most of the Ayers's albums contain only a few Designer Pages, such as one Panorama, one Fold-out Page, and one Diamond Page. When he is pressed for time, Michael says he can build a Panorama Page in about 15 minutes. However, learning to make exotic folds in photographs takes time and raises many questions. Michael cautions:

> Should I score the print, crease it, and then apply adhesive? At what stage should I trim the edges—after I add the marbled paper backing? Did I forget to blacken the edges of the prints with a permanent marker? All of these questions and more eventually become part of the ritual after building many paper demos, and ultimately, finished inserts.

Michael and Pamela Ayers charge an additional fee for their Designer Pages according to the degree of difficulty of the design. For example, a basic fee is charged for a Double Designer Page, and an even higher fee for a Special Designer Page. The size of the album doesn't matter, and the Ayers do special pages in most of their albums, even in smaller parent albums. Michael suggests that if photographers offer wedding packages, then they should consider adding Designer Pages to provide their clients with an incentive to move up to a more expensive package.

The importance of choosing a quality album in which to display wedding photographs is a matter of concern to Seattle-area studio owners Bruce and Sue Hudson. Sue explains:

> We choose to offer mainly Capri albums because of their quality, design flexibility, and the fact that clients have the option of designing their own titles, which is a great marketing tool. We've observed that many photographers choose albums that don't live up to the quality of their photography. We go out of our way to educate our clients on the merits of a "book bound" album, its archival qualities, and the advantages of permanently bound albums. Many bridal couples need to be educated about the value of their wedding album as an heirloom for future generations: something that they can't buy at a local photography shop or department store.

CHAPTER 6
PRICING YOUR PHOTOGRAPHY

Of all the many services for hire, wedding photography is one of the most difficult to price. In fact, it is a challenge to determine how much to charge for most types of portrait or candid photography because of the complex nature of the service being rendered. Most business owners either sell a product or deliver a service.

Photographers, however, provide a service and sell a product, and most supervise the "manufacture" of the product. This makes the management aspect of a photography business quite complicated; it also adds complexity to the task of pricing. However, when you understand the relationship between what it costs for you to do business and how much you must charge in order for the business to be profitable, then pricing your work won't be such a difficult undertaking.

FUNCTIONS THAT AFFECT PRICING

The profession of portrait and candid photography encompasses four essential functions: marketing and merchandising, client consultation and education, product sales, and product manufacture. Each of these areas is affected by a pricing structure that, in turn, has a profound impact on the photographer's ability to manage these vital areas.

Unfortunately, far too many novice photographers set their prices according to what their competitors charge. This can be a fatal management mistake, not simply because a competitor may have set prices too high or too low, but because the prices most likely don't reflect the new photographer's cost of doing business or place in the market. No two businesses are alike, and it is the differences among businesses that affect pricing.

FACTORS THAT AFFECT PRICING

Before you create a price schedule for your wedding photography, you must clearly define the positioning of your business in terms of the clientele you intend to serve. This positioning might change as your business grows, and how you price your work will change to reflect the repositioning. The various elements that affect wedding-photography pricing structures include: the quality of the photography, the perceived value of the work, and the cost of doing business.

THE QUALITY OF THE PHOTOGRAPHY
Technical proficiency and an understanding of the demands of wedding photography are essential for charging a reasonable price for your work. If you are still in the learning stage of your career, you can't expect to receive the price for your product that a well-established photographer does if the public recognizes that you produce a lower standard of work.

THE PERCEIVED VALUE OF THE WORK
Even when your work is as good as or better than that of your competition, pricing yourself at the same or at a higher level can be a problem if your business is incorrectly assessed. How the public perceives you and your work is of crucial importance in positioning yourself to attract business in the wedding-photography market of your choice. Among the factors that influence this perception are your business reputation, your competition, and your self-confidence.

A good business reputation takes time to build and is an invaluable asset in a competitive marketplace. In general, a reputation results from the public's perception of you, as well as your work, prices, business facilities, customer service, and business ethics. A good reputation enables the business to be thought of as "successful," and this perception, in turn, can both

create a demand for services and persuade buyers to pay more for these services.

Most photographers pay entirely too much attention to what their competition is doing and not enough to improving their products and services and promoting their businesses. Nevertheless, you must keep in mind that competition can affect your success in reaching a targeted market when a rival business delivers a credible product at a much lower price than you do. Tough competition, however, never justifies lowering your prices below the cost of doing business. A better solution is to develop strategies to make the public regard your business as superior to or a better value than that of the competition in terms of product quality and/or customer service.

Finally, your own self-esteem also can affect the public's perception of your work. Your confidence and attitude toward business is reflected in the staff you employ, the facilities you use, the promotions you create, your participation in the community, and the way in which you interact with people.

THE COST OF DOING BUSINESS

The quality of your work and its perceived value are qualitative attributes affecting pricing, and they are somewhat subjective. The business expenses you incur, however, are quantitative. As such, they are the most important indicator for setting prices.

Everyday photographic expenses fall into two categories that are accounted separately: Cost of Sales and General Expenses. Some people refer to cost of sales as "cost of goods" or "direct expenses," and to general expenses as "overhead" or "indirect expenses." A good way to differentiate between the two is to remember that you incur cost-of-sales expenses only when you have a customer to serve, but general expenses are ongoing because they exist whether or not you have any business. For example, you don't have to buy film in January if you don't have any weddings to shoot in January, but you still have to pay the studio's electric bill.

DETERMINING YOUR COST OF SALES

Whether you are a part-time wedding photographer or a full-time studio owner, accurate financial record keeping is an essential part of successfully operating your business. Financially successful wedding photographers don't run their businesses by seat-of-the-pants accounting. They know where their money comes from and where it goes. Pricing is directly related to careful record keeping and affects both money coming in (income) and money going out (expenses). You should consider the expense side of the equation first.

You begin the process of pricing your work by identifying the cost of sales for each item you intend to price, from wedding packages to individual photographs. In wedding photography, the cost of sales is made up of those goods or services that are required to create the products you sell. Some of these items are easy to identify and account, such as film, processing, proofing, albums, frames, and presentation mounts. Others, such as proof albums that you might reuse several times before discarding them, are harder to account because you must arrive at a figure that accurately reflects their "useful life."

Other cost-of-sales items are easily overlooked. These include the packaging materials for your proofs and finished pictures, retouching costs, mounting materials, and finishing sprays. Retouching costs are particularly easy to miss when an employee serves as both an office worker and a retoucher. In this case, you must assign a per-wedding, retouching-cost estimate when calculating prices.

Another tricky cost-of-sales expense is the salary paid to the person who does the wedding photography. As a general rule, full-time salaried employees are considered part of business overhead; therefore, these wages and benefits are accounted under general expenses. However, the wages paid to contract laborers you hire occasionally to do specific client assignments, such as photographing weddings, are accounted as a cost-of-sales expense.

When it comes to pricing, some studio owners prefer to assign a "time charge" per wedding, whether it is done by a salaried employee or a contract laborer, as a means of equalizing charges from wedding to wedding. This is perfectly acceptable from a cost-accounting perspective.

The following list shows possible cost-of-sales categories and items that you are likely to encounter in a typical wedding-photography business:

- Film: black-and-white and color
- Contract-labor or time charge, which is based on an hourly charge estimate for the type of wedding service being priced
- Lab costs: processing film, printing proofs, making finished prints (be sure to include chemical and paper costs for all items produced in a house lab in addition to the costs incurred through a commercial color lab), shipping charges
- Retouching and print-finishing costs: retouching, artwork charges or supplies, print spray charges or supplies, mounting charges or supplies (if an employee provides these services, a charge must be established per job when pricing)
- Frames, albums, and accessories, including proof folios and presentation mounts, invitations, and packaging materials

WHY COST OF SALES IS IMPORTANT

The obvious reason why calculating your cost of sales is so important is that you must know what your costs are in order to charge enough to make a profit. Believe

it or not, some novice photographers, because of their enthusiasm for making pictures, charge less for their finished work than they spend for the raw materials. This happens because it is easy to overlook certain charges, such as retouching or shipping and handling. And more than a few photographers have forgotten to list film as an expense!

Once you know how much it costs to make your product, how do you decide how much to charge? You can't answer this question until you know how much profit you intend to make, as well as the total of your general expenses. In any business, the relationship between cost of sales, general expenses, and profit, can be expressed in percentages. That relationship, presented for a typical photography studio, is shown in the chart below right.

This formula defines an ideal ratio (expressed as a percentage) between sales as compared to cost of sales, gross profit, general expenses, and net profit. Look first at the total-sales, cost-of-sales, and gross-profit figures shown in the chart directly below. What the formula establishes is that for every dollar received from the customer, you shouldn't spend more than 40 cents of that dollar to make the product. By determining that the maximum allowable cost of sales is 40 percent of the total sales, you establish a discipline that affects not only your pricing, but also the rest of your business structure.

As you can see, when you subtract the 40 percent cost-of-sales percentage from your total-sales percentage, the result is a gross profit of 60 percent. Gross profit is the amount of money remaining after your product is produced. If, as the chart below suggests, you are successful in limiting your general expenses to 50 percent of your studio's total sales, you'll realize a net profit of 10 percent.

DETERMINING PROFIT

Total sales	100%
–Cost of sales	40%
Gross profit	60%
–General expenses	50%
Net profit	10%

These ratios help you determine the troublesome areas of your business. Should you experience a drop in profits that isn't related to a decline in sales, you can pinpoint where the problem lies by looking at your cost-of-sales and general-expenses percentages. (General expenses are discussed in more detail in Chapter 11, so for now simply concentrate on how the relationship between sales and cost of sales affects your pricing.)

As suggested earlier, your cost of sales shouldn't exceed 40 percent of your total sales. This means that for every dollar you take in, it shouldn't cost more than 40 cents to manufacture your product. This is a maximum guideline. Industry experience shows that when the cost of sales exceeds 40 percent, only a business with exceptionally low general expenses can survive. So studios with higher overhead must operate on a lower cost-of-sales percentage. Most financially successful photographers, in fact, suggest that 30 percent is a more realistic cost-of-sales guideline.

As you become accustomed to working within a cost-of-sales parameter, you'll learn that when you lower your cost of sales to 35 percent from the original 40 percent relationship, with all other factors being equal, your net profit increases (see chart below). And if you lower your cost of sales to 30 percent of your total sales, you can increase your general expenses to 60 percent of your total sales without changing your net profit of 10 percent.

COST-OF-SALES GUIDELINES

Cost of sales	40%	35%	30%
General expenses	50%	50%	60%
Total sales	100%	100%	100%
–Cost of sales	40%	35%	30%
Gross profit	60%	65 %	70%
–General expenses	50%	50%	60%
Net profit	10%	15%	10%

MONITORING YOUR COST OF SALES
Monitoring your cost-of-sales percentage is one of the most important keys to business success because it enables you to bring discipline to the manufacturing function of your business. If you begin to see a trend toward a higher cost of sales over a period of months, you'll be alerted to the need to lower your manufacturing-cost ratio. Otherwise, you'll be jeopardizing your bottom line, or net profit. There are only three methods of lowering your cost-of-sales ratio:

- Find less costly ways of making the product
- Use smaller amounts of goods, such as film, to make the product
- Raise the price of the product

THE MECHANICS OF PRICING
Setting prices begins with the mathematical exercise of determining all of the goods and services that go into the manufacture of a product. Next, you multiply this

figure by a markup factor that will give you a desired cost-of-sales percentage. To determine the factor itself, divide the cost-of-sales percentage into 100. Consider the following examples:

- To arrive at the multiplication factor for a cost of sales of 40 percent, divide 40 into 100; the result is a markup factor of 2.5.
- To arrive at the multiplication factor for a cost of sales of 35 percent, divide 35 into 100; the result is a markup factor of 2.9.
- To arrive at the multiplication factor for a cost of sales of 30 percent, divide 30 into 100; the result is a markup factor of 3.3.

Suppose that the production of an item takes $100 worth of materials. Consider the following examples that show how to calculate the price of the item at various costs of sales:

- At a 40 percent cost of sales, multiply $100 by 2.5; the item price would be $250.
- At a 35 percent cost of sales, multiply $100 by 2.9; the item price would be $290.
- At a 30 percent cost of sales, multiply $100 by 3.3; the item price would be $330.

Take a look at the chart below to review the actual mechanics involved in pricing a wedding-photography package for a hypothetical wedding studio. Here, you see the pricing for a wedding package consisting of 6 hours of coverage, which resulted in a selection of 24 8 x 10 images in an album and 2 parent albums, each with 20 4 x 5 images.

PRICING A WEDDING-PHOTOGRAPHY PACKAGE

10 rolls of film @ $3.50 per roll	$35
Processing and proofing of 10 rolls of film @ $6.50 per roll	$65
Proof shipping	$2
6 hours of contract labor @ $25 per hour	$150
Proof book, including shipping	$50
8 x 10 album with 24 pages, including shipping	$110
24 8 x 10 deluxe candid prints @ $4.10 per print	$99
2 parent albums with 24 pages @ $70 per album	$140
40 4 x 5 deluxe candid prints @ $1.00 per print	$40
Print-order shipping	$2
Total cost of sales	$693

* To calculate the wedding-album-package price using a 40 percent cost-of-sales guideline, multiply the total cost of sales by 2.5. Here, $693 x 2.5 = $1,733.

* To calculate the wedding-album-package price using a 30 percent cost-of-sales guideline, multiply the total cost of sales by 3.3. Here, $693 x 3.3 = $2,287.

CHAPTER 7
CREATING A PRICE SCHEDULE

Pricing your photography would be a fairly simple issue if all you had to consider was the mathematical process discussed in Chapter 6. But as mentioned earlier, achieving a satisfactory price level involves additional factors pertaining to the quality and the perceived value of your work. In essence, you must make sure that your schedule of prices makes sense in relation to your place in the market, your reputation, your competition, and so on. This requires a great deal of adjustment and fine-tuning until you reach a comfort level that enables your prices to be accepted in the marketplace at the cost-of-sales level you've determined is necessary to ensure your financial success.

ELEMENTS OF A SUCCESSFUL PRICE LIST

Wedding-photography price lists and pricing structures vary dramatically from photographer to photographer. But all of the good ones provide a platform beneath which a sale can't sink and, at the same time, don't establish a ceiling above which the sale can't rise. When using a well-crafted price list, photographers are protected against wasting their time doing unprofitable work; simultaneously, there is no restriction to increased profit potential.

As you examine the sample price lists included in this chapter, keep in mind that a pricing system is successful when it accomplishes the following:

- It enables photographers to take in more than it costs to make the product and enough to contribute substantially to overhead and profit.
- It presents a price level and pricing structure that are appropriate for the targeted market.
- It presents a price level that is competitive with those of other photographers targeting the same market.

PRICING CONSIDERATIONS

In Chapter 6, you learned the mechanics of pricing involved in arriving at profit-producing levels. Rarely, however, do photographers price their work according to the exact dollar amount arrived at through this mathematical exercise. Instead, they use the mathematics to put their prices in the ballpark. They increase the prices for some items over and above the cost-of-sales guideline because it is possible to do so without jeopardizing competitiveness, and they sometimes lower a few prices below the guideline. Items priced below the established cost-of-sales guideline are referred to as "loss leaders." Many businesses use loss leaders to entice clients to come to their businesses to take advantage of the advertised special. Loss leaders can be profitable, providing that the customers purchase something else, either in addition to or instead of the promotional item.

Using a bridal shop as an example, you are likely to see even the finest bridal stores advertising a "special collection" of wedding gowns for only $200. But when a prospective client comes to the store, she finds that the gowns at this price level aren't attractive. When shown gowns in much higher price ranges, she immediately sees the difference in quality and is easily persuaded to purchase a better, more expensive gown. While the $200 advertisement drew the bride-to-be's attention to the bridal shop, it was the comparison of the low-price product to the obviously superior gowns that made her decide in favor of a better product.

Having an entry-level financial commitment in your pricing structure offers two advantages. First, it gives you something to work with in your advertising. It also provides you with a minimum charge to quote to

prospective clients who call requesting price information over the telephone. Be aware, however, that this low-level commitment shouldn't be far more appealing than your other price offerings to prospective customers. If it is, you are likely to sell this unprofitable product.

Keep in mind that how you charge for your work serves to regulate two important management functions of your business. Pricing establishes your position in the market, and you can use it to control the volume of work you do. Upscale studios can signal the type of clientele they wish to serve through the high-end prices they charge. This type of price structure will appeal to those who insist on buying only the best, and many such clients believe that you get what you pay for. On the other hand, mass-market studios position themselves through their lower-level price structure. Many of these businesses rely heavily on "after-selling" as a means of deriving more profit from a low initial commitment.

Pricing also serves as a primary means of controlling the number of weddings photographers want to work. When photographers get to the point where they can no longer handle the volume of weddings themselves, they must make a decision. Should they hire one or more part-time wedding shooters or increase prices as a means of decreasing the wedding volume without sacrificing their bottom-line profitability in this product line?

Once you determine what type of price structure is best for your working situation, the next step is to figure out how to create your printed price list. The price lists included in this chapter show various approaches to price-list design and printing. These examples range from those produced by a commercial printer to computer-generated lists copied on a plain paper copier. All of them, however, are part of a seamless progression that begins with the photographer's choice of a promotional plan that reflects a conscious market placement, and concludes when the final sale is made.

If your wedding-photography business is new, you would be wise to generate your price lists using a computer, at least for the first several years of your business. This way, you can adjust your price schedule without incurring printing costs.

CHOOSING A PRICE STRUCTURE

For many years, package pricing was the dominant method of pricing wedding-photography services. In recent years, however, many successful photographers have moved to a less-structured, a-la-carte method of pricing. Still others have opted for a minimum-purchase fee or a combination of various pricing arrangements in order to arrive at a pricing structure that is both profitable for the business and competitive in the marketplace. (I've included price schedules in this

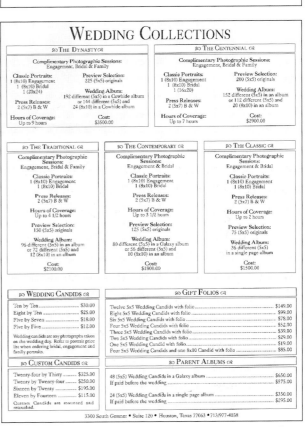

Alvin Gee's attractively printed price list presents his studio's wedding-package options in an easy-to-read manner. The brochure also includes an eye-catching image and some brief promotional copy.

chapter for the sole purpose of illustrating pricing structures. Prices for each individual studio must be set according the cost of sales and general expenses of that specific studio.)

PACKAGE PRICING

There is no single "correct" price structure. While many photographers have moved away from package pricing to systems they say create more profitable sales, others find that package pricing can be quite profitable when each package ensures an acceptable profit percentage. Houston photographer Alvin Gee favors package pricing:

I believe the monies that clients set aside for photography might be used for something else

Victoria

Calvin Hayes, recognized as a premier wedding photojournalist, has designed exclusive unlimited coverage for the discriminating client. Hayes' unobtrusive style intuitive flair allows him to capture spontaneous moments artistically as they reveal themselves.

Hayes personally designs your exclusive bridal album with acute sensitivity to your preferences. You review 600 original color photographs from which you select up to 200 poignant images. Masterfully arranging your selections, Hayes sizes and groups the images to create a balanced and stunning narrative to be presented in two 50 page volumes. An exclusive over-sized panorama print captures the essence of the event and is included gratis.

Each Calvin Hayes print is hand processed to insure outstanding color integrity. Textured to futher enhance the photographic presentation and lacquered to insure optimum preservation, these exquisite images are destined to become treasured family icons.

Your bridal album is crafted of the finest imported leather and bound using Old English hand-tooling techniques. Parchment pages elegantly imprinted and glided monogramming graces the leather cover and spine. Two individualized family albums, each containing 40 8 x 8 custom color photographs, complement your bridal collection. Crafted to the same meticulous standards, these keepsake books serve as stunning remembrances.

Victoria Coverage also includes six 8 x 10 heirloom **Calvin Print** portraits, ready for framing, exclusively designed by the photographer to capture the bride's unique spirit in concert with the aura of her surroundings. Photographic jewels, Calvin Prints embody the timelessness of this cherished moment.

Calvin Hayes offers this comprehensive photojournalititic wedding coverage exclusive to discerning clients who demand excellence, sensitive and stunning wedding photojournalism, masterfully and elegantly presented for posterity.

$10,000.00

CALVIN HAYES

Curricle

40 page leather bound Bridal Album containing up to 120 color photographs in full, half, and quarter page size, 450 color originals provided for selection purposes, two 30 page 8 x 8 Family Albums, one picture per page. Two 8 x 10 Calvin Prints ready for framing. Up to 8 hours of coverage of home, cermony and reception.

$7,500.00

Landau

36 page leather bound Bridal Album containing up to 80 Black and White photographs in full, half and quarter page size. 15 contact sheets totaling 350 images in small and medium format will be provided for selection purposes. One Family Album containing 24 5 x 7 Black and White photographs, one per page.. Up to 7 hours coverage of home, cermony and reception.

Landau coverage available in color upon request.

$4,900.00

Cabriolet

30 page leather bound Bridal Album containing up to 50 color photographs in full, half, and quarter page size. 250 color originals provided for selection purposes, one 8 x 10 portrait ready for framing. Up to 6 hours coverage of home, cermony and reception.

$3,250.00

Rehersal dinner and Black and White coverage available, please inquire.
Additional coverage available at $150.00 per hour.
Shipping charges and travel expenses will be added when applicable.
Maryland events add 5% sales tax.

Revised 07/95

Garrett Nose Photography
1122 Koko Head Avenue Suite 203
Honolulu, Hawaii 96816

(808) 732-1816
(808) 735-1761 Fax

Wedding Photography Agreement

Client: _____

Address: _____

Phone: _____ (Home) _____ (Bus.)

Date of Wedding: _____

The following deposits are required to reserve our services for the above date:

_____ at time of booking _____ Date Rec'd

_____ upon delivery of invitation _____ Date Rec'd

_____ upon delivery of proofs _____ Date Rec'd

One half of the remaining balance is due with album order. Final balance, plus tax, is due upon delivery of the album and prints.
It is agreed that deposits will not be refunded in the event of cancellation, postponement or any other change in the wedding date.

EXTRA PRINT PRICES

ULTIMATE PACKAGES

SIGNATURE PACKAGES

HEIRLOOM PACKAGES

CLASSIC PACKAGES

Full Coverage of the Wedding Day including
Garden Formals, Ceremony and Reception

Premier Presentation Video

Art Leather Aristohyde Album

40 - 10X10 photos $1,950
50 - 10X10 photos $2,100
60 - 10X10 photos $2,300
72 - 10X10 photos $2,900
100-10X10 photos..... $3,400

Garrett Nose Photography

1122 Koko Head Ave Suite 203 (808) 732-1816
Honolulu, Hawaii 96816 (808) 737-4714

Hudson's
DESIGNER PORTRAIT IMAGES

WEDDING PLANS
By Hudson's

OPTION #1 $2400.00
3 hours of photography time for coverage of the wedding and reception (generally in one location). $450.00 of this plan is the reservation fee to reserve our services for your wedding date and time. The remaining $1950.00 is a design credit (or minimum order amount) and is applied toward the the Bride and Groom's order after the wedding for their album, gift prints, folios and frames.

OPTION #2 $3000.00
5 hours of photography time for coverage of wedding and reception. $600.00 of this plan is the reservation fee to reserve your wedding date and time. The balance of the plan, or $2,400 is your design credit (or the minimum order amount) and is applied toward the Bride and Groom's order after the wedding for their album, gift prints, folios and frames.

OPTION #3 $3800.00
7 hours of photography time for coverage of the wedding and reception. $700.00 of this plan is the reservation fee to reserve our services for your wedding date and time. The remaining $3100.00 is a design credit (or the minimum order amount) and is applied toward the Bride and Groom's order after the wedding for their album, gift prints, folios and frames.

This plan also includes a $550.00 credit toward a beautiful canvas wall portrait. Many couples choose to be photographed in a special location and then display a stunning engagement portrait at their reception.

OPTION #4 $4400.00
9 hours of photography time for coverage of the wedding and reception. $800.00 of this plan is the reservation fee to reserve our services for your wedding date and time. The remaining $3600.00 is a design credit (or the minimum order amount) and is applied toward the Bride and Groom's order after the wedding for their album, gift prints, folios and frames.

This plan also includes a "**VIDEO MAGIC**" slide presentation at your reception. The **VIDEO MAGIC** slide presentation includes all the sessions necessary to create a once-in-a-lifetime slide show, transfering baby and family snapshots to slides, includes selected excerpts from your old home movies and video as part of the presentation, choice of music from Hudson's exclusive custom library, production of a custom soundtrack inlcuding voice overs and a video tape copy of your slide show to keep forever. The creative things we can do together are only limited by our imagination!

18627 BENSON ROAD SOUTH, RENTON, WASHINGTON 98055 206-271-9709 FAX 206-226-4363

OPTION #5, STORYBOOK $5800.00

Unlimited amount of time for every moment of the wedding day, beginning with timeless portraits taken in the bride's home to the last wave goodbye at the reception. The Storybook Wedding includes pre-wedding photography, ceremony, candids and reception coverage until the bride and groom depart.

You have the choice of a "**Special Event**" with this plan, i.e. wedding shower, rehearsal dinner, bachelor party or gift opening. A professional make-up artist is also included to assit the bride, nervous mothers and bridesmaids with their make-up before and during the formal photographs at the church.

Our unique "**VIDEO MAGIC**" program is included in this total day coverage as well. This includes the unlimited sessions, production of the show using music from our copyright-free library, transferring your baby and family snapshots to slides, insertion of old home movies and presentation at the wedding! $1,000 of this plan is the reservation fee to reserve the Hudson's for entire day of your wedding. The balance of the plan ($4,800) is your design credit (or the minimum order amount) and is applied toward the Bride and Groom's order after the wedding for their album, gift prints, folios and frames.

9/1/94

Calvin Hayes's computer-generated price list, printed on plain paper, is eloquent in its simplicity as it explains his four wedding-photography-package options (opposite page, top).

Garrett Nose lets his clients choose from a simple, four-package price structure (opposite page, bottom). The costs are spelled out in a distinctive client-information folder. The packages are described in "stepped" inserts, beginning with the least-expensive coverage on the first step, and moving to higher-priced packages on each succeeding step. The folder also contains prices for extra prints, as well as promotional information and press releases about Nose's business.

Bruce and Sue Hudson's computer-generated price list is printed on their distinctive letterhead, which echoes their elegant studio decor.

Hudson's
DESIGNER PORTRAIT IMAGES

WEDDING PRINT PRICING BY HUDSON'S

PRINT PRICES
Gift or album prints $ 22.00 each/$28.00 reorder
4 x 5 $ 30.00 each/$38.00 reorder
5 x 7
8 x 10 $ 40.00 each/$48.00 reorder

Quantity pricing is available when purchasing 5 or more images from the same pose from the same order. If interested, please ask! The first prices listed are applicable to orders placed on the evening of the premiere viewing; reorder prices apply to any orders placed after that time and subject to change without notice.

Hand coloring to black and white prints available at $40.00 per print for 8x10 or smaller.

WALL PORTRAITS
16 x 20 $ 650.00
20 x 24 $ 950.00
24 x 36 $1200.00
28 x 40 $1400.00
30 x 50 $2200.00
40 X 60 $3000.00
 $3500.00
All wall portraits are bonded on canvas.

PANORAMA PAGES
Full Panorama Pages $250.00
Half Panorama Pages $150.00
(Available in Capri albums)

Hand coloring to black and white prints available at $40.00 additional charge per half-panorama page; $65.00 per full panorama page.

GIFT FOLIOS
Hudson's carries a variety of folios that are ideal gifts for grandparents and the wedding party or for your desk at work! There are a variety of colors and imprinting available.

Love Story Folio (1-8x10,4-4x5's) ... $158.00/$170.00 reorder
Encore Folio (8-4x5 prints) $180.00/$250.00 reorder
Mini-Folio (2-4x5 prints) $ 49.00/$60.00 reorder
Tri-Folio (3-4x5 prints) $ 71.00/$89.00 reorder

ALBUMS
All albums are by quotation since the albums carried by Hudson's are custom designed for your wedding. Each album price will be quoted in advance and you'll have a choice of cover colors, insert colors, custom imprinting and album styles.

9/01/94

18627 BENSON ROAD SOUTH, RENTON, WASHINGTON 98055 206-271-9709 FAX 206-226-4363

Engagement Portraits
for memories that last a lifetime

ART RICH
PHOTOGRAPHY

Super Portrait Special
1-16x20 Signature Portrait with Frame
Coffee Table Book
Includes 10-8x10 Portraits

1-8x10 Portrait with Frame
4-5x7 Gift Portraits
32-Wallet Size Portraits
Complete Set of Previews with Folio
Unlimited Poses

Economy	Deluxe	Supreme
79	**$599**	$619

Package 1
1-11x14 Wall Portrait
4-5x7 Gift Portraits
24-Wallets Size Portraits
Complete Set of Previews with Folio
Three Poses

Economy	Deluxe	Supreme
$295	**$307**	$319

Package 2
2-8x10 Portraits
2-5x7 Portraits
16-Wallet Size
Two Poses

Economy	Deluxe	Supreme
$165	**$172**	$184

Package 4
Portraits of Woman
Portraits of Man
Portraits of Couple
in 2 Triple Folios

t Size Portraits
ne pose above
ee poses

	Deluxe	Supreme
207	$219	

with 3 Triple Folios

	uxe	Supreme
67	$279	

Wallet Special
16-Wallets
added on to any package
ONLY
$22.95

Package 3
1-8x10 Portrait
2-5x7 Portraits
8-Wallet Size
One Pose

Economy	Deluxe	Supreme
$118	**$130**	$142

Add On Prints
Added on to any package from above

	Economy	Deluxe	Supreme
1-16x20	$225	$235	$245
1-11x14	$125	$130	$135
1-8x10	$ 22	$ 24	$ 26
2-5x7	$ 22	$ 24	$ 26
4-3.5x5	$ 22	$ 24	$ 26
8-Wallets	$ 15	$ 19	$ n/a
16-Wallets	$ 25	$ 29	$ n/a

Portrait Units
If you choose more than one pose, your package can be divided into units. Use at least one complete unit per pose. A unit is an 8x10 piece of photographic paper divided in the following ways:

1-8x10 2-5x7 4-3.5x5 8-Wallets

Black & White Photos
Black and White glossies are available from any Color Pose at $14 each. With any package purchase of $118 or more, we will include up to 3 glossies at no extra charge.

All package prices are based on the pose you choose for your Black & White photographs. If you choose additional poses, please add $15 per pose for retouching, handling and finishing.

Previews
Portrait previews in a Deluxe Folio can be purchased alone for **ONLY $200**
With a package order, please refer to the enclosed Preview card.

Choice Of Finish
Supreme - Our finest textured finish, with a vibrant protective surface for maximum protection for your portraits.

Deluxe - A smooth velvety finish with a satin surface to help protect the surface of your portraits.

Economy - A plain linen textured finish. No surface coating.

Finishing Touches
Your portrait previews are unretouched and should be viewed for expression and pose ONLY. Your finished portraits will be carefully retouched, color balanced and made from the finest quality materials and procedures. Retouching includes removing blemishes, lines under eyes and softening smile lines. It does not include glare, teeth or hair corrections. These corrections are available at an additional cost.

Joan and Rene Genest's Art Rich Photography price list indicates the various packages prospective clients can choose from, as well as a-la-carte offerings. The attractive price-list cover is a four-color piece printed by Marathon Press; it was designed to match the studio's promotional materials. Both the inside pages of the brochure and the studio's engagement-portrait price list are imprinted on paper purchased from the Paper Direct Company.

The New Yorker
Complete Wedding Coverage, up to 8 hours, includes:

58-8x10 Photographs
1-Full Page Panorama Portrait
Professionally Bound in a Genuine Leather Album
in Your Choice of Color

1-16x20 Wall Portrait
Beautifully Framed in Our Oak and Brass Wedding Frame

2-5x5 Gift Folios
For your Maid of Honor and Best Man
(Each with 1-5x5 Photo of Your Wedding Party
and 1-5x5 Photo of Your Choice)

6-Wallet Size Gift Photos

3-5x7 Black & White Newspaper Photos
$2249.00

Same Package with 2-Parent Folios
Each with 1-8x10 and 4-5x5 photos
$2369.00

Same Package with 2-Parent Albums
Each with 12-5x5 Photos in a White Vinahyde Album
$2479.00

The Bride's Dream
Complete Wedding Coverage, up to 8 hours, includes:

6-10x10's
22-8x8's
32-5x5's
In a Custom Imprinted Perma-Bound Album
in Your Choice of Color

1-16x20 Wall Portrait
Beautifully Framed in Our Oak & Brass Wedding Frame

2-5x5 Gift Folios
for Your Maid of Honor and Best Man
(Each with 1-5x5 Photo of Your Wedding Party
and 1-5x5 Photo of Your Choice)

6-Wallet Size Gift Photos

3-5x7 Black & White Newspaper Photos
$1925.00

Same Package with 2-Parent Folios
Each with 1-8x10 and 4-5x5 photos
$2045.00

Same Package with 2-Parent Albums
Each with 12-5x5 Photos in a White Vinahyde Albu
$2155.00

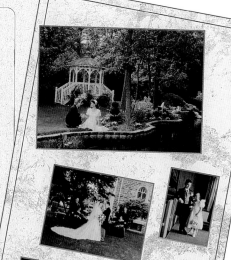

on the wedding unless they're budgeted for upfront. Therefore, the bridal package is paid in full two weeks before the wedding. We also give clients $50 off the price of parent albums if they're prepaid prior to the wedding. I believe in the idea that "spent money is forgotten money," so having as much of the basic photography costs paid before the wedding enhances the probability of additional print sales after the wedding.

Calvin Hayes, whose studio is located next to Baltimore's Inner Harbor, also prefers package pricing and has adopted a simple, four-package strategy:

I like prospective clients to know what they're getting for their money, so I've established a value upfront that keeps me from having to do hard-sell after-selling. Each package features a coverage time: six, seven, eight, or unlimited hours. Approximately 70 percent of my Baltimore brides book at the lowest level, while most of my out-of-town clients book a higher package. I like this system because each level is priced in a manner that it becomes a natural progression to add more pictures. So I'm nearly always assured of selling up to the equivalent of the next pricing level without having to resort to hard selling.

Hayes derived the titles for his packages from the names of antique, horse-drawn carriages that he found in the book, *Expanding Your Knowledge*. He explains,

I was looking for something different to name my packages, and I loved the elegant look of these old carriages. So I chose the four most regal-sounding names.

A-LA-CARTE PRICING
Bruce and Sue Hudson, who own and operate a studio in Renton, Washington, a Seattle suburb, have adopted an a-la-carte pricing system that is based on a coverage-time and minimum-purchase structure. Sue explains:

There are a great many benefits to this way of pricing. Choosing a wedding plan based on hours of coverage is easy for clients to understand. This makes the consultation process very simple: the more elaborate the wedding, the more hours required to cover it.

The reservation fee is paid to reserve the date, based on the time and amount of coverage needed. It is a professional fee and isn't applied as a credit toward photographs. The "design credit," which is a minimum order amount, is prepaid at least 14 days prior to the event. This usually amounts to between 70 and 75 percent of what the couple ultimately spends on their wedding-album collection. This eliminates "buyer's remorse" the day after the sales presentation, and we don't have the pressure of having to "sell up" to be profitable.

We also like the flexibility that a-la-carte pricing gives when it comes to raising prices. We can choose to raise the print prices one year, and the minimum order amount the next, keeping up with the actual costs involved.

Los Angeles wedding photographer Gary Fong is a powerful advocate for a-la-carte pricing without a minimum-purchase fee. Instead, he charges his clients a wedding-photography-services fee, which ranges between $750 and $1,750, depending on the type and size of the wedding. Fong explains why he advocates this method of pricing:

What seems like "speculation" in fact liberates couples to purchase more pictures because they aren't "locked in" to a set package. And I prefer the challenge of having to earn the order. With each shot I create, I know which ones will be sellers, and I deliver a better product. And the fact that couples don't have to choose the numbers of pictures until they see the previews gives us a great competitive advantage in selling our services.

COMBINATION PRICING
Joan and Rene Genest of North Haven, Connecticut, have structured their album prices in a manner that incorporates the advantages of both packaging and a-la-carte pricing. Joan explains:

We offer six established packages ranging in price from $1,365 to $3,600. They're organized in a good, better, best album choice. We also have a "Designer Package" that is an a-la-carte option. Most of our brides choose a straightforward storytelling album. In order for us to be productive and maintain consistent quality, our albums follow set formats of single sizes or a combination of 5 x 5, 8 x 8, and 10 x 10 photographs. The "Designer Package" allows couples to break away from the format if they wish to. We try to have the best of both worlds: set packages at affordable prices and a-la-carte flexibility (the Designer Package) at a higher price.

PROMOTING YOUR BUSINESS

For any type of photography business, nothing happens until the telephone rings with a prospect inquiry. Getting that telephone to ring is a function of promotion, but when compared to other facets of the photography business, the path to success in wedding-photography promotion is somewhat narrow. Accomplished wedding photographers report that their primary method of gaining new clients is through referrals from previous customers or from other wedding-industry professionals, such as caterers, bridal shops, and florists. These photographers agree that the very best impetus for referrals is a beautifully finished wedding album, filled with artful and expressive images, that potential new clients see and enjoy. The challenge for would-be and novice wedding photographers, then, is how to get on the road to referrals in the first place.

WHEN TO PROMOTE

The majority of wedding photographers start out by working part-time, usually out of their homes. Many get started by agreeing to photograph the wedding of a friend; they find they enjoy the work, and then they begin to show the results to other engaged couples. So from the very beginning, promotion is a word-of-mouth issue. Couples who are pleased with the novice's work refer the photographer to their friends, and the friends are willing to hire the photographer on the basis of seeing a sample of the work.

During this period of "on-the-job training," novice photographers are usually satisfied with charging just enough to cover expenses and come away from the wedding with a few dollars in their pocket. And so it goes until the photographers become sufficiently confident that they've developed skills that they can market more extensively, and until they are ready and willing to cultivate a broader client base and charge more for their work. At this point, promotion becomes critical. Referrals will continue to be the bedrock of any wedding photographer's business, but you need to look to other avenues to create a demand for your services.

THE ADVERTISING-TO-SALES PROGRESSION

One of the most frustrating aspects of promoting a business is observing how certain types of advertising can work wonders in promoting a studio in one area, when the same advertising fails to create business for a comparable studio in another area with similar characteristics. To understand why this can happen, you must know why and how the public responds to promotional advertising. "The Five Steps to Making a Sale" move people from the position of being unaware of your business to the point that they are ready to become your clients.

Step One: Awareness. This step establishes that "awareness" is the first and most fundamental challenge your advertising must meet. In order to achieve awareness, your advertising must clearly define your business identity: who you are, what you do, and where you're located. If you call your business "Pine Tree Studio," there is a good chance that you'll confuse prospective clients. They won't know whether your business is an art gallery, a hair salon, or a nature preserve. Contrast that identity to the one that "Smith Studio of Photography. Downtown—Next to the Courthouse" suggests.

Step Two: Comprehension. The second step establishes "comprehension," which involves creating an understanding of the type of work you do. That is why you must carefully choose the images you feature in printed promotional material, as well as why dis-

plays of your work in public places are so important. Every time prospective clients see examples of your work, they have another opportunity to comprehend what you do. This moves the prospective client one step closer to becoming a customer.

Step Three: Conviction. This step establishes "conviction," through which potential clients begin to believe that the product and service that you offer might be worth considering. Conviction is established in many ways, especially through word-of-mouth recommendation. That is why partnership marketing is such an important promotional device (see page 48). It carries with it the recommendation of another wedding professional. Testimonials from satisfied clients also are a powerful way to facilitate conviction.

Step Four: Trial. The fourth step in the progression establishes "trial." This is the most difficult step because prospective clients must decide to give your business a chance and to become customers. The two most successful methods of facilitating trial are to make the prospect an offer that can't be refused, and to eliminate as much risk as possible in doing business with you. Many successful studios offer a special bonus to prospects who book their services within 24 hours of the studio consultation as a way of ensuring the booking. Another appealing offer is a complimentary engagement session from which the couple can choose images to include in an "opening chapter" of their wedding album.

Risk is, of course, one of the biggest concerns of potential wedding-photography clients. Everyone has heard at least one horror story about a couple whose wedding photographs were ruined. That is why written testimonials from happy clients are appropriate to include in your promotional presentation. They'll help to allay the fears of potential clients. "Payment enhancers," such as credit cards and payment plans, also can help to encourage trial.

Step Five: Loyalty. The final step is "loyalty." Assuming that everything went well at the wedding, that the photographs are outstanding, and that you've provided your client with a high level of service each step of the way, you can reasonably expect that the couple and their families will come back to your business again and again. They'll want to take advantage of other studio-photography services. Of course, you need to have a promotional plan in place that reminds them frequently of the various services you offer. You can also expect these satisfied customers to be an excellent source of referrals for new clients as they progress through the five steps.

When you understand how a potential client moves along this promotional progression, you'll find it much easier to recognize why an advertisement might work well for some photographers, but not for others. Photographers might have the best of all possible trial offers, but if their previous promotional efforts failed to achieve "awareness," "comprehension," and "conviction," the promotional effort will be a flop. So, as you plan your individual advertising activities, make certain that each serves to facilitate one or more of these critical promotional steps.

ESTABLISHING A BUSINESS IDENTITY

The image that your business presents to the public is one of your most critical concerns. The many elements that go into creating a positive image include you: your physical appearance, your attire, your personality, your enthusiasm, your ethics, and your professionalism. Other factors are your personnel, who must adhere to the same high standards you set for yourself; your studio facilities, which must at all times be attractive, neat, and clean; and your participation in community activities, which labels you as a concerned and caring professional.

Through your studio name, logo, and promotional materials, you establish your business identity, so you must choose each one with care. These issues have a profound effect on the "awareness" and "comprehension" steps of the sales progression. When selecting a studio name, stay away from bizarre or obscure references that make it difficult for the public to determine what you sell. Lending your name to the business is appropriate when you wish to be closely identified with the product. If your eventual intent is to sell the business, then you might consider a name that will be easy for a new owner to assume.

Once your studio has a name and you've decided what type and style of photography you intend to sell, it is wise to hire a design professional to come up with possible logo designs that can be adapted for a variety of uses. Make certain that the designer understands the type of clientele you're seeking to impress, as well as any unique features about your business that might be translated in a visual presentation of your logo. These same considerations will become important as you create stationery, business cards, advertisements, direct-mail pieces, brochures, and business signs—in fact, anything that involves a visual reference to your studio. A unified look to all of your promotional and support media helps to reinforce your studio's identity.

PROMOTIONAL MEDIA

While most successful wedding photographers report that the majority of their new business comes from referrals from former clients who were pleased with their wedding coverage, every new wedding photographer must rely on one or more methods of building a client base sufficient to generate those valuable referrals.

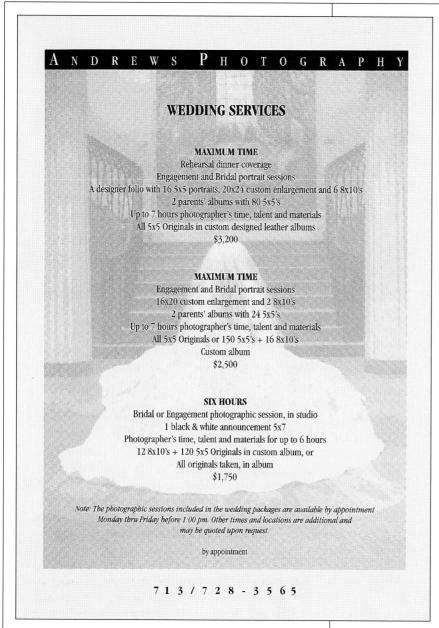
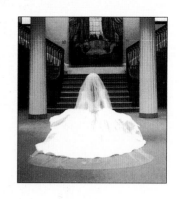
The promotional materials of bridal-portrait specialist Carol Andrews benefit from a unified design that is appropriate for the immediately recognizable, fashion-and-fine-art identity she has established for her business. This orientation is consistent with the types of images she creates, the location of her business in a professional artist's complex, and the design and decor of her loft studio.

Fortunately, new and experienced wedding photographers alike can choose from a number of media to promote their businesses.

BRIDAL SHOWS

Bridal shows, which are sometimes referred to as "bridal fairs," literally are "Where the Brides Are"; therefore, they are a vital promotional medium for new or established wedding photographers. For many studios, bridal shows are their only organized promotional activity. Nearly every moderate-size and large town—and sometimes even small towns—hold at least one bridal show each year, usually in January or February. Sometimes a second show is scheduled for the fall.

Professional Displays. If you plan to participate in a bridal show, you must be prepared with attention-getting, framed, wall-size images to display; several sample albums for visitors to view; and handouts that promote your business. Some bridal shows supply display apparatus, but others may require that you provide your own. If so, this equipment must be professional-looking and reasonable to transport. An effective display apparatus, whether you purchase it from a display company or manufacture it yourself, is fairly expensive. But its appearance will undoubtedly affect the image you present to prospects, so you must select it with great care.

Contacting Bridal-Shop Owners. The best way to learn about bridal shows in your area is to consult with the owner of the most prominent, local bridal shop. This contact could turn out to be quite important in promoting your business, not just at bridal shows, but throughout the year. Many business owners

Each year, Houston's Bridal Extravaganza attracts more than 600 merchants and thousands of engaged couples and their families. Houston bridal-portrait specialist Carol Andrews, who has participated in the January event for the past 11 years, offers savvy advice on how to be a bridal-show pro.

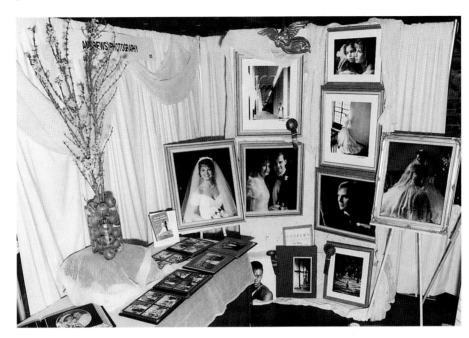

This is the bridal-show booth that Carol Andrews sets up at Houston's Bridal Extravaganza, an annual event.

DO'S

- Be selective about the events you participate in. Do your research to learn which events are the best promoted and best attended. Ask other wedding vendors for their recommendations. If possible, visit the event before you participate. If booths are cheap and unprofessional, then look elsewhere. Beware of scam promoters.
- If possible, select your booth location. Stay "upwind" of caterers offering samples, or your wedding albums will be handled by sticky fingers.
- If you can't afford staff to help in the booth, ask a satisfied former client to work with you in exchange for additional photographs.
- Before the show, update your complimentary vendor photographs so other vendors will have examples of your pictures of their flowers, cakes, wedding gowns, etc., in their booths, bearing your studio hot stamp.
- If the show has no means of providing you with an attendee list, create your own through a door-prize drawing involving yourself and selected participating vendors. Co-op the mailing list with these merchants, and do a joint mailing after the show.
- Before setup day, find out where your booth will be, and locate the exit door closest to your space.
- On setup day, wear comfortable clothing and shoes (bring show clothing to change into). Also, bring snacks and beverages, a well-stocked tool box, a garbage bag, and the indispensable roll of gaffer tape.

- Come prepared with a dolly to haul your stuff.
- Create a custom tablecloth and booth decor to establish an identity.
- Bring a 6 x 8-foot area rug, and tape it to the floor.
- Bring only three display albums, four to six large portraits on easels, and a floral decoration.
- Be friendly and approachable in a low-key manner. Ask open-ended questions to break the ice, such as "When is your wedding date? Have you purchased your gown? Where are you being married?"
- Invite booth visitors to come and meet with you at your studio. Book consultations only.
- Come early on closing day to get a parking spot close to your best exit. Use the extra time to network with other vendors. What better place to strike up a marketing partnership!
- Immediately after the show, begin your direct-mail follow-up.

DON'TS

- Don't overdo your display; the brides are there simply to get a taste of your style.
- Don't leave any valuables unattended.
- Don't eat, chew gum, or sit down in your booth.
- Don't brag about yourself; get brides talking about their plans.
- Don't sign contracts without a studio consultation. You want to be certain that both parties are comfortable with the photography arrangement.

are pleased to offer advice to newcomers in a related field, and they can become valuable mentors. An appropriate approach would be to send a letter of introduction to the bridal-shop owner. In it, you explain that you've opened a wedding-photography business and that you would like to ask the owner's advice on several issues involving the local wedding market. Be sure to state that you'll follow up the letter with a telephone call.

When you call, offer to take the shop owner to lunch or ask for an opportunity to meet at the bridal shop. If the owner declines, get as much information as possible about marketing opportunities, including bridal shows, over the telephone. If the owner agrees to meet face-to-face, take examples of your work along. This personal contact might result in a display opportunity or some other type of cooperative marketing partnership, which is one of the most valuable and low-cost means of promoting your work to the public.

MARKETING PARTNERSHIPS

In order to be successful at creating marketing partnerships, you need to keep in mind several important factors. First, you must understand the value of marketing partnerships and how they work. Partnership marketing, sometimes called "cooperative marketing" or "joint-venture marketing," is a low-cost way to promote sales in cooperation with noncompeting businesses.

This kind of marketing involves reciprocal endorsements by professionals who share a similar client profile. By teaming up with successful professionals who service the wedding market, you take advantage of the goodwill they've already created with their customer base. You benefit "by association" with these well-established vendors who have spent a great deal of time and money developing their customer relationships. A recommendation by this "third party" constitutes a powerful endorsement of your services.

Finding the Right Partner. The key to effective marketing partnerships lies in finding the right partner and providing something of value in exchange for the partner's referral or exposure to your product. Naturally, you should go after partners who have successful profiles in the community. When approaching them, you must recognize that you have one of the most valuable forms of referral compensation: you can supply vendors with photographs of their products or their facilities in use. This might involve creating some setup shots until you begin to get steady referrals from the firms you create partnerships with. Then at every joint affair you cover, simply photograph the products and provide prints for your partner.

Clay Blackmore of Monte Clay & Associates of Silver Spring, Maryland, understands the value of marketing partnerships. He nurtures these relationships by providing leading area wedding professionals with photographs of their products or services in use. He explains:

> When an advertising person calls and asks if I would like to run an ad in *Jewish Week* for $1,300, I stop to think how many photographs $1,300 would buy for me to deliver to florists of their flowers or to banquet halls of their facilities. Advertising money spent this way seems to go a lot further.

Displaying Your Work. One of the best ways to take advantage of the marketing partnerships you develop is to create examples of your work to place as a featured display at your partners' facilities. For example, a bridal shop might permit you to display wedding portraits and candids, particularly if the brides are wearing gowns from the shop. The same applies to floral shops, tuxedo-rental services, and limousine services, among others. If displays are out of the question, provide your partners with an album

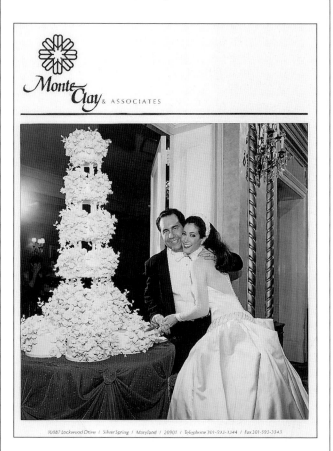

In exchange for referrals from prominent, area wedding professionals, Clay Blackmore and Monte Zucker reward these "marketing partners" with this attractive piece. This 10 x 10 image, which is mounted on an 11 x 14 sheet that bears the photographers' studio logo and information, shows the partners' products or services in use. Two such sheets are then mounted back-to-back and laminated to create an impressive presentation.

and place it in a prominent location. Be sure to include a sign that advertises your services, as well as appropriate handouts for interested clients to take with them to remind them of your services.

Any time that you have an opportunity to show your photography in a public place, take advantage of it. This is particularly important if you can display your work on a long-term basis. Experience has proven that there is no better tool for promoting your photography than public displays and exhibitions.

Cooperative Mailings. Another way to take advantage of marketing partnerships is to send out cooperative mailings to lists of engaged couples, sharing the mailing costs. In some communities, wedding photographers have organized "vendor groups" that create "catalogs" of their services. The firms share the cost of this and other advertising joint ventures.

HANDOUTS AND DIRECT MAIL

Handouts and direct-mail materials are essential for promoting a wedding-photography business. With these printed materials, you can directly convey promotional messages to potential clients. The advent of desktop publishing and "preproduced" promotional materials have made it possible for studio owners to create a seemingly infinite variety of professional-looking, cost-effective, and timely advertising pieces that can be as unique as the studios they represent. Such materials satisfy a range of promotional functions, including bridal-show and display handouts, follow-up mailings for telephone inquiries, client-education materials, and direct-mail campaigns aimed at engaged couples and their families.

Creating effective promotional materials begins with an understanding of advertising and promotional fundamentals. Whether you decide to produce your own advertising materials or hire a professional to do so, it is vital for you to gain an understanding of these basics.

Exploring Resources. Among the best educational resources on the subjects of marketing, advertising, and promotion are the *Guerrilla* book series by Jay Conrad Levinson. Particularly helpful are *Guerrilla Marketing* and *Guerrilla Advertising.* Any small-business owner will benefit from reading all of the titles in this series.

The Professional Photographer's Marketing Handbook covers the following marketing topics:

- The Promotional Campaign
- Portraiture Displays and Exhibitions
- Advertising Portraiture
- Person-to-Person Promotion
- Using Direct Mail Marketing
- Writing Sales Letters
- Studio Telemarketing

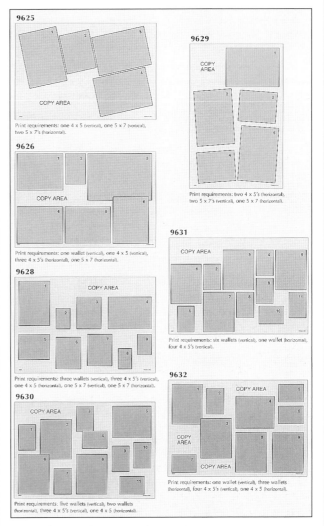

Preset formats from Marathon Press are a money-saving alternative to custom printing; they enable photographers to blend their images with predesigned formats. Copy, background, and design elements can be added to produce a customized look.

- Other Marketing Media
- Partnership Marketing
- Client Education
- Customer Service
- Relationship Marketing

The Ultimate Sales Letter by Daniel S. Kennedy discusses the power of sales letters to carry your message, how to write inventive copy, and how to maximize direct-mail campaigns.

Developing a Strategy. Whatever form your promotional pieces take, you must devise a strategy for getting these materials into the hands of prospective wedding-photography clients. In addition to direct handouts and follow-up mailings to bridal-show participants, you can send your promotional materials via direct mail to engaged couples whose names you can obtain from various sources. Many local newspapers

What is a Wedding?

A wedding is a declaration of love, a celebration, a union of families, a beginning of the rest of your life together.

*W*hat a unique day! Never again will this group of special people... family and friends of both the bride and groom...be gathered together at the same time and place.

*T*he memories of your wedding day will be among the most cherished of your life. Your wedding photographs will be one of the few treasures from your special day that you will be able to share with your family and children.

*W*e pledge to help you have a great wedding experience. We strive to create images that show genuine emotion. Your photographs will bring back wonderful memories and the romance will remind you of your promise to each other and your ever growing love.

*E*xpert planning and coordination is part of our photographic service; but our artistry, a God-given talent, is the most essential element of our Storybook Weddings.

*A*s with most art the availability is limited. We can only provide photography service to one bride at a specific time. There is no charge for consultations and popular dates are often confirmed many months in advance. Call and let us help to make your dreams come true!

*T*he photography is going to be one of the largest investments you will make . Let us make it worth what you will pay.

*J*ohn and Mary are committed to excellence in wedding photography! Whether you prefer a traditional coverage or have special considerations, we will cover your wedding the way you desire it covered. By combining elegant relaxed portraits with unposed candids, your wedding album will tell the story of your wedding day from beginning to end.

*O*ur photography packages come in a variety of sizes; one wedding coverage will not cover all weddings. We will be happy to provide you with complete printed information concerning our services and prices at your appointment. Please call John & Mary at your earliest convenience.

*O*ur brides tell us the most important reasons for their selection of **John & Mary, Photographic Artists** are many : friendliness, patience, professional expertise, and coordination of services in addition to the creativity, fun, and romance visible in our pictures.

Important Points to Remember...

*A*mong our most important accomplishments: We have won Nine First Place Wedding Album Awards in Georgia, (a record in the state), Seven in the Southeastern Region, and Six Kodak Gallery Awards for photographic excellence...

*W*e create wonderful moods with our lighting...

*O*ur romantic poses are unique and emotional...

*O*ur attention to detail is unequaled...

*W*e work as a team...giving you the best of both worlds...

*W*e use the finest quality albums with a lifetime guarantee...

*S*hiney faces and eyeglass glare are removed from all photos in the album...

*A*lbums consist of different size photos and tell a love story of your day...custom designed by you, with us using enlarged finished prints.

*V*ery accomodating to out-of-town family members with regard to ordering, payment, and delivery...

Romantic Storybook Weddings!

John & Mary, Photographic Artists

John and Mary Beavers promote their photography business through two attractive pieces designed and produced via desktop publishing (above). A photographer friend helped with the design of a trifold brochure that was printed on a heavy paper stock featuring a preprinted border. The brochure is illustrated with actual color photographs carefully glued in place.

This coordinated collection is typical of promotional postcards, brochures, and client information materials produced by Marathon Press, the industry's largest supplier of printed materials (left).

From the day you said "yes" . . . nothing has been the same. Your life is now a loving mixture of excitement, anticipation, and emotions that you've never felt before. Perhaps you find these feelings difficult to put into words. But the way you look at each other will say it all when you choose our studio to create a wedding story that's more than just a collection of wedding pictures. Your wedding album will be a treasured heirloom that you will enjoy now and many years to come.

An exceptional wedding album requires creative artistry and technical skill.

These are the tools we will use to go beyond the "basics," to capture the beauty, joy, romance, and emotion of the day that will mean so much to you, your family, and your friends.

Our commitment to you is simple . . . We'll take the time, do the planning, provide the service, and accomplish anything else that is necessary to create a uniquely artistic record of the most important day of your life. Long after the celebration is over, the flowers fade, and the bridal gown packed away, your wedding photographs will preserve your legacy of love . . . Now & Forever.

include the bride's address in the engagement announcements that are found in the society or lifestyles section of the paper. In addition, you can purchase mailing lists from direct-mail mailing-list brokers. And don't forget to check for qualified leads from your marketing partners.

When it comes to creating effective printed promotional materials, it is important for you to present a professional image. Select your printer wisely: choose one that offers professional design services and is geared toward short print runs (unlike the huge print runs that mass marketers require).

You can save money on promotional printing two ways, by using either preproduced or preset products. Preproduced products feature stock images of typical wedding photography. Often it is possible to imprint your studio identity on the color portion of the card or brochure, as well as to imprint your promotional message and/or special offer on the back. This type of promotional product offers the advantages of excellent quality, low cost, and quick turnaround time. Preproduced products are a good choice for both start-up and experienced businesses, provided that the style of photography and the promotional message are appropriate for the studio they represent.

Like preproduced products, preset products aren't as costly as custom-printed products. This less-expensive type of printing involves blending your photographs with a preformatted layout that can be imprinted with your studio's identity and promotional message on both the front and the back of the piece. Most promotional needs can be filled by selecting a money-saving, preset layout that can be further personalized through various choices of backgrounds, type styles, and decorative elements.

Suppose that you plan to publicize your business through direct-mail campaigns. You should contact your post office for information on a bulk-mail permit. This offers significant savings on mailings that include a minimum of 200 pieces.

Advances in desktop publishing have provided small-business owners with an incredible array of tools that they can use to design and produce promotional materials. The downside of this technology, however, is that the materials produced in-house often lack the professionalism required to enhance the image of the photographer they represent. For photographers who are willing to study the disciplines of design, typography, and copywriting, desktop computers and printers are excellent resources for producing timely promotional materials, as well as many other studio

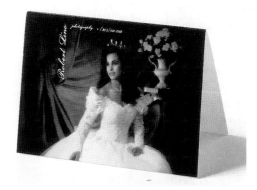

"Keep it simple" is Robert Lino's promotional philosophy. His tent cards are printed on photographic paper through a negative of the bride or the bride and groom that includes a negative mask of his name and telephone number. The 3 x 5-inch cards are folded in half, so they can stand alone on reception tables to serve as business cards that guests can pick up and take home.

Robert and Karen Palmer consider brochures to be an excellent promotional choice. They come in handy when you want to provide prospects with both visual images of your work and verbal statements about it in more detail than a postcard message allows.

CALVIN HAYES

A well-designed, four-color postcard, like that of Calvin Hayes, is a cost-effective way to reach prospective clients. You can buy postcards in large quantities and have them imprinted with different messages or special offers as new promotional needs arise. Experience shows that individuals who pick up postcards at bridal shows tend to hold on to them, so they serve as an excellent reinforcement of your message.

support pieces, including price lists and client-education information.

OTHER MEDIA

Although the majority of wedding photographers don't use additional types of media to promote their businesses, some have found these alternative approaches to be helpful in creating a demand for their services.

The Yellow Pages. Advertising in the *Yellow Pages* directory can help to call attention to new businesses, but this strategy is less valuable to established businesses that gain clients through referrals. Because there are competing directories in most areas, it is easy to over-spend precious promotional dollars on directory advertising. Most successful photographers opt for only a listing or a small advertisement; they prefer to spend their promotional dollars on advertising that directly targets their desired clientele.

Tent Cards. Miami photographer Robert Lino runs a successful business by making his advertising dollars count. His most effective promotional tool is a reception table "tent card" that features a portrait of either the bride alone or the couple and his studio information. As Lino explains:

> I give the bride about 60 cards to place on guest tables, and I get referrals years later from these little cards.

Video Brochures. Seattle-area studio owners Bruce and Sue Hudson use a "video brochure" to inform potential clients about their wedding-photography services. The well-produced video features an enthusiastic

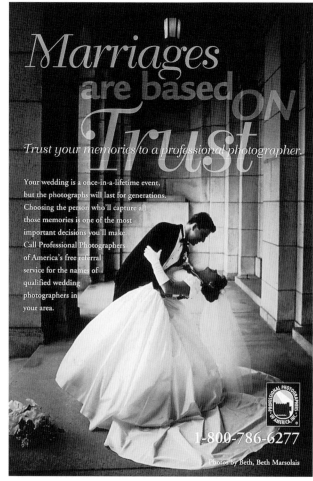

Associations like PPA provide consumer-referral services for their members through initiatives, such as this advertisement that was featured in a wedding issue of Martha Stewart Living magazine.

Whenever Andy Marcus finds himself in the news, he creates reprints of the article to include with future client-information materials). Such articles serve as an important third-party endorsement that is even more valuable than paid advertising.

testimonial by a couple whose wedding the Hudsons photographed. Sue describes the piece:

> Because the video shows us in action, the couple gets the feeling that they know us, even before they meet us. This is a great advantage in helping to book the couple.

The video also provides an opportunity for viewers to learn about the many awards that Bruce has won for his work, and it creates a sense of urgency to book by reminding viewers that the Hudsons limit the number of weddings they do each year.

PUBLICITY AND PUBLIC RELATIONS

Shrewd business owners recognize the value of public-relations efforts that result in positive publicity for their businesses. Wedding photographers have a number of avenues open to them through which they can stimulate publicity.

Print competitions sponsored by Professional Photographers of America (PPA) and their state and local affiliate organizations are an excellent way to call attention to your work. Any images that these associations select for exhibition provide you with an opportunity to generate publicity for your work. You can place these distinguished images on display or send out press releases about your honors to local newspapers.

Many newspapers publish an annual or semi-annual bridal-supplement issue in which vendors who serve the wedding market advertise their goods and services. Such issues include editorial copy that is of interest to engaged couples. This, in turn, provides an opportunity for you to submit an illustrated article on what couples should look for when choosing a wedding photographer, all from the standpoint of an "expert" on the subject. Any time that you're featured in a newspaper or magazine, you can extend the positive impact of this publicity. Make copies of the article to include in client-information folders that you present to prospective customers.

Another beneficial public-relations effort is presenting programs about photography on local-television talk shows or at service clubs. Wedding planning is a subject matter common to many talk shows, and it is appropriate to offer your services as an authority on wedding photography. Service organizations are always in need of qualified speakers, and photography is a subject of universal interest. A program that informs attendees about how to improve their own photographs would be suitable for a service club, and it gives you a chance to feature some of your work as well. No matter what the topic, just presenting yourself in a professional manner in front of an audience will help to expand the public's awareness of your business.

PROFESSIONAL ASSOCIATION MEMBERSHIP

Membership in professional associations on a national, state, and/or local level provides a way to establish credibility with prospective clients. It conveys your commitment to the professional standards that these organizations espouse. PPA and many of its affiliated state and local organizations sponsor recognition programs that attest to these standards.

PPA's "Certified Professional Photographer" rating is awarded to photographers who pass a written test and a juried image-submission process. The "Merit and Degree" program that PPA offers rewards outstanding accomplishment with the prestigious "Master" and "Craftsman" degrees in several professional-imaging categories. Many associations on the state level run similar programs. Becoming a member in any of these organizations gives you outstanding opportunities for professional growth as well as professional credibility.

BOOKING THE WEDDING

If you've read the chapters in this book in order, you know how much work it takes to position a wedding studio for success. It is only through the step-by-step process of market targeting, product development, product pricing, and promotional planning that you get to the point where you are face to face with a living, breathing, prospective wedding-photography client. Everything you've accomplished so far merely sets the stage for the opportunity of booking the client.

What happens during the consultation, then, is central to the success of a wedding-photography business. Understanding the dynamics of the session itself and mastering the attributes of "personal selling" are essential. You need this knowledge in order to obtain that all-important booking.

WHY DO PEOPLE BUY?

In nearly all cases, the primary clients for wedding photography are either the bride and groom together or the bride's parent or parents. The consultation that you conduct with either group is, in actuality, a sales session: you're selling yourself and your work, and you're doing so to highly motivated prospects. They have a need, so it is up to you to demonstrate why and how you can fulfill that need better than anyone else. Like all aspects of good business management, selling the booking requires a structured process that aims to satisfy the various buying motives of the potential customers.

SCREENING CLIENTS

The usual life cycle of a wedding-photography business finds novice photographers willing to shoot weddings in a low price range to gain experience. Then once the photographers' businesses are established enough to place a demand on their time, they can raise prices to a more profitable level in order to control volume. But the higher prices mean that bookings will be harder to achieve. As such, it is helpful to screen, or prequalify, clients before scheduling a consultation appointment. You can accomplish this several ways.

Prospective clients will often begin a telephone inquiry by asking how much you charge for wedding coverage. In response, you might decide to provide them with a range of prices; this enables you to position yourself with respect to the types of bookings you're willing to accept. By quoting low-level pricing, you'll be able to attract more clients. By quoting a range of moderate to high prices, you'll be able to screen out prospects who consider low price to be the overriding issue. Keep in mind, however, that by quoting prices in this high range, you might also eliminate prospects for whom a well-developed sales presentation will result in a booking.

Another approach is to respond to the inquiry by first asking a series of questions about the wedding, such as where the wedding and reception will take place, what type of reception is planned, and how many wedding attendants and invited guests there are. These answers will give you insight into the scale of the affair. Assuming that the event is to your liking, you can respond to the inquiry as follows:

"From the type of affair you've described, Mrs. Smith, I would recommend one of our coverages that start at "X" dollars. I'll be happy to set up an appointment to show you samples of a typical wedding coverage in this range. This meeting also will provide me with an opportunity to learn more about the specific plans for your daughter's wedding, so that I can make more specific recommendations. Would next Tuesday at two in the afternoon be a convenient time for you?"

PERSON-TO-PERSON SELLING

The telephone conversation described above indicates that person-to-person selling begins the minute a prospective client calls for information. Either you or your employee(s) must become adept at telephone presentations, so that they result in the scheduling of a wedding consultation for qualified prospects. Of course, you and your staff members must learn how to do a skillful presentation at the consultation itself. This presentation can be divided into several well-defined steps.

The first step involves preparation. You must decide what to wear, what kinds of samples and promotional materials you'll need, and what you intend to say to the prospect. This planning involves knowing how your photography compares to that of your competition; which key points are important to most brides and grooms; and what, if any, resistance you might encounter, so that you're prepared to overcome possible objections.

The next step is your introduction to the potential customer. The first few minutes with any prospective client are decisive. You must develop interpersonal skills that enable you to put your clients at ease and to develop a rapport with them. Involve your subjects in your presentation by asking questions about their event. By posing well-thought-out questions, you'll begin to uncover client needs and wants. You can then steer the presentation in a direction that will permit you to explain how you can fulfill their expectations.

The third step is the presentation itself. This is when you "show and sell" your story. Be sure to avoid a long monologue. Keep the dialogue flowing by asking such questions as "I can tell this is very important to you, isn't it?" This is also the time when you should handle any objections that might come up. If a prospect protests a price, dig deeper to find out what the client is actually having a problem with. Many times a price objection simply means that you haven't added sufficient value to your product to convince the prospect that it is worth the higher price. Stressing benefits to the client is always the best way to increase your products' perceived value. Begin by saying, "I can understand that the price might seem high, but let me tell you what you're getting for this price."

The fourth step involves asking for the sale, which sales experts refer to as the "close." You have many different types of closes to choose from, depending on how the sales presentation has progressed. Simply ask-

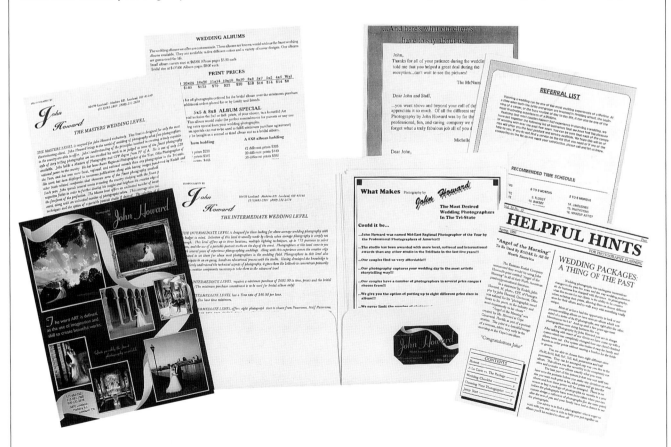

John Howard has an impressive client-information folder; it is a mixture of facts about his business and helpful resource material of interest to engaged couples and their families. The studio information contains descriptions of Howard's various wedding services, reasons why prospective clients should choose his studio, publicity about his studio awards, testimonials from former clients, and a four-color promotional flyer. The other materials include a "Helpful Hints" newsletter and a referral list of recommended wedding vendors.

ing for the sale often is the best starting point: "Are you ready to go ahead with the paperwork that will book the date, Mrs. Smith?" If a prospective client wants to "think it over," try to learn what issues remain unresolved and continue selling by addressing these concerns.

If a potential client plans to visit other photographers before reaching a decision, a "booking incentive" might give you a competitive edge. Explain the incentive as follows:

"Mrs. Smith, I certainly would encourage you to compare our wedding-photography services to others'. From what you've told me about your event, it is one that I would truly enjoy photographing, and I'm confident that you'll be pleased with the results. And I very much appreciate your willingness to spend so much time with me this afternoon. I know that planning a wedding is terribly time-consuming, even though the wedding isn't until next June.

As you might imagine, June is a very busy time for me as well. But I'm willing to hold the date open for 24 hours, as well as honor our bonus of a cameo portrait of the bride that usually applies only to clients who book at the time of the consultation. How does this sound?"

This straightforward approach can keep the lines of communication open. It often prompts prospective clients to reveal what issues are getting in the way of their making an immediate decision. This approach also gives you another opportunity to counter possible objections.

If the prospect is about to leave without booking the session, provide a client-information folder filled with promotional information about your studio. In addition to your price list and promotional brochures or cards, the folder should include important selling points about your business, copies of newspaper articles about your work, copies of thank-you notes from satisfied clients, and a list of wedding vendors that recommend your business. These materials will help to reinforce what you presented during the consultation. They'll also remind potential customers of the strengths of your business when they compare it to those of your competitors.

When you don't succeed in booking a wedding even though the consultation with the prospect seemed to have gone well, it is wise to call the party and ask what factors influenced the eventual decision to use another photographer. If you conduct this inquiry in a pleasant, nonintimidating manner, you'll probably come away with important insights that will help you improve your presentation.

THE PRICE FACTOR

Like many photographers who serve an upscale clientele, Los Angeles photographer Gary Fong has

encountered brides and their families who are planning lavish affairs but who are looking for the least expensive photography they can find. Fong says he understands why this is so:

I've discovered that brides will look for the cheapest price because all they've seen is photographer after photographer with such uninspiring work that photography is simply not a high priority for them. Photography has become an unexciting necessity, and with such an opinion, it is no wonder that brides want to find the cheapest photographer available. Therefore, the goal of our presentation and meeting with prospective clients is to shift the priority of photography for the wedding day to the top of the priority list, which is where it should be.

I believe that the most important determining factor when a client selects a photographer is comfort. How comfortable a couple feels with the person whom they intend to entrust with their wedding-day coverage is what delivers the booking. Presentation of pricing levels is the common threat to a photographer's comfort level. Priced too high, the photographer faces rejection. Priced too low, and the photographer harbors resentment for putting forth a high level of professionalism for a low rate of compensation.

When a photographer is uncomfortable, the couple senses this, and they, too, become uncomfortable. The impression of professional competence is far more important than pricing. Once you define what it is that will excite this quick-to-become-bored client, it is easy to conduct an exciting presentation.

THE IMPORTANCE OF SHOWMANSHIP

Santa Barbara, California, photographer Heidi Mauracher agrees with Gary Fong that the development of a comfortable rapport between the photographer and the client is essential to a successful booking. She also believes in the importance of carefully setting the stage for each consultation with a potential customer. Mauracher explains:

Ambiance is an important part of my presentation and includes music, scents, and taste. I select music to please the style of the couple, according to what I've discerned from the telephone interview. When the couple arrives, they're greeted by the smell of sweet flowers, and I serve refreshments to facilitate the mood of hospitality.

Education is the most important aspect of the client interview. I stress that no two couples are alike. My goal is to create the album as a piece of "Commissioned Art." From the beginning, I plant seeds of suggestive selling to help the cou-

ple understand the value of the "Visual Treasures" that result from an experience that years after the wedding, they will want to share with friends and loved ones at holiday reunions and with unexpected guests alike. My strong interaction with the couple is what makes the experience worth the investment, and a key to artistic and business success is to keep the couple involved and working with me to create a team approach to the wedding planning.

What goes on during the initial interview? In addition to introducing the couple to my "Album Story" and "Commissioned Art" concepts, I explore their expectations about photography, their practical needs, and their wedding fantasy. I observe their body language, and I pay close attention not to "push" the sale. We discuss the need for teamwork and my desire to involve them as much as possible in order to create a positive experience that will pay off in terms of the emotional investment they are making in their wedding day. I also stress the social necessity of good organization and scheduling of the wedding-day events. I want them to plan carefully so the photography part of their wedding day is hardly noticed by the guests. I believe this is good showmanship.

SELLING FROM THE CLIENT'S PERSPECTIVE

It is impossible to overstate the importance that genuine enthusiasm and well-developed interpersonal skills play in the success of person-to-person selling. Whoever makes the presentation, you or an employee, the individual must approach that part of the process with eagerness and assurance.

In Bob and Karen Palmer's Salem, Oregon, studio, Karen handles all aspects of sales, from the booking consultation through the album-design session. Her natural enthusiasm, combined with keen insight into what benefits are most important to prospective wedding clients, create an ideal climate for successful selling. Karen explains some of the major selling points of her presentation:

People always remark that Bob's work looks so natural and unposed. I let them know that the pictures don't "just happen." I explain that just as movies have directors to lead and edit the action to make it look real, Bob and I are there to "direct" the action so the quality of the work has the same type of authenticity that a well-directed movie has.

Of course, there will be lots of candids of the unplanned things that always happen at the wedding and the reception. So our clients feel like they are getting the best of both worlds: natural-

WEDDING PHOTOGRAPHY AGREEMENT

(Booking-information form and contract of Alvin Gee Photography, showing client information, location, tentative order, studio services, payments, and acknowledgement sections.)

TERMS & CONDITIONS

CONSULTATION
In order for us to properly photograph your wedding, we suggest you have a consultation with your photographer one week prior to your wedding.

EXCLUSIVE PHOTOGRAPHER
In order to eliminate confusion on the day of the wedding, it is understood we are exclusive photographers. ANYONE ELSE wishing to take pictures will first consult your designated photographer and abide by his/her judgement. It is the responsibility of the family and bridal party to enforce this rigidly.

ONE ORDER
Each wedding photographed will be considered one order no matter how many individual parties are to receive photographs. One party will be responsible for the entire order and no partial orders will be given out until the balance is paid-in-full.

PAYMENT
Payment of any order for additional prints is due when order is placed. Payment is available through major approved credit cards. It is understood and agreed that any photographs, albums, frames, folders or other items left with you will be returned to us within twenty one (21) days. Any item(s) not returned will be billed at regular prices. You further agree that if it becomes necessary for us to turn this account over to an attorney for collection, you will pay all costs incurred for collection, plus a reasonable sum as an attorney fee.

COPYRIGHT-ADVERTISING RIGHTS
Negatives and originals remain the exclusive property of Alvin Gee Photography, Inc. It is agreed that rights to exclusive use of negative materials and reproductions, including copyrights, are reserved by Alvin Gee Photography, Inc. It is further agreed that you, acting as representative for all members of the wedding party, grant us all rights for display, publication and advertising use of all photographs taken under this agreement.

REMINDER
The prices shown on the reverse side are estimates. These estimates are based on information available at this time. Because of changing conditions within the economy, the estimates on the reverse side are subject to change. In the event the prices do change, we will attempt to give you notice thirty days prior to the date that the photography is to be done. All items are subject to sales tax.

CANCELLATION
In the event of postponement or cancellation of the wedding, notification is required 90 days prior to the scheduled date of the photography. The deposit shall be applied toward services rendered within 24 months of the notification. For notification less than 90 days, the deposit shall not be applied toward photography nor be refunded.

STUDIO LIABILITY
Alvin Gee Photography, Inc. takes the utmost care with respect to the exposure, development and delivery of photographs. However in the event that Alvin Gee Photography, Inc. fails to comply with the terms of this agreement, due to negligence, accident, or any other avoidable or unavoidable action in performing the function set forth in this agreement, the studio's and/or photographer's liability is limited to refund of retainer. It is also understood because of the color fading nature of photographic sensitized materials that Alvin Gee Photography, Inc., and/or photographer assumes no responsibility or liability for defects or shortcomings including color changes or instability of the materials used and processed in accordance with manufacturer's specification. Accordingly, for the color film and color prints, Alvin Gee Photography, Inc. and/or photographer disclaims the implied warranties or merchantability and fitness for a particular purpose. For all photographs, whether black-and-white or color, we also disclaim liability for any consequential or special damage you may suffer, and in no event shall our liability, whether in tort or negligence, in contract or otherwise, exceed the actual cost of materials used. If, for any reason, your designated photographer is unable to photograph your wedding, an equally qualified photographer will be chosen by Alvin Gee Photography, Inc.

To formalize a booking, the photographer and the client should draw up a contract that spells out the obligations of both parties. This formal agreement should include such issues as payment for services, legal liability, and copyright. Here you see the front and back of photographer Alvin Gee's booking-information form and contract.

Joan and Rene Genest of Art Rich Photography have combined their contract with a wedding schedule, order form, and payment record.

ly posed portraits and exciting candids. I also let them know that one of Bob's abilities is understanding how to make people look good—how to turn them or pose them in a manner that is always flattering.

Another important benefit I stress is that both of us work the wedding. My job is to make certain that everything we discuss—all of the client's needs and desires—are taken care of. I also assist with the details of posing and lighting and make sure that all events of the wedding and reception happen as they should. This attention to detail—because both of us are there—is a major selling point for our studio.

Seeing the world through a client's eyes is precisely the intent of an audiovisual presentation that Seattle-area photographers Bruce and Sue Hudson use as a focal point of their wedding-consultation session. The visual content consists of a series of images from several different weddings that they show while an audiotape plays the voices of the clients in the photographs. The former clients describe why they had such a positive experience with the photography and service they received from the Hudsons. The program is effective not only because it represents a third-party testimonial, but also because it focuses on issues of importance to most bridal couples.

AFTER THE BOOKING

Once the wedding is booked, the selling process isn't over because weddings have a much longer sales cycle than other product lines such as portraiture. As much as a year might elapse before the event takes place, so be sure to keep in touch with your bride, groom, and

Before The Ceremony

____ Bride in dress at window
____ Bride with Mother
____ Bride with Father
____ Bride with Mother and Father
____ Bride with siblings and Grandparents
____ Bride with Maid/Matron of Honor
____ Bride alone with maids
____ Bride with maids showing garter
____ Bride at mirror with Mother
____ Bride holding Groom's wedding ring
____ Flower Girl and Ring Bearer

____ Groom alone
____ Groom with Mother
____ Groom with Father
____ Groom with Mother and Father
____ Groom with Best Man
____ Groom with groomsmen
____ Groom alone with each groomsman
____ Groom with siblings and Grandparents
____ Groom holding Bride's ring

At The Ceremony

____ Bride with Father going into church
____ Bride at altar with Father and Groom
____ Bride at altar with Groom kneeling, exchanging vows
____ Bride and Groom coming up aisle
____ Wedding party couples coming out of church
____ Bride and Groom in front of church
____ Whole wedding party at altar
____ Bride and Groom with bridesmaids
____ Bride and Groom with groomsmen
____ Bride and Groom with Maid and Best Man
____ Bride and Groom with Bride's Mother and Father
____ Bride and Groom with Bride's whole family
____ Bride and Groom with Bride's Grandparents
____ Bride's Mother and Father alone
____ Bride's Grandparents alone
____ Bride and Groom with Groom's Mother and Father
____ Bride and Groom with Groom's whole family
____ Bride and Groom with Groom's Grandparents
____ Groom's Mother and Father alone
____ Bride and Groom - candlelight
____ Bride and Groom with hand on candelabra
____ Soloist / Organist
____ Bride and Groom - head and shoulders
____ Bride and Groom - full length
____ Bride and Groom getting into limousine
____ Bride and Groom getting out of car at the reception

Joy Batchelor uses this simple checklist as a guide when working with wedding clients.

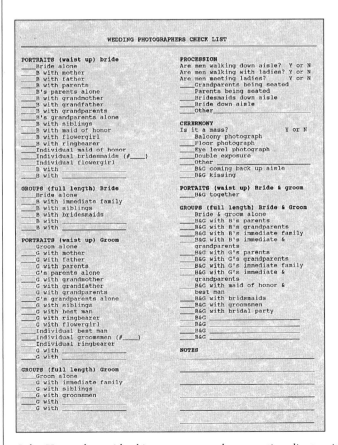

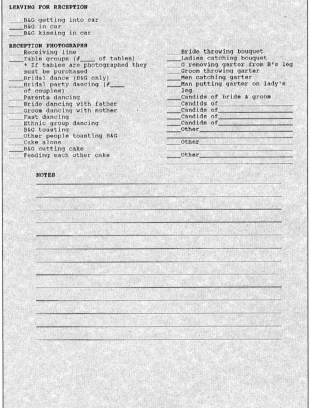

John Howard provides his customers and prospective clients with resource material, including this photography checklist. He also gathers in-depth data about the bridal couple and their families to enable his photographers to provide a high level of customer service.

families from time to time. A simple thank-you card will let them know they've made the right decision in hiring a photographer who truly is looking forward to the wedding.

Smart marketers exploit this longer sales cycle by providing reminders and incentives for taking advantage of other studio product lines, such as family portraits or a glamour portrait of the bride to give to the groom as a wedding gift. Many photographers also offer couples an engagement or "love-story" session, as well as prenuptial portraits of the bride or of the couple together. These portraits become an important addition to the wedding album and provide more opportunities for sales of wall portraits.

SCHEDULING THE PHOTOGRAPHY

Many photographers prefer to schedule most of the formal photography before the wedding ceremony. This is because they can create better images of the bride and groom and their families when they don't have to worry about the time constraints that exist between the wedding and the reception. It is much less stressful for both the photographer and the wedding participants, and it is much kinder to the guests who aren't forced to stand outside the church or be left waiting at the reception while the formal photographs are made. There is another critical consideration: the participants look their best before the wedding. Hugging, kissing, and climactic problems can wreak havoc on appearances.

Photographers who wish to guide their clients in this direction should discuss the issue during the consultation. Be prepared to counter the typical objection that "the groom shouldn't see the bride until she walks down the aisle." Explain that this is a superstition left over from the time when families arranged marriages. A better interpretation is that the groom shouldn't see the bride until the day of the wedding.

Suggest that the bride and groom spend a few minutes of quiet time before the pre-ceremony photography begins. This is a far better way for them to enjoy one another's reactions than during the ceremony, when they're bound to be nervous. Tell them that the couples you've photographed in this manner are unanimous in their feeling that they were able to enjoy the ceremony because they got rid of their wedding-day jitters during the time they'd spent together prior to it.

You can help clients understand the wisdom of doing pre-wedding photography by reviewing the timing of the day's activities during the consultation. By the time couples get around to interviewing photographers, they've already booked the reception hall, and most couples forget to add time for the photography between the wedding and the reception. This oversight doesn't present a problem when you shoot the formal photographs before the ceremony.

PROVIDING CUSTOMER SERVICE

Gaining new client referrals is a primary focus for successful wedding photographers. You earn more referrals through outstanding customer service than through outstanding photography. Showing a genuine concern for the wants and needs of the wedding participants, exhibiting good organizational ability before the wedding, and demonstrating both an efficient manner of working and a supportive demeanor at the wedding itself are the types of issues that compel former clients to recommend your services to friends and family.

When a wedding is booked through Roy and Deborah Madearis's Arlington, Texas, studio, Deborah follows up with a letter to both the bride and the groom's families. She provides them with information about the studio's wedding services, as well as what to expect both at the pre-wedding "final interview" and on the day of the wedding. Deborah explains:

> A lot of studios ignore the groom's family. This isn't a good business practice because the groom's family has just as much of a need for wedding photographs as the bride's family. By opening the door for the groom's family to express their photographic preferences, you increase your probability of sales to them, as well as to their family members.

Many studios provide a photographic checklist for clients to complete before the wedding. A good list serves merely as a guide for understanding what types of photographs are most important to the clients. It doesn't limit the photographs taken, a point that you should convey to clients when you discuss the checklist.

CHAPTER 10
SUCCESSFUL SELLING

Today, the creativity of wedding photographers isn't limited to the way in which they shoot weddings or design albums. Their inventiveness spills over into the area of sales, determining the manner in which they present the results of their wedding-day coverage to the newlyweds. This is the critical moment. The bride and groom are at the high point of their anticipation, the photographer is "on stage," and a great deal is at stake. Will the photographs live up to the clients' expectations? Will the sale live up to the photographer's needs?

Resolving these questions to everyone's satisfaction requires sales strategies that begin with the initial bridal consultation, carry through the wedding-day experience, and culminate when the order is placed. Just as artistic styles vary from photographer to photographer, sales methodology often is a matter of the style that is most comfortable for the seller.

PRESENTING YOUR WORK

In the business of wedding photography, no single process proves to be better than others when it comes to successful selling. What the owners of profitable wedding studios have in common is that they've found a comfortable presentation method, and they've learned to fine-tune and exploit it to their artistic and financial benefit.

For many years, photographers presented their wedding proofs in a proof book that clients would take home for a specified length of time. When the time was up, they would bring the book back to the studio and place an order. Many photographers became disenchanted with this system, however, because some couples would delay the return of their proofs. In addition, the size of the sale was often disappointing because the newness of the photographs had worn off.

Photographers looking for more profitable ways to sell their wedding photography turned to a number of different methods. For example, some photographers have clients select the photographs for their album in-house during an "album-design session," so that the proofs don't leave the studio. Other smart marketers now project "transparency previews." Here, the photographers copy the negatives onto a positive/negative transparency film and then project the resulting slides on a large screen. This gives the salesperson much better control of the sale. Clients then have a set of pictures to take home only if they purchase the images. The slide-proof method also facilitates the sale of wall portraits because the clients can view large-size images.

In the 1980s, Florida photographer Alan Feldman combined a video device, the Tamron Fotovix, with a "home-theater" television. This system enables photographers to project wedding images through the television screen by moving negative strips through the Fotovix. The advantages of this setup are: the photographer is in complete control of the selling system; the studio saves money on proofing; and a videotape of the album images can be created, marketed as an "add-on" product, and sent to friends and relatives in an attempt to generate more print orders.

Los Angeles photographer Gary Fong is the co-developer of a widely used, preview-presentation computer software called Montage, which is designed for use with Art Leather albums. This inexpensive program enables photographers to create a suggested layout of the album, using scanned images dropped into the album pages on which the photographs will appear. This type of unified "storyboard" presentation enables clients to view the album pages on a computer monitor and/or on page printouts, so that they can visualize the album story from beginning to end. This invariably results in large orders.

The Montage system also facilitates album production. Because it keys the print to the album mat, album-

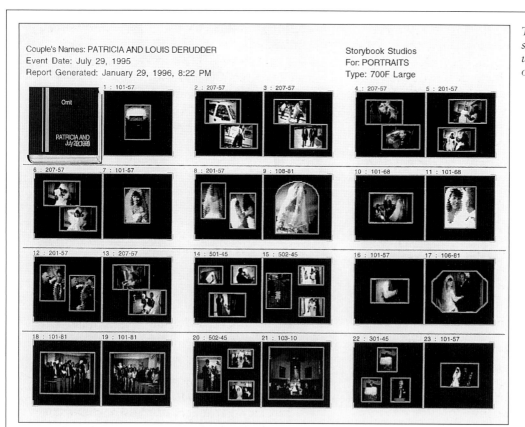

Couple's Names: PATRICIA AND LOUIS DERUDDER
Event Date: July 29, 1995
Report Generated: January 29, 1996, 8:22 PM

Storybook Studios
For: PORTRAITS
Type: 700F Large

The Montage software system enables clients to view the proposed layout of their wedding album.

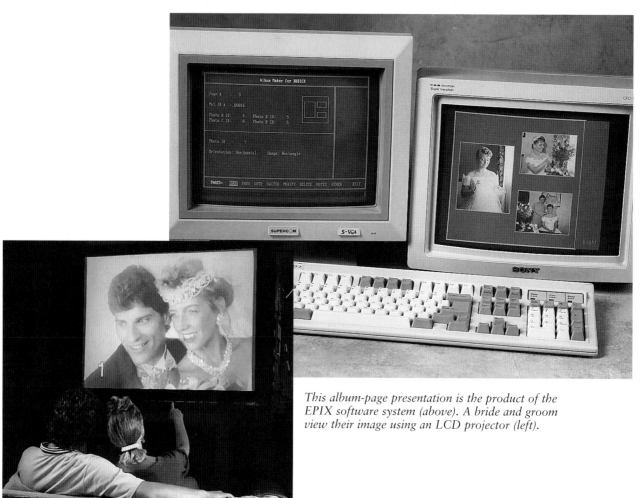

This album-page presentation is the product of the EPIX software system (above). A bride and groom view their image using an LCD projector (left).

and print-order mistakes don't occur. The program also produces customer invoices, compiles album orders, and prints labels that you can use for placing print orders. Art Leather also offers in-house assembly of albums that are designed through the Montage system. This means that photographers don't have to keep inventories of album leaves and mats.

Another software system, EPIX Album Arranger, was developed by photographer Chris Norris, who lives and works in Cleveland, Ohio. This system requires either a Fotovix or Fujix Photo-Video Imager to input the wedding negatives to a personal computer. The wedding images then appear on a monitor in the window openings of suggested mats. As such, clients can see exactly how the photographs will appear on each album page. The software includes a complete inventory of all mat designs and colors for 12 major album companies.

Some photographers prefer to create the album design together with the clients and then provide them with a videotape of the album. Album Arranger also facilitates album production by creating customer invoices, album-assembly instructions, a list of everything needed from the album company, and labels for each negative to send to the lab.

A new EPIX product called IMPAX, which includes the Album Arranger system, also handles wedding reprints; collates lab orders; and provides statistical analyses of orders, such as the average sale statistics and the ratio of images shot to sold.

Through a licensing agreement with EPIX, a number of national photofinishing labs can now process film and capture as many as 400 wedding images on a single 135 MB SyQuest disk. Photographers can then present the order to clients through the software and the finished print order back to the lab via a modem. But be aware that when photographers use any of these systems to predesign the album, clients find it rather difficult to eliminate photographs because the wedding story is broken up.

MAKING THE SALE

With so many selling tools at their disposal, photographers can now choose the ones that best suit their selling style. Here is a sampling of how some of the successful studio owners profiled in this book approach the business of sales. Joan Genest, who with her husband, Rene, owns and operates a studio in North Haven, Connecticut, describes their method:

We present our previews in a 5 x 5 proof book that usually includes between 200 and 250 previews. We spend a lot of time at the "pick-up preview appointment," showing couples their options and explaining how to make their choices. This is an important time to plant "sales seeds." Our order forms give couples many options, and

we've created a "Folio Flyer" to boost our sales of folios.

Our "Photographer's Choice" form helps to increase sales. On it we show our selections for the perfect album. We find that about 25 percent of our brides select the Photographer's Choice. It is beneficial to the client because they receive a discount on additional photographs included in their album under this plan. It always contains more than their original package, and this layout also guides them in making their selections, even if they don't take all of our suggestions. And it helps the couple fill out their order form correctly with less frustration. Currently, we're incorporating the Montage Storyboard printout with the previews.

Bruce and Sue Hudson, who operate a studio in Renton, Washington, prefer the slide-projection method of preview presentation because it allows them complete control of the sale: previews never leave the studio. Sue explains their approach:

We've sold our weddings by slide projection since 1985. When potential wedding clients visit our studio, they're introduced to the slide-presentation concept through an audiovisual production of our wedding photography that features testimonials from former clients. The concept is reinforced during the year-long planning relationship. At the final consultation, we establish an evening when family and friends will be invited to attend their special "premier showing." Typically, this happens four weeks after the wedding, and interested parties are informed via a written invitation that explains what we'll be doing.

All sales are finalized that evening in a process that takes approximately 2½ hours, but which reaps the rewards of increased album sales and no proofs to chase after for months. Best of all, it allows us to conduct an educated and artistic sales process—all at the push of a button. We serve light refreshments during the evening, so the session becomes a party, not a sales presentation.

Through projecting wedding previews, we've increased our sales by eliminating any "mental ownership" of the images. Clients can't touch the image, they can't show it to their friends (for free), or spend weeks or even months processing the images into their personal memory banks. Once the image has left the screen, it is gone forever unless it is purchased. This urgency for ownership is what increases sales.

You can sell only what you show, and we increase our sales that evening by having a variety of albums on display, along with appropriate wall portraits hung in the projection room. This helps to educate clients about the decorative

Photographer's Choice Album

All of us here at the studio would like to congratulate you on your wedding. We hope you had a wonderful celebration and we wish you the very best in your married life! As a beautiful reminder of your wedding day, we hope you will cherish your wedding album. Your photographs will tell the story of the touching moments and great excitement you experienced as you celebrated your love in marriage and we would like to help you arrange the perfect album.

The following pages represent our *Photographers Choice Album*. In this album we have included all the photographs necessary to tell a pictorial story of your wedding day. We have tried to capture everything from the pre-ceremony portraits, to the solemnity of your wedding vows to the magic of your love captured in your post ceremony portraits, to the GREAT fun at your reception.

We have included as many family members, friends and relatives as were possible to make your day extra special. Each page is coordinated in a storytelling fashion, with each photo leading into the next. This helps your Wedding Story flow elegantly and will make your album a masterpiece.

The album story we have created may include more photographs than were included in your original package and they can be added at a special rate. If you choose to design your album exactly as we have prepared for you, just return this with your order. The extra photos are available at a special price. Please see the listing below. If you choose to design your album on your own, please list all your selections on the enclosed order form. Additional prints are available per the enclosed price list.

> It is our sincere wish that you cherish your wedding album for many years to come. We would like to do everything possible to make you Wedding Story the absolute best it can be. Please let us know if we can help you in any way.

Photographer's Portrait Choice - Size _____ **Pose #** _____

In order to complete your *Photograph's Choice Album*, we have added these photographs to your package:

_____ 10x10
_____ 8x10
_____ 8x8
_____ 5x7
_____ 5x5

Regular Price $ _____

> If you order your album exactly like our *Photographer's Choice Album*, the additional cost would be only:
>
> $ _____
>
> You save $ _____
>
> *Thank You!*

Wedding Folios

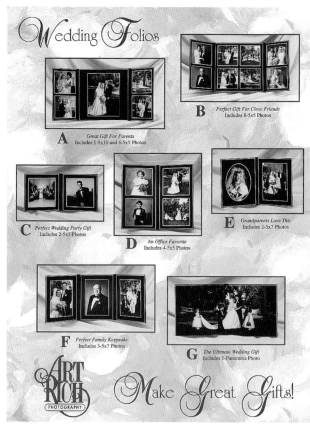

A — *Great Gift For Parents* Includes 1-8x10 and 4-5x5 Photos

B — *Perfect Gift For Close Friends* Includes 8-5x5 Photos

C — *Perfect Wedding Party Gift* Includes 2-5x5 Photos

D — *An Office Favorite* Includes 4-5x5 Photos

E — *Grandparents Love This* Includes 2-5x7 Photos

F — *Perfect Family Keepsake* Includes 3-5x7 Photos

G — *The Ultimate Wedding Gift* Includes 1-Panorama Photo

ART RICH PHOTOGRAPHY

Make Great Gifts!

Joan and Rene Genest of Art Rich Photography facilitate their wedding-photography sales through carefully planned sales-support strategies and materials that make it easy for clients to place orders. The "Photographer's Choice Album" layout encourages couples to increase their order by offering a 20-percent savings on the wedding album when they purchase it as suggested in the plan. Each couple receives 12 order envelopes that make it easy for friends and relatives to purchase photographs. The full-color "Wedding Folios" flyer shows a variety of gift-giving possibilities.

potential of wall portraiture as an option in addition to albums, and it plants seeds for future wall-portrait sales.

The fact that most parents are present at the showing increases the likelihood of their purchasing individual parent albums. Our parent-album sales range from a small 4 x 5 collection to an extensive 8 x 10 combination album. Our most popular album for parents is a 5 x 7 flush-mount album that is priced in the middle range of our price list. Parents make their purchasing decisions that evening because of a two-tier pricing schedule that allows them to purchase at a lower price level than the "reorder" price level, which is 25 to 30 percent higher. The financial incentive makes the process go very smoothly.

I've noticed that many photographers aren't successful at selling parent albums, mainly because they don't display them in the sales room. During the initial consultation, we show brides and grooms (and mainly parents), all the possibilities in parent albums. These samples include 4 x 5, 5 x 7, and 8 x 10 reversible and flush-mount styles with such titles as "Our Daughter's Wedding," "My Granddaughter's Wedding," and even "My Sister's Wedding." This plants the idea that additional albums are appropriate for many family members.

Our weddings are priced a la carte, based on the number of hours of coverage required. We made the change from packages when we began presenting with slides in order to eliminate the restrictive boundaries of packages (where clients think only about numbers) and to get clients to think in terms of "design"—letting the merit of each image determine what size it should be.

Los Angeles photographer Gary Fong is a leading proponent of a-la-carte pricing as a means of increasing the sales potential of each wedding event. As the developer of Montage software, he has helped countless photographers improve their sales through the use of his Storyboarding technique. Fong explains how the system works:

After much experimenting with presentation and pricing, we've arrived at an efficient and effective presentation. We simply provide the couple with a set of previews from which to order—up to 1,000 images on a large wedding. The proofs are loaded into two large proof albums—one for portraits and one for candids—along with a finished album-design "Storyboard" that takes me less than an hour to produce with Montage software. The Storyboard shows the couple finished layout and matting choices. At their presentation appointment, when they are at the peak of emo-

tional excitement, we show them, page by page, the suggested album layout. We go over parent albums and show them that albums are so much better than a stack of loose prints that will go into a drawer. We also explain our special promotions that reward higher sales levels.

Finally, the couple is instructed to take the proof book home, review the originals, and cross off all the images in the Storyboard they don't want. Clients are very reluctant to break up the story of the wedding because they see the story being revealed in the page layouts. This allows us to achieve a bigger sale without high pressure because the clients sell themselves.

Toronto, Ontario, photographer Stephen Rudd takes a collaborative approach to creating his uniquely designed wedding albums. Rudd explains how he is able to minimize the proofing process and deliver finished albums to the majority of his bridal couples.

We are almost totally a proofless studio, and our usual method is to present clients with a finished album. This isn't a rigid policy, and we'll use paper proofing or video proofing if there is a good reason to do so. However, about 95 percent of our clients either receive a finished album or help us to design the album by viewing video proofs in the studio.

When the client sees the finished product, it contains the best I have to offer because I've personally controlled how the images were created and whatever special techniques have been applied. Only occasionally will a client request a change in the finished album, and then it is only a minor change. I believe this is a far more artistic way to approach the design of the wedding album than to hand over some proofs. This is becoming an even more important issue in the age of photocopy machines. If photographers continue to send out proofs without being paid for them upfront, they are going to go broke. And by saving the cost of paper proofing, they can apply that cost to retouching and enhancing images for the album.

Wendy Saunders, who has studios in both Boulder, Colorado, and St. Augustine, Florida, has devised a system of sales that lets couples choose a level of coverage that suits their needs and desires. At the same time, this system allows the sale to increase through optional fees and upgrades. She explains:

Our strategy for building the sale is simple: photograph a massive number of exceptional images, and clients will purchase! We refer to our pricing structure as "Level Pricing." With five levels available, the couple can choose the services and goods that suit their needs, including hours of

OFFERING A BRIDAL-REGISTRY PROGRAM

Loveland, Ohio, photographer John Howard recently implemented a bridal-registry program designed to increase wedding sales. Modeled after bridal-registries that department stores offer, the program informs friends and family members of the bride and groom that they can purchase wedding photography as a wedding gift. The program is supported by a letter explaining the registry to the bride and groom, a personalized letter to wedding guests, and a handsome gift certificate that gift-givers can present to the bride and groom.

John Howard's wedding-gift registry program includes an introductory letter, a wedding-photography-gift letter, a gift-certificate folder, and a gift certificate.

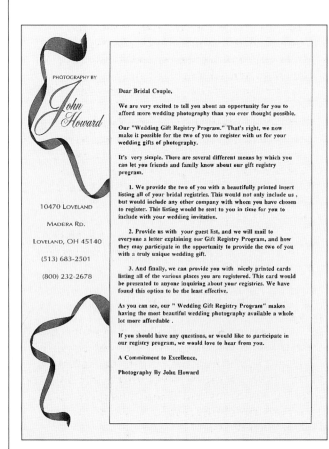

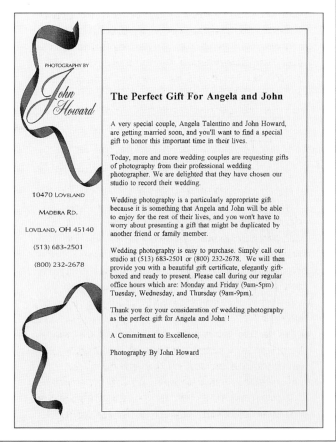

coverage, album size and style, image sizes, original viewing, publication photographs, and a "Get-To-Know-You" session prior to the wedding. Couples decide on the structure before the wedding, and additional features can be added to any level of pricing. Through this system, couples know exactly what they are spending for wedding photography. This method sets us apart from competitors, and clients tell us they like our sales philosophy.

Options available at extra fees are: black-and-white coverage; album upgrades, such as Leather Craftsmen albums; panorama pages; additional coverage (per image); preview albums (a purchase minimum of 300 previews); handcolored images; frames with custom matting (this service is provided by a frame shop); reorders, "signing photos" produced from the "Get-To-Know-You" session, and wedding invitations.

Kenner, Louisiana, photographer Robert Faust believes that preview presentation is an important element in gaining future referrals for his business. So he goes to unusual lengths to put together an exceptional preview presentation for all of his clients. Faust explains why he has chosen this method of presentation:

We present previews to our clients in Art Leather Galaxie albums. Since most of our business comes from word of mouth, we want the first impression of our photography to be the best one. When the bride receives her originals two weeks after the wedding, this is the album that all of the friends and family members see. We want it to be our finest work because this is where our future weddings come from. By the time the bride receives her finished album, approximately eight weeks after the wedding, everyone has already seen the preview book, and the excitement has died down. This is why all of my packages include a preview album that displays the complete wedding story. I believe that photographers who don't use previews are truly missing the boat when it comes to referral business.

We tried a-la-carte pricing but weren't pleased with the sales results. I think it is best to get as much money as possible before the wedding. We work with only four packages. Our largest package is strictly a "whopper" that we don't expect to sell. We designed it to make clients feel more comfortable selecting from the middle of the line, where we make the most money. We've never sold our smallest package, but we include it in the brochure just to get clients who haven't seen our work into the studio. We are one of the highest-priced studios in our area, but we have a low-end package so that we can stay in line with other studios. Once prospective brides see our

work, we can sell them on the advantages of a larger package.

We have a slightly different policy on wedding reorder prints. I believe that most studios overprice their reprints. We tried raising our reprint prices quite high at one point, and our reorders went way down. We investigated the situation and found that most of our reorders were coming from friends and relatives of the bride and groom and not from the immediate family. Friends and relatives aren't going to pay high prices for photography; they'll simply do without. So we reduced our reprint prices, and our sales increased dramatically.

Karen Palmer does the selling in the Keizer, Oregon, studio that she shares with her husband, Bob. Karen explains how switching to an album-design session helped to revitalize their once-sagging wedding sales:

Our "album-design session" is responsible for our profitability in weddings. One reason why this session works so well is that from the very beginning, when the couple comes for the wedding consultation, I stress that my job is to make certain that the bride and groom get exactly what they want in their wedding photography. A big selling point is that we don't rely on any kind of formula, and the couple gets to design their own custom album. They appreciate the fact that we let them make the decisions. As a result, I don't have to high-pressure the clients to get the sale. They literally sell themselves. The pressure for a larger sale comes from them and not from me, so the comfort level for me is very high.

At the consultation, I stress the benefits of the design session: being able to see the images on a large-screen television (using the Fotovix), having me there to help them with the design and to answer all the questions that inevitably come up, and the fact that they can see how any of the images will look if printed in black and white by dialing the color out of the video image. After this explanation, they see the design session as a real plus for our studio. There is nothing threatening about this method of sales, and the benefit to our profitability is enormous.

MASTERING YOUR PRESENTATION

Most photographers agree that successful selling is difficult to master. Creative people often feel awkward when they have to translate their art into dollars, particularly when they're faced with clients who are concerned about the expense. Gary Fong believes that anyone's sales technique can be improved through practice and refining:

Selling success is measured by the strength of your belief. For many couples, price isn't the primary concern. Comfort in the photographer's professional competence is far more important: comfort and trust.

For photographers who feel inhibited in selling situations, I suggest that they memorize a script. In this way, the presentation will become comfortable. Being hesitant when answering questions regarding your product leads the customer to lose confidence in what you have to say. All good sales methods teach specific phrases, insisting that you use memorized comments to explain your point clearly. So part of your self-imposed sales training should be dedicated to scripting your lines. Once your confidence has developed, you can then use your own creative input in your sales presentation. In the interim, memorizing helps you close a higher percentage of sales.

For example, when we give a quote to our inquiring customers, we feel that it is important to use this precise wording when explaining our pricing: "We charge between $750 and $1,750 for wedding-photography services. There is no time limit and no minimum order. You choose only the pictures you want, in the sizes and quantities you'd like, after you see your finished photographs." Not knowing how to say this smoothly will cause you to blunder whenever prospective clients ask, "What do I get for my $750?" Through proper scripting, the question never comes up because you already have told them the answer. This kind of attention to detail will help you in all forms of selling that you do to run a profitable business.

MONITORING YOUR FINANCIAL PROGRESS

One reason why many studio owners shy away from the business side of photography is that they find conventional accounting methods to be a chore that yields very little data for making practical management decisions. This occurs when studio owners receive custodial accounting reports rather than managerial accounting information. Custodial accounting is the process of collecting and interpreting the information necessary to report tax liability to the various federal-, state-, and local-government taxing agencies. This information is almost useless in helping you to understand and make decisions about your business.

Managerial accounting serves this purpose. Without a working knowledge of the photography business or specific guidelines from the photographer as to the data needed and how to present it, an accountant can be of little value to a business. This chapter will help you understand which functions of your business must be tracked and how to monitor them clearly and concisely.

ESTABLISHING AN ACCOUNTING SYSTEM

The simple data-collection system that follows will enable you to gather information for both tax and management purposes in a form that is easy to comprehend. It will also help you to communicate with your accountant as well as take charge of your business. (I've added some interpretations of my own to this system, which is based on the teachings of Charles H. "Bud" Haynes, Honorary Master Photographer, Photographic Craftsman, and Associate (ASP), former president of both PPA and the Photographic Arts and Science Foundation. I am grateful for the knowledge Bud has passed on to me, and I'm pleased to pass it on to others.)

ESTABLISHING PRODUCT LINES

The foundation of any business comprises the products that it sells. Classifying and grouping products are vital steps because these product lines form the basis of not only your marketing plan, but also the accounting records required to monitor the financial progress of your business. If the only product you sell is wedding photography, establishing your product lines will be quite simple.

You are likely to need only two product lines: wedding photography and bridal portraiture. However, most wedding photographers eventually add other product lines as their businesses grow, and as they receive requests to do portraits of their wedding clients' relatives. Soon the photographers are creating portraits of family groups and individual family members. Many photographers eventually decide to photograph high-school seniors, nursery schools, and/or sports teams as a means of increasing their cash flow during the week. So even if your business now consists only of wedding photography, it is wise to understand how to structure a range of photography product lines that you might introduce in the future.

Three issues determine how product lines are structured: commonality of production cost; special requirements, such as longer duration of shooting time; and marketing considerations.

Cost of Production. In the following list (see page 70), different categories of portraits are included under the "Studio portraits" heading. This assumes that the cost of production of the proofs and finished prints is roughly the same for each category. Glamour photography, however, is listed as a separate product line because the additional cost of a beauty makeover is involved, which, in turn, increases the production cost.

Special Requirements. Although the cost of production of a location portrait might differ very little from that of a studio portrait, location photography requires additional travel and setup time. It also means

more wear and tear on your lighting equipment. These special considerations make it advisable to consider location work as a separate product line.

Marketing Considerations. In some studios, the cost of producing senior portraiture may not vary much from that of regular studio portraiture. But promoting to seniors requires a much different marketing approach. Therefore, senior portraiture is listed as a separate product line. The following is a breakdown of standard studio-photography product lines:

- Studio portraits
 - Individual men
 - Couples
 - Children
 - Brides
 - Individual women
 - Families
 - Pets
 - Executives
- Glamour photography (sessions include a makeover)
- Location portraits
 - Home
 - Office
 - Other locations
- Seniors
 - Studio
 - Other locations
- Undergraduates
 - Nursery schools
 - Public schools
- Activities
 - Sports teams
 - Dance groups
 - Proms
- Weddings
 - Candid weddings
 - Studio weddings
- Service (black-and-white publicity portraits; passport pictures)
- Promotions (list each promotion by subject matter)
- Commercial
 - Products
 - Public relations
 - Location
- Restorations
 - Family wall
 - Family album
- Frames and accessories (items not sold as part of a portrait order from a product line listed above)

ESTABLISHING COST-OF-SALES LINE ITEMS

An effective data-collection system shows you where the strengths and weaknesses of your business lie. To accurately monitor your business expenses, you must break your noncapital-expense line items into two separate categories: cost of sales and general expenses.

Figuring out the cost of sales of a photography business is vital because this enables you to determine how much it costs to bring your product to market. Knowing your cost of sales will then let you calculate the percentage of each dollar of sales that goes toward the manufacture of your product. You need this figure when you set prices. And monitoring it as a percentage of sales will help you to control your production costs.

Cost-of-sales line items are made up of those goods or services required to create or manufacture your photography. Some are easy to identify, such as film, processing, proofing, albums, frames, and presentation mounts. Other cost-of-sales items, however, are easy to overlook. These include the packaging materials for your proofs and finished pictures, retouching costs, mount board, and finishing sprays. Retouching costs are particularly easy to miss when an employee serves as an office worker as well as a retoucher. In this case, you must assign a certain percentage of the employee's salary to cost of sales, and the remainder to general expenses.

If you have difficulty determining whether a business expense should be accounted to cost of sales or general expenses, simply ask yourself the following question: If I didn't have any business this month, would I incur this cost? If the answer is no, then the item is a cost-of-sales expense. For example, if you don't have any business in January, you don't have to buy film, prints, or a wedding album. And you don't require the services of an occasional wedding photographer or a retoucher. These, then, are cost-of-sales expenses. However, you must still pay your electric bill, and you still need a salary that month; therefore, these costs are general-expense items.

The following cost-of-sales items are typical of a photography business:

- Film
 - Black-and-white and color
- Lab costs
 - Processing film
 - Printing proofs
 - Making finished prints
 - Shipping charges for proofs and prints
 (include chemical and paper costs for all items produced in a house lab in addition to the costs incurred through a commercial color lab)
- Retouching and print finishing
 - Retouching
 - Artwork charges or supplies
 - Mounting charges or supplies
 (if an employee does any of these services, you must establish a charge per item when pricing; when you calculate profit and loss, you must allocate a percentage of the employee's salary to cost of sales, with the remainder charged against general expenses)
- Contract labor (a salary paid to anyone who does per-job photography for you and who isn't on your staff payroll)
- Job-specific costs (costs incurred to fulfill the

requirements of an individual session, such as prop or equipment rental, or the purchase of a prop that might not be used again)
- Frames, albums, and accessories
 Frames
 Albums
 Proof folios and presentation mounts
 Packaging materials

ESTABLISHING GENERAL-EXPENSE LINE ITEMS

It is vital that you understand the functions that your general expenses pay for. Knowing this enables you to monitor the financial impact that these functions, which are listed below, have on your business.

- Owner's salary (include benefits, such as health and life insurance)
- Employee salaries (include benefits and employer taxes, etc.; if an employee does both office work and retouching, you must assign an appropriate percentage of that salary to cost of sales, and assign the balance to general expenses)
- Outside services (janitorial services, trash removal, etc.)
- Rent (you should pay a monthly rental fee even if you operate from your home)
- Utilities
- Building maintenance
- Insurance (excluding car insurance)
- Property tax
- Advertising
- Postage
- Telephone
- Operating supplies (small-budget props, camera accessories and maintenance)
- Office expenses (items needed for administrative purposes)
- Education expenses
- Travel and entertainment (if travel is done only in association with educational activities, charge it to "Education expenses" and omit this category, which is a favorite target of the IRS)
- Interest
- Auto expenses (include car insurance here)
- Accounting and legal costs
- Miscellaneous
- Depreciation

Owner's Salary. It is essential that you pay a salary to yourself and any family members who work in your business. The longer you don't pay yourself—because you don't want to place additional financial strain on your business—the longer it will take your business to become profitable. There are two reasons why this is so. First, when you don't pay yourself a salary, you're artificially deflating the cost of doing business, and your prices are likely to be correspondingly deflated.

Look at it this way: If suddenly you are unavailable to work in the business and your spouse or associates had to hire a replacement for you, they obviously would have to pay this new employee a salary. The likely effect on your business is that you would have to raise prices in order to cover the new salary, thereby reflecting the true cost of doing business.

The second reason for paying yourself a salary is that you need the pressure that the salary deduction places on your business as a motivating factor to increase sales. It will exert a subtle psychological pressure on you to make certain that your marketing efforts are what they should be to ensure adequate business levels.

Employee Salaries. If you want to monitor the cost of any elective benefit programs that you pay employees, break it out as a separate line item. Otherwise, you can include all employee costs under the single line item in order to keep your monthly income-and-expense statement short and easy to read.

Outside-contractor Services. You buy these from people who aren't on your payroll. If costs in this area rise above the level of a single employee's salary and benefits, it might make sense to hire another staff member.

Building Overhead. These are expenses associated with your place of business. By monitoring them, you'll know whether it is more economical to buy or rent a business building.

Promotion. These are the costs associated with bringing business to your studio. If you do a lot of direct mailings, include advertising postage here in addition to the advertising products themselves.

Administrative Costs. These include the day-to-day costs of doing business in any location, whether you rent or own it.

Depreciation. This is the method by which you expense capital purchases.

DETERMINING PROFIT AND LOSS

Once you've established your product lines, cost-of-sales expenses, and general expenses, you are ready to establish the relationship between your business income and expenses that will determine whether or not your business will be profitable.

Begin by adding the total sales from each of your product lines (see the chart on the top of page 72). Suppose that your studio has total sales of $150,000, cost of sales of $50,000, and general expenses of $90,000. When you subtract the cost of sales from the total sales, the result is referred to as "gross profit."

Next, you subtract the general expenses from the gross profit to obtain the net profit (or the net loss if general expenses exceed the gross profit).

THE INCOME/EXPENSE RELATIONSHIP

Total sales	$150,000
–Cost of sales	$50,000
Gross profit	$100,000
–General expenses	$90,000
Net profit (loss)	$10,000

From a management perspective, the most helpful information gained from the income/expense relationship shown above is how the cost of sales, gross profit, general expenses, and net profit can be expressed as a percentage of the total sales (see the chart below).

INCOME AND EXPENSE RATIOS

Total sales	$150,000	100%
–Cost of sales	$50,000	33%
Gross profit	$100,000	67%
–General expenses	$90,000	60%
Net profit (loss)	$10,000	7%

This relationship indicates that for every dollar your studio takes in, you spend 33 cents (or 33 percent) to manufacture the product, 60 cents (or 60 percent) on general expenses, and retain 7 cents (or 7 percent) as profit.

MONITORING SALES AND EXPENSES

Once you can account the total sales, cost of sales, and general expenses of your business, you'll have completed the first step toward good management. The next step is to determine how high your cost of sales should be. Then you can monitor that cost and make responsible management decisions regarding how you manufacture your product and what you charge for it.

As a reasonable guideline for cost of sales in the studio- and/or wedding-photography business, these costs shouldn't exceed 30 to 40 percent of total sales. This means that for every dollar you take in, you shouldn't spend more than 30 to 40 cents on all aspects of the creation of that product.

If your studio is located in your home and enjoys a relatively low overhead, a cost-of-sales guideline of 40 percent is reasonable. If your business is located in a commercial building that you own or rent, then a cost-of-sales guideline of 30 percent is more realistic.

Only you can determine a cost-of-sales guideline that is appropriate for your business. As you become more knowledgeable about your business costs, you'll be able to assess what your guideline should be. Until then, it is reasonable to limit your cost of sales to 40 percent if you are in a low-overhead situation, or to 30 percent if you are in a high-overhead location.

Consider the following example (see the chart below). You can see the effect on general expenses for the cost-of-sales scenarios of 40 percent and 30 percent, respectively. Assume that you're striving for a net profit of 10 percent of total sales.

THE COST-OF-SALES/ GENERAL-EXPENSES RELATIONSHIP

	40% Cost of sales	30% Cost of sales
Total sales	100%	100%
–Cost of sales	40%	30%
Gross profit	60%	70%
–General expenses	50%	60%
Net profit (loss)	10%	10%

If your cost of sales exceeds your target percentage, you must take steps either to lower your production costs by using fewer or cheaper materials—which in most cases isn't realistic—or to raise your prices to a level that will fall inside your cost-of-sales guideline.

COLLECTING FINANCIAL DATA

The most simplified system of record keeping is "pure-cash accounting." This method relies on the accounting of payments or sales only; it does away with deposits, which can cause a great deal of cash-flow confusion. Pure-cash accounting monitors cash as it flows into your business, at the time payments actually are made. It also accounts funds as they flow out of your business, at the time bills are paid. So, when a client pays you a retainer to book the wedding date, you account it as a sale, not as a deposit. Of course, you must keep a record of that payment on file as part of your client-record form.

RECORDING SALES

The client-record form constitutes the first step in your record keeping. On it you record the following essential information:

• Personal information about the client
• The session number (hint: begin numbering your sessions with 1-0001; after you reach 1-9999, make the next number 2-0001)
• A payment record for the transaction

- A work-flow record
- The type of product line being purchased
- A record of the purchase
- Notes about the order, such as retouching instructions
- A model release and verification of the order

This record can be printed on carbonless paper with different color copies. The top copy (white) is the studio's permanent reference-file record, which is used to track the order through its various stages of processing. Ultimately it is filed for future reference. The second copy (yellow) remains with any parts of the order that are waiting for completion, such as the wedding album and the negative file. Eventually the second copy is filed with the negatives when the order is completed. The third copy (pink) is the client's receipt, which is presented when the order is placed.

As your business grows, you'll want to use a computer to automate much of your record keeping. It is best, however, to understand how to record essential data and to track your client orders by hand. This knowledge will help you when you begin to set up your computer database and financial spreadsheets.

KEEPING TRACK OF WORK FLOW
Having an efficient work-flow tracking system allows you to keep jobs moving through your studio and to

pinpoint where a job stands should a client call to inquire about an order's status. It also assures that you can retrieve filed negatives if they're needed for a future order.

You can achieve work-flow control by using the work-flow-box portion of the sittings/sales/invoice form. The box provides an area in which you can record the date as the order moves through each stage of processing: when the film goes to the lab, when the client picks up proofs (or when you are ready for the client to view projected proofs), when the order is sent to the lab, when the order comes back from the lab and is in the process of final print finishing or framing, and when the client is notified that the order is completed.

As the order moves through the various stages, the sittings/sales/invoice form is itself moved through a filing system called a "post-it file." The form is placed inside a Kraft negative envelope and filed behind the appropriate section designation as follows:

- Film at lab
- Proofs out
- Order at lab
- Order in finishing
- Notified
- Accounts receivable (special orders to be billed to the client or regular orders that are 30 days or more past due)

The file also contains a "hold" section where forms are kept for jobs not yet done, but for which money has been received. These include wedding reservations and gift certificates. When an order is completed, the negative envelope, with the yellow copy of the sittings/sales/invoice form enclosed, is filed numerically (by session number) in a cardboard negative-file box. The white studio copy of the sittings/sales/invoice form is then placed in an alphabetical file as the permanent reference record.

Once you've established this order-tracking system, you simply have to go through your post-it file once a month. You need to check dates on the order-tracking portion of the sittings/sales/invoice form. This way, you can determine if orders are progressing on schedule and take appropriate action if they aren't. You also can total the unpaid balances of all orders in progress or accounts receivable. In fact, you can even do sales projections on the jobs you've shot but haven't received orders for yet. These totals will help you forecast anticipated cash flow.

COLLECTING PAST-DUE ACCOUNTS
One of the most important aspects of the order-tracking process is making sure that finished work is picked up and paid for promptly. The proper handling of past-due accounts will help you collect unpaid balances efficiently. Two weeks after telling a client that

This client-record form is the first step in record keeping.

the order is completed, send a notification that states: *In case you missed our first notification, please be advised that your order is completed. To avoid having to pay interest on the unpaid balance of your order, please make your final payment within two weeks.*

If you don't get a response, send a statement with interest added and the following notation 30 days later:

Please check your records, and if this bill has not as yet been paid, send us a check or money order for the amount indicated. If there is any problem with your account as shown, please contact us immediately.

If another 30 days passes without a response, send a statement that contains additional interest and the following notation:

This statement shows your account to be 60 days overdue. Since we haven't heard from you, we assume that there is no problem with the amount of the bill or the services you received from us. Please give this matter your immediate attention.

If another 30 days passes and you still don't get a reply, send a statement with additional interest and the following notation by certified mail:

This is your third and final notice regarding your overdue account. Unless payment is received within 10 days, this matter will be turned over to a District Justice for collection. The District Justice is empowered to issue a judgment against you and to seize property for sale in order to satisfy the amount owed to us. You may avoid this action by contacting us immediately and arranging to make payment.

If payment isn't rendered within 10 days, take action against the client through your county's appropriate judicial office. Be sure to keep duplicate copies of all statements sent so that you can assure the authorities that you've made a good-faith effort at collection. This record of your correspondence with the client also will protect you from any attempt by the client to countersue you for harassment.

Be aware that the longer an account goes unpaid, the less chance you have to make collection, so by adhering to this collection schedule, you are likely to have few bad debts. Take into consideration, however, that you should allow reasonable terms to any client who might be experiencing a financial problem but who puts forth a good-faith effort to make payments each month.

WORKING WITH AN ACCOUNTING SERVICE

An accounting service can be of considerable value to a small business. Comprehensive Business Service, the foremost service of this type, has offices throughout the United States and provides its clients with solid managerial data. For a reasonable monthly fee and a one-time tax preparation charge, your Comprehensive accountant will structure a simple system whereby you report your weekly income, expenses, payroll, and sales taxes. The service will then provide you with a monthly income-and-expense statement and balance sheet. The company will also prepare all government tax-collection forms. If you're audited by the IRS or the state or local tax-collecting authorities, your Comprehensive accountant will represent you at no additional charge. An accounting service is ideal for a new business that isn't large enough to support a bookkeeper; it might even be appropriate for a large firm that might have a full-time bookkeeper.

THE DAILY-RECEIPTS RECORD

If you're reporting your income to an accounting service, a daily-receipts record is all you'll need to give to your accountant. Whether you keep your own books or let a service do them for you, this sheet serves two purposes. It serves as a record of all cash transactions by date, client, and product line, and as a record of your bank deposit.

Take a moment to study the transactions listed on the form (see page 75). Each deposit is not only listed by "Amount Received," but also broken down, in the two right-hand columns, as to whether the payment was made in cash or by check or credit card. So, when you are ready to make your bank deposit, you'll know precisely how many checks or credit-card payments, how much they total, and how much cash constitutes that deposit. When you add the cash and check/credit-card columns, they'll total the amount of the bank deposit. You can make deposits daily or weekly, depending on the number of receipts your business takes in.

Note the two shaded columns marked "Frame?" and "Tax." The frame column is useful in calculating how much of any given sale results from the sale of a frame. The frame sale is accounted when the final payment for the order is received, as is the case in the October 4 entry under the name "Blouch." From this entry, you know that the $46.00 of the total Blouch order came from a frame sale. Contrast this with the "Winter" entry on October 8. Here you see that a client purchased a frame for $112.36 ($106.00 + $6.36 tax) that wasn't part of a portrait order. In this way, you can tell how many frames were purchased as part of a portrait order and how many were purchased independently.

Sales tax also is accounted when the final payment is rendered. Accordingly, the total tax on the sale is listed in the tax column. Note that the amount appearing in the tax column represents the amount of the total sale that is composed of tax and isn't accounted as "in addition to" the sales amount. In other words, of the entire bank deposit of $10,648.81 made on October 10, $245.45 consists of sales tax that must be paid to the state sales-tax-collection agency. Because regulations regarding the timing of

Daily Receipt Record — Year 1996

Date	Customer's Name	Amount Received	Product Line	Frame?	Tax?	Cash	Check/Credit Card
10-4	Johnson	400.00	P				400.00
	Snelling	600.00	P				600.00
	Blouch	179.35	S	(46.00)	(18.73)		179.35
	Miller	35.00	S			35.00	
	Thompson	900.00	P				900.00
	Cleary	50.00	P				50.00
	Mathias	50.00	P				50.00
10-5	Kent-Rogers Wedding	3292.00	W		(186.34)		3292.00
	DeRoy	50.00	P			50.00	
	Mayer	50.00	P				50.00
	Wentling	750.00	P				750.00
10-6	Seele	200.00	S				200.00
	Johnson	317.45	S		(34.02)		317.45
	Hall	175.00	S				175.00
10-7	George-Stone Wedding	2,000.00	W				2,000.00
	Carducci	22.00	S		(22.00)		
	Holland	315.65	P				315.65
10-8	McCrory	50.00	P				50.00
	Marshall	50.00	P				50.00
	Ebersole	400.00	P				400.00
	O'Hara	650.00	P				650.00
	Winter	112.25	Frame		(6.36)		112.36
		10,648.81		(46.00)	(245.45)	107.00	10,542.81

Bank Deposit 10-10-96 10,648.81

Weekly Sales & Sittings - Accumulated From Daily Receipt Record & Appointment Book

October (Month) 1 (Week No.) 1996 (Year)

DAY / DATE		Studio Portraits	Location Portraits	Seniors	Weddings	Service	Promotions	Commercial	Copy/Rest.	Frames/Acces.	Misc.	TOTAL	SALES TAX
TUES 4	Sittings	2		1								3	18.73
	Sales	2,000.00		214.35						(46.00)		2,214.35	
WED 5	Sittings	2										2	186.34
	Sales	850.00			3,292.00							4,142.00	
THURS 6	Sittings		2									2	34.02
	Sales			692.45								692.45	
FRI 7	Sittings			1			1					2	
	Sales	315.65		22.00	2,000.00							2,337.65	
SAT 8	Sittings	2										2	6.36
	Sales	1,150.00								112.36		1,256.00	
TOTAL	Sittings	6	2	2				1		(46.00)		11	245.45
	Sales	4,315.65		928.80	5,292.00					112.36		10,648.81	

Monthly Sales & Sittings - Accumulated From Weekly Totals

October (Month) 1988 (Year)

		Studio Portraits	Location Portraits	Seniors	Weddings	Service	Promotions	Commercial	Copy/Rest.	Frames/Acces.	Misc.	TOTAL	SALES TAX
1st Week	Sittings	6	2	2				1		(46.00)		11	245.45
	Sales	4,315.65		928.80	5,292.00					112.36		10,648.81	
2nd Week	Sittings												
	Sales												
3rd Week	Sittings												
	Sales												
4th Week	Sittings												
	Sales												
5th Week	Sittings												
	Sales												
TOTAL	Sittings												
	Sales												
YEAR TO DATE	Sittings												
	Sales												

13-Week Planning Calendar - 1996

January - 5 Weeks
S	M	T	W	T	F	S
28	29	30	31	1	2	3
4	5	6	7	8	9	10
11	12	13	14	15	16	17
18	19	20	21	22	23	24
25	26	27	28	29	30	31

February - 4 Weeks
S	M	T	W	T	F	S
1	2	3	4	5	6	7
8	9	10	11	12	13	14
15	16	17	18	19	20	21
22	23	24	25	26	27	29

March - 4 Weeks
S	M	T	W	T	F	S
29	1	2	3	4	5	6
7	8	9	10	11	12	13
14	15	16	17	18	19	20
21	22	23	24	25	26	27

April - 5 Weeks
S	M	T	W	T	F	S
28	29	30	31	1	2	3
4	5	6	7	8	9	10
11	12	13	14	15	16	17
18	19	20	21	22	23	24
25	26	27	28	29	30	1

May - 4 Weeks
S	M	T	W	T	F	S
2	3	4	5	6	7	8
9	10	11	12	13	14	15
16	17	18	19	20	21	22
23	24	25	26	27	28	29

June - 4 Weeks
S	M	T	W	T	F	S
30	31	1	2	3	4	5
6	7	8	9	10	11	12
13	14	15	16	17	18	19
20	21	22	23	24	25	26

July - 5 Weeks
S	M	T	W	T	F	S
27	28	29	30	1	2	3
4	5	6	7	8	9	10
11	12	13	14	15	16	17
18	19	20	21	22	23	24
25	26	27	28	29	30	31

August - 4 Weeks
S	M	T	W	T	F	S
1	2	3	4	5	6	7
8	9	10	11	12	13	14
15	16	17	18	19	20	21
22	23	24	25	26	27	28

September - 4 Weeks
S	M	T	W	T	F	S
29	30	31	1	2	3	4
5	6	7	8	9	10	11
12	13	14	15	16	17	18
19	20	21	22	23	24	25

October - 5 Weeks
S	M	T	W	T	F	S
26	27	28	29	30	1	2
3	4	5	6	7	8	9
10	11	12	13	14	15	16
17	18	19	20	21	22	23
24	25	26	27	28	29	30

November - 4 Weeks
S	M	T	W	T	F	S
31	1	2	3	4	5	6
7	8	9	10	11	12	13
14	15	16	17	18	19	20
21	22	23	24	25	26	27

December - 4 Weeks
S	M	T	W	T	F	S
28	29	30	1	2	3	4
5	6	7	8	9	10	11
12	13	14	15	16	17	18
19	20	21	22	23	24	25

Daily, weekly, and monthly reports, along with a 13-week calendar help you keep track of your accounting.

sales-tax collection vary from state to state, you should consult with your custodial accountant to make sure you're complying with your state's rules.

THE WEEKLY SITTINGS-AND-SALES REPORT

Compare the daily-receipts record to the weekly sittings-and-sales report shown above. The daily form is designed so that each day you account, by product line, both the number of sittings completed and the total dollars received. Such data is referred to as "self-accumulating" because one day's totals are added to the next. As you can see on the final "Total" line on the weekly report, this ultimately gives you a full-week total for both sales and sittings.

So, by the end of the week, you have a valuable record of how many sittings, by product line, you've completed that week, as well as how much money you've collected within each of these product lines. You can then transfer that total line to a monthly form.

THE MONTHLY SITTINGS-AND-SALES REPORT

Like the weekly report, this form is self-accumulating (see above). As mentioned earlier, you complete it simply by transferring the final "Total" line from the weekly sittings-and-sales report to the appropriate time period on the monthly report. In the example shown here, the "Total" line of the first week in October, taken from the weekly report, has been transferred to the "1st Week" line of the monthly report.

Continue to transfer weekly totals in this manner until the month is completed. Then, by adding up the week's figures, you'll arrive at a total for the month in question. (Note that the monthly form also includes a "Year to Date" line that enables you to add the result of your monthly total to the combined total for the year up to that point.)

THE 13-WEEK PLANNING CALENDAR

The purpose of collecting data about your current sales is twofold. This process shows you exactly where

your business comes from and lets you compare your current sales performance to sales projections that you've based on the past year's sales performance (see Chapter 12). Because of the nature of the Gregorian calendar, in which there are differences in the lengths of months and in the days when each month begins, it is difficult to compare similar periods of time from one year to the next.

This is the reason why accountants have developed the "13-Week Planning Calendar" (see page 75). It enables you to compare similar periods based on a calendar in which each month begins on a Sunday and ends on a Saturday, no matter what the date might be. Accordingly, the weekly and monthly sittings-and-sales forms refer to "first week," "second week," and so forth.

RECORDING EXPENSES

For many business owners, paying bills and recording those expenses in a ledger are a terrible chore. But you can make this drudgery a bit easier by using an expense record (see page 77). Note that this form has room for an account number and name at the top. One form is prepared for each of the cost-of-sales and general-expense categories or "accounts." Each account name is assigned an account number from the "Chart of Accounts" that you and your accountant set up.

Note also that each expense-record sheet details expenses for a three-month, or quarterly, period; therefore, you must complete a sheet for each quarter and for each expense category. (For the time being, concern yourself only with the "Bills This Month" section of the report. The "Projected Expenses" portion is discussed in Chapter 12.)

Next, you place the various expense records in a looseleaf notebook, interspersed with plastic page protectors that serve as repositories for bills corresponding to the category listed on the expense record that precedes it. As you receive each bill, record it on the appropriate sheet under the "Bills This Month" section, and then place the bill in the plastic pocket. Take a close look at the completed record; you'll see that the bills show the payee, as well as a description and the amount of the expense.

As you pay your bills, enter the date paid in the "Pd." column. At the end of the month, the various amounts paid are added to arrive at the total spent in each of your expense categories (both cost-of-sales line items and general-expenses line items). If you decide to defer payment of a bill until the following month, merely cross off its listing in the current month, and list it for payment in the next month.

The information obtained in the "Bills This Month" portion of the expense record will help you estimate expenses for the coming year—but only if you establish good bill-paying habits. If you are short of cash during an off month, it is better to borrow from a reasonable line-of-credit account than to let bills pile up month after month. The interest you pay on your line of credit should be viewed as a necessary cost of competing in a business that is somewhat seasonal in nature. As in all things, you should establish a limit as to what is reasonable borrowing in order to avoid risky borrowing. (See Chapter 12 for more detailed information about forecasting this limit.)

Documenting expenses isn't a problem unless the IRS audits you. This step then becomes a nightmare! So it is best to proceed under the assumption that at some later date you'll be required to show proof that all of the monies you've spent from your business account were legitimate business expenses. To do this, you must have on file an invoice from the seller that states which goods or services you purchased.

Some purchases, however, require even further documentation when you're being audited. Assume, for example, that you buy a dining-room table and chairs from a furniture store for use in a conference room. The invoice probably will say "dining-room table and chairs." This is just the type of purchase that will look suspicious to an IRS agent, who is likely to conclude that you're charging personal items to your business. In this kind of situation, you'll need to take a picture of the furniture in your office surroundings as proof of its use.

When drawing from a petty-cash fund, be sure that you make a note of each withdrawal and its purpose, since many petty cash transactions don't have invoices to back them up. This record will suffice as evidence of these minor expenditures. Finally, make certain that you carefully document all travel and entertainment expenses, so you can justify them if you're audited.

MONTHLY INCOME/EXPENSE/SITTINGS REPORT

Through the use of the weekly and monthly sittings-and-sales reports, you can learn, on a monthly basis, if your wedding-photography business is showing a profit or a loss. You can also determine which areas you're doing well in and which areas need improvement. You can then record all of this information on a monthly income/expense/sittings report (see page 77).

To fill in the form, simply transfer the totals you've obtained from your monthly sittings-and-sales report and the individual expense records to the appropriate lines. (Disregard the shaded "Goal" columns of the form for now; these are covered in Chapter 12.) Next, do the mathematical calculations for the monthly income/expense/sittings report as follows. Subtract the cost of sales from the total sales to obtain the gross profit. Then subtract the total expenses from the gross profit in order to obtain the net profit or net loss. Net loss is expressed by placing the loss figure in parentheses.

By calculating the "% of sales" column, you have another important informational measure of your business. You can see quite readily where your sales come from in terms of percentages, as well as the important cost-of-sales percentage relationship and the various percentages of each general-expense category. You'll soon recognize that as any expense percentage increases, the effect is to decrease the percentage of the net profit proportionately.

Of particular interest regarding your monthly income/expense/sittings report is the recapitulation of the expense categories by business function. These totals assist you in understanding the financial realities of the component parts of your business. Then as these amounts change from year to year, you can take appropriate managerial actions to be able to control any function of your business that is out of line with your annual financial projection.

Expense Record Account No: __534__ Account Name __Advertising__ Year __1996__

MONTH: JANUARY			
PROJECTED EXPENSES			
Payee	Description	Amount	

BUDGET:

BILLS THIS MONTH

Payee	Description	Amount	Pd.
Steiner	Newsletter	459.61	1-9
Daily News	ad contract	350.00	1-9
Kravitz	Plaza display	110.00	1-9
Lawton	B-ville display	110.00	1-9
Seegar	C-Park display	100.00	1-9
H-B Symphony	program ad	250.00	1-9

TOTAL 1379.61

NOTES:

MONTH: FEBRUARY			
PROJECTED EXPENSES			
Payee	Description	Amount	

BUDGET:

BILLS THIS MONTH

Payee	Description	Amount	Pd.
Daily News	ad contract	350.00	

TOTAL

NOTES:

MONTH: MARCH			
PROJECTED EXPENSES			
Payee	Description	Amount	

BUDGET:

BILLS THIS MONTH

Payee	Description	Amount	Pd.

These typical expense-record and monthly-report forms enable you to assess how well your photography business is doing.

MONTHLY REPORT MONTH: __MARCH__ YEAR: __1996__

Income & Expense Statement (P&L)

SALES	This Month Goal	This Month Actual	Year to Date Goal	Year to Date Actual	% of sales
301 Portraits	8,532	9,549	43,921	44,421	65%
302 Location	0	0	0	0	00%
303 Seniors	478	1,274	3,491	3,888	06%
304 Weddings	2,049	3,650	3,545	4,205	06%
305 Service	0	223	1,251	1,698	02%
306 Promotions	535	154	3,006	3,981	06%
307 Commercial	0	0	0	0	00%
308 Restorations	0	319	95	1,834	03%
309 Frames	5,118	6,338	8,383	8,239	12%
399 Total Sales	16,712	21,507	63,692	68,266	100%
400 Cost of Sales	6,356	6,921	17,787	18,231	27%
499 GROSS PROFIT	10,356	14,586	45,905	50,035	73%

EXPENSES

	This Month Goal	This Month Actual	Year to Date Goal	Year to Date Actual	% of sales
510 Owners Salary	4,289	4,289	12,867	12,867	19%
512 Office Salaries	845	921	3,016	2,010	3%
515 Outside Serv.	149	223	499	402	.5%
517 Rent.	1,000	1,000	3,000	2,901	4%
518 Utilities	346	431	1,515	980	1.5%
520 Maintenance	329	311	634	902	1%
526 Insurance	1,080	1,298	1,080	1,350	2%
529 Property Tax	0	0	0	0	0%
530 Advertising	824	1,235	3,758	2,160	3%
534 Postage	214	106	729	691	1%
535 Telephone	135	149	469	770	1%
538 Operating Sup.	0	215	261	350	.5%
540 Office Expense	98	100	645	545	1%
550 Education	3,070	2,869	3,672	3,770	6%
552 Interest	0	209	1,613	1,520	2%
564 Auto Expense	185	104	1,551	1,524	2%
556 Accout/Legal	311	311	933	1,102	2%
575 Miscellaneous	145	258	374	321	.5%
595 Depreciation	1,100	1,100	3,600	3,600	5%
598 Total Gen. Ex.	14,120	15,129	40,216	37,765	55%
599 NET PROFIT	-3,764	-543	5,689	12,270	18%

Sittings Record

	This Month Goal	This Month Actual	Year to Date Goal	Year to Date Actual
Port.	10	8	27	24
Loca.	0	1	0	2
Sen.	1	2	3	6
Wed.	0	1	3	5
Serv.	0	2	3	4
Pro.	1	1	17	13
Com.	1	0	1	0
Rest.	1	1	3	2
Frames				
Total Sit.	14	16	57	56

Expense Line Item Totals
(Expressed by Function)
and
Percentage of Total Sales
(Expressed by Function)

I. Owner's Compensation
$ 12,867 19%

II. Employee Expense
$ 2,010 3%

III. Outside Services
$ 402 .5%

IV. Building Overhead
$6,133 8.5%

V. Advertising
$ 2,160 3%

VI. Administrative Costs
$10,593 16%

VII Depreciation
$ 3,600 5%

Owner's Compensation +
Net Profit
$ 25,137 37%

CHAPTER 12

PLANNING AND MANAGING

Ordinarily, it takes several years for a wedding-photography business to become profitable enough to support the owner on a full-time basis. No business becomes profitable and stays profitable without detailed planning and ongoing management strategies. Among these strategies are a year-round marketing plan, annual financial projections, operations strategies, and personnel-management issues. These behind-the-scenes activities give your business structure. They also enable you to take control of your business, so that it can support both your artistic and financial goals. Ultimately, they ensure the longevity of your business.

BUSINESS PLANNING

Much of the management process involves planning. A business plan gives your company direction, as well as charts a course of action. A business plan also helps you check your progress along the way. The plan should include sittings, sales, and expense projections, along with a year-round marketing plan because finances and marketing are interdependent.

THE YEARLY FINANCIAL PLAN

The beginning of the last business quarter of the year is the time to devise your business plan for the coming year. Mark off several days on your calendar to accomplish this planning. Some business owners prefer to do their planning as part of a retreat at a pleasant vacation-like location that serves as a pre-Christmas-rush respite. The first order of business is to construct financial projections for the coming year by creating an income-and-expense budget.

PROJECTING SITTINGS, SALES, AND EXPENSES

The first step in the income-and-expense budgeting process is completing the sittings-and-sales plan (see page 80). You simply fill in your studio's various product lines under the "Product Line" heading and then, month by month, determine your sittings and sales goals for each product line. The factors that dictate these goals are your performance in each product line in the current year, and any changes that you anticipate for your business, such as a cutback in one product line and an expected increase in another.

Probable price increases also can affect sales goals, particularly if they are sizable enough to cause a decrease in clients. Bear in mind that you must allow for inflation when figuring the amount of sales growth you plan for the coming year. If, for example, you want to increase sales by 15 percent, you'll have to increase your sales projection by 17 percent, given an inflation rate of 2 percent.

After totaling your projected sittings and sales, transfer the "Totals" line to the "Total Sales" line of the income-and-expense budget (see page 84). Next, calculate your projected cost of sales. To do this, multiply each monthly sales projection by the cost-of-sales percentage you've established for your business. Then subtract these cost-of-sales figures from the "Total Sales" line in order to calculate your projected gross profit.

To complete the "Expenses" portion of the budget, list each of your expense categories (expense-line items) under the heading indicated, and, month by month, determine your expense budget for each of the line items. The "Projected Expenses" portion of the expense record (see page 79) is helpful in this effort. It provides space for the listing of expenses you expect to incur. These are based on your study of the preceding

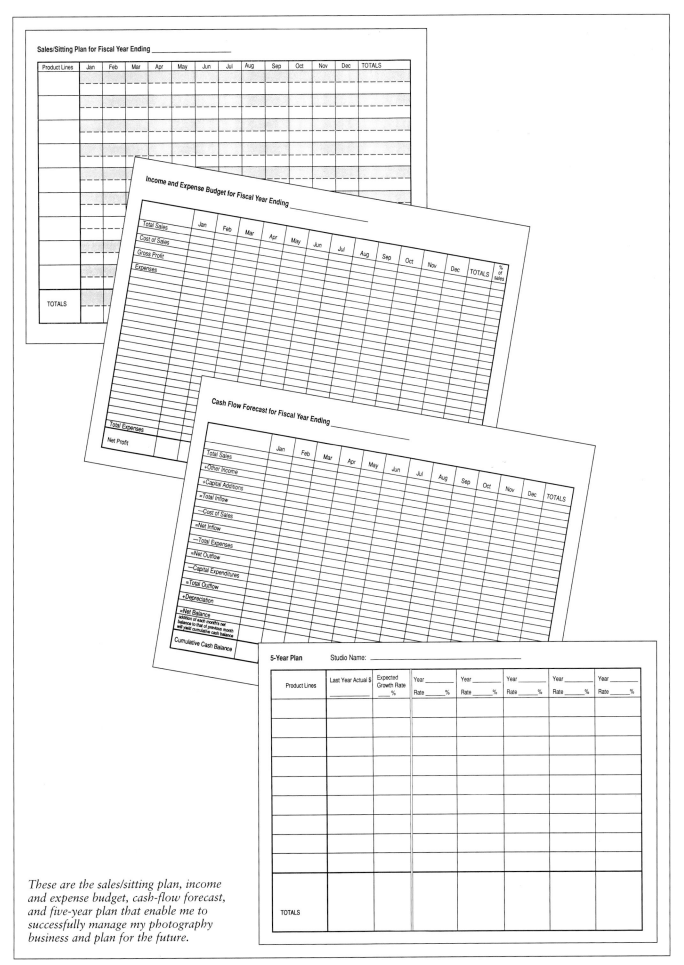

Sales/Sitting Plan for Fiscal Year Ending _____

Product Lines	Jan	Feb	Mar	Apr	May	Jun	Jul	Aug	Sep	Oct	Nov	Dec	TOTALS
TOTALS													

Income and Expense Budget for Fiscal Year Ending _____

	Jan	Feb	Mar	Apr	May	Jun	Jul	Aug	Sep	Oct	Nov	Dec	TOTALS	% of sales
Total Sales														
Cost of Sales														
Gross Profit														
Expenses														
Total Expenses														
Net Profit														

Cash Flow Forecast for Fiscal Year Ending _____

| | Jan | Feb | Mar | Apr | May | Jun | Jul | Aug | Sep | Oct | Nov | Dec | TOTALS |
|---|---|---|---|---|---|---|---|---|---|---|---|---|---|---|
| Total Sales | | | | | | | | | | | | | |
| +Other Income | | | | | | | | | | | | | |
| +Capital Additions | | | | | | | | | | | | | |
| =Total Inflow | | | | | | | | | | | | | |
| —Cost of Sales | | | | | | | | | | | | | |
| =Net Inflow | | | | | | | | | | | | | |
| —Total Expenses | | | | | | | | | | | | | |
| =Net Outflow | | | | | | | | | | | | | |
| —Capital Expenditures | | | | | | | | | | | | | |
| =Total Outflow | | | | | | | | | | | | | |
| +Depreciation | | | | | | | | | | | | | |
| =Net Balance
addition of each month's net balance to that of previous month will yield cumulative cash balance | | | | | | | | | | | | | |
| Cumulative Cash Balance | | | | | | | | | | | | | |

5-Year Plan Studio Name: _____

Product Lines	Last Year Actual $ _____	Expected Growth Rate ___ %	Year _____ Rate _____ %	Year _____ Rate _____ %	Year _____ Rate _____ %	Year _____ Rate _____ %	Year _____ Rate _____ %
TOTALS							

These are the sales/sitting plan, income and expense budget, cash-flow forecast, and five-year plan that enable me to successfully manage my photography business and plan for the future.

year's expense records, inflation factors, and anticipated business changes that will raise or lower expenses. Next, total the various projected expense items within each expense category to arrive at a budget figure. Then transfer this figure to your income-and-expense budget. You can file the completed expense-record sheets until you need them for the purpose of monitoring expenses for the coming fiscal year.

Finally, add up all general-expense-line items, and subtract this total from the gross profit. The result is your budgeted net profit or loss. If your budget projects a loss, you must adjust your business plan so that you achieve profitability.

THE CASH-FLOW FORECAST

Another important part of your annual business plan is the cash-flow forecast (see page 79). This document provides the vital link between projected profit and loss and capital expenses. It shows how the ups and downs of various periods affect the flow of cash in and out of your business, as well as how planned capital expenditures will affect that cash flow. Therefore, you can determine to what extent, if any, you'll need to borrow working-capital funds from the bank. It is much better to make arrangements for credit before the need arises than when you are in the midst of a financial emergency. Knowledge of cash flow also can help you to schedule capital expenditures at times when you aren't short of cash.

You begin the cash-flow forecast by completing the capital-additions-and-expenditures line. You simply list what capital items you intend to purchase during the year, when you intend to purchase them, and the approximate purchase price. In the same manner you list any capital additions, such as business loans or proceeds from equipment you expect to sell. Then total both capital additions and capital expenditures on the lines indicated.

To complete the cash-flow-forecast form, simply transfer data, as indicated, from your income-and-expense budget and capital-additions-and-expenditures budget. The "Other Income" line enables you to add any interest you might expect to receive from bank accounts, etc. Note, too, that provision is made for you to add back your monthly depreciation since this is a noncash expense. The cash-flow-forecast form indicates where to add and where to subtract in order to calculate the final cumulative cash balance. By doing so you can project how much borrowed capital you'll need to finance your business.

THE FIVE-YEAR PLAN

The five-year plan is important because it tells you where your business is headed in terms of sales volume (see page 79). This information enables you to plan ahead for staffing, financing, marketing, and capital expenditures. As such, it gives you the power to manage the direction of your business. You complete it by beginning with the preceding year's sales, projecting the desired growth by product line, and making the necessary mathematical calculations.

THE BALANCE SHEET

Another important business document is the balance sheet. The purpose of this form is to provide your business with a quarterly inventory of what it owns and what it owes as a means of figuring out how much money you've invested in your business. Through the balance sheet, you can determine if your net profit is adequate to compensate you for your investment. The balance sheet also reveals the net worth, or value, of your business. It is vital to know this figure because the growth of net worth means that a business is successful, and the decline of net worth is a business danger signal.

Net worth is calculated by totaling all business assets and subtracting all business liabilities from that amount. There are two types of both assets and liabilities: current, or short-term, and fixed, or long-term. Current assets are those that you presumably can turn into cash within the next 12 months, such as accounts receivable, balances on orders in process, and inventory. Fixed assets are those that you presumably wouldn't sell.

Current liabilities are those items that must be paid for within the next 12 months, such as accounts payable and all short-term debts. Fixed liabilities comprise all loans remaining beyond one year. These debts include mortgages and long-term loans.

Take a look at a typical balance sheet for XYZ Studio (see the chart on page 81). Note that when you total your fixed assets, you must take the additional step of subtracting the accumulated depreciation that has been expensed against these assets in order to arrive at the total book value of your assets. In other words, the subtotal line of your fixed assets represents the amount of capital you've invested in the assets, while the total line represents their value on paper.

MANAGING CREDIT

From time to time, nearly every business must rely on credit to finance its capital expenditures or to sustain its cash flow. It is critical, however, to avoid the business pitfalls that imprudent uses of credit can cause. Among the common mistakes are buying something the business doesn't really need just because credit is available. Another frequent error is using credit to purchase low-priority items, so that the credit limit is used up when it comes time to finance a purchase of major importance. When this happens, either it is impossible to buy the vital item, or the business has to pay a higher-than-normal interest rate.

XYZ STUDIO BALANCE SHEET, 3RD QUARTER 1996

Current Assets			Current Liabilities		
Cash in checking account	$3,260		Accounts payable	$2,074	
Cash in escrow account	$5,820		Sales tax owed	$1,374	
Cash in depreciation account	$18,987		Payroll taxes owed	$3,293	
Accounts receivable	$12,380				
Accounts notified balances	$8,201				
Orders in process balances	$30,082				
Frame inventory	$5,290				
TOTAL	$84,020		TOTAL	$6,741	
Fixed Assets			**Long-term Liabilities**		
Studio building	$110,270		Demand note	$40,223	
Studio land	$20,380				
Equipment	$33,247				
Furniture/fixtures	$42,065				
Automobiles	$30,790				
SUBTOTAL	$236,752		TOTAL	$40,223	
Less accumulated depreciation	$115,000		TOTAL ALL LIABILITIES	$46,964	
TOTAL	$121,752		Net Worth	$161,808	
TOTAL ALL ASSETS	$208,772		Total Liabilities + Net Worth	$208,772	

A third mistake stems from not understanding the full cost of the debt. When a business uses credit to purchase goods from suppliers, it forfeits access to trade discounts. This type of discount is usually 2 percent of the total purchase when the invoice is paid within 10 days. Over the course of a year, trade discounts can amount to a substantial savings for a business. Conversely, they can add significantly to the cost of credit when you don't take advantage of them.

Yet another problem involves using short-term credit to make long-term investments. Be sure to delineate clearly the difference between a long-term loan and a working-capital loan. A long-term loan, as its name suggests, is used for financing long-range business assets, such as equipment, leasehold improvements, and automobiles. A working-capital loan is used to finance temporary cash shortfalls and is repayable within a 12-month cycle.

Keep in mind that when a long-term debt is financed via a short-term loan, the cost of borrowing can rise significantly. The interest rates on these two types of loans vary, as do the rates of different types of lending institutions. By selecting the right loan and the right lender for each purpose, you can substantially reduce financing costs.

Most successful businesspeople agree that small-business owners should borrow conservatively. But the most important factor to remember about borrowing is to do so only to increase profitability. Don't ever borrow money in an attempt to make up for poor profitability.

INVENTORY MANAGEMENT

Inventories have been called the "graveyards of business" because excessive or improperly managed inventories often lead to business failure. The key to inventory management in a photography studio is to carry the minimal inventory necessary to service clients satisfactorily. This prevents you from losing a sale because an item isn't available, but at the same time doesn't tie up your working capital, which happens when you keep an excessive number of items on hand.

Inventory isn't a major problem for photographic studios because most photographers don't process their own color negatives and prints. Maintaining adequate inventories of chemistry and paper adds greatly to the complexity of running a photography business, and it simply isn't cost-effective for most studios. This, then, leaves film, frames, folders, packaging materials, and wedding albums as the primary inventory items for most studios.

For these items, the rule of thumb is to keep on hand only the quantity you expect to use within a month. If you adhere to this guideline, you'll be paying for items used with money generated by items sold; you won't be tying up funds needed to pay your firm's general expenses. Consider also that when you

This employee-evaluation form simplifies performance reviews.

reduce inventories, you might free up storage space
that you can then use to generate additional income
through the creation of a specialty camera room.
Clearly, a review of your firm's inventory system is an
important part of your overall business plan.

WORKING WITH A PROFESSIONAL LAB

A studio is only as good as the photofinishing labora-
tory that backs it up. In many ways, the relationship
that you build with your lab is like a marriage: it must
be nurtured. Among the characteristics of a quality lab
are: consistent print color and density, fast turnaround
time, the range of services offered, a toll-free telephone
number, and reliable customer service.

Once you find a lab that you like, stick with it. Use
the telephone frequently to communicate with the lab's
customer-service personnel. Get to know key lab
employees by name, and build a close working rela-
tionship with them. No lab is perfect, so when you
detect a problem, no matter how small, report it. Over
time, the better you communicate, the better the lab
will be able to serve your business and artistic needs.

CONSULTING WITH BUSINESS ADVISORS

With business growth comes change, and sometimes
change can lead you into areas where your business
experience might not be broad enough for you to rec-
ognize potential hazards or opportunities. This is why

you should meet with experienced business advisors
once a year. They can include your accountant,
banker, attorney, business consultant, and/or another
photographer who has demonstrated a long-standing
record of business success. They can assist you with
such important matters as deciding which type of busi-
ness entity—sole proprietorship, partnership, or cor-
poration—your firm should assume, given its current
financial position.

You should also consider an insurance planner as a
business advisor. This individual can inform you about
opportunities for personal insurance protection, such
as health insurance, life insurance, income protection,
and retirement plans, that you can deduct as business
expenses.

PLANNING THE SALE OF YOUR BUSINESS

The day will come when you are ready to sell your
business and retire. Careful advance planning can
maximize the asset value of your business. A period of
good earnings, for example, will increase the net asset
value. Because earnings can be augmented by such
means as slowing down depreciation and limiting cap-
ital spending, planning ahead enables you to produce
a balance sheet that enhances your company's value.
Ideally, of course, you should dispose of your business
at a time of economic prosperity.

Planning for the eventual sale of your business is
particularly critical when family members are involved
in the business. Far too many families become bitterly
divided when business assets are part of an estate dis-
pute, for example, between the children who have
worked in the family business and those who haven't.
You must arrange for the orderly disposition of the
business in the event of an estate settlement. You can
achieve this through proper estate planning, stock
transactions, and insurance protection. Such a strategy
is one of the most important matters that your regular
business advisors should address in formulating your
overall business plan.

PROFESSIONAL DEVELOPMENT

As a company grows, the founder must learn to
accomplish tasks through the efforts of others, rather
than doing everything alone. For most business own-
ers, this is an unfamiliar role. To grow professionally,
you must develop leadership skills. You also need to
acquire the ability to attract qualified and talented
associates in order to mold your staff into a dynamic,
successful organization.

PERSONNEL MANAGEMENT
Personnel management begins by your clearly articu-
lating what attributes are required of employees.
Pinpointing these characteristics will let you create an

effective advertisement. Some experienced studio owners have found that good sources for office workers or salespeople are their former clients. After all, these satisfied customers are already sold on the studio. Sending a letter to individuals in your client file referring to the position you hope to fill might be all the advertising you need.

You can shorten the interview process by speaking with prospective employees over the telephone as a first step. This usually eliminates about half of the applicants. Next, send an application form to those still in the running and schedule an in-person interview.

Hold the interview in a relaxed atmosphere, and break it down into two parts. During the first stage, determine if the applicant is a likely candidate for the position. If so, you can explain more of the specifics of the job during the second stage. If the candidate isn't likely to be a suitable employee, you can quickly conclude the second stage.

Among the most important and beneficial personal qualities to look for in a potential employee are: a desire to succeed, persuasiveness, humor, a willingness to assume responsibility and take chances, intelligence, optimism, good health, tact, and creativity.

Before you offer the job to the most qualified candidate, make sure that the applicant fully understands the responsibilities of the job and all terms of employment, including compensation and benefits. Any new employee should become familiar with your firm's policy manual as soon as possible. Such a document is critical for effective personnel management, so be certain to have one.

You should also give each new employee a copy of your job-performance evaluation (see page 82). This form lists specific tasks that you'll review every three months for the first year of employment, with the individual's salary adjusted upward according to successful completion of the review. At the review itself, both you and your employee should complete the evaluation rating. Then when the two of you compare the ratings, you can discuss and reconcile any differences in perceptions of job performance.

DEVELOPING LEADERSHIP SKILLS

Leadership begins with knowledge. As a businessperson, you can't lead unless you're informed about a host of subjects, including finance, markets, economics, and personnel management. You can increase your knowledge on these subjects by reading such publications as *The Wall Street Journal, Business Week, Boardroom Reports, U.S. News and World Report, Advertising Age, Reader's Digest, Fortune, Forbes, Money,* and *Inc.*

Other learning opportunities are available through business courses at local community colleges or your local chamber of commerce. Active participation in professional associations, such as PPA and its state and local affiliates, is essential if you want to keep up with the new technologies and market trends specific to photography. Participation as an officer or committee chair in these groups also provides you with chances to develop additional leadership skills.

Texas photographer Carol Andrews is a past president of the Professional Photographers Guild of Houston. She credits membership in the Guild with helping her to improve her skills as a photographer, as well as making her business more profitable. She explains the many benefits of membership:

> The Guild represents a wealth of shared talent and information. Not only do we have access to top industry talent, we also host a roundtable luncheon once a month with a speaker from the community on a business-related topic. We have studio members who talk about marking efforts and a mini-workshop once a month that is a "hands-on" session. Our "emergency network" is an important benefit. When you join the Guild, you agree to back up any Guild member in an emergency. This is a selling point to the public as to why they should choose a Guild member over a non-Guild photographer. The Guild also offers a wedding-referral network in which a member who is booked on a date when a prospective client needs a photographer, refers the prospect to a fellow Guild member.
>
> In addition to enjoying the fellowship of our organization, the opportunities for professional growth have helped to put my business on the map and to strengthen my leadership skills. My advice to any photographer is to share as much information with your fellow photographers as you can. You'll be repaid with self-assurance and a sense of constant innovation.

In a *Fortune* magazine article on the subject of successful business leaders, the following attributes were listed as the "Seven Keys to Business Leadership":

1. Trust your subordinates. You can't expect them to go all out for you if they think you don't believe in them.
2. Develop a vision. Planning for the long-term pays off. And people want to follow someone who knows where he or she is going.
3. Keep your cool. The best leaders show their mettle under fire.
4. Encourage risk. Nothing demoralizes the troops like knowing that the slightest failure could jeopardize their entire career.
5. Be an expert. From boardroom to mail room, everyone had better understand that you know what you're talking about.
6. Invite dissent. Your people aren't giving you their best or learning how to lead if they are afraid to speak up.

7. Simplify. You need to see the big picture in order to set a course, communicate it, and maintain it. Keep the details at bay.

LOOKING TO THE FUTURE

Much of the management process involves planning. An old but truthful maxim says, "If you don't know where you want to go, then it is certain that you won't get there." An annual plan that addresses both the short- and long-term development of your business is as important as knowing how to make great wedding photographs, and financial issues are an essential part of this plan.

Houston, Texas, studio owner Alvin Gee is a passionate believer in the need for long-term planning:

One adage that helps me keep my mind on the business side of things is this: When you are self-employed, you are unemployed until your next job. Recognizing this led me to a business practice that I believe is good discipline for any business owner: Become good savers, and at the same time work to improve your own salary.

My wife, Janice, and I are very disciplined savers. We are debt free: our house and our cars are paid for. In my early career, her income supported us. Janice worked hard to get her college degree and her C.P.A. I worked equally hard to make my business successful, so about 10 years ago I began to give myself raises in an effort to catch up with her income. Every time she got a raise, I gave myself a raise; after five years, I finally eclipsed her income.

Too many photographers treat their salaries as a matter of whatever is left over at the end of the month. As a result, they get no raises. In fact, they often lose ground. This isn't a good business practice.

Long-term planning is extremely important in a small business. Far too many studio businesses lack good management controls, so the owners simply "put out fires" as they occur, and management and marketing strategies fall by the wayside. They think that all you need is a handful of business cards, and that isn't so. Business owners need to think in terms of business insurance: disaster and liability insurance, life insurance, stock portfolios, mutual funds, and pension plans.

For the typical person to retire comfortably, it will take a million-dollar investment. Statistics show that only 2 percent of the population is financially able to retire without having to rely on their family members. I don't want that to happen. I want to spend plenty of time enjoying my family, and planning makes this possible.

John Howard of Loveland, Ohio, is another photographer who believes in planning for the future. He is excited at the possibilities that it holds:

The wedding market will continue to evolve. The smaller photographers may have a more difficult time competing with larger studios. If we look at the retail market as a whole, there are many examples of how businesses and industries have changed across the nation over the last 25 years. History has shown the transition from the mom-and-pop stores to mega-malls and superstores. In this day and age, we must become as efficient as possible, recognizing that most fixed expenses will stay the same whether we have 100 clients or 1,000.

There has been a dramatic increase in the quality level of photography over the last 10 years. Our profession provides anyone with a desire to learn the opportunity to obtain a wealth of information. With this information, there evolves a more educated photographer, which in turn provides clients with a better-quality product. Our clients also are becoming more educated. With this education comes the expectation for a higher level of quality in their photography.

Technology will continue to change the way we run our businesses and how we interact with clients. As with any business, our longevity is directly related to our ability to provide clients with the products and services they desire. If we continue to stay on the forefront of technology, we'll never lose ground to our competitors.

PROFILES

CAROL ANDREWS

HOUSTON, TEXAS

Carol Andrews studied home economics at the University of Houston and worked as a retail buyer and as a caterer until 1980, when she became interested in a career change to photography. This interest took shape while Andrews assisted her late husband, Bob, who was in the wedding-photography business before he opened a computer consulting firm. But she had a problem: "I didn't even know what an f-stop was." So Andrews took an introductory course at the Winona International School of Professional Photography of Professional Photographers of America (PPA) and began photographing portraits. Since then she has continued her education by taking classes at the Texas School of Professional Photography and by attending seminars and programs of the Houston Guild of Professional Photography, of which she is the immediate past president.

Today Andrews operates one of the few studios in the country that specializes in bridal portraiture. It is located in Houston in the Kelvin Group, an artists' complex, near Rice University and the city's museum district. Her shooting sessions are by appointment only so that she can make time for Molly, her seven-year-old daughter.

Andrews has created numerous PPA Loan Collection prints, including images selected for display at Epcot Center in Walt Disney World and at Photokina in Cologne, Germany. Her signature print, a black-and-white rendition of the back of a bride seated on a bench in the Houston Museum of Fine Arts, has received considerable acclaim and won numerous awards. She holds the Master of Photography degree and will receive the Photographic Craftsman degree in 1997.

I began my photographic career as a typical home business. I had a small set of lights, a Hasselblad, and that was it. Later I co-oped space with a designer and also worked with a partner in a commercial space. In 1989, I went back on my own, working at home again and trying to decide what I wanted to do: stick with bridal portraiture or expand to other product lines.

In retail sales, you hear a great deal about "niche marketing." What concerned me was the question of how small a niche you can carve out if you want to be a specialist. It was obvious that there is a well-established base of wedding photographers in Houston. But it occurred to me that there had to be brides who are purchasing their wedding dresses in Houston, but who are being married in other cities. I kept coming back to the realization that what I did best and got the most satisfaction from was bridal portraits. So I stopped fighting my instincts and decided to market myself as a bridal-portrait specialist. That strategy has worked very well.

Brides tell me they really appreciate having a woman help them during the portrait session. The bridal portrait is, in many respects, a dress rehearsal for the wedding. It is when the bride discovers that the bodice of her gown might not fit properly or the headpiece isn't secure. I can help brides with foundation garments, reshape a headpiece, and discuss hair and makeup.

Because of my background in retail sales and as a caterer, I can discuss wedding issues from an insider's perspective, and brides are naturally inclined to trust me. I tell them that "I have experience on both sides of the cake table." What I'm really selling is expertise and service. Sometimes I think that 80 percent of what I do is hand-holding. But all of this works to help me get great photographs.

I work together with David Jones, who does candid wedding photography. We have a kind of "team approach" that provides the best of both worlds for brides. We co-op our studio with a videographer. The space, which has separate entrances for each business, is in a perfect location. The courtyard complex was built in the 1960s by a group of graphic designers and architects. It is a very creative place in which to work and is surrounded by other professionals in the arts: artists, painters, graphic designers, an architect, and illustrators. It is a great fit for the image I want to project to prospective clients. Our clients are sophisticated, well educated, and graphically astute. Many are professionals in the arts who appreciate both creativity and

unusual approaches to the subject matter.

My philosophy is that weddings are fashion-related events, so the photography should be trend-related also. It really disturbs me to see portraits at bridal shows that look as though they were made 35 years ago. I tell brides that "This ain't your granny's bridal portrait. It is yours, and it should look like today." Women don't wear girdles any more. They enjoy a casual, informal lifestyle.

Brides are used to seeing unstructured images in magazines, and they like these visual statements. I don't get so far out as to put brides on ladders, but I do adapt stylish fashion poses. I like images that are casual and a little sexy. Whenever possible, I like to do portraits that include the groom prior to the wedding so that the couple can present the images as thank-you gifts on the wedding day.

During the bridal-portrait session, I create some poses for mom and others for the bride. Mothers are looking for something traditional for their wall, while daughters want to look as if they stepped out of a magazine. Mothers generally buy a custom-framed 20 x 24 portrait, but yuppie couples think a 16 x 20 is huge. They usual buy an 8 x 10, an 11 x 14, or occasionally a 16 x 20. Mothers usually prefer color, while the couples often prefer black-and-white or sepia. And most brides require between one and four black-and-white prints for the newspaper. To keep it simple, I expose color negative film and make Panalure prints when black-and-white or sepia is requested.

My clients view their session previews by projection of transviews. I project the images onto canvas to plant the seed of purchasing canvas portraits. At the projection appointment, I also walk clients through the studio so they can see finished prints on the wall and take a look at frame corners. I talk to them about machine prints versus custom prints and what can be done through retouching. When clients want black and white, I show them a selection of 4 x 5 test prints. They select several views, and I make 8 x 10 test prints to visually confirm their selection. I like the term "test prints" because it comes from the advertising world. I mark the prints with a marking pen to show cropping and printing instructions. All of this helps to underscore the concept of creating a piece of artwork.

Today my business is expanding. I'm photographing family groups and children, and doing some corporate work. I also enjoy creating Polaroid transfers, emulsion transfers, and acetate transfers

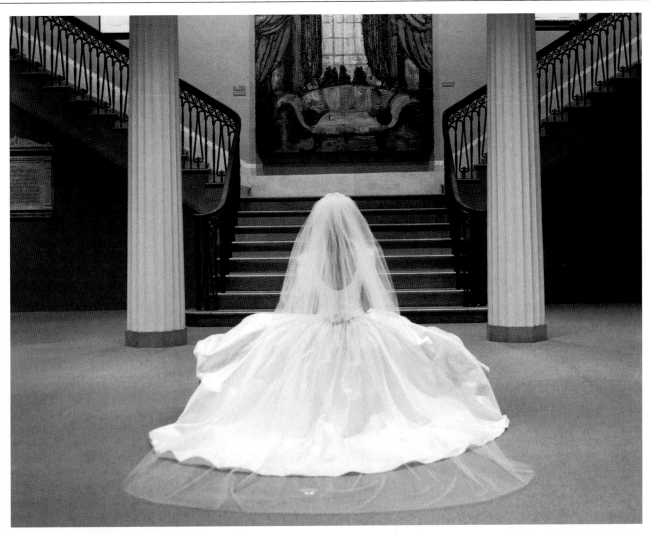

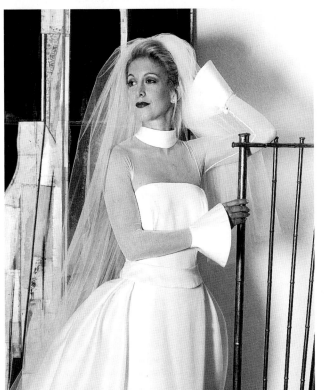

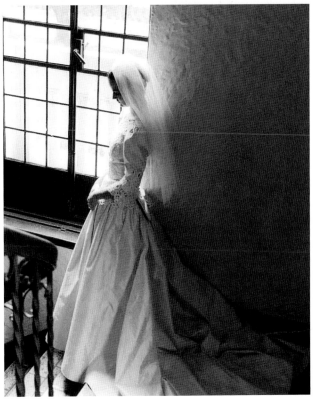

with watercolors. These images hang in my studio, and the transfers are sold through Houston's Contemporary Arts Museum. Still, my ideal assignment is when I get a call from a prospect who tells me she was married a year ago, wasn't pleased with her bridal portraits, and wants to know if I'm willing to do a portrait session. This thrills me because I know the portrait is something she really wants, and she's willing to spend the time and the money to get it.

I believe that most wedding photographers don't recognize how important a bridal portrait is to a woman. Most women are socialized about being brides, practically from birth. It is called the "Cinderella Syndrome." To me, the portrait is important because it represents a threshold to be crossed only once. I tell brides that over the years their expectations and their beauty will change, and the portrait exists to mark where they were at this time in their lives. It records their femininity as they assume careers and before they become mothers. When they've passed through all these stages, they should look back on their bridal portrait with a sweet poignancy. That is the job I like best: recording this cherished spirituality on film.

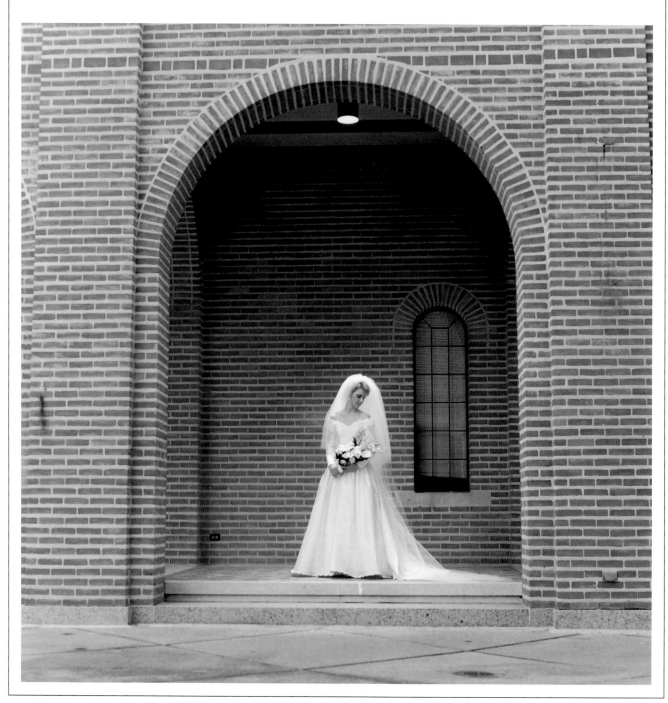

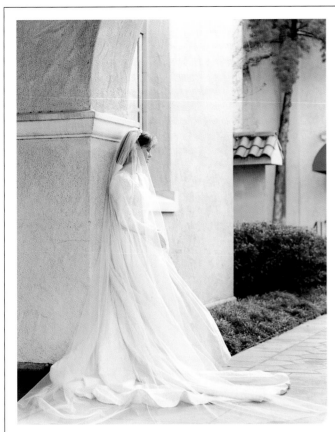

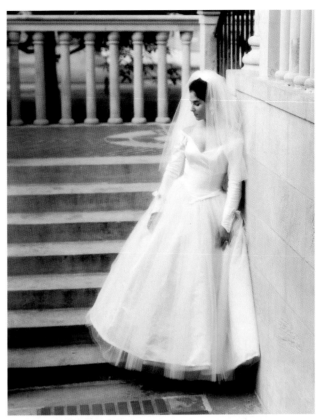

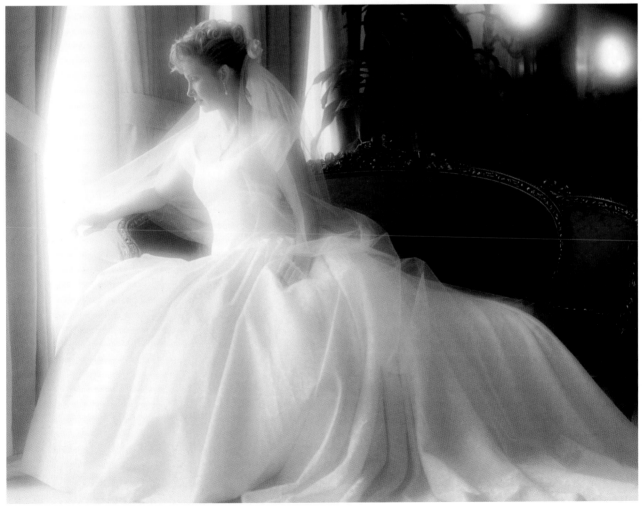

MICHAEL AND PAMELA AYERS

LIMA, OHIO

When Michael Ayers turned his back on civil engineering to become a professional photographer, little did he know that one day he would put some of his college training to work in "engineering" wedding-photography albums. Few photographers can claim that their wedding albums command as much attention as do those in which Ayers makes use of groundbreaking construction methods he calls "Album Engineering," part of a discipline he has dubbed "Album Architecture."

Ayers began his career in photography in 1984 during service in the United States Navy. Later he studied civil engineering, surveying, and photography at Ohio State University before opening his first studio in 1987. In the ensuing years, he has perfected the craft of building world-class wedding albums that defy convention. These extraordinary albums have attracted admiring wedding clients from as far away as Newfoundland, Mexico City, and India. Art Leather selected one of Ayers's albums for its 1994-95 advertising campaign, and several albums have been displayed at trade shows around the world, including Photokina in Cologne, Germany, in 1995 and 1996.

Ayers holds the Master Photographic Craftsman degree from Professional Photographers of America (PPA) as well as PPA's Certified rating. His wife, Pamela, a former legal secretary, is his studio manager. Together they present programs on their unique approach to wedding-album design for fellow professionals.

As a child, I was always fascinated by pop-up books, so much so that I would spend many hours trying to construct them myself, using construction paper. About midway through my college studies, I decided that preserving people's memories was more important to me than building roads, bridges, and buildings. When I made that decision, it never occurred to me that someday I would use aspects of my engineering training to create one-of-a-kind wedding albums.

Over the years we've used Art Leather "Futura" albums because of the wide selection of mats and inserts available in this line. But one day a bride asked if we could place five photographs on a single page. This presented a challenge because standard mats allow a maximum of only four photographs per page. So I got to thinking: "Why place a limit on the number of images on a page, and why be limited to a 12 x 24-inch panorama print?" As a result of this challenge, I began to develop techniques that would become the "Album Architecture" concept. That was eight years ago, and the discipline continues to evolve because with each new wedding come new challenges and opportunities.

Even though every wedding is different, what doesn't change is my basic approach to the wedding itself. To be an effective "design engineer," you must throw out the rules and recognize that the process involves being an artist as well as a craftsman. I look at the album itself as a blank canvas upon which I can create anything I want. My artist's palette consists of the various design elements, such as underlays, stripe tapes, and the photographs themselves, which can be enlarged, cut out, and even segmented into an infinite number of designs. My brushes consist of the various tools of the trade that allow me to implement the designs.

Although each album is a unique presentation, the constructions fall into three basic categories that we refer to as "Designer Pages." A "Single Designer Page" involves construction on one side of an insert; "Double Designer Pages" usually are constructed on an Art Leather panorama page; and "Special Designer Pages" are arrangements that don't fit either of the previous categories, and usually they are much more complex in their construction.

Anyone who is inspired to experiment with "Album Architecture" should keep in mind that it takes a lot of experimenting and practice to perfect the art of folding, cutting, pasting, and adding finishing design touches. The old adage, "Practice makes perfect," certainly applies to this form of art and craftsmanship. With each new album, I learn something new, so it is wise to look at "Album Architecture" as a process, not as an event; as a journey, rather than a destination.

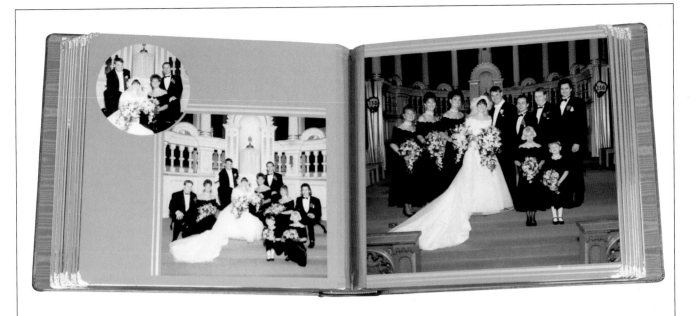

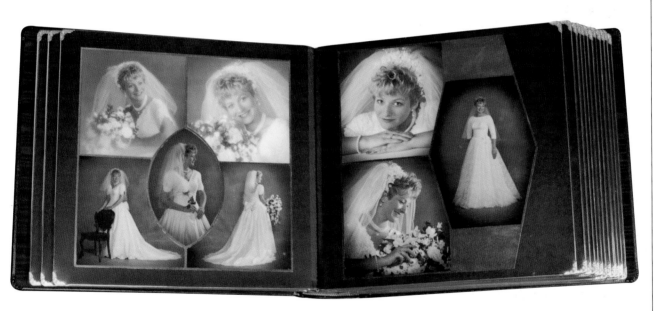

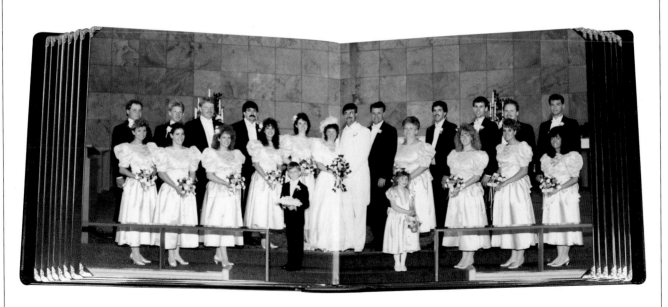

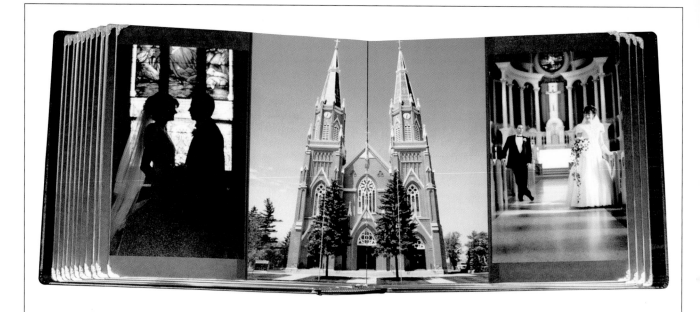

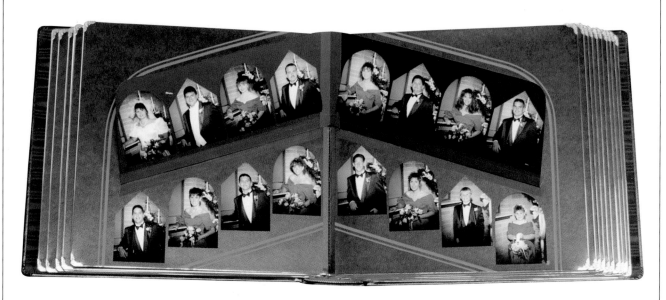

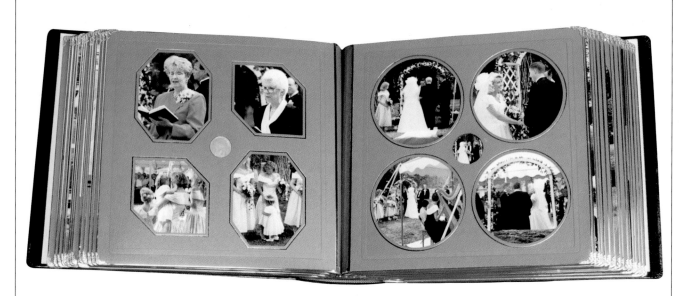

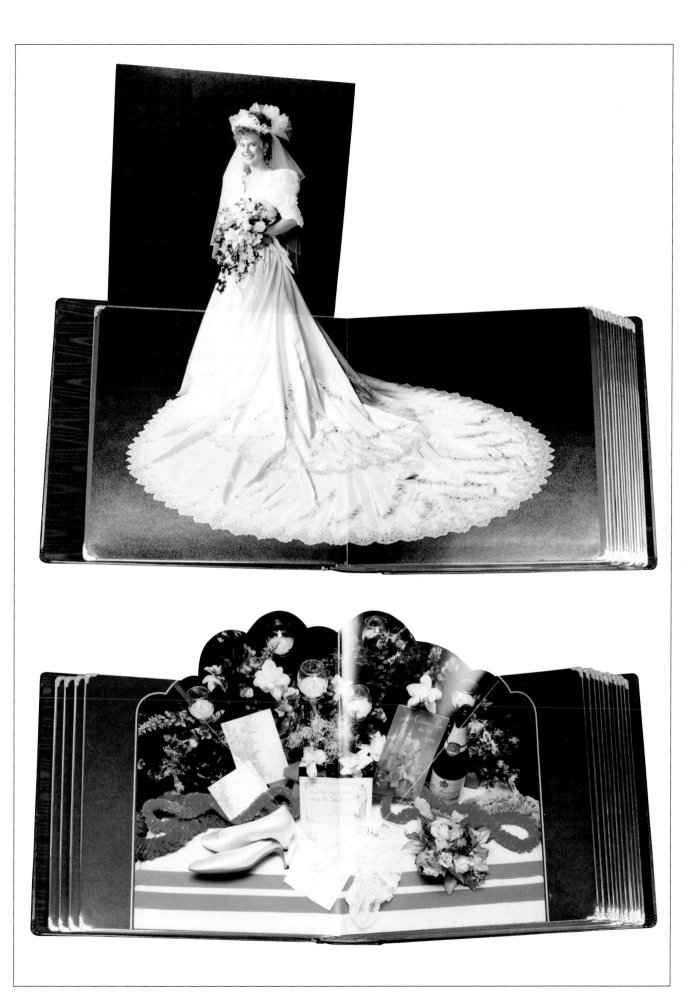

JOY BATCHELOR
RALEIGH, NORTH CAROLINA

Originally intending to pursue a career in retail sales, Joy Batchelor earned a B.A. degree in fashion merchandising from the University of North Carolina at Greensboro. After working for several years as a clothing buyer for the Virginia-based retail chain, Thalheimers, Inc., she decided to change careers. She moved back to her hometown of Raleigh, North Carolina, to join the family photography business, Burnie Batchelor Studio, which is the oldest family-owned-and-operated studio in Raleigh.

Begun by Joy's father, Burnie, in 1954, the business continues to specialize in portraiture of children, families, and brides, as well as candid wedding photography. The studio is also widely known for oil paintings, baby portraits, senior portraits, and executive business portraits for publication. The business is situated in the heart of Raleigh's shopping district and is housed in a commercial building that Burnie constructed in 1961 to accommodate his studio and laboratory facilities.

Joy holds the Photographic Craftsman degree from Professional Photographers of America (PPA) and is the immediate past chair of the organization's Wedding Group. She also is a member of the Professional Photographers of North Carolina (PPNC) Board of Directors, which she serves as secretary. In 1990, when her father retired, Joy became president, owner, and CEO of the family business, which includes a staff of two full-time and three part-time employees.

My father is a great believer in education, so when I came to work for him, the first thing he did was to enroll me in numerous photography classes. I joined the PPNC and PPA. Membership in these organizations has been very valuable to me.

We are a full-service studio, and weddings represent approximately 22 percent of our gross sales. Weddings are a very important part of the mix because it is through the relationships that we establish with the brides, grooms, and their families and friends that we draw many referrals for the other product lines of our business. We photograph about 30 weddings a year at locales throughout the state.

Our style of wedding photography continues to be classical and includes the traditional, posed bridal portraits, as well as candids that portray the personalities and the emotions of the day.

We broaden the style of the album by including wide-angle images, panoramas, closeups, and soft focus, as well as some black-and-white images in every book. We photograph the bride and groom privately before the ceremony to include those moments unknown to the other. We believe that this approach adds warmth and an expression of uniqueness to each album. Our goal always is to create an album that shows style and sophistication.

Most of the events we cover I would characterize as typical southern weddings. The bride and groom don't see one another before the wedding. Most of the families we serve are large and very close-knit, with all kinds of in-laws and out-laws attending. So one of the most important parts of the photography for me is at the reception, where I do as many family groups and "relationship" groups as possible, such as the mother of the bride with her sisters, the mother of the bride and her mother, "generation" pictures, grandchildren together, grandparents, the groom's family groups, etc.

These are the photographs that really boost our sales. In most cases our family-group reorders exceed what is spent on the wedding photography. So receptions for me are a lot more than just pictures of the eating, toasting, and dancing.

The couples fill out a "list brochure" before the wedding, indicating which photographs are important. The picture list aids the wedding party by organizing the events photography and providing a method to document family relationships in addition to covering the wedding. Usually they'll add a page or two to the list. This enables us to make future sales of the family-group reorders.

We publicize our studio through mall displays and advertisements of seasonal specials in the print media. But our greatest publicity tools continue to be our 40 years of satisfied customers who proudly display our portraits in their homes and offices, and the fact that we are a family-owned business that treats our customers like family.

Our business benefits greatly from the traditions begun by my father. We are now photographing the grandbabies of the brides he photographed. I'm photographing the weddings of children whose parents' weddings my father photographed. We've created family portraits for many second- and third-generation families. We take pride in the fact that many former customers continue to travel long distances to be photographed at our studio.

Our studio is strongly committed to community volunteerism, and we support the community through our photographic expertise. Some of the groups we assist are the Raleigh Chamber of Commerce, the Junior League of Raleigh, Hospice, Planned Parenthood, Rex Hospital, Interact, private and public schools, the United Way, Theatre in the Park, and numerous other civic and religious groups. Through this community interaction, the studio continues to build a broad base of new customers, while at the same time fosters continued relationships with our established customer base.

I believe that being a woman is a definite advantage in wedding photography. I've built a reputation for providing a warm, compassionate, feminine touch to the weddings I photograph. I spend a lot of time with each couple before the ceremony, getting to know their family members by name, checking out the layout of the church and reception hall, and determining with the couple what photographs are most important for their albums. The couples and their families view me as a family friend, and I would be disappointed if they didn't give me a hug when I leave.

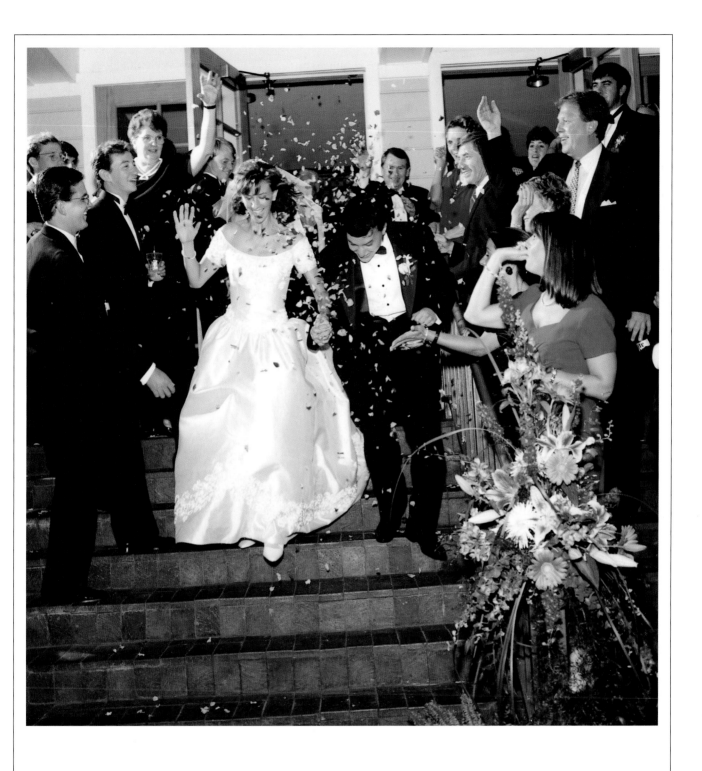

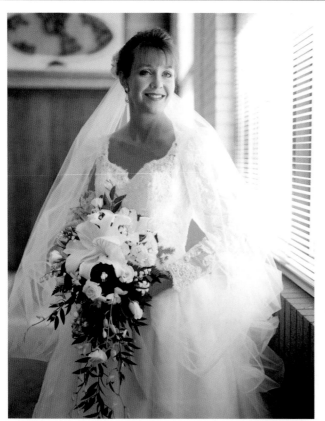

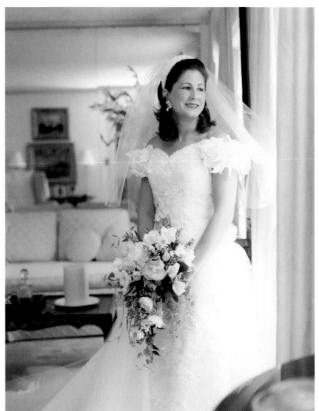

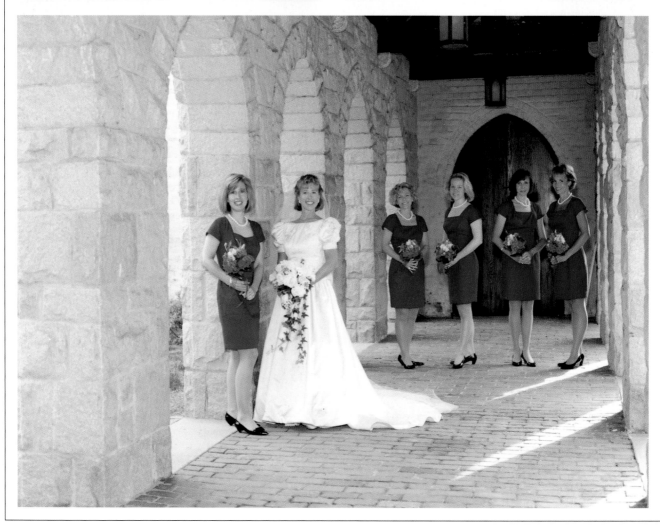

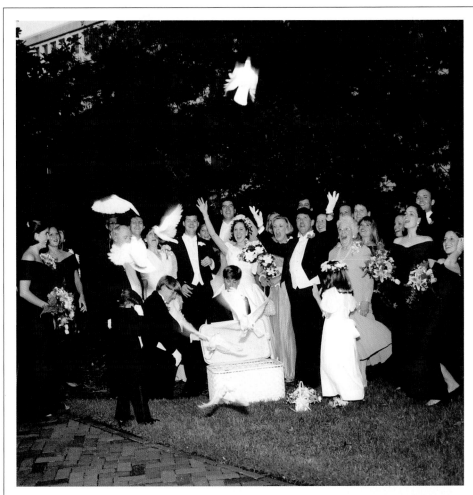

JOHN AND MARY BEAVERS

ATLANTA, GEORGIA

John and Mary Beavers began a part-time wedding-photography business in 1972. At that time, Mary was working for Georgia Educational Television. After the birth of the couple's second son in 1974, Mary decided to devote herself to photography full-time. In 1987, faced with the prospect of moving out of state to keep his General Motors job, John decided to join Mary in the business full time.

Since then, they've operated in the greater Atlanta area at three different locations: in their home for several years; in a small shopping center for six years; and in their current home/studio location, which they purchased 14 years ago. The building is a traditional, two-story home in an affluent neighborhood right off a major highway. The business occupies the lower level of the house, where the Beavers use some of the rooms for window-light environmental portraits.

In the 1970s and 1980s, wedding photography was 90 to 95 percent of the couple's business; John and Mary averaged 80 weddings per year. Over time, their portrait photography has grown by word of mouth to the point that weddings account for only about 65 percent of their business. They now shoot an average of 50 to 55 weddings each year.

The couple's wedding albums consistently take top honors at state, regional, and national competitions sponsored by Professional Photographers of America (PPA) and its affiliates. Both John and Mary hold PPA's Master Photographic Craftsman degree, and they teach classes at their studio and for PPA-sponsored affiliated schools throughout the United States.

We produce wedding albums in a timeless, classical style that doesn't date itself. We refer to it as a traditional style with a creative and romantic flare. Our coverage is very thorough, in a storybook format of consistent quality, in which the end of the book is as interesting as the beginning. Clients tell us that our enthusiasm, professional expertise, and personal attention are responsible for our success and reputation. Our goal is to present each bride and groom with a story of their wedding that will capture the emotion, the beauty, the love, and the family and friends who mean so much to them. We want to preserve the wedding day for those unable to attend.

Recently, we've observed that some prospective clients appreciate a candid style more than we've seen in the past. But at the same time, they still want the beautiful lighting, flattering poses, and soft filtration that make them look great. They fear leaving everything to chance with a completely candid coverage. The people who don't want any "posed" photographs don't book our studio. Most of our clients tell us they appreciate that the subjects in our albums look comfortable and not stiffly posed.

We rely primarily on word-of-mouth advertising, although we do some occasional advertising through color ads placed in bridal magazines, and we network with other wedding vendors, providing them with samples of our (and their) work. Mainly we've built our business on fairness ("Do unto others...") and referrals from satisfied clients.

We are fairly simple in our approach to the technical side and don't buy all the latest gadgets. The Mamiya RB67 and Hasselblad cameras are our workhorses, and we get full use and long life out of our equipment. We edit our processed film on the Tamron Fotovix, and sometimes the brides and grooms share the editing experience with us. This has cut our lab costs significantly. By printing the actual 8 x 10s and 5 x 7s that will be used in their albums, we're saving on reorders for the finished album.

During the album-design session, we'll suggest cutting some of the 5 x 7s down to 4 x 5 or 5 x 5 size, to create multiple sizes in the album. This allows for more "sequence selling," such as three poses of the same group of people, presented to show action and reaction. A couple might ordinarily choose only one if they were just "picking pictures." Sometimes we even trim a 5 x 7 into wallet-size images, occasionally getting two wallets from the same print. This adds variety as well as

action to the book. By our having the couple design the book with us, our album sales have increased by approximately 25 percent.

Our method of pricing consists of packaging by the number of hours a client wishes to engage our services to cover the wedding. We start all of our hourly packages with higher minimum purchases than normally are used by most photographers. We know that our customers will purchase many more than 100 photographs in their albums; therefore, the higher minimum places them much closer to the desired end product than a low minimum would.

The style and design of our albums are fairly basic. We don't believe in "gimmicks" to sell our product. We're convinced that quality photographs will last through the years, whereas trendy approaches won't. We also sell parent albums, wall portraits, frames, and folios. The most popular parent album is our "mixed album," which is a condensed version of the wedding story and consists of a minimum of 6 8 x 10s and 14 5 x 7s.

Payments are divided into equal deposits of one-third of the total package, plus sales tax. The first payment secures the date, the second is due one month prior to the wedding, and the balance is due at the time of the album-design appointment.

A personal computer is very important in our photography business. We use it for mailing lists for our seminars and to keep business checkbook information for income-tax purposes, and we use it to design our advertising brochures.

As things stand today, wedding photography consumes many working hours. There is so much personal attention required to provide a high level of customer service and so many hours needed for appointments, detail work, order and assembly of albums, telephone consultations, etc. It takes away from the time that could be spent in financial planning, business projection, and marketing. Often we have good intentions in these areas, but we don't find the time to follow through.

We've elected to keep our business a small mom-and-pop studio, and we prefer to keep it simple. We've had the opportunity to hire photographers to work for us, but we believe that no one works for you the way you do for yourself. This way, we have only ourselves to answer to for customer service. We can keep tight quality control and know that we've done our best. This simple approach has supported our family, contributed to the tax base, and provided much satisfaction for us and our clients.

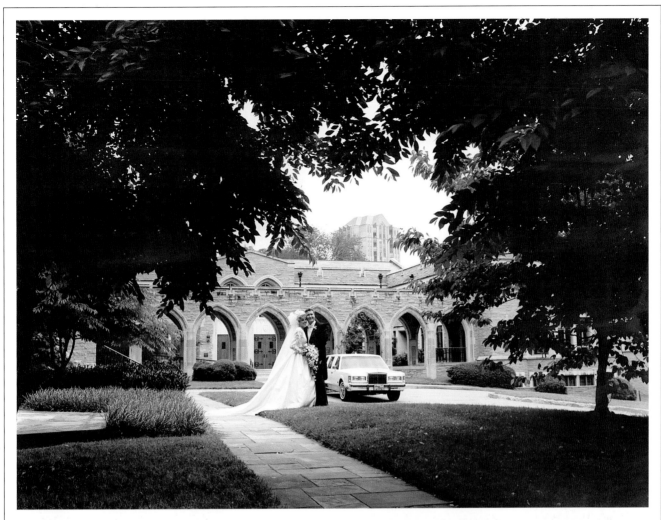

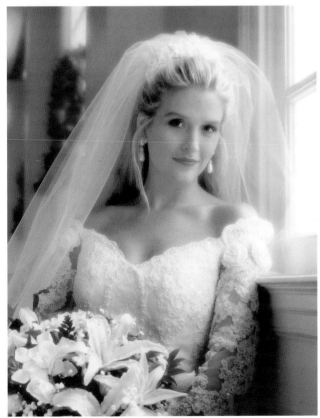

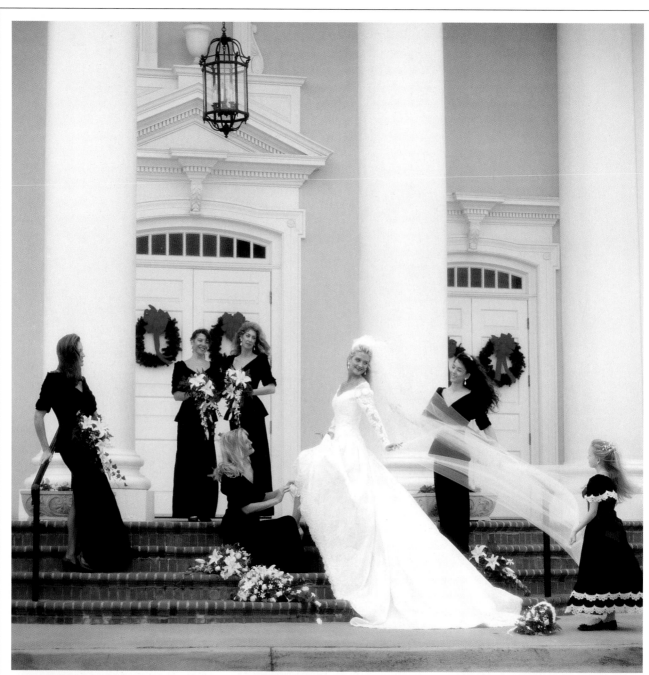

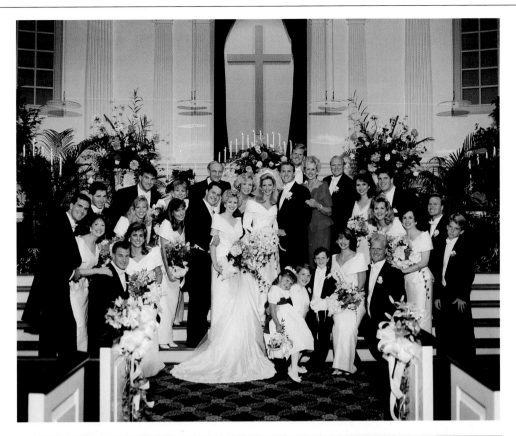

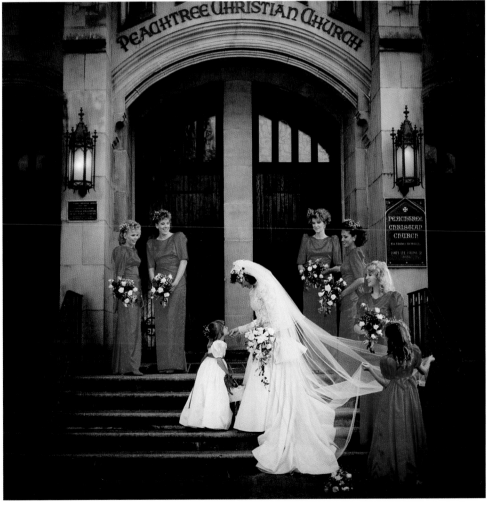

PETER AND PAM DYER

ENFIELD, LONDON, ENGLAND

In 1957, at the age of 15, Peter Dyer took his first job in photography, working for a local photographer who specialized in social events and industrial photography. "But after just six weeks, I was sacked and told I would never make it as a photographer," he says. Undaunted, Dyer moved on to do darkroom work in London's newspaper district for four years, and then to a job as a photographer for British Petroleum. While there, he photographed weddings on weekends and did celebrity photographs of such notables as the Rolling Stones (in 1962) and John Lee Hooker.

Following a three-year tenure spent working for a color lab, Dyer started his own color-processing facility in 1966, making dye-transfer prints and duplicate transparencies. The lab was to become one of London's top labs, employing as many as 40 people, with Dyer as Master Technician. In 1972, he achieved his ultimate ambition by establishing Peter Dyer Photographs with Pam, his wife and partner.

Averaging 420 events per year, weddings now account for approximately 65 percent of the studio's business. In addition to Peter and Pam, the business is staffed by four full-time employees in the studio and processing area, and seven part-time photographers.

Peter, who enjoys an international reputation for his photography, is a Fellow of the British Institute of Professional Photography (BIPP), has earned the Master Photographic Craftsman degree from Professional Photographers of America and the prestigious Fellowship of the American Society of Photographers. Pam is an Associate of BIPP.

I have two well-established and striking studios. The first is in a prominent, main-road position with a good window display and reception area, plus top administration and color-processing facilities. The second studio is solely for photography purposes and is located in a picturesque conservation area of my hometown. This studio is situated in a street in which some of the houses date from 1610, in an area where Queen Elizabeth I ran her stag hounds. The studio is an impressive two-story building, like a Masonic hall, boasting a 40 x 30-foot camera room, which has many different backdrops to attract the customer. Its amazing lighting facilities make it a mini-Universal Studios. In fact, it is the first "theme" portrait/wedding studio in Britain. My business draws clients from a radius of 15 miles and 4 million people.

In addition to the quality of the photography, clients are attracted to our studio because we provide a fast preview service—4 to 24 hours—and a fast turnaround—within one week—for the finished orders. Pam believes that studios have a maximum of only six weeks after the wedding to achieve the greatest sales impact with clients because during that time, the "big day" is still fresh in their minds and the photographs are a means of backing up their pride. This quality and efficient service have become talking points because they aren't practiced by all photographers in the United Kingdom.

When I photograph a wedding, my style takes on a different slant, depending on whom I'm photographing. I would say my style is "sympathetic" and "loving" in family-group shots, but can be more fashion- and advertising-oriented for bride-and-groom poses, reflecting my experience in the world of advertising photography.

I have immense enthusiasm for and a genuine love of photographing people. This enthusiasm is catching and enables me to make photographs beyond the "Stand there, shut up, and smile" routine. Among the keys to success are knowing when to click the shutter for the right expression and arranging different and pleasing poses. Also, my reputation precedes me, and the majority of my bookings are by recommendation.

What I love best about wedding photography is the hubbub of a busy group session when all the guests are around. I find the camaraderie helps my creative ability, and I thrive when I have to think on my feet. What I enjoy least is taking the money. The reason behind this is that when I'm photographing clients, I aim for perfection and get immense pleasure from this. I would hate to think any client believed my motives were financial when indeed they are purely artistic. However, Pam likes taking money, so that's okay!

Big changes are happening in our wedding market. First, more people are living together without getting married. Although a good percentage of these couples eventually ties the knot, their weddings tend to sell fewer pictures. Could this be because the parents who at one time felt immense joy at the prospect now feel immense relief? Second, the number of traditional Church of England weddings is decreasing. For example, the local church, which at one time would have had four weddings on a busy Saturday, now takes only 16 weddings during the year. The medium-size, traditional weddings that used to be the standard are being replaced by either very grand civil ceremonies, with clients spending hundreds of thousands of dollars, or by a very small, 20-guests-only ceremony. But even small weddings can be profitable when time and materials are carefully monitored.

In preparing for the future, I intend to make more use of my wonderful two-story studio as a place where the smaller wedding parties can be encouraged to spend more than they might do otherwise. I also want to create more pictures of the bride and groom, making use of the studio's superb, complex lighting facilities that can produce many different visual opportunities, often unavailable on location. In the long-term, I see my business developing in both candid photography and portraiture. As more videographers and photographers make use of digital imaging to capture candid stills, I'm determined to develop my skills of posing, expression, and lighting to ensure my photographs are of a far superior quality.

Successful events photographers must have many aspects to their characters: determination, sociability, artistic ability, quick coordination between the hand and eye, an ability to command, patience to suffer fools gladly, receptiveness, responsiveness, sensitivity, persuasiveness, reliability, likability, presentability, and clear vision of what the final image should be. My loving wife, Pam, makes up for my deficiencies in these areas. Without her love and care for the last 30 years, my life, home, and business would be naught.

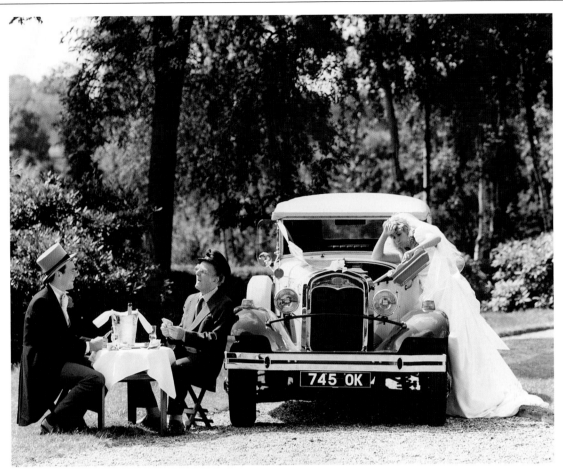

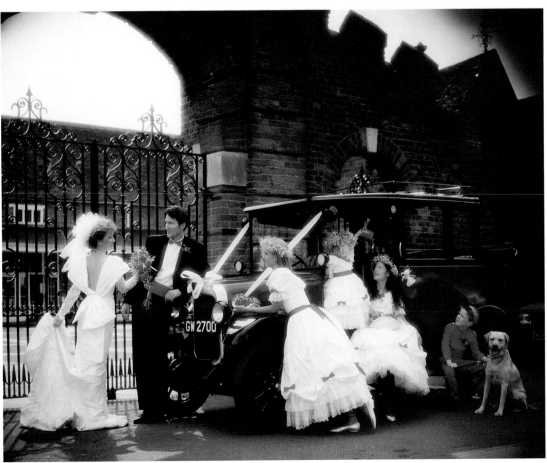

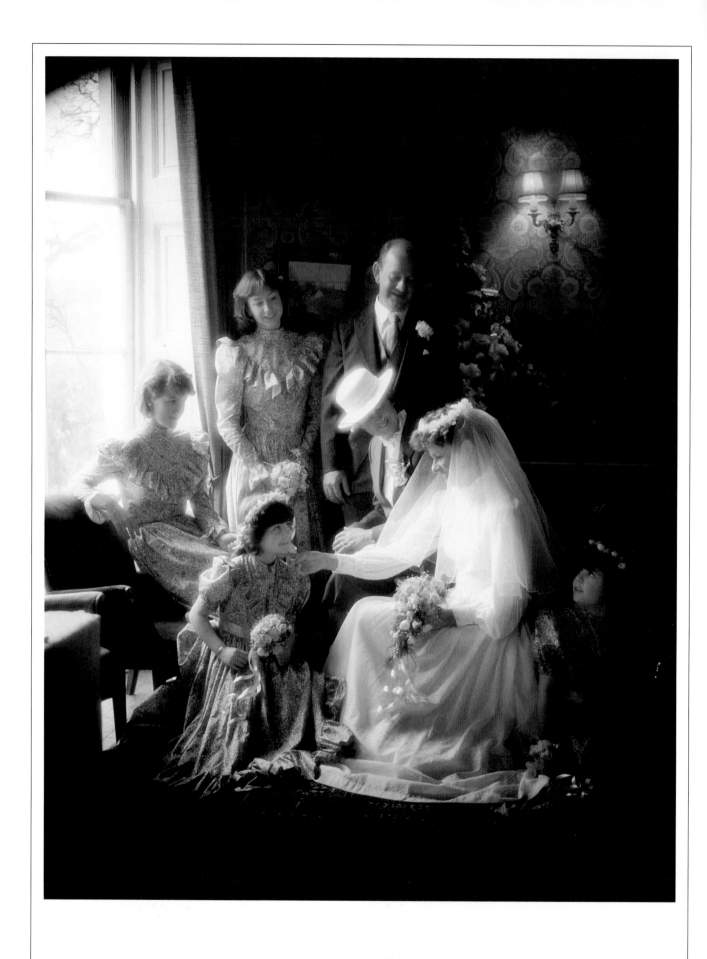

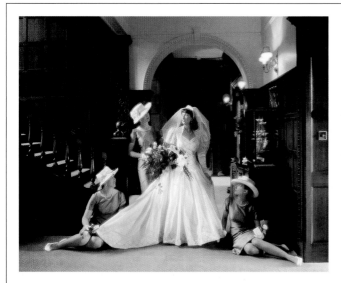

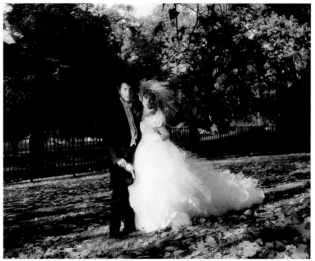

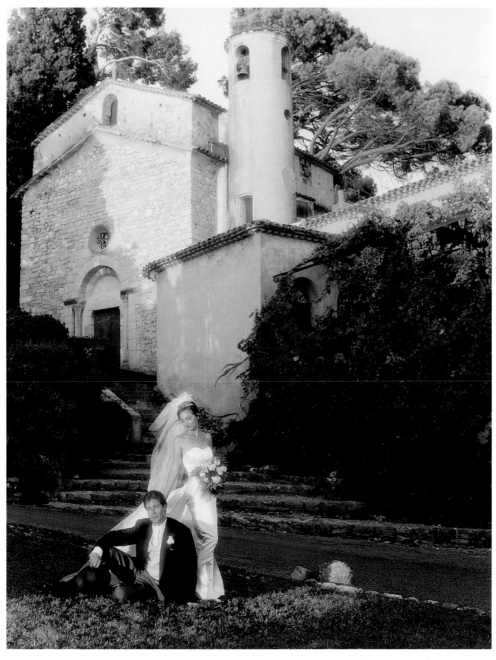

ROBERT AND CINDY FAUST

KENNER, LOUISIANA

During the 1990s, New Orleans-area photographer Robert Faust has made quite a name for himself in state, regional, and national print competitions, for both his elegant wedding photographs and the innovative way in which Cindy, his wife and business partner, designs the studio's wedding albums. Robert, who first entered national print competition in 1992, earned 19 print merits in just two years, including three prints and two wedding albums that were accepted into the Loan Collection of Professional Photographers of America (PPA) international print competition. In 1995, one of Robert's images was accepted for exhibit at Epcot Center in Walt Disney World.

Faust was named Louisiana's "Photographer of the Year" in both 1993 and 1994, and he has won first-place wedding-album honors in the state for the last four years. In 1995, his wedding album was awarded "Best of Show." He also has earned three Kodak Gallery Awards and four Fuji Masterpiece Awards in three years for wedding, portrait, and illustrative entries, and he won top honors in PPA's Southwest regional conventions for the past three years.

Faust holds the Master Photographic Craftsman degree, the Master Artist degree, and the Certified rating from PPA, and he has presented numerous seminars to other professionals, including three presentations at PPA's annual international convention.

Before becoming a full-time photographer in 1988, I owned and operated a truck-repair business in the New Orleans area, and I photographed weddings as a sideline. Cindy worked as a claims analyst for the Travelers Insurance Company before joining me in the business, just before we opened the business full-time. I have no formal training in photography: I am completely self-taught and gained all of my knowledge from trial and error and through reading and attending seminars.

Cindy and I opened our first studio in Destrehan, a small town outside of New Orleans, and we built a very large wedding business there. By our second year we were photographing well over 100 weddings from areas as far as 75 miles from the studio. Then we began increasing our prices twice a year for the next several years to reduce the volume. Now we raise prices once a year, with a goal of photographing 50 weddings per year.

When we ran out of room at our rental location in Destrehan, we decided to relocate to Kenner, which is five minutes from New Orleans. We purchased a two-story building and spent one year renovating it, opening the new studio in 1990. The building is located in an area where there is a mix of commercial and residential real estate. We built a home in the upper level, and the street level is our studio. The studio consists of nine rooms, including a camera room, a sales-and-projection room, an office, a dressing room, a black-and-white darkroom, a retouching room and spray booth, a workroom, and a prop-and-frame room.

Since Cindy and I are so close to New Orleans, we draw business from a metropolitan area of more than a million people. There are more than 40 photography studios within a 15-mile radius of our studio. Today, our business consists of approximately 50 percent weddings, 20 percent portraits, 20 percent high-school seniors, and 10 percent retouching and digital artwork.

Cindy and I are the only employees. We handle all phases of the work ourselves, from the initial contact with prospects, through the delivery of the finished album, with the exception of film processing and printing. I handle the wedding consultations and bookings, and Cindy and I work the weddings together. I do all of the photography, and Cindy assists with the posing, backlighting, and equipment setup. After the wedding, she designs and assembles the finished bridal albums.

My wedding style has evolved over the years from listening to my client's wishes and studying the work of some of the all-time great wedding photographers. My style of lighting and posing is unlike any other photographer in my area. This, combined with Cindy's unusual album designs, is what I feel has been the basis of our success in the wedding market. We do very little marketing, with 90 percent of our business coming from word of mouth. We do participate in two bridal shows each year and run a small ad in a local bridal magazine. We aren't even listed in the Yellow Pages.

One of the trends I've seen for the last couple of years is that couples are older when they get married than they were in the past. Today, most women are career-oriented and like to finish their formal education and get their careers on track before planning a wedding. I also find that weddings are getting back to a more traditional style. For a while, the trend was toward the photojournalistic style. However, most of the brides I see today want the more traditional posed photographs.

Cindy and I are now in the process of increasing our high-school-senior base. Over the last few years, we've been cutting back on weddings by increasing the prices as we've built the senior market. Over the long-term, I'm considering the possibility of going into full-time digital artwork. I recently invested in a high-end digital workstation to gain experience. I now do a limited amount of digital and traditional artwork for outside studios, and I'm working toward increasing the digital market in my area. As I gain more work in the digital field, I plan to continue to cut back on other areas of traditional photography.

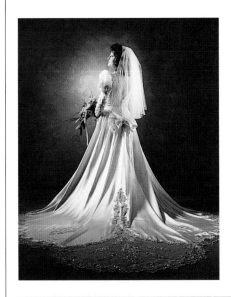

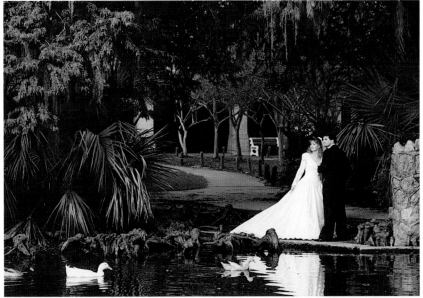

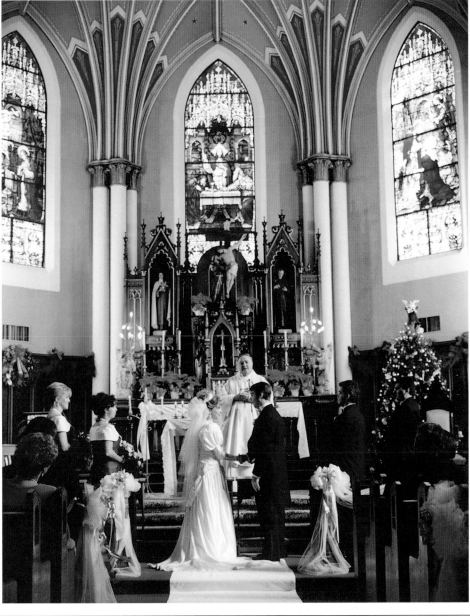

BRUCE AND DIANE FLEISCHER

RESTON, VIRGINIA

Bruce and Diane Fleischer are pioneers in the brave new world of applying digital-imaging techniques to wedding photography. The new look of their artfully conceived images is attracting a great deal of attention in the metropolitan Washington, DC, area.

Bruce has photographed weddings for the past 14 years, during which time he also served as staff photographer for the Virginia Museum of Fine Arts and as a freelance photographer for the Smithsonian Institution in Washington, DC. His formal training includes two Master's degrees in Studio Photography from the University of Iowa. He has taught photography in the Resident Associate Program at the Smithsonian, and he developed the Color Photo and Electronic Photography curriculum at the Arlington Career Center in Virginia. His creative work is displayed in public and private institutions across the country.

Bruce's wedding business took a dramatic turn when Diane, his wife, joined the business two years ago, and they began to experiment with digitally enhanced wedding photography. Diane, who has a B.A. degree in Fine Art, is experienced in the field of illustration and graphic design; her work has won numerous national awards.

In undergraduate school, I studied "straight photo documentation." This journalistic approach to photography forms the basis of my ability to record each wedding-day story on film in a way that captures the spirit of the day. I've also found that my experience as a museum staff photographer has given me invaluable training in lighting and quick setups. Graduate-school work in highly creative black-and-white and color photography provided a "vision" that encouraged Diane and me to search for a new way of looking at wedding and portrait photography. With Diane's experience as a graphic designer, she became our computer wizard, enabling us to merge today's new technology with my photographs.

Our business serves Northern Virginia, Maryland, and Washington, DC. We'll photograph 50 weddings in 1996, at an average initial booking of $2,000. Our average bride and groom are 25 years old, with a combined income of more than $50,000. They are well educated and employed full-time. The budget for the wedding is approximately $18,000, with a guest list of about 200.

We reach our clientele locally through referrals from selected hotels, conference centers, and bridal consultants. We advertise in a bridal magazine that distributes 50,000 copies at all major bridal shows in our area. We also attend bridal shows that attract approximately 2,000 brides each. And, of course, we rely on our former clients to refer their friends and families to us. We also have a World Wide Web homepage that Diane designed.

We use Hasselblad systems to shoot our weddings on Kodak film. For our digitally manipulated images, we use a Linotype-Hell Saphir Scanner for input to a Macintosh Power personal computer, with output to an Iris 4012 printer.

Our computer-enhanced photographs encompass methods that advertising agencies have used for many years. Our sophisticated clients are aware of these types of effects because they appear in ads in magazines that they read. We offer the digital effects as an addition to our standard portfolio package. Each couple seems to have a favorite from among our digital-effect designs, and most elect to use several in their final wedding portfolios. At present, we have an inventory of about a dozen effects for which Diane has worked through the creative process. We'll add to this inventory as clients come up with suggestions that are practical for us to develop or as we come up with new directions we want to explore.

In 1996, there are close to three dozen vendors offering digital cameras. Currently, only one exceeds the capabilities of its film-based counterparts. I believe that in the near future we'll see creative wedding photographers going to digital backs on their Hasselblad cameras, downloading their stored images to their own computer systems, and outputting the photographs themselves with high-end printers. This, I believe, will soon revolutionize the wedding-photography industry. Today, the cost of these systems is somewhat prohibitive. But as the prices go down, there will be a great deal of excitement in store for the wedding photographer who "goes digital." Together, Diane and I are finding great enjoyment exploring today's state-of-the-art wedding photography.

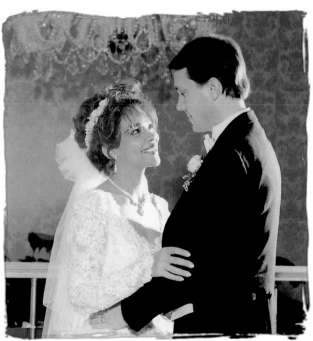

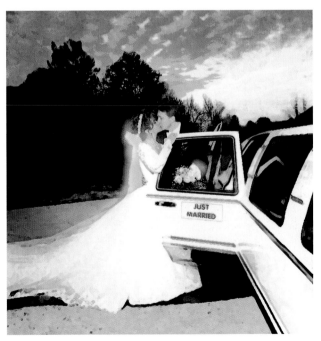

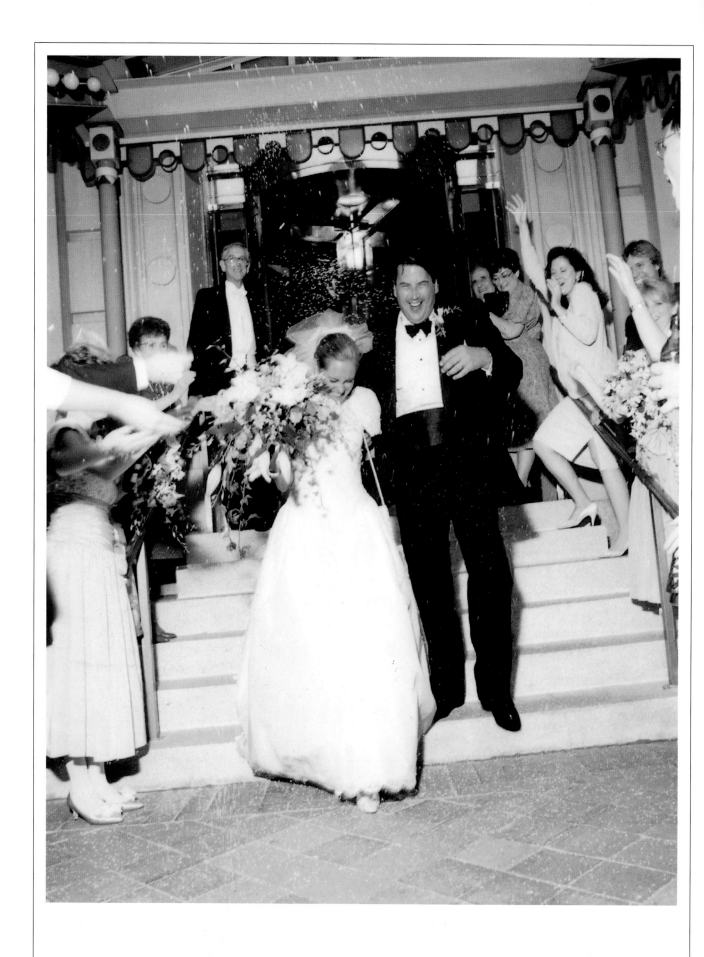

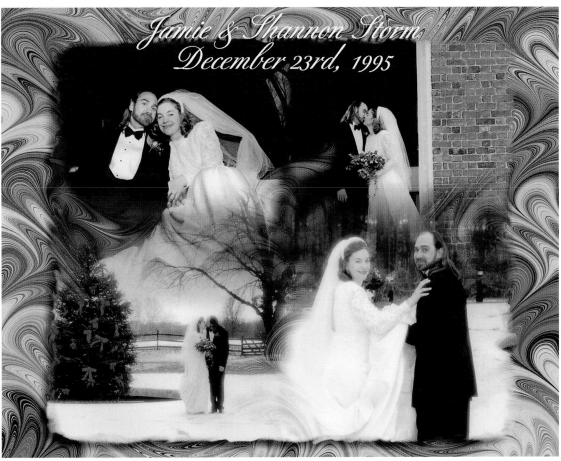

Jamie & Shannon Storm
December 23rd, 1995

GARY FONG

LOS ANGELES, CALIFORNIA

After a chance meeting with legendary wedding photographer Rocky Gunn, whom Gary Fong had admired for many years, he went to work for Gunn. Fong carried Gunn's equipment from place to place and eventually joined the master's staff as an assistant photographer. Gunn encouraged Fong to open his own studio and pursue his unique direction.

After Gunn's untimely death, Fong had to decide what to do with his life. He thought he wanted to be a photographer, but he wasn't sure. So he tossed a coin. Heads, he would be a professional photographer; tails, he would be a musician. The coin came up heads.

From humble beginnings in a bedroom of his parents' small apartment, equipped with one camera and a display album, Gary Fong's Storybook Weddings Photography has grown into a prestigious, "weddings-only" business that occupies a suite in the West Century Plaza Building, a 16-story office complex near the Los Angeles Airport. Through another business interest, Planet Software, Gary helped to develop Art Leather's "Montage" album-production software package. This software makes it possible for wedding photographers to order album prints from the lab at the same time that they place the album order. The lab then forwards the prints to Art Leather for final assembly.

A pioneer in the use of modern bare-bulb technology, Fong also co-developed the "Gary Fong Lightsphere" flash system by Norman Enterprises, which exploits the latest in bare-bulb, manual-flash, and, in the near future, nonreflective, automatic-flash technology.

Today's couple is looking to be different, but they still value some traditions. Many couples are reevaluating the standard wedding traditions and rituals to see if they are appropriate for their self-expression. The result is a wedding that is more individualized and personal. Couples today are thirsty for new ideas and open to suggestions.

Suppose that a typical package consists of 32 8 x 10s in the album. The photographer works from a list of the standard photographs. By the time the compulsory photographs have been made, there is little room for candids. The photographer limits candid coverage to preserve profits common to the pre-sold wedding package. Photographers typically don't like to shoot candids. "Candids don't sell," they say. "People who want candids won't pay for a professional photographer." How wrong they are!

From the time I began concentrating on creating exciting candid images, I've seen a dramatic increase in the number of candids sold. In fact, a majority of the images that we sell are candids: fresh, unposed, and expressive of the moment. What has made the difference in our ability to sell candids lies in the presentation of the album. In fact, what we've done is to redefine the wedding album in a way that catches the imagination of the creatively starved couple. Through our presentation, they find something so new, different, and innovative that it changes their perception of wedding photography.

Although I've encountered a few couples who are enthusiastic about having totally unposed, spontaneous, candid coverage, I've found that the typical couple isn't prepared to abandon the traditional wedding-day portraiture. Most couples want portraiture as well as a photojournalistic essay of the wedding day. That knowledge has profoundly affected the way we design our albums.

Lisa Coplen, my studio manager-photographer, came up with a brilliant idea: one album dedicated to portraiture, and a second album dedicated to a photojournalistic "storybook." By explaining this concept from the start, we not only redefined the wedding album, but also added greatly to the couple's excitement about wedding photography, causing it to move higher up on the wedding-priority list and receive a larger percentage of the budget. Instantly, we went into action, producing display albums in two-volume sets, and instantly the concept was accepted. Now, the majority of our weddings go out in two-volume sets,

resulting in a much higher average wedding order.

This mixture of styles requires several camera formats and types of film. I use the Hasselblad system: the 903SWc with a 38mm Biogon lens for wide-open scenics, illustrative bridal photographs, and wide-angle group photographs and panoramas. My Hasselblad 503cx is equipped with the following lenses: CF 50mm f4, CF 60mm f3.5, CF 80mm f2.8, and CF 120mm f4 macro. For much of the photojournalistic work I use the Canon EOS equipped with an 85mm f1.2, a 70-200mm f2.8 zoom, and a 15mm fisheye. In working with this equipment, as well as the "Lightsphere" bare-bulb system I helped the Norman Company to develop, I use a variety of films with speeds ranging between ISO 100 and 1600.

Once the story is captured, the challenge remained as to how to present this story to the couple. The first order of business was to re-educate couples through our approach to pricing. Our pricing policy is very unusual in that we charge a "wedding-photography-services fee" (between $750 and $1,750 depending on the type of wedding being covered), with no minimum purchase required for the portraits. This a-la-carte pricing approach offers a great promotional advantage because it says, "Hey, I don't know how many photographs you'll want, and neither do you! After all, you haven't seen them yet! You don't have to decide now! Decide after the wedding, when we show you the complete selection!" This sets us up for album planning, enabling us to participate in the selection process and to present the case for why the couple shouldn't reject these photographs. Ultimately, we deliver a better product.

Couples receive their paper previews in two large preview albums that accompany a Montage software "Storyboard"—one for the candid album and one for the portrait album. The preplanned storyboards are essential because they illustrate the photographer's professional opinion. The couple understands that when they delete prints from the selection, the intricate design of the book collapses. Pages that are meant to face one another are ruined. So the couple has two choices: to splurge and get this beautiful book as it is, or save money and make painful deletions from the album. About one out of four couples leaves the book basically unchanged. The rewards are great with this system: it liberates both my creativity and the studio's profitability, and it reinforces my belief that wedding photography is the best job in the world.

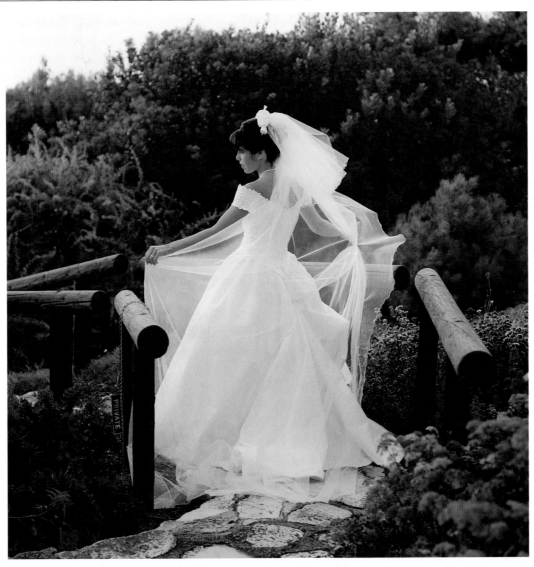

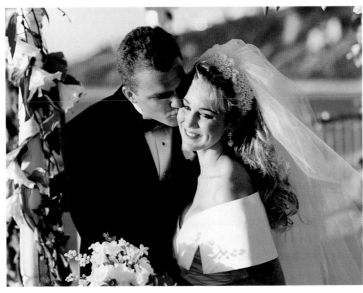

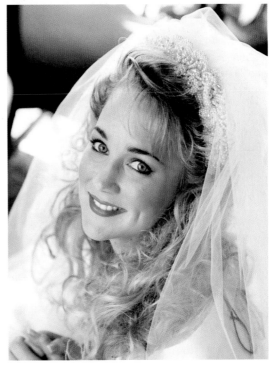

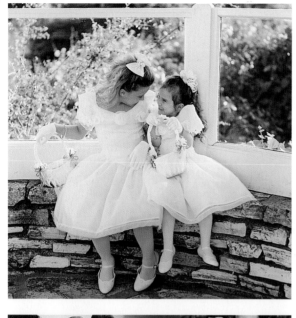 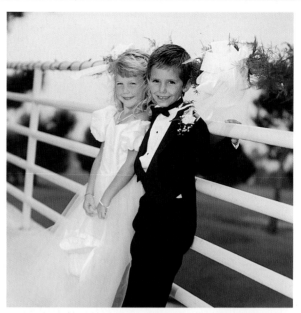

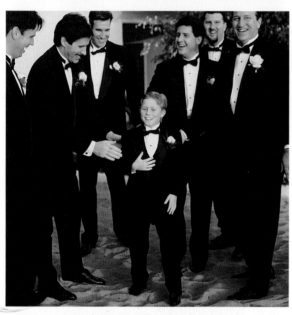

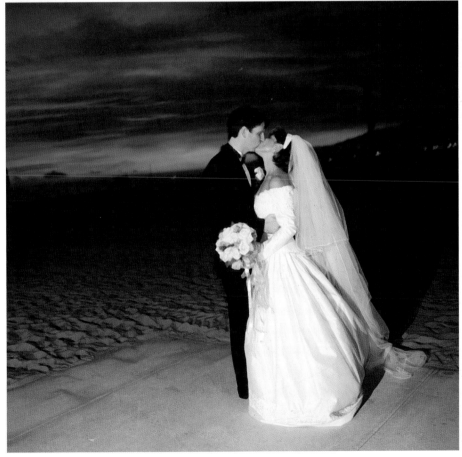

ALVIN GEE

HOUSTON, TEXAS

Alvin Gee, whose parents emigrated to the United States from Canton, China, before he was born, became interested in photography as a member of his high-school-yearbook staff. Then during his senior year at the University of Houston, where he majored in radio and television, he served an internship as a camera operator at a local television station. It was then that he decided the medium of television was too confining and his real passion lay in still photography.

Today, he owns Alvin Gee Photography and is widely recognized for his photographic excellence. In 1992, he was received into Cameracraftsmen of America, an elite organization of 40 of North America's finest photographers. He holds the Master Photographic Craftsman degree from Professional Photographers of America and has served on several of that organization's national committees.

A past president of the Houston Professional Photographers Guild, which named Gee "Photographer of the Year" on four occasions, he also has served on the Board of Directors of the Texas Professional Photographers Association. He shares his expertise with other photographers as an instructor at the Winona International School of Professional Photography and its affiliated schools and as a lecturer at professional-association seminars.

I opened my studio 16 years ago, when I was 25. I knew I would have lots of competition, but I was living with my parents at the time, so I knew at least I would have a roof over my head if things didn't go well. And at that point, I was young enough to go back to work for someone else if I had to.

I always recommend to anyone who wants to start a photography business to apprentice with someone else for a year or two first. After college, I worked at a portrait-and-wedding studio and then for a commercial studio where I learned how to photograph rocks and pipes—very unglamorous things. But both jobs helped me because I was able to observe and learn before I went on my own.

Early in my business, I worked out of an office warehouse, and there were times when I would sit on my hands all day. It was a very humble beginning. As the business grew, I moved to an office park, and later to my current location in an office building situated at a busy intersection of two familiar streets in the west-side business district. The studio is located on the first floor and lobby area. Today, my business consists of approximately 50 percent wedding photography, with the rest composed of children, family, and executive portraits, as well as some commercial photography for annual reports and catalogs.

My approach to wedding photography is very traditional. I believe that the most important aspect of wedding photography is to make the bride look and feel beautiful on her wedding day. My style is classic and reflects the influences of many of the wedding photographers I've studied with: David Ziser, David Smith, Joe Butts, Rocky Gunn, and Bill Stockwell, to name a few.

My goal is to create an album that has balance between images that portray intense emotion, combined with those that tell a story about the day of the wedding. Because you're working in a very emotionally charged environment in which retakes are out of the question, to achieve this balance takes careful planning with the bride prior to the wedding day. It is important to review all of the events, from pre-ceremony preparations through the reception, to make sure you understand how the wedding will unfold.

To be successful in the wedding business, a photographer must possess so much more than a basic knowledge of photography. He or she must be a director, psychologist, and motivator. On the wedding day itself, the wedding participants need understanding and direction from their photographer. My approach is to provide direction when it is most needed: before the ceremony, when all participants are the most nervous, and after the ceremony, to move events along. At the reception, everything should go smoothly if properly planned. Then, only a little direction is required to capture the spirit of the event as the action unfolds.

Another quality that is essential to succeeding in wedding photography is business management. Like most photographers, I don't enjoy the business side of photography because it takes me away from what I love: photography. That is why I surround myself with people who are proficient in this area. I have three full-time employees with different areas of expertise, but all of us are cross-trained in customer-service matters, so that we're prepared to provide a high level of customer service. In addition, we attend marketing and management seminars, outside the photographic industry, where we learn techniques that are helpful in everyday business situations.

Every aspect of the business is computerized on a Macintosh system, so we can track orders, execute invoicing and billing, monitor financial progress through spreadsheets, generate thank-you letters to clients, and create promotions on a timely basis.

My marketing strategy has been to create a high demand for my photography by keeping the supply low, so I schedule only one wedding per day on weekends. I personally photograph between 40 and 50 weddings each year, and in 1995, my associate of six years, Emy Johnston, began photographing weddings as well. She has a degree in photography, is very talented and personable, and brings to the business a woman's point of view. Our clients give her work rave reviews, and I now refer to her as our "wedding specialist." I tell clients that if my daughter were about to be married, Emy would do the photography. Eventually, I expect Emy to take over most of the wedding business, allowing me to concentrate on portraiture.

I keep my work in front of the public by hanging bridal portraits in the finest bridal salons in the area, by advertising in the bridal section of the newspaper, and by keeping in touch with the best catering-department head in Houston who recommends my services. As a result, most of my clients come to me because they've seen the quality and style of my photography, and they've heard about me by word of mouth. These referrals are possible because I always strive to create the highest quality of photography and the best customer service possible.

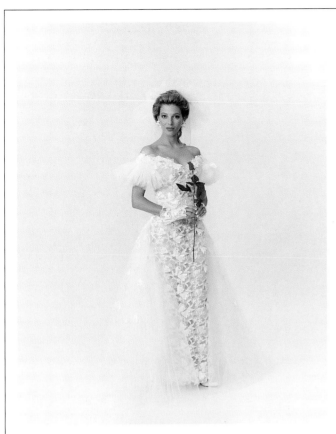

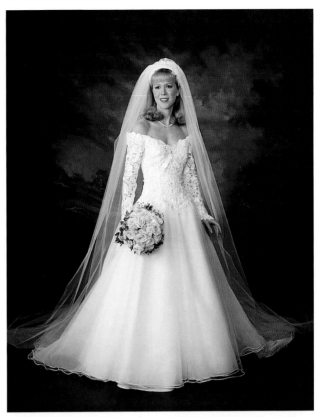

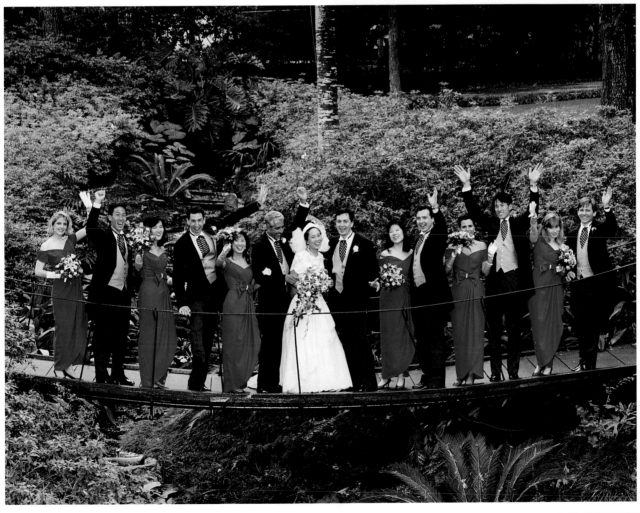

I present previews in paper form, using an incentive for clients to return them promptly. The couple gets two free 8 x 10 candids when the previews are returned within three weeks. We use Art Leather albums with a combination of large and small candid shots in order to achieve both variety and a storytelling effect. In addition to parents' albums, we offer our clients custom framing, easel-back frames, and folios of all sizes. Everything can be upgraded, such as vinyl albums to leather.

I have no regrets about starting my own business. In a world where so many people dislike their work, I feel lucky. A friend once told me, "Never worry about money. Just take care of your clients, and do what your heart tells you." That remains our policy.

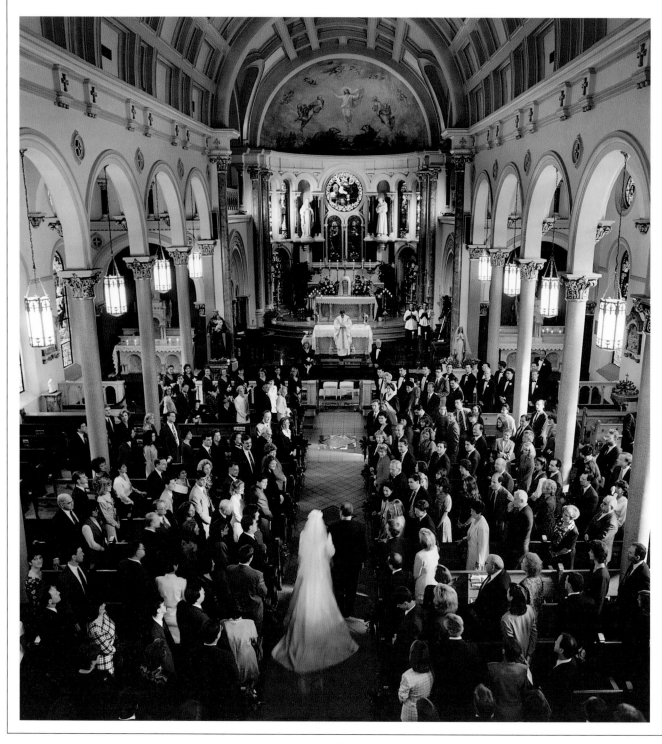

Alvin Gee

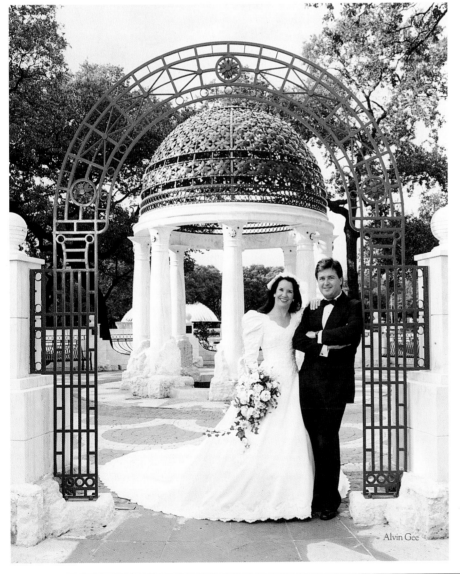

Alvin Gee

RENE AND JOAN GENEST

NORTH HAVEN, CONNECTICUT

After high school, Rene Genest worked briefly in his family's construction business. In 1974, he went to work part time for Art Rich Photography, a prominent studio located between New Haven and Hartford in the town of Southington. Eventually he became a full-time wedding-and-portrait photographer and in 1980 formed a partnership in a second studio location, Art Rich Photography of North Haven. That partnership still continues.

Joan Genest studied French at the University of Vermont to further her career goal of being an interpreter, and later she received a B.A. in French from Central Connecticut State College. When she started dating her future husband in 1978, she also began assisting him at weddings. As she says, "I got the bug." By 1980, Joan was managing the new studio where today she handles all functions of the business, including photography and selling.

Rene holds the Master Photographer degree of Professional Photographers of America (PPA), and Joan has earned the PPA Master Photographic Craftsman degree. Their prints hang consistently in state, regional, and international print competitions. Joan is a former board member of the Connecticut Professional Photographers Association, and Rene currently is second vice president of PPA of New England.

From the beginning, our management plan was to build the wedding business, then senior portraits, then family and children's portraiture. We've grown in all of these areas, plus we've created a division of our studio to do proms, elementary-school portraits, and "one-shot" team packages. We do between 65 and 75 weddings each year, and this represents approximately 22 percent of our business. In addition to Rene and me, we have a staff of five full-time employees, plus three to four part-time, seasonal employees.

In 1982, we purchased a home, then constructed a 29 x 30-foot studio addition of two floors plus a basement at the rear of the house. The living space and the studio space are completely separate. Proper signage, sidewalks, and entrances ensure personal privacy for our home at all times. We're zoned "residential/professional," which means we can have a professional business in our home. It is a great location as we are on a main artery, near the center of town, that is the major access to an interstate highway. We have wonderful visibility, but no walk-in traffic. All of our work is by scheduled appointments only.

We've done extensive work on the grounds over the past 10 years, creating several park-like, outdoor shooting areas, including a gazebo, stone wall, brick walkway, gates, and fences. Recently, we added an outdoor, pavilion camera room with a dressing room and prop-storage area.

Couples book us because wedding photography is a high priority for them. They're willing to pay our prices and to give us the time needed to photograph them properly. We are very courteous, friendly, caring, and energetic. We learn everyone's name (parents, bridesmaids, ushers, etc.), and we use their names all day. We employ an efficient photographic strategy to make the best use of our time and that of the wedding participants. Eighty percent of our skills are people skills, and the rest are good photography skills.

Rene and I each photograph our own weddings, but our styles are similar. Our albums feature portrait poses and "controlled" candids. We begin our portrait poses at a pre-ceremony session at the bride's house. They include the bride, parents, and bridesmaids. During the post-ceremony session, we create portraits of the groom, the families, grandparents, ushers, and wedding party, and a series of portraits of the bride and groom. We also do candlelight poses of the bride and groom during the reception, plus any large groups they may want. About 60

percent of the bride's album is made up of these portraits. Twenty percent is ceremony coverage, and the remaining 20 percent is devoted to reception candids, including the introductions, toast by the best man, first dance, parents' dances, cake cutting, bouquet and garter tosses, and other dance candids.

We attend three large bridal shows each year, at which we display large samples (20 x 24, 24 x 30, and 30 x 40). We show sample albums and a few preview books, and we make use of special offers to couples who book consultation appointments. We also advertise in bridal supplements and reception-hall advertising books, do direct-mailing to bridal-show names, and display our work in the offices of reception halls and in bridal salons.

Planning is a very important part of our business. Our annual business plan includes examining and reexamining the past year's sales records. We compare to the previous year, month, and quarter and look for areas to improve. We then set our goals and begin to implement the plan. We are always alert for new markets in which to expand and broaden our base. We prefer to cover several market areas to keep our cash flow constant.

Another key element to our success is that we are part of a network of four Art Rich Photography Studios. I am very much aware that many partnership arrangements don't work out. I attribute the success of our partnership to the fact that it functions on two levels: one financial and the other operational, and our nonworking partner has nothing to do with the day-to-day operation of our business. Having complete autonomy is very important to the success of our arrangement. While we operate independently, we do brainstorm together and share many marketing and advertising expenses.

In the short term, we don't foresee any major changes. We'll continue to focus on service. Good sales require a great deal of personal attention and sales guidance because customers won't "upsell" themselves. In the longer term, the digital, electronic world is on the horizon. It isn't hard to imagine a time when we'll capture the wedding on digital cameras. Then there will be no paper previews, and all sales will take place in the studio. This is scary in one sense because the technology now is fairly complicated and quite expensive. Only the major color labs can afford it. However, once it reaches the studio level, I am certain that it will come to us in manageable increments. This will happen when digital cameras become affordable. Right now, film is still the way to go.

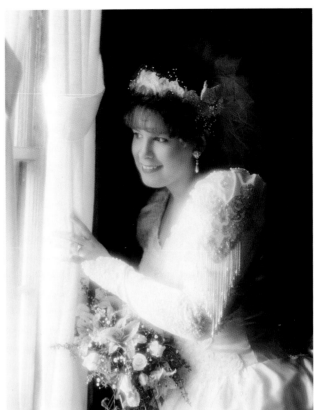

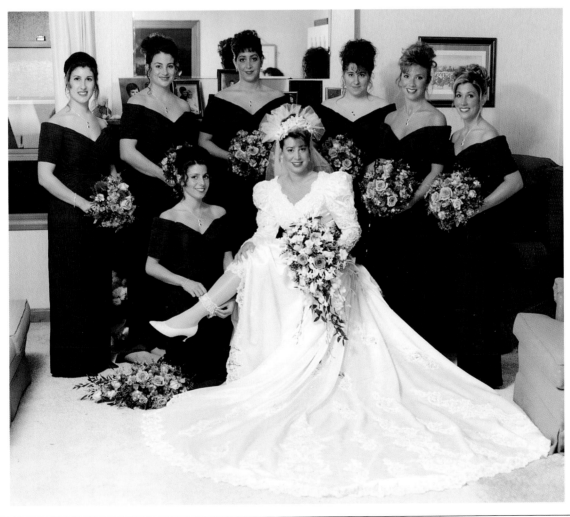

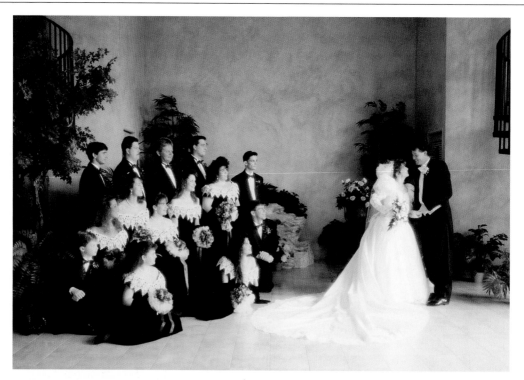

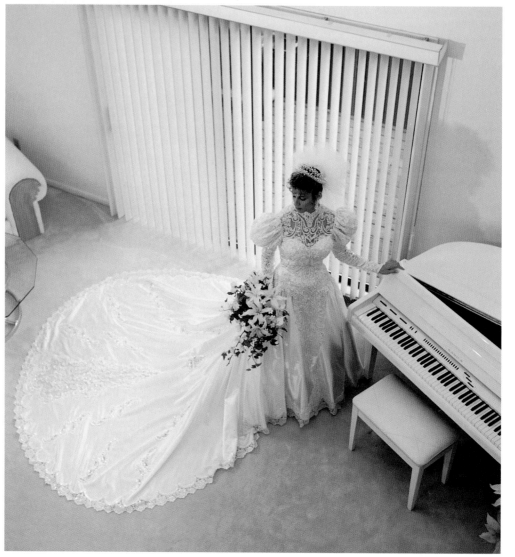

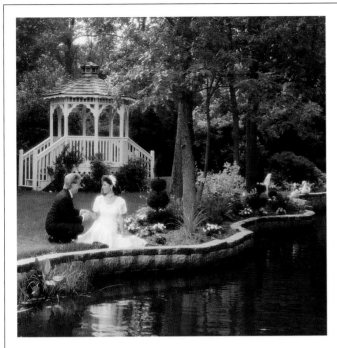

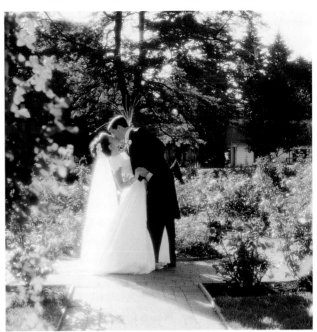

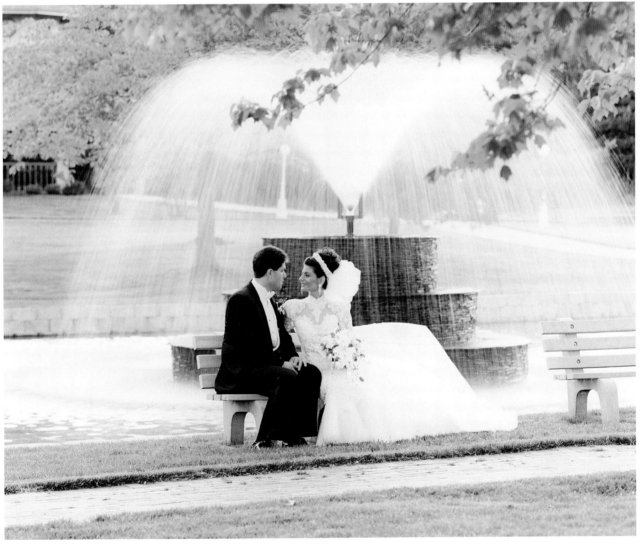

JOHN HOWARD
LOVELAND, OHIO

The Kroger grocery-store chain has played a significant part in John Howard's business, Photography by John Howard. While Howard worked in retail management for the Kroger Company, a colleague introduced him to wedding photography as a sideline business. And, Howard says, much of his approach to customer service in the studio has to do with his Kroger training: "Our philosophy is a simple one: to provide our clients with the best product available at a competitive price. We recognize that the single most important factor in the makeup of a business is the consumer, and without the consumer, the business would cease to exist."

Howard holds the Master of Photography degree from Professional Photographers of America (PPA) and has earned numerous awards for his images, including Mid-East Regional "Photographer of the Year," Ohio "Photographer of the Year," and two Kodak Gallery Awards. Major national publications have displayed his images, and the Eastman Kodak Company has purchased several of his photographs to illustrate its product and promotional literature. In January 1996, Howard married Angela Talentino, formerly a marketing assistant for a major public accounting firm. She now has a full-time position in her husband's business.

While working for Kroger, I had a good friend and colleague who photographed weddings for a studio on weekends. At the time, I was working third shift as a night leader. Each Sunday night, Keith had another story about a wedding that he'd photographed. It was easy to see that weddings were the high point of his week. His enthusiasm and excitement about photographing those weddings were contagious.

I was already bored with retail hours and the job's repetitiveness, so I made a visit to the studio where Keith was working. The owner must have thought I was crazy when I told him I wanted him to hire me to photograph weddings. I'd never photographed anyone, let alone a wedding. He must have been impressed by my sincerity because he gave me a list of equipment that I would need and told me that if I bought this equipment, he would hire and train me. The equipment cost nearly $10,000, and a week later I went back to him, equipment in hand. He probably felt obligated to hire me because I'd bought everything on the list. That was October 1985.

After about 10 classes, I got my first assignment. I don't remember being terribly anxious about photographing the event, although I do recall the events of a wedding I photographed within the first several months. I was standing at the front of the church, getting ready to photograph the brides-maids and bride as they walked down the aisle. The bride's mother was sitting in front of me. I can remember her smiling and reaching up to put her hand over mine. Then she asked if I shook this much at every wedding.

After the very first wedding assignment, the studio owner called to tell me that the photographs were back and that he would like to go over them with me. Ten years later, I can still remember the anxiety I felt as I arrived at the studio. He sat me down in one of the showrooms. He told me that of all the weddings he'd seen photographed by a novice, none had turned out as well. I was ecstatic and even more compelled to excel at this art! The exhilaration, excitement, and anticipation that Keith had shared with me so often on those Sunday nights constitute the way I still feel about each event I photograph.

Over the next two years, I learned as much as I could about lighting, posing, and the technical aspects of photography. I joined the local PPA affiliate, the Professional Photographers of Ohio, and PPA. I believe that if you want to be the best, then you have to learn from the best. I was very fortunate to learn from David Ziser, whose clients also come from the greater Cincinnati area, and from other photographers whose work I admire.

As I learned more about the profession, I knew that I wanted to have my own studio. In May 1988, I rented a 400-square-foot office/studio above a quiet strip mall. The same ambition that fueled my passion for creating exciting photography also fueled a great desire to develop a successful business. It took three years to generate enough income to be able to leave the Kroger Company without having the loss of income affect me personally.

Today, our 2,200-square-foot studio is located just off an interstate highway, between the city of Loveland and the township of Indian Hill. Indian Hill is the thirty-third wealthiest community per capita in the country, and Loveland is a very family-oriented, upscale community, both of which are suburbs of Cincinnati. I employ a staff of nine, and approximately 75 percent of our business is weddings. In 1995, we photographed more than 200 weddings. In 1996, with the addition of new photographers, we expect to photograph more than 300 weddings.

I believe that my photography commands attention because of the energy applied to every detail: expression, posing, subject illumination, composition, and the conscious use of secondary and tertiary subjects, always assuring that the main subject is the emphasis of the image. When this happens, the mood is created by the story that is portrayed. While it is our reputation and the quality of work that bring couples to our door, it is the excitement we bring to each consultation that the wedding couple relates to and feels comfortable with. We make the couple know that they'll be part of something special.

Clearly, what I most enjoy is the art of photography: creating works that reflect my inner soul. I like the recognition that comes from creating a piece that is admired by my clients, as well as my peers, and I enjoy the day-to-day interaction with clients. But I also enjoy the challenge of running a business. For me, it is like fitting all the pieces together and making them run as a well-oiled machine. I like the challenge of coming up with new ways to market the business and then implementing those ideas.

For the most part, I feel guilty every day. I feel as though I'm being nourished by this playground that is called a business. Far too many people work in environments that are mentally unhealthy for them. So to anyone who is in this position, my only advice would be to seek out what you really have a passion for, and go for it!

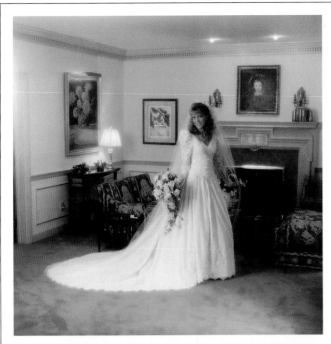

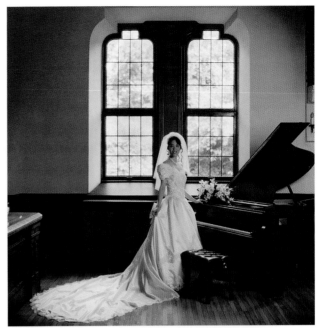

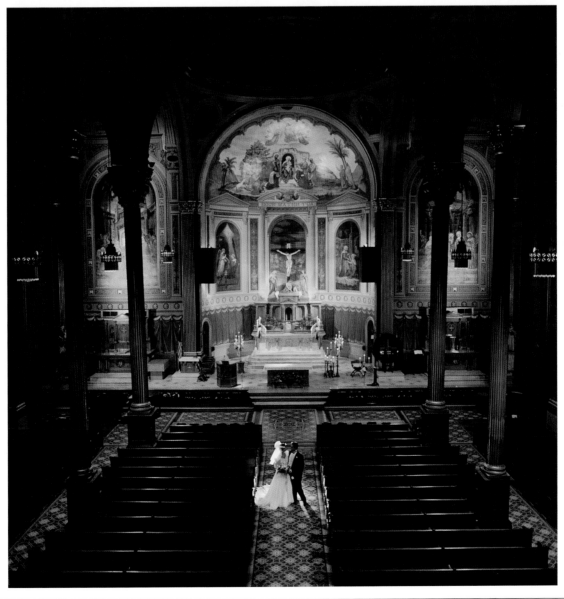

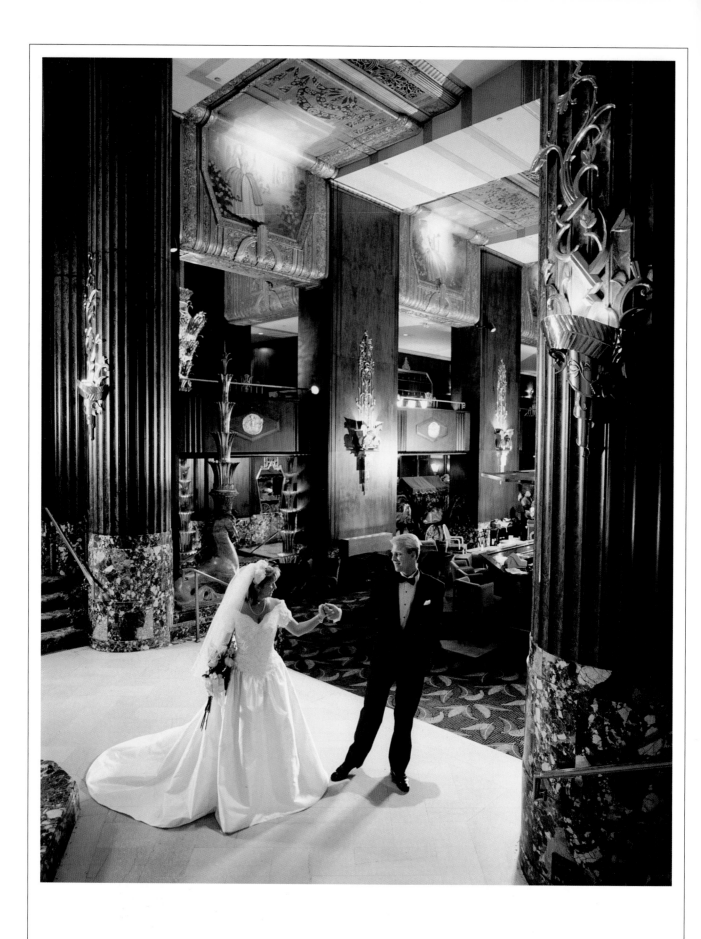

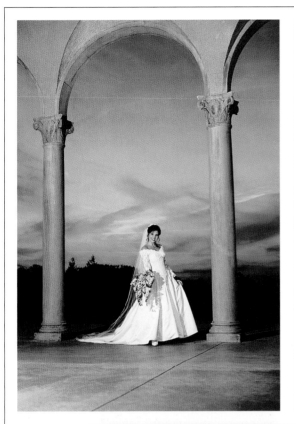

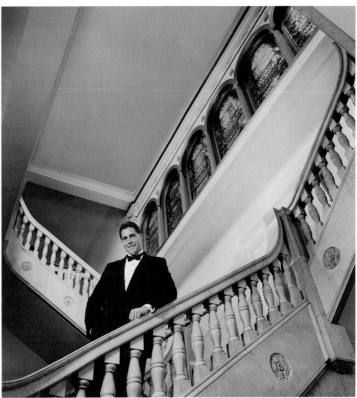

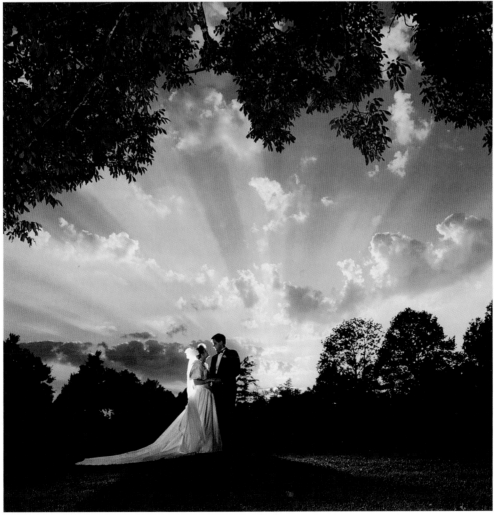

BRUCE AND SUE HUDSON

RENTON, WASHINGTON

Bruce and Sue Hudson met in high school as members of one of the top, scholastic jazz bands in the country. According to Sue, "Music taught us the value of practice, as well as the importance of teamwork and of the 'performance' itself—which relates more to wedding photography than to any other part of our business." After Bruce received his Master's degree in music, he taught high-school band for four years. Sue left the music scene after high school to become a legal secretary. Bruce adds, "Sue's legal training gave us an understanding of how the system works, but more importantly, her office and organizational skills increase our profitability."

The Hudsons continue to draw upon their former work experiences in the daily operation of the portrait/wedding business that began in 1975. Today, Hudson Portrait Design is highly regarded for the quality of its photography. The couple has lectured before professional groups throughout the United States and abroad. Bruce received the Master Photographic Craftsman degree from Professional Photographers of America (PPA), and Sue earned the PPA Photographic Craftsman degree.

Author's note: On February 17, 1996, cancer claimed the life of Sue Hudson, at the age of 43. Her loss is a tragedy not only for her family, friends, clients, and associates, but also for the industry that she made so many important contributions to. Sue dictated the following interview while convalescing after surgery and did so with the same cheerfulness and optimism that now serve to memorialize a life richly lived. She'll be greatly missed.

Little did we know where the journey would lead us back in 1975, when a friend asked Bruce and me to photograph his wedding. "Sure," we said. After all, we had everything we needed: an old Argus 35mm camera and a hand-me-down Rollei flash. So the Friday night before the wedding, we visited a local camera shop to buy film, and we decided to purchase a book on how to photograph weddings. We still have that book by some California photographer we'd never heard of—one Rocky Gunn. We quickly progressed to doing other friends' weddings on weekends, charging $50 plus film and processing costs.

In 1979, we met a studio owner who was thinking about going into the wedding business. We showed her some of our work, and she hired us. It was really easy: just show up, shoot the wedding, drop off the film, and collect a check. This lasted for about two years, until we started receiving our own referral calls.

By 1982, the thought of going into business for ourselves as full-time photographers was all-consuming. Even back then, we realized that being different was the key to success. In February 1982, we attended our first bridal fair and booked 60 weddings from our display because it was different—and, of course, we were cheap. We learned a valuable lesson that day: If you book everyone who shows an interest in your work, then you need to raise your prices. We began to understand the idea of controlling volume with price.

On August 1, 1982, we opened our first studio in a local strip mall we'd chosen based on demographics and economic factors. Our families thought we were crazy. Interest rates were 18.5 percent, and the Seattle area was in a deep Boeing-induced recession. But failure and fear were never options as we'd experienced total burnout in other previous jobs, and our first child was on the way.

We made it through those early years by keeping busy with a variety of product lines that included sports teams, seniors, family portraiture, and boudoir portraiture, in addition to the weddings. As we increased our sales of more profitable product lines, we would decrease bookings in less profitable ones. Since 1988, our product mix has consisted of 40 percent weddings; 30 percent seniors; and 30 percent family, boudoir, and miscellaneous portraiture.

In 1986, we decided to update our image, so that we could raise prices. This meant that we had to increase the perceived value of our product, and we just couldn't do that in the shopping-center location. We also wanted to invest in real estate as part of our future-retirement planning. So in February 1988, we realized our dream when we opened our present location in a renovated home in an area of town that is zoned for commercial buildings.

As we've raised prices, we had to expand our marketing area, so we now promote to a 30-to-35-mile radius around the studio, drawing from a population base of 1.2 million. Approximately 75 percent of our weddings come from former family-portrait and senior-portrait clients. We've reached our goal of limiting ourselves to 40 weddings per year, while earning more than we did when we photographed 80-plus weddings each year. Our current goal is 3 weddings per month, giving us one entire weekend off to be with our children.

There is so much more to a wedding than many photographers see. We see it as the most romantic journey anyone can take. Everything is centered around the impending marriage: engagement parties, dress fittings, bridal showers, jewelry design, planning for a new home, and the wedding day itself. Few photographers will take the time to document this journey or charge enough to make possible such an artistic heirloom. When you begin to view weddings this way, you realize that from the time of the booking, you have a year full of opportunities to pamper your clients and build a relationship of trust as you capture this romantic journey in photographs.

Our photographic style is a blend of portraiture and pictorials, using a variety of locations and making use of each location to its fullest. Our goal is to make even ordinary locations look extraordinary, and to make beautiful locations look refreshingly different. We do this through the use of as many as 10 different lenses, using both color and black-and-white films to enhance the location. We want people who view our albums to say, "Your photographs don't look posed" or "The people in your pictures look like they're having a great time!"

That is the real challenge and joy of wedding photography: each and every weekend, making less-than-perfect situations look great, and experiencing the adrenaline rush of producing award-winning images under the pressure of the moment. We thrive on that pressure, and we always try to live up to our mission statement: to create clients for life by providing an exciting and artistically fulfilling experience for them . . . and us; to be truly honored by their friendship; and to maintain the relationship long after the sale.

JIM JOHNSON
WASHINGTON, DC

A native Washingtonian, Jim Johnson earned the Master of Science degree in engineering from Howard University and worked for seven years as an environmental engineer for private industry and the federal government before he followed his heart into the photography business. Sixteen years later, his reputation for artful portraiture and photojournalistic wedding photography enables him to target middle- and upper-income clients, including the famous and not-so-famous ("from presidents to paupers," he says), all of whom appreciate his intelligent yet mellow approach to the craft.

Johnson's studio is located in a three-story townhouse near the banks of the Potomac River, in southwest Washington. A past president of the Professional Photographers Society of Greater Washington, he encourages other professional photographers to operate in the spirit of cooperation rather than competition. He shares his expertise with professionals throughout the country as a teacher and public speaker. Currently vice president of the Professional Photographers Minority Network, a national affiliate of Professional Photographers of America (PPA), Johnson is a member of PPA's Council and an Ambassador to the International Photography Hall of Fame and Museum in Oklahoma City. He holds the PPA Photographic Craftsman degree and has earned numerous awards in national and international print competition.

I describe my approach to wedding photography as documentary: a journalistic style of photography. It is because of this documentary style that I'm hired by a specific type of client, so it is important that everything I put out in the public about me helps to select the client I want to deal with by appealing to a certain kind of thinking. So when people call and say, "How much are your packages?" I know they're looking for a box to be fit in—but I don't have any boxes.

My documentary style is appropriate for couples who value authenticity. The number-one need of human beings—and the reason why many buy what they buy—has to do with acknowledgment. When these individuals see that what you do is about who they are, they're more inclined to buy from you or to use your services. Therefore, if your clients have a vision and you capture that vision on film, you are much more valuable to them. Just as authors are routinely paid more when they're commissioned to write a book by a publisher, as opposed to writing a book about their own vision or passion and presenting it to a publisher, a wedding photographer is more valuable to a couple when they "commission" him or her to communicate their special wedding vision. Thus, I approach every wedding as an opportunity to celebrate the uniqueness of the couple, their wedding day, their authenticity.

For a documentary style to be effective, it requires preparation, part of which is for me to establish trust with the couple. Building this rapport begins at the initial interview with the bride and groom, so studio environment is very important. I've designed my studio to appeal to an upscale audience. From the colors and furnishings to soothing New Age music played in the background, I want to minimize any possible barriers between myself and prospective clients.

I explain to couples that I come to the wedding to tell a story, and in doing so, I want to interpret the story through their eyes. I record the story based on what expectations they have about the wedding day. I ask the couple to give me some adjectives to describe what they hope their wedding day will be. When they are able to do this, it is like magic. They give me what I need to make their wedding story incredibly intimate and meaningful. Obviously, different people have different tastes, and this will affect how they view their wedding coverage. By making sure that the concept of the wedding is fully articulated by the couple, it is they who set the ground rules as to

how they'll evaluate my performance in recording the story of their wedding and interpreting each image.

The interview, then, is part of a marketing philosophy that is consistent with my belief that wedding photographs are more valuable before they're taken. Instead of tangible "packages," I prefer to sell the more intangible concept of my being there at their wedding to record their story. What I tell couples is, "The only direction I'm going to give you on your wedding day is to be yourself." This notion works to my benefit because couples want to work with people who understand them.

Most of my business comes from referral, although I do take part in wedding trade shows and engage in networking with other wedding professionals who recommend one another's services. I'm convinced that the most powerful advertising occurs when you succeed in setting the clients' imagination free to envision their own wedding.

On the wedding day itself, my concern is to record the events without having an impact on the story. I want to be an intimate yet unobtrusive observer. I use a "hit-and-run" technique requiring that I prefocus while moving to where the next bit of action will occur. For example, if I see three people that I want to photograph engaged across the reception hall, I focus at 6 feet, move across the room, and shoot. I am in and I am out, and often the subjects don't recall that they were photographed. I want to portray as much real action as I can, and most of the time I'm looking over the camera to see the action so the camera is ready to fire. I am always alert for diagonal lines to help reinforce the action.

The equipment I use is simple: two Mamiya 6 Rangefinder cameras, one equipped with a 50mm lens that I use for 90 percent of the candids, as well as a 150mm lens and a 75mm lens for the other. Using Kodak 400 PPF film, I am able to set my aperture at 5.6 and keep it there. The Metz CT-60-4 is my workhorse on-camera strobe. Under ideal conditions, when the ceiling is between 8 and 12 feet, I can set it to bounce 80 percent of the light, with 20 percent aimed directly at the subject. Set this way, you don't notice the flash in the photographs as it gives the impression of high ambient light. In some scenes, such as the processional and dancing at the reception, I use a second light: a Vivitar 283 mounted on a lightstand that I place according to how I expect the scene to unfold. It can serve as a fill light, rim light, or backlight, depending on how the action moves. During the ceremony, I never

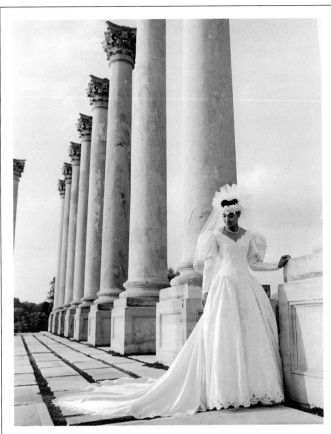

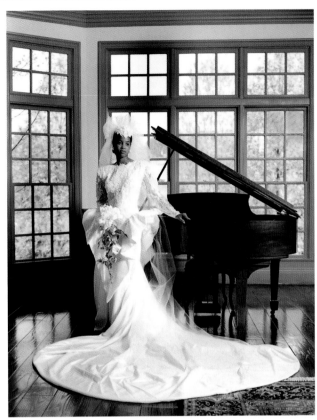

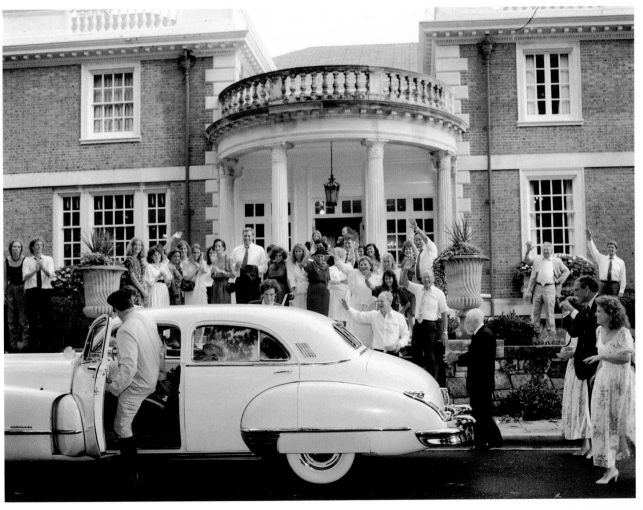

use flash. This allows me to move with the motion of the ceremony in order to achieve photographs that are sensitive and intimate.

This style of photography requires that you anticipate the action. You must learn to trust your instincts and not to be too judgmental. If you spend too much time looking for the right moment, you can overlook the real moment. Technical factors must be second nature, so that you are free to focus on the action.

In addition to recording the events of the day, I do the compulsory portraits, with the time spent on them varying depending on how much value the couple places in them. Often this can be done in as little as 15 minutes. My hope is to have achieved enough rapport with the participants that they're willing to just be themselves—just as candid as they are when their friends are photographing them. The goal of these portraits is to say something about the relationships of those being photographed. With big groups, I place the central party, then ask the others to place themselves where they think they belong. I tell the men and women to "couple up." When people put themselves together in groups, they'll put themselves in a juxtaposition that reflects their true relationships.

A typical full-coverage wedding lasts for about six hours, and I produce between 250 and 350 photographs, of which I might edit out 10 to 15 percent of the images. I present the 5 x 5 images in a four-to-the-page "Wedding Journal" that maintains the sequence of events. I want the couple to see the story unfold, with each image signifying a meaningful step in the story. They then select the images to appear in their bound Leather Craftsmen album.

My price schedule is structured in such a way that I'm paid for my time as well as my talent, based on an hourly charge plus charges for materials. The amount a customer will pay me is limited by what I think I am worth. As I escalate my self-concept and learn to communicate more value to the client, my compensation increases. Over the years, what worked best for me was when selling at a certain level became too easy, I would ease the prices up to the next level.

For me, success in wedding photography comes from being excited about what you do. The best photographers are exceptional communicators. They use the camera the way a writer manipulates pen on paper. Their photographs succeed in capturing the human experience through tears, fears, and laughter: vivid vignettes that challenge the imagination and speak to the soul. Photography is an incredibly powerful medium of communication because it expresses itself in the same way the brain works—in pictures.

I'm always looking for new ways to make photographs as real as the moments they portray. Documentary coverage works for me because there are no formulas. Each event is a new challenge, and there are no boundaries to prevent me from creating images from the passion of my heart.

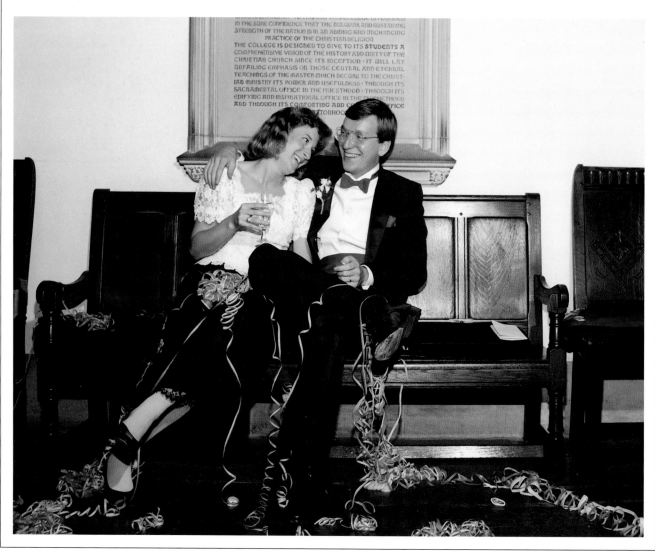

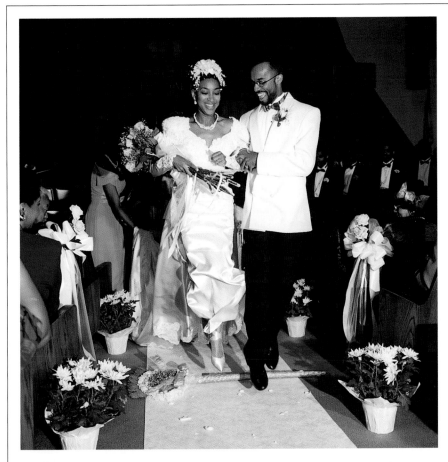

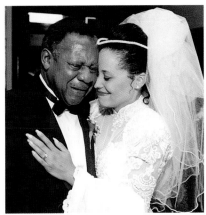

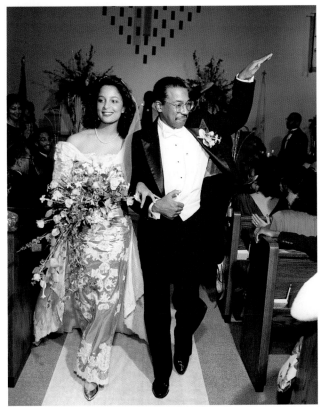

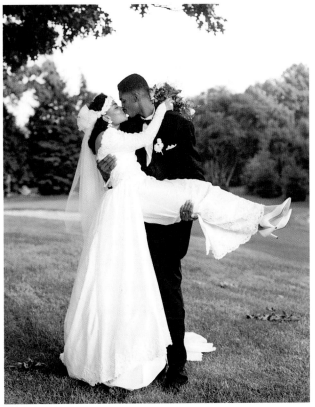

ROBERT LINO
MIAMI, FLORIDA

In 1969, when he was 11 years old, Robert Lino's family immigrated to the United States from Cuba and settled in Miami. Lino became interested in photography while in high school but put that interest aside until after he'd earned an associate's degree in education, his intended vocation. Ultimately, he decided that photography would be his career, and he received on-the-job training, working 11 years for a high-volume photography business. He continued his education by taking numerous courses from the Winona International School of Professional Photography of Professional Photographers of America (PPA) and its affiliated schools. He holds the PPA Master of Photography degree and Certified rating.

Years before he was to start his own business in a shopping center, Lino saw a house that he thought would be a perfect location. It was situated on a main street in a residential area that was being transformed to a commercial district, surrounded by the exclusive neighborhood of Coral Gables and eight blocks from the upper-middle-class suburbs of West Miami and Westchester. In May 1990, Lino ful-filled his dream by purchasing that property and converting it into a studio where he specializes in portraiture and social functions.

Lino's work hangs consistently in state, regional, and international print competitions, including selections for display at Epcot Center in Walt Disney World. In 1995, one of his photographs received "Best in Show" honors at the Southeastern Professional Photographers' Association regional print competition.

Since my business operates mostly on client referrals, I don't miss the storefront or the big sign in the window. Of my four years in a shopping center, I probably booked only three walk-ins. When clients come to the studio, they enter a large reception area that I sometimes use for photography. In this area, I placed large columns, a grand piano, and very little furniture to look like a hotel or building lobby. Even though the first impression is very formal, the atmosphere is casual and relaxed. Even though it was once a house, there are no traces of a residence; it is all business.

Since day one, we've photographed weddings, Hispanic debutantes or "Sweet Fifteens," and some portraiture. For those who aren't familiar with the debutante concept, it is a Hispanic tradition that when a girl reaches her fifteenth birthday, there is a big celebration. The affair consists of a grand ball where the debutante is presented to society, and she usually is escorted by a group of 14 couples of her friends. Like a wedding, the event depends on the social and financial status of the family for its grandeur. In addition to the party, there also are portrait sessions that are becoming more elaborate in keeping with the girl's desire to be a model and using this opportunity to create her own kind of "portfolio." These events are very lucrative to our business, and now they're being promoted by many photographers outside the Hispanic community as "Sweet Sixteen Portraits" or "Debutante's Portfolio."

Our county has a population of approximately 2 million people of diverse social and economic levels and from a great variety of cultures. Although my market has been primarily the Latin working class, through changes in location, my style of photography, and marketing strategies, I'm seeing a change that includes an increasing Anglo and Jewish clientele. We photograph between 150 and 200 weddings or debutante parties each year. Gradually we're decreasing our numbers to follow the "less-events, more-money" trend. However, I expect always to maintain a healthy volume, as I believe volume creates popularity and demand.

Our photography style is formal, elegant, romantic, and storytelling. Although we like images to look natural and candid, we depend a great deal on posing. Most brides don't go around on their wedding day being affectionate or romantic, and often we create situations that could really happen and look spontaneous and candid, but they're very much planned.

Cultural preferences also dictate the style of photography. Most Hispanic clients prefer the more posed and composed photographs: the gowns perfect, subjects looking at the camera and smiling. They want the photographer to create the shots and direct the whole affair. The attitude is "things happen so that they can be photographed."

On the other hand, American couples prefer not to be bothered as much. They want to enjoy their wedding and have candid photographs of the events as they happen. Usually the consultant or band director conducts the affair. The photographer merely records the events as they happen.

The opportunity of working for different cultures has enabled me to select the best characteristics from each one, and this is an advantage for our business. Now we communicate the different traditions to clients. And I'm finding that the Americans appreciate the fact that a professional will be taking care of details, such as fixing the bride's train, and making sure that events happen in an orderly fashion to obtain better results in the still and candid-looking shots. And the Latin couples enjoy the idea of more spontaneous participation in their wedding.

We try to provide images and a finished album that are somewhat different from those of other studios in the area. We use various print sizes as well as panorama pages and special mats, paying attention to the storytelling quality of the album. All the album prints are enhanced and lacquered.

Another difference is that we strongly promote formal portraiture. All of our wedding selections include a formal session. We stress that the portraits should be of the couple, not just the bride alone. We show how different the album looks with portraits of both, nicely done another day without the pressures and the nerves of the wedding day. Usually this is done after they get back from the honeymoon. To solve the problem of displaying a portrait at the reception, we suggest engagement portraits—something "different"—and stress the point that it is the groom's wedding as well, so why show a portrait of just the bride?

I strongly believe that formal portraiture is my biggest asset, so I stress it: starting with the engagement, the wedding portraits, and occasionally "glamour" or "intimate" photographs, depending on the couple. From a business perspective, this increases the number of photographs in the album, not to mention the family orders when the portraits are so "perfect."

I enjoy making changes in the business: new props, furniture, and new

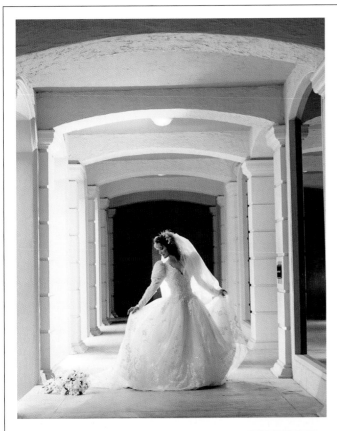

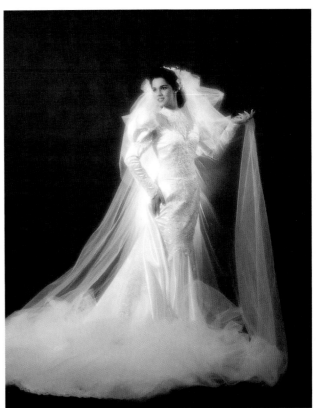

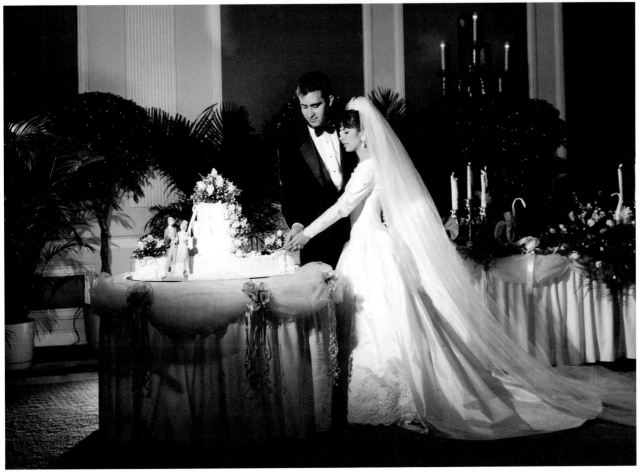

approaches to making and selling images. I'm building a new sales area to project previews of the portrait session. And I'm remodeling the backyard, creating areas designed for photography. I'm looking forward to learning more about computers because I don't want to be left behind. But I don't intend to become one of those businesses where computers run the humans.

Recently, I've moved toward a less stressful method of covering weddings.

In the past, I used to photograph one wedding myself, and if time allowed, I would go on to the next. Now if I book three weddings, I'll assign a photographer to each of them, and I myself will visit all three, carrying no equipment. I pose the formal portraits and make certain that everything is going well. This way I don't have the pressures of photographing a whole wedding, and the clients feel that their work has received the "Robert Lino touch."

My long-term goal is to become known as "The Wedding Portrait Photographer" to whom couples come for their formal portraits, even if I'm not contracted to cover their wedding. I hope to remain a wedding photographer for as long as there is a demand for my services. I'll continue to set myself on the couple's side and view the day from their perspective. I think this philosophy shows through and is reflected in our work and the client's response to our business.

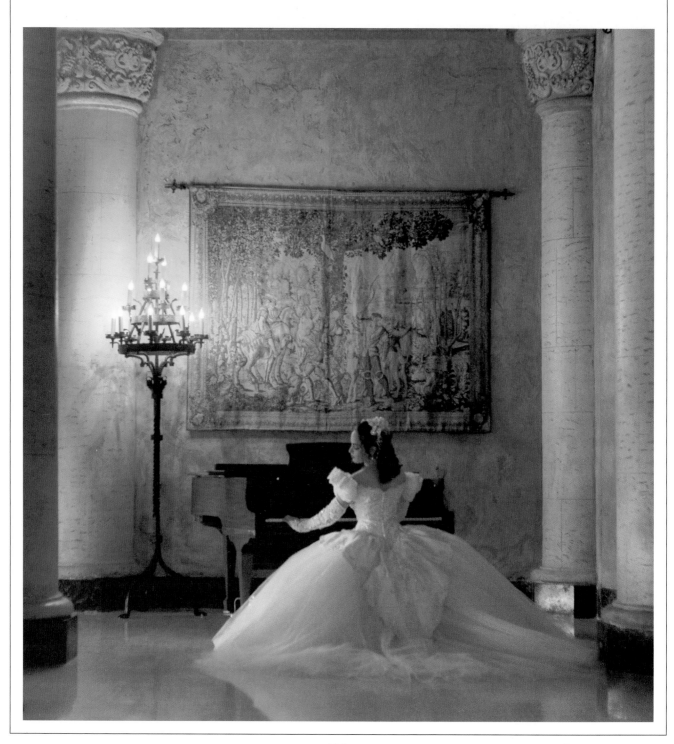

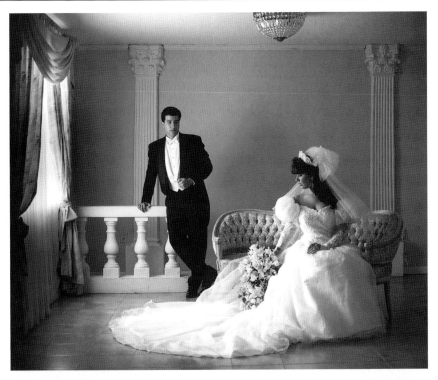

ROY AND DEBORAH MADEARIS

ARLINGTON, TEXAS

Madearis Studio, which today covers approximately 100 weddings each year, had its beginnings in January 1968, when Roy Madearis photographed his first wedding as a weekend warrior. An accounting major in college, he'd worked at Bell Helicopter and in the banking industry. In 1979, Deborah Madearis, a behavior-modification specialist in the special-education field, joined her husband's thriving, full-time business that they describe as a "one-stop shopping center for wedding photography and bridal accessories."

Roy, Deborah, and their studio's two associate photographers have distinguished themselves in state, regional, and national photographic competitions for both their portraiture and wedding photography. Roy has been honored as "Top Wedding Photographer of Texas" an unprecedented 10 times, and staff members have won another five trophies.

Roy holds the Master Photographic Craftsman degree from Professional Photographers of America (PPA). Deborah has earned the PPA Photographic Craftsman degree and is nearing completion of her Master of Photography degree. Nationally known for their expertise in both photography and studio marketing, Deborah and Roy conduct professional-association seminars and teach classes for the Winona International School of Professional Photography and its affiliated schools.

Our first full-time studio location opened in 1971 in a strip center. As the business grew, we moved to two other strip malls and finally to our current building in an area that is called "Old Town Village." The 1 1/2-story building, which we own, is situated in a neighborhood that is dominated by law offices. We rent out office space in the upstairs portion of the building.

There is plenty of competition in the area: six studios are within a 2-mile radius of our business, including two right on our street. Our building was designed to resemble a home. There are no windows for display, so we must rely on aggressive marketing to draw new customers, approximately half of which is portraiture, with the rest being mostly weddings and a few commercial assignments.

We rely on direct mail for much of our studio marketing. Each year, we get information from the chamber of commerce, as well as from our Yellow Pages office. This information is broken down by zip codes. Because we are in the Dallas-Fort Worth metroplex, we draw clients from a wide market area. Our mailings regularly target a total of six zip codes, two each that are north, south, and west of our studio.

The two major factors that have helped to make our wedding business successful over the years is the high level of customer service we deliver and networking with major players in the wedding industry. We do two bridal fairs a year, and we send our various networking merchants photographs from every wedding that we service jointly.

We find bridal fairs to be an excellent way to generate immediate bookings. Our entire staff works the shows, so that we can talk to as many prospects as possible. Our booth consists of an eye-catching collage of wedding photographs behind a table that holds sample albums and that is covered with wallet-size wedding photographs that include the studio logo. The wallets serve as handouts, and we've found them to be a really effective tool in helping prospective couples remember who we are.

For bridal fairs to be effective, studios must be prepared to make a follow-up call to each couple that seems to be a likely prospect, so it is important to get address and telephone information. The follow-up call to schedule a studio consultation should happen the day after the show because this is when the brides are most excited about their wedding plans.

Bridal couples refer our studio to others because of the level of personal attention we provide at each wedding. These are the elements that make or break a business over time. When a bride visits our studio, she learns that we really want to photograph her wedding. Our mission statement is very simple: "Above even the quality of the product that we strive to perfect, the manner in which we present, sell, and stand behind our product is what we address daily."

Our wedding style is very traditional. We focus on the couple, family, attendants, and the storytelling aspects of the wedding day. Our shooting sequence is well structured. We have two associate photographers and one in training, so we've developed a training manual for their use. It consists of a series of images to be created at every wedding, based on the size of the wedding. Each photographer then has creative license to compose any additional formal or candid poses.

We use the Kodak Prism system for all studio sessions, and it has greatly increased our portrait sales. Brides can see the image at the pre-wedding session in the various sizes, and we offer a price-reduction incentive if they purchase a 20 x 24 or larger portrait prior to the wedding. Most brides choose this option.

We've developed a multilevel pricing structure that appeals to a large cross-section of brides who call for information. This structure features a-la-carte pricing, package pricing, and customer collections that include all images from the wedding. Currently, 56 percent of our couples book a custom collection. More than anything else, what we rely on are great images with great expressions and a storytelling layout to make the albums sell themselves.

An important part of our sales strategy is that we see our wedding business as having a far more lengthy sales cycle than most studios. It is common for our staff to see the bride, bride and groom, and members of the family from five to seven times during the interval between the booking and the wedding. This gives us an opportunity to market additional wedding products and services. We display and sell a complete line of wedding accessories and are one of the accessory company's largest distributors. We also carry gifts for groomsmen, such as personalized luggage, china for bridesmaids' gifts, candy favors, hostess gifts for showers, wedding invitations, bubbles to blow (instead of throwing rice), and even a sixpence for the bride to carry.

Because we have several bridal consultants on staff, we also offer a concierge service for our brides to attend to wedding details ranging from

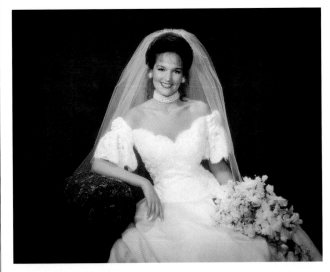

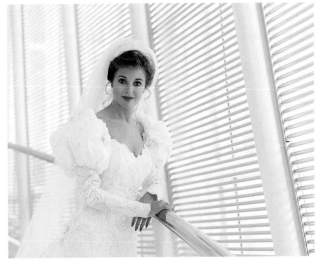

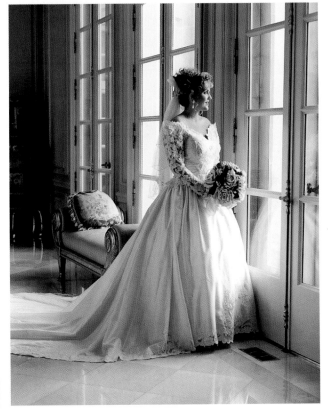

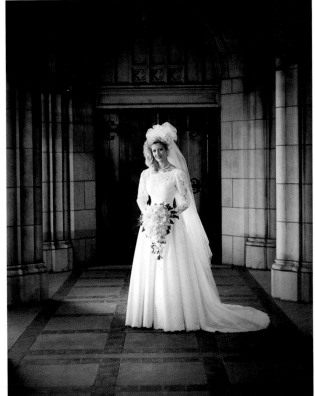

ordering goods and services from other wedding professionals to serving as an on-location coordinator for the ceremony and reception. What we've created is a "one-stop-shopping" wedding service. We see no reason why our clients should have to go elsewhere to purchase products and services that we can provide in a way that is a convenience for our brides and profitable for our business.

One of the most popular extras that we offer is Kodak's "Friends of the Bride" packs that contain five Fun Saver 35 cameras with flash. This allows wedding guests to take candids at the reception, which is fun for them and makes our photography job much easier. Sales of candids at the reception never are as good as the ceremony candids and formals, so we are free to concentrate on the reception photographs that we know will sell. We provide the couple with a coupon that entitles them to one complimentary 5 x 7 enlargement for every roll of film processed at a one-hour lab. That way, we aren't bothered with the processing, printing, or mounting of these photographs.

We strongly believe that little details reinforce the fact that we offer a high level of service, such as maintaining a file of images at each church where we've photographed a wedding, showing weddings photographed at different times of the day. Both the bride and her family are impressed that we have a working knowledge of their church. Because we offer so many wedding services, we're prepared to attend to many special details, particularly when the family of the bride lives outside the area. These little courtesies not only increase our wedding revenues, they also are the types of things that clients remember long after the wedding. This helps to ensure future referrals.

The mark of success that means the most to us is when a bride's parent compliments the quality of our service, as well as the photography quality. This means we are on the right track for future profitability.

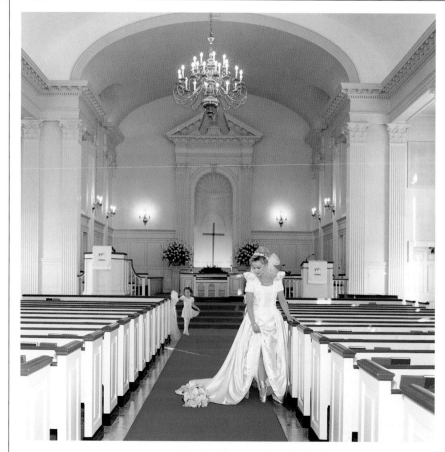

ANDY MARCUS

NEW YORK, NY

Nearly 50 years ago, Fred Marcus started a photography business on New York's Upper West Side. Today, Fred Marcus Photography photographs and videotapes some 800 social events (weddings, bar and bat mitzvahs, anniversaries, birthdays, and corporate events) each year—more than any other studio on the east coast. At the age of 85, Marcus still comes to work every day, although the business is now run by his son, Andrew (Andy), who at age 17 began working in the family business that also included his mother, Gerda. Andy's wife, Judi, whom he met 21 years ago at a wedding, also works for the company. Andy has won numerous first place awards in Professional Photographers of America's "Brides' Choice" and Wedding Photographers International competitions.

Today, Fred and as many as seven associates travel the world to photograph the social events of the prominent and powerful, in addition to covering high-profile events that take place in the finest cathedrals and hotels in New York City. Among the events that the studio has photographed are the weddings of Mary Tyler Moore, Donald and Marla Trump, Eddie Murphy, Princess Yasmin Khan, Art Garfunkel, Itzhak Perlman, Harry and Leona Helmsley, Billy Baldwin and Chynna Phillips, and all the couples married on the "Live With Regis and Kathie Lee" television program. Prices for social-event coverage range from $2,000 to an occasional $40,000 or $50,000 for customized work that includes photography, videotaping, wall portraits, and photo sculpture.

This whole wedding thing is about fantasy, and it is all about women and fulfilling their dreams. Men have very little to do with it. The two most important people are the bride and her mother. If you make beautiful pictures of these two, then most of your problems are solved.

Although we do many high-profile weddings, the bulk of our business is from everyday couples. Our studio is a household word in the New York area, so most of our clients come to us by referral or they see our images displayed at fine hotels, such as the Pierre and the Plaza. About 40 percent of the business is from New York, 40 percent from Long Island, and 20 percent from Connecticut and New Jersey. Last June, the studio did 130 weddings, including a nationally televised Orlando wedding when Walt Disney World opened its wedding pavilion.

The last few years have been hard on wedding photographers because many people have scaled back on the size and expense of their weddings. But recently I've noticed that the big wedding is definitely making a comeback. We like to focus on these big events because we expend almost the same effort at a small wedding that we do at a large one. The size of the wedding is what dictates how many photographers we send. The minimum number for any event is two, but when there are more than 250 guests, we recommend more than one photographer and a single assistant. At a particularly lavish affair, we had 24 photographers, videographers, and assistants.

Coverage of the wedding is only a small part of the job. I prefer to shoot the unusual. Basically, receptions are pretty much the same. They make a toast, they cut the cake, they dance. What makes it interesting are the people and where you pose them. I like to use New York City as a backdrop. Many of my clients get married in Fifth Avenue hotels near Central Park, so I can use spectacular city locations.

For example, I can get the couple on a double-decker tour bus. I just stop the bus, get the passengers off, and put the couple on. Nobody minds. I've solicited help from taxi drivers and street vendors, and even placed couples in parades and surrounded them with marching bands and spectators. I call these pictures "Urban Environmental Images," and my clients just love them. They are what separates my albums from competitors', and they provide the couples with unique photography and the memory of a wedding day adventure.

Our wedding-photography style is a mixture of traditional portraiture and candid coverage. Some studios are giving up formal portraiture altogether, but our clients still expect and appreciate such portraits. I prefer to take the formal pictures before the wedding, before everyone is worn out by the events of the day, and so that the reception pictures can be strictly candid. That way the couple is free to enjoy the reception. The key to reception photography is anticipating each major event, so that you are in the right place at the right time.

At the wedding, timing is critical, so I work fast and simply. I continue to use a 25-year-old Hasselblad 500CM. I have newer, fancier equipment, but I'm used to the old Hasselblad. It has been dropped and put back together, but it is like an old pipe—a comfortable old friend. I use a variety of lenses, from the 30mm fisheye to the 250mm telephoto, to achieve changes of perspective, and most often I shoot candids from the hip with the camera prefocused. I pose people very quickly, making them look casual and comfortable, not stiff and formal.

About 60 percent of our clients order video services as well as stills, and we take a very candid approach to this coverage, working without bright lights that call attention to themselves and detract from the mood of the event. Our goal is always to blend in with the guests. If the wedding is a black-tie affair, our photographers come dressed in black-tie. If the guests will be wearing dark suits, our photographers wear dark suits. We go out of our way to work closely and well with the other professionals involved in the wedding, to make certain that everything goes smoothly and that all aspects of the event are covered.

More than anything else, consistency is the key to success in wedding photography. Almost anyone can get good wedding photographs once in a while. What makes your reputation is getting great pictures at every wedding you photograph. This means that you can never, never be complacent when you're photographing a wedding.

Nothing about weddings and social events surprises me anymore. Between my father and myself, we've just about seen it all. One of my favorite stories is the bride who called me the day after a really crazy affair. She said, "Don't develop the film. The guy's a jerk."

Vanity is very much a part of this business. A few years ago, a woman came in and complained about some of my father's photographs: "Mr. Marcus, you didn't do me justice." My father said to her with a smile, "Mrs. Schwartz, you don't want justice; you want mercy." That's why we have four

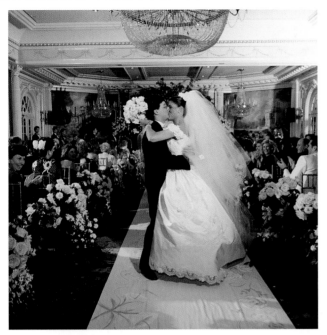

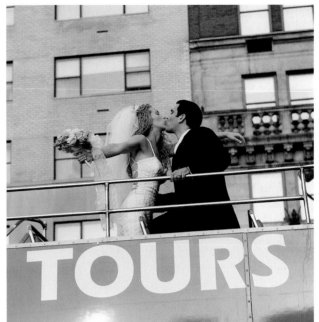

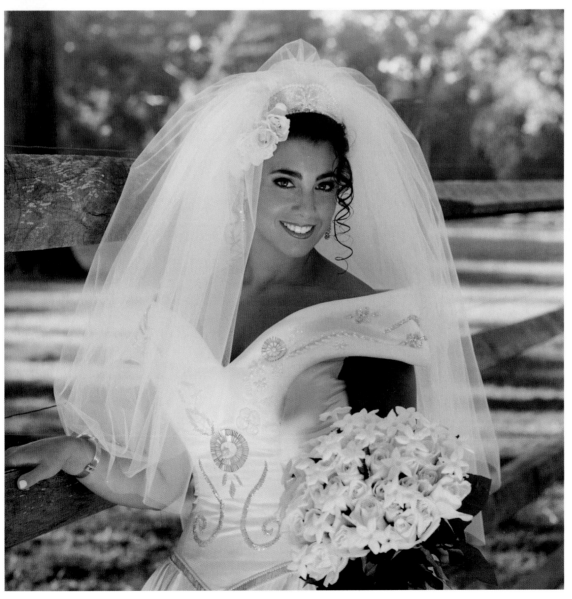

retouchers softening hard lines and blemishes. When you charge top dollar, you must make people happy about the way they look.

A good thing about this business is that even when the economy is down, people still get married. And they're willing to pay to see their fantasies fulfilled. A great customer to me is the family that might book us at a minimum order price, but when they see all the pictures, they can't say no. They just have to have more. So I believe that the best way to increase the size of the sale is simply to produce good photographs.

To do this job well, you must be part shrink, part showperson, part diplomat—especially when you're dealing with divorced parents who haven't spoken in years—and part stand-up comic. Many of the pictures we take you could call "manipulated memories." But this is the only thing that is left after the wedding. In five or six hours, when the wedding is over, these photographs are all that remains. The food will be eaten, the flowers will die, the music stops, and the dress is put away. Twenty years from now, you're going to have family that won't be around anymore, but you'll still have them in photographs.

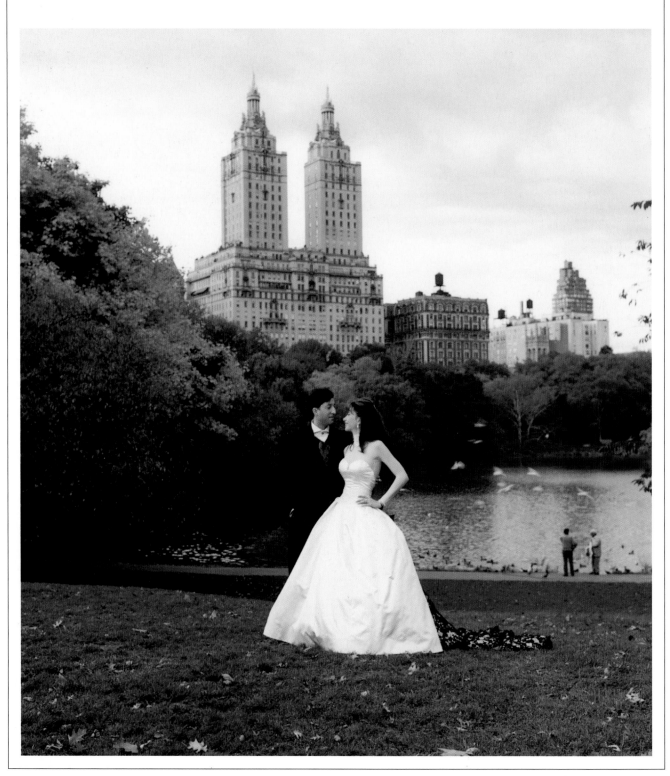

HEIDI MAURACHER

SANTA BARBARA, CALIFORNIA

Although she graduated with top honors from École Normal de Musique in Paris, Heidi Mauracher decided that a career as a classical guitarist wasn't for her when she began to question "whether I wanted to spend the rest of my life alone practicing." Since 1988, Mauracher has used the discipline and artistry she learned as a musician, along with practical knowledge gained from attending seminars at the West Coast School, to shape her career as a wedding photographer who routinely molds prospective brides and grooms into dream clients from her Santa Barbara, California, studio. She specializes in the storybook concept of full wedding coverage, photographing approximately 35 to 40 weddings a year in the resort community of roughly 100,000.

In addition to holding the Master Photographic Craftsman degree from Professional Photographers of America, Mauracher earned fellowships from the British Institute of Professional Photography and the Master Photographers Association of Great Britain. In 1994, she was named "Photographer of the Year" by Wedding and Portrait Photographers International, and her portraits have hung at prestigious international print competitions, as well as in the Photography Hall of Fame in Oklahoma City and Epcot Center in Walt Disney World. She has lectured to professional audiences throughout the United States, England, Ireland, and Scotland.

Most of the work I do is on location due to the nature of weddings. I don't have a "fixed studio setup." Should a client want this look, I can set up all the necessary equipment on location. This isn't a frequent request, as I usually display what I want to sell: the romantic, environmental look. I promote the concept of capturing the beauty and mood of each couple's chosen location. The southern California climate allows for weddings all year, and many take place out of doors.

I encourage a variety of looks to my clients. These include environmental, pictorial, fashion, romantic, dramatic, illustrative, and fun. My wedding style is overwhelmingly romantic and designed to capture the energy that exists between the couple. I work with their emotions to evoke a mood appropriate for each couple's story. An important tactic is to build rapport by allowing for a warm-up period at the initial interview. Observing the mood of the couple helps set the stage for designing the photo sessions to come.

My studio is in my home, 15 miles south of Santa Barbara proper. The house is roughly 2,000 square feet, with two stories and large windows. The light in the house is magic. The community is a small, planned, unit development consisting of 40 homes. There is no soliciting, and actually no business practices allowed. However, my clients come by appointment only, and I schedule my appointments carefully. I avoid the word "appointment," which can sound rather clinical. I strive to establish a more relaxed mood through suggestions, such as, "Would you like to get together to chat about your wedding plans and allow me to show you some photography ideas?" This has been very workable for me with my low-volume, selective clientele. I hold a casual, warm meeting with prospective couples, who view a slide show with music, while enjoying refreshments.

After the wedding, I want the sales process to be as casual and friendly as the rest of my service. I strive to "soft sell" emotionally, as soon as possible after the event, using 5 x 5 originals. When meeting to design the album storybook, we include as many people as possible, parents and family, and most important, the financial decision-makers. Because this meeting is scheduled shortly after the honeymoon, emotions are still high, and the glow is still there. My goal is to keep everyone truly excited about their investment.

I work with a "creation fee" and an a-la-carte pricing system, but I'm searching for a new way. I would like to incorporate the creation fee into the pricing structure to keep the process as simple as possible. I sense that my clients would prefer this type of structure. Currently, my couples pay the creation fee when they sign their agreement to reserve the date. I use the term "agreement" because it sounds a lot more hospitable and less cold than "contract."

A week before the wedding, during a final photography consultation, I receive an additional deposit that is applied toward the wedding album. This is an amount the couple decides upon when they sign the agreement. I accept credit cards because they are a big help for increasing sales.

My goal is to sell the complete wedding story in "chapters." The couple is in control, but I edit the photographs very carefully, knowing which images I'll encourage them to leave behind. Here, they see I'm not pushing all the photographs on them. There are no duplicates of any two images. Still working as a "team," we select the images together. Then, privately, I design the finished album with mixed sizes. The book is a combination of black and white and color, and incorporating a panorama page is becoming increasingly popular. This mixture of sizes and media adds to the custom-designed look of each volume.

When I design the book using an Art Leather or Leather Craftsmen album, my goal is to support the mood of the wedding in the layout. In addition to the album, I sell folios and larger prints for wall display. With my low-volume business, I don't carry lots of little extras. I've chosen 10 different styles of simple, elegant frames. The fewer the choices, the easier it is for the customer.

What I enjoy least about my work is promoting myself and my work, but this is very necessary, particularly when the economy is subject to such ups and downs. I always lean toward the emotional, soft-sell approach. When talking to couples, I find the best approach is to contrast the "practical purchase" to the "emotional investment." I want clients to understand that their wedding album is a "family treasure," as opposed to the purchases the family makes that later are replaced, such as the car, the sofa, golf clubs, braces for the kids' teeth, and so on.

I listen to what they say during my meetings, and some couples tell me they're spending more than they originally planned on for the food, the location, the dress, etc. This tells me that emotion drives much of their spending. We are a luxury business that is driven by emotion. Fortunately, our

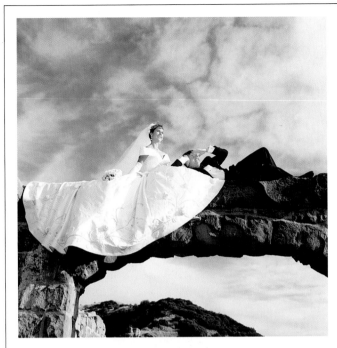

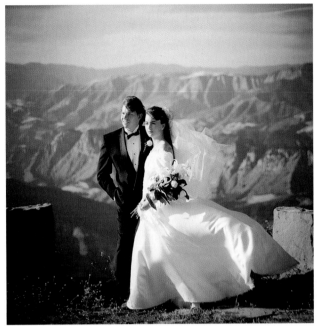

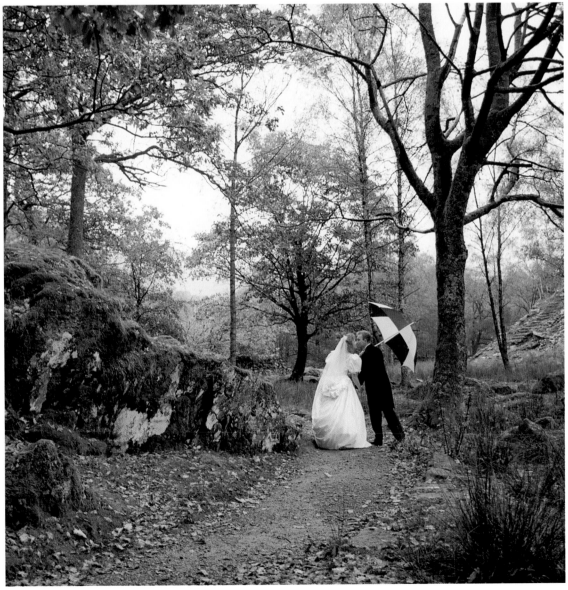

product is one that holds its value over time, but we need to remind the couple of this fact.

My work is displayed in florist boutiques and hotels in the area. I belong to a small "family" of vendors who refer one another to prospects. Networking by word of mouth is a great confidence booster to prospects when they hear the same name two or three times. I participate in bridal fairs as well. Because Santa Barbara is a resort community, I see many people drawn from the Los Angeles and San Diego areas. Believe it or not, my telephone ad has been a great source. The ad is simple, and it works.

I use the Hasselblad system, and my film is Kodak VPS 120, but I've begun to experiment with a variety of films to achieve different looks. I employ one assistant and sometimes two on the wedding day to help with equipment and lighting. My concern is to keep from breaking the flow of the session because of mechanical issues.

When the camera comes out of the case on the wedding day, it is as if I'm performing on stage to an audience. This is part of the experience I want the couple to remember. Ultimately, I want my clients to associate a positive photographic experience and a final product of quality with the name of "Heidi Mauracher Photography."

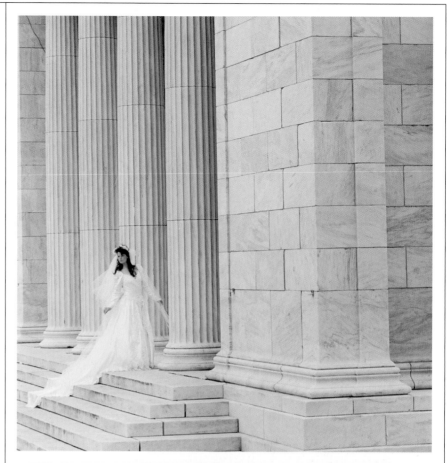

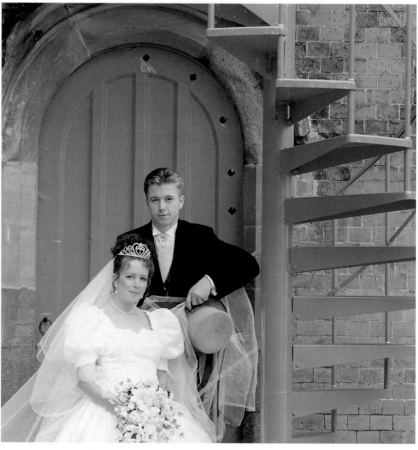

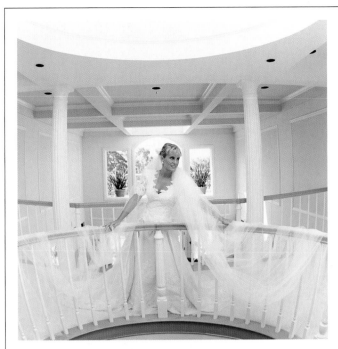

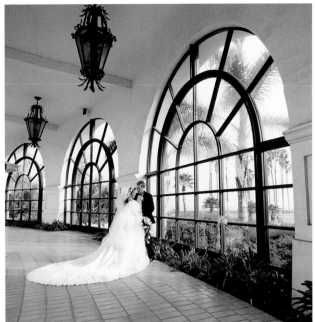

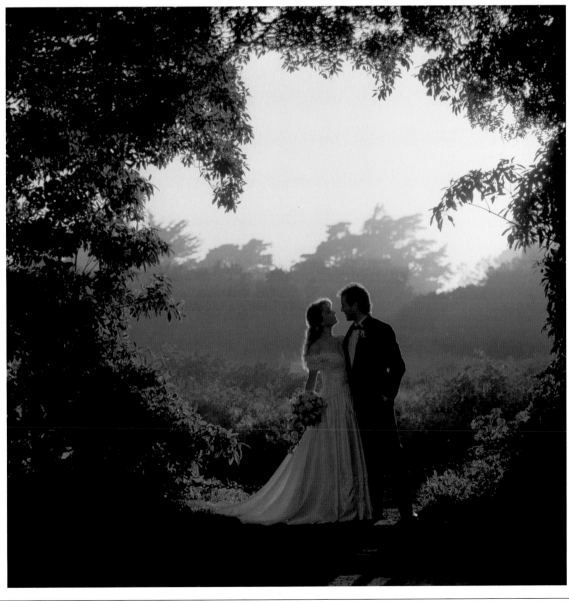

THOR AND TRINE MELHÜÜS

TRONDHEIM, NORWAY

Since 1962, Thor Melhüüs and his family have served the photographic needs of the people of Trondheim, Norway, a west-coast city located on a picturesque fjord. So in 1971, he formed a professional alliance among his colleagues and lab clients, the "FAME Portrait Group." FAME is an acronym that combines the first two letters of the Norwegian word for "profession" and the first two letters of Melhüüs. The purpose of the group was to create a professional environment of knowledge and skill, and to make himself and those involved better photographers and businesspeople. The FAME group has grown to include nearly 100 non-competing photographers.

By 1985, the laboratory business had grown so large that Melhüüs decided to construct a building to house the organization and turned its operation over to his 21-year-old son, Torgrim, who had worked part-time at the lab since he was 16. Under Torgrim's leadership, the lab has become a state-of-the-art facility, employing a full-time staff of 40, located in "The Mediahaus," a 12-story structure built by the Melhüüs family.

In 1994, Thor turned over the day-to-day operations of the studio, "Fotograf Melhüüs," to his daughter Trine, who received her Master of Photography degree from Professional Photographers of America (PPA) at the group's 1995 convention in Chicago. On hand at the convention awards banquet to celebrate his daughter's accomplishment, Thor was completely surprised to receive one of PPA's highest honors: the prestigious Honorary Master of Photography degree, presented only to past presidents of the association and those individuals who have made exceptional contributions to the industry.

In Norway, it isn't common for photographers to go to the church to photograph weddings. Instead, the bride and groom, the honor attendants, and sometimes the children in the wedding come to the studio to be photographed. To understand this way of doing weddings, you have to consider that Norway has winter almost six to eight months every year. Professional photographers must have a studio to be able to do weddings in an arctic winter. This provides an advantage in competition with amateurs; as professionals, we believe in wedding portraits with a "timeless" style. In the studio, it is possible to create light to our satisfaction.

Once, a young American woman who had seen the quality of our photography asked me to do a "U.S.A.-style" wedding for her. I told her that I can't do my very best work for her at the church. On the wedding day, I surprised her by being at the church to do some formal portraits since I felt I'd disappointed her, even though I'd been honest with her. When it came time to see the previews, she liked the portraits at the church, but when she saw the studio portraits, she cried. Later her sister came to me to have her wedding pictures made—in the studio.

This way of doing wedding photography is very good business because on a Saturday, Trine and I can do as many as 12 bridal sessions—usually 8 or 9 in the studio, some outside, and some as a combination of both locations. On average, we used to shoot two rolls of film, but today the trend is toward making more previews. I don't expose as much film as many younger photographers because my training was on the view camera in which every exposure was important. For a normal sitting back then, we would do four 4 x 5 exposures, and each one had to be good and different from the others.

Another difference about our way of doing business is that we charge more for sessions that occur outside of normal business hours. For example, we charge more for Saturday and evening appointments and even more for Sunday sessions, which we very seldom do. And we charge more for bridal sessions than we do for a portrait of a child. So when we use our Saturdays and late afternoons to photograph weddings or any other type of session, we're better paid for our time.

The fact that I'd been a life-insurance salesman for seven years was a big help to me in business. I also benefited from my eight years as an army officer. I started traveling in 1967 and was fortunate enough to meet Dennis Constantine from England and John Howell from America at a Europhot Portrait Seminar in November of that year. As I would learn from other successful photographers outside of Norway, I would adapt what I learned to Norwegian conditions and traditions and then give it away to the photographers here. By doing this, the person who learned most was myself! The plans for starting a photographer's group were born in 1969, and I held my first seminar the next year.

I started to tell my colleagues that if photographers wanted to be regarded in their communities as professionals and accepted as artists, and not just people who process film and sell cameras, we had to change our image. Portraits at that time were something that hung at the back of the store because cameras and supplies were sold in the front. What I wanted to do was to create a "new profession" where the portraits—making them, having them exhibited in show windows, and selling the work—were the idea. After 33 years in the profession and seeing people excited about my images that proudly hang in their homes as large canvas-mounted prints, I have great confidence in this idea.

We've been fortunate to study with many wonderful international teachers I've brought home to teach us in Norway. I always visited their studios and saw their work before I invited them to teach here. My portraiture was most influenced by Dennis Constantine and Paul Yaffe from England. Paul has been here many times because the photographers I trained liked him as much as I did, and he has become a good friend.

Trine was most influenced by Paul Yaffe, Leon Kennamer, and Jerry Pokorny from the United States. Leon came to Norway several times to teach us how to do artistic photography. He is the best teacher of the fundamentals of how to work with lighting, indoors or outdoors, of anyone who came here. He made us understand how to photograph outside: to use a clean source of light from the open sky and how to use "subtractive light" to illuminate the subjects. And he taught us the value of attending to small things and to take away anything that disturbs the view of the subject.

I believe that the most important lesson, besides how to take good pictures, is that good business is a very simple, step-by-step process:
- Your studio must be nice and clean with good photography displayed
- You must do promotion to reach the market
- You must learn to handle people on the telephone and in the studio

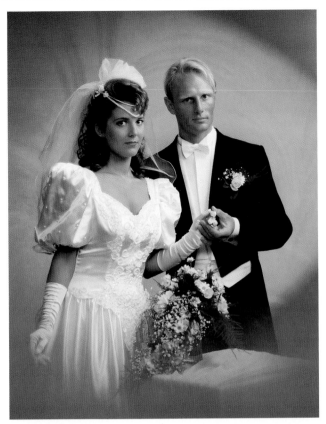

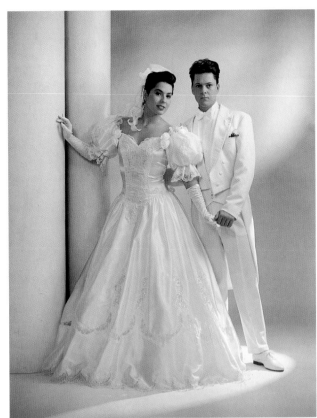

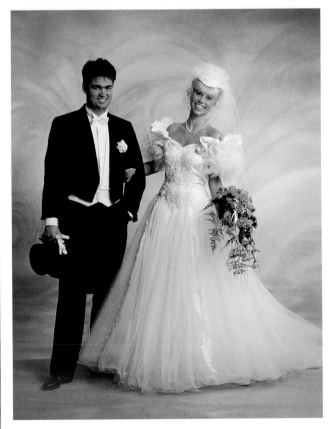

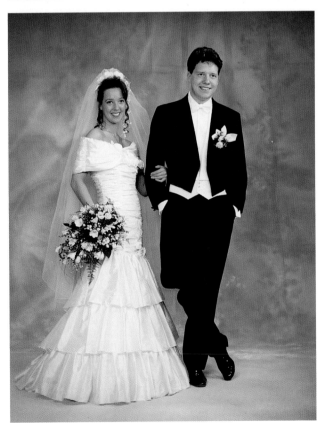

- You must conduct the sitting in a pleasant and professional manner
- You must project the previews or sales slides to get the right order (right for the customer is good for you)
- When the order is picked up, you must use this as an opportunity to sell frames

Finally, there is one more job to do. You must talk with the customers about when it is time for them to be photographed again and have a system to remind them at the correct time. Our former customers should be our best "new customers." If you do these things well, you'll earn the respect of the community for your business skills. They'll see you as a member of the professional community.

For many years, my wife, Gretha, was the central person in taking care of the business of the studio. The person who represents you and sells your pho-tography must be well trained to say the right things and make clients feel comfortable. Today, Trine has taken over the management of the studio business. Trine is well qualified: she has studied art, and even before she studied photography, she was always at the studio watching, from the time she was a small child. When she needs to, she asks me for advice or to do a sitting when the customer asks for me. Torgrim has managed the laboratory business since 1985, and he still talks to me about new plans for the business, as I am chairman of the board.

I must admit that it would have made me unhappy if they didn't need me. This gives me the opportunity to take the portraits of the people I find interesting. You'll still, for some years, I hope, see good photography from my camera and my hand.

Now that I have more free time, I want to enjoy my grandchildren and spend more time with Gretha. Working at becoming a better photographer will be my hobby. My goal as a photographer has always been to work in a style that is right for the person. My task is to present people as they are, to show their character. This is my way of telling people looking at the portrait how I see the person. The photographer's influence on the behavior of the subject mustn't change the impression of the subject's character, only help to put aside the subject's inhibitions. So the choice of location for a sitting can be of great importance to the final result presented to the viewer.

I truly believe that portraiture is a special language between people: families, friends, and lovers. As photographers, I know that we'll never make the perfect picture, but we should strive through the language of photography to make pictures that are as perfect as we can.

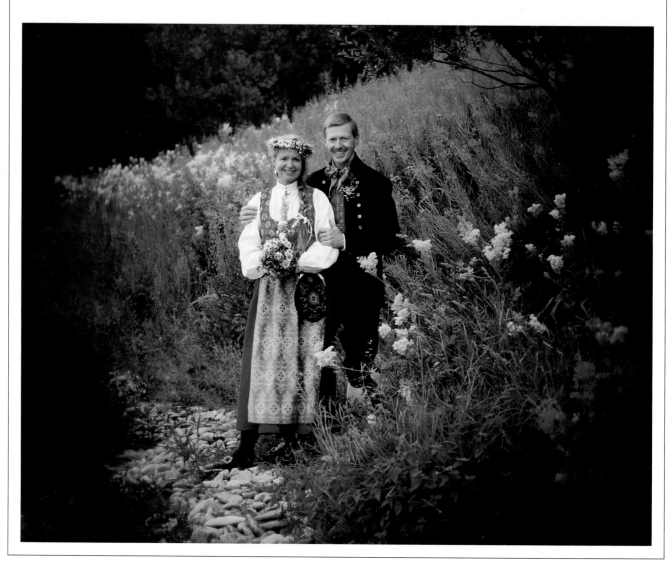

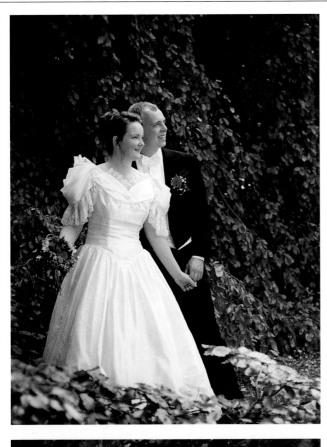

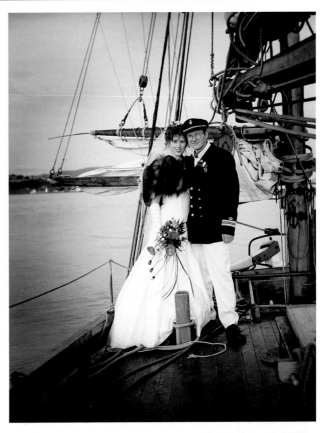

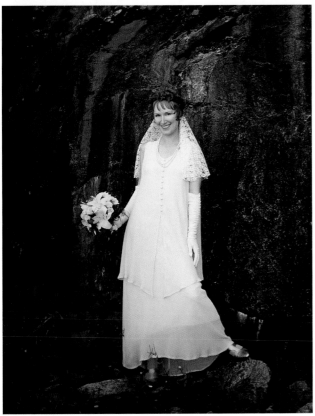

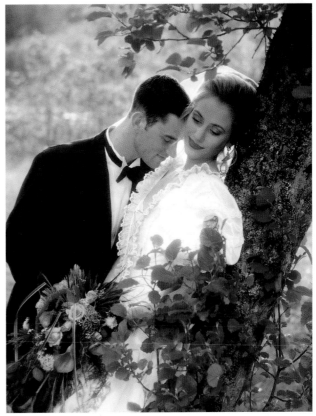

GARRETT NOSE

HONOLULU, HAWAII

In 1989, Garrett Nose abandoned his four-year-old career in investment and insurance sales to become a self-employed photographer. He'd learned the business in the early 1980s, working for a year as an assistant to a commercial photographer and four years as a staff photographer in a portrait studio, all the while operating a part-time wedding business from his home.

Nose earned the Master of Photography degree of Professional Photographers of America, and his work hangs consistently in state, national, and international print competitions. He won first place in the wedding category of the Professional Photographers of Hawaii Print Competition six out of the past seven years. In 1995, Wedding and Portrait Photographers International named him "International Wedding Photographer of the Year."

When I decided to make photography my full-time profession, I joined with two other wedding photographers to start a studio we call "Image Works." We all have our own businesses, but we share studio expenses, such as rent, utilities, and office equipment. We even do some marketing and advertising together. Our studio is a small, 1,300-square-foot space on the second floor of a two-story building in Kaimuki, a relatively old section of Honolulu. I photograph between 65 and 80 weddings each year, drawing on a marketing area of approximately 850,000. At present, my business consists of about 80 percent weddings, and the remainder is family portraits.

I have a hard time describing my style of wedding photography. I suppose it is a mixture of classical and contemporary styles. It draws heavily on the styles of Hanson Fong, Bruce Hudson, and Stephen Rudd. I particularly like to make use of the architecture of the church and reception area for much of my portraiture.

To create a demand for my wedding photography services, I rely on word-of-mouth advertising, local professional-association print exhibits, bridal fairs, and print advertising in a local bridal magazine. In addition to my magazine ad, I supply the magazine with editorial photographs and material, and I photograph the cover for them. To encourage referrals, I do a lot of networking with other wedding-oriented businesses, such as hotels, formal wear, and gown shops—and even other photographers. A good percentage of my bookings involves direct referrals from past clients and their friends and family. I don't have a formal "reward" system for referrals. I'd rather have people refer me because they were pleased with my services in the past, rather than because there was something in it for them. I've found that most couples

call me not as result of any one of these strategies, but because of a combination of many, if not all, if my marketing efforts.

I've done away with paper previews and switched to Epix Album Arranger software to create video slide shows that are used for image selection. The software allows us to present a finished album on videotape, complete with images, matting, and even panorama pages. This system has not only decreased my out-of-pocket expenses, but also has increased the total sales. Another advantage is that it reduces the possibility of clients making unlawful copies of the wedding photographs.

I market the video preview as a "Premiere Presentation Video," which is included in each of the wedding plans. These plan prices are established as a modified package system in which each coverage features different sizes of albums, but I'm considering changing to an a-la-carte pricing structure in the future.

I am truly a sole proprietor. I have no employees, and I use independent contractors for wedding assistants. As such, I handle all aspects of the business. What I enjoy most is meeting so many interesting people and the creative freedom that wedding photography provides. What I like least is the production side of the business: carding negs and assembling albums rank at the bottom of my list!

In the short term, I'm contemplating increasing prices to decrease volume and pursuing more intensive marketing efforts using video and the Internet. In the long term, I expect to produce storybook albums using digital images, perhaps even albums on disc. The world of digital imaging is likely to have a significant impact on the wedding-photography industry. I hope to be prepared to exploit the creativity that this new technology will make possible.

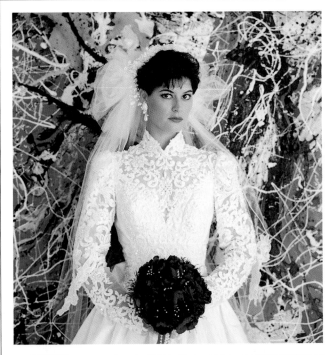

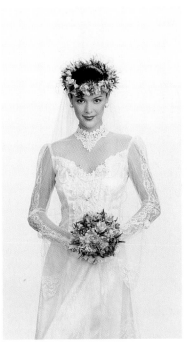

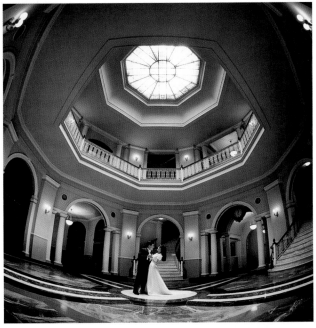

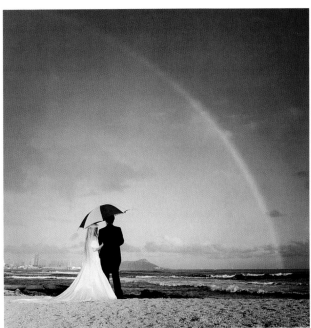

BOB AND KAREN PALMER

KEIZER, OREGON

For Bob Palmer, there was no "life before photography." He grew up, he says, "on location" at the family business, Palmer's Photography in Dallas, Oregon. By age six, he was busy in the darkroom printing black-and-white Christmas cards. As the years passed, Bob continued his education in photography, as well as music and electronics.

It was music that brought Bob and Karen together. They met in Florida in 1975 while touring the country in a musical drama group. They were married in 1976 and went to work for Bob's parents in the family photography studio. By 1979, Karen and Bob decided they were ready to establish their own studio business, so they opened Palmer's Award-Winning Portraits in a downtown area of Salem, the state capital. In 1991, they moved the business to a studio building they designed for a lot located behind their home in Keizer, a Salem suburb.

Bob, who, is past president of the Professional Photographers of Oregon, holds the Master Photographic Craftsman degree from Professional Photographers of America and has won numerous awards for his photography, including four Kodak Gallery Awards, two Fuji Masterpiece Awards, the "Sweepstakes Award" and the "Peoples' Choice Award" of the Professional Photographers of Oregon. Bob has also had images selected for exhibition at Epcot Center in Walt Disney World. Karen, who photographs children primarily, also has many award-winning prints to her credit.

The goal that Bob and I've always had for our studio is to become "the family photographer" for our clients. We appreciate building long-term relationships with clients because it is much more enjoyable to cater to clients that you get to know as friends. And it certainly costs much less, in terms of marketing and promotion, to have customers come back again and again, and to have them refer their friends, than it is to go out and create brand-new clients all the time. So our studio supports a mix of product lines that includes weddings, seniors, families, and children, allowing us to serve all aspects of a client's "life cycle."

About five years ago, however, we were on the verge of giving up wedding photography entirely. There were the usual problems: long hours, being away from our kids on Saturdays, and while some weddings were profitable, the sales from others were disappointing. At that time, our price structure was built around wedding packages, and most of the couples would book a less-expensive package. So to make the wedding profitable, we were forced to "sell up" to a higher-level package when the clients returned their previews.

The turning point came when we booked the wedding of a bride whose family was wealthy in the extreme. We were thrilled! I just knew that this would be our "wedding of the year." The event was lavish, we covered every aspect of it, and the previews filled several proof books. I just couldn't wait for the bride to pick up her previews and then come back to place the order. It took forever to get the previews back, and when the bride finally came in, the proof books were a disaster. Some were even broken apart, and the pictures were a mess. What had happened was that the mother had literally flown the pictures with her around the world to show all her friends this fabulous event they'd orchestrated. Our pictures were the testimony to all the money they'd spent on the affair.

So what was the order? The bride stuck with the original lower-level package she'd booked originally, and the mother bought 2 5 x 7s, one of the family and one of the bride and groom together. The bride and her mother had no more need for all the pictures because they had already gotten full value in terms of enjoying them with their friends. In effect, the wedding pictures had outlived their usefulness for this family.

At that point, Bob said, "I'm never doing another wedding again. Bring me families, seniors, children, dogs, cats,

anything—but no more weddings!" Instead, I started to rethink how we were doing business and completely changed our method of presenting weddings. Everything else remained exactly the same: same photography, same album design, just a different method of presentation. Suddenly, our sales quadrupled, and our attitude toward weddings was changed forever.

Now, instead of packages, couples select a "wedding plan" that covers only the photography time, ranging from four to seven hours, and the number of desired locations, ranging from one to three. This fee is a minimum investment that is applied to the album, photographs, and/or gift folios and frames. There are no packages, only individually priced items.

Our sales are now accomplished during an "album-design session" that takes place 10 days to two weeks after the wedding. Our lab processes the film, and then we pre-edit using a Fotovix. The lab then prints finished 5 x 7s of each image we select. At the design session, I have everyone put on a pair of art gloves to handle the pictures because this reinforces that they're dealing with original photography, not just "proofs." If parents come along, that is fine. We sit around a table and pass each picture on, until everyone has seen the entire collection. This takes about an hour.

Then I go to work. First I show samples of the Art Leather albums we've designed, so they can see how we present storybook sequences using a mix of image sizes. I've already placed the 5 x 7s in storytelling order, so I simply go through the chronology, making suggestions as to which pictures would look best as enlargements, and how to group the smaller prints. I work through this process in "segments," pre-wedding images first, ceremony next, and so on. I tell the couple to select only the photographs they really love, and I remove any they don't want. I keep a sample album right there, so that I can point to the type of page design I'm suggesting. The couple often says, "Yes, I want the pictures to look just like that."

After the design process is completed, I total the cost of the images and the album, and I deduct what the couple has already paid. Many times, the bill is much higher than the minimum commitment. But this doesn't come as a surprise to the couple. I don't believe in hard sell; and in all of my dealings with clients prior to the wedding, I am very honest. I stress that many couples decide to spend three times the amount of the minimum they pay before the wedding, and that what they ultimately

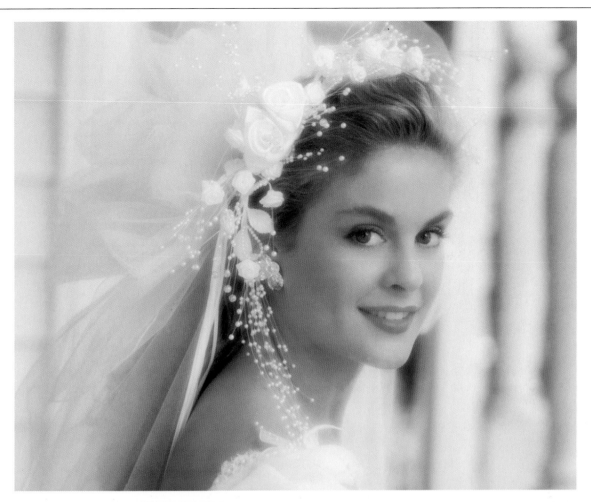

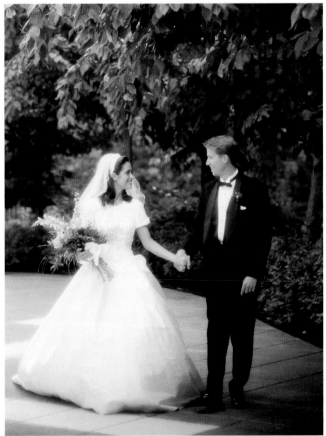

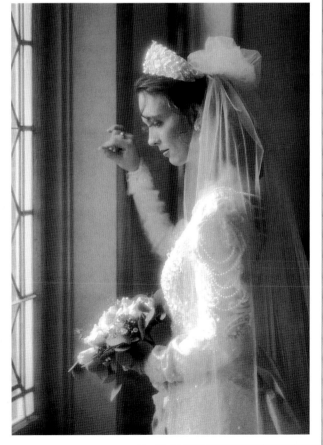

decide to spend really depends on their particular needs and desires.

Just before I total their account, I ask them to look at the image choices one more time, so that they can see what the album will look like from beginning to end. Doing this allows them to recognize that their choices truly do present the story of their wedding, just the way they want it to. The number of photographs they've selected has to do with only one thing: telling the story of the wedding. What is going on is that they're selling themselves. In no way am I applying sales pressure. I am just there as a helper. The emphasis is on recording the events of the wedding in an artful and stylish way, and not on how little they can get away with spending. Should the clients express any concern about the order total, I offer a payment plan or let them know they can pay by credit card. I am perfectly happy to help them take away some photographs if cost truly is a consideration.

I know that my clients are comfortable with their expenditures because they come back to us for other photo-graphic services, such as family portraits or to have a new baby photographed. Often they say they are glad they made the investment they did because of friends who say how disappointed they are with the albums they got from other studios. And even though our lowest minimum plan—the place where they start—is considerably higher than our average sale was when we worked with packages, every year we're increasing the number of wedding bookings. This results, I believe, from our clients' perception of being able to participate in the design session as an added benefit. They get to decide what the finished album will be, instead of having to make their wedding coverage conform to some preset "limit" dictated by a photographer and his packages. They trust us and understand the validity of the order because we're responding to their needs and wants, instead of setting ourselves up as a studio trying to sell something.

The entire design and sales process can take as much as three hours, depending on who is present. Some parents who come along decide to wait to place a personal order at another session, so that all of the focus can be on the bridal album first. Others will jot down the photographs they want and place the order right then. We're very obliging to friends and family who want to order prints, so that the bride and groom don't have to be responsible for the orders of others. For out-of-town orders, we create a video of the images using the Fotovix, numbering the images as they're copied.

The change to this method of presentation has made a marked improvement in both our profitability and our ability to enjoy serving our clients with wedding photography. Through this system, if clients want to enjoy the photographs, then they have to purchase them. This is only fair. Another interesting byproduct of doing business this way is that we're seeing the style of our work continuing to grow in new and exciting directions. I am certain this is because we now approach each wedding with a great deal of enthusiasm. It is really amazing what a difference one change in the way you do business can make!

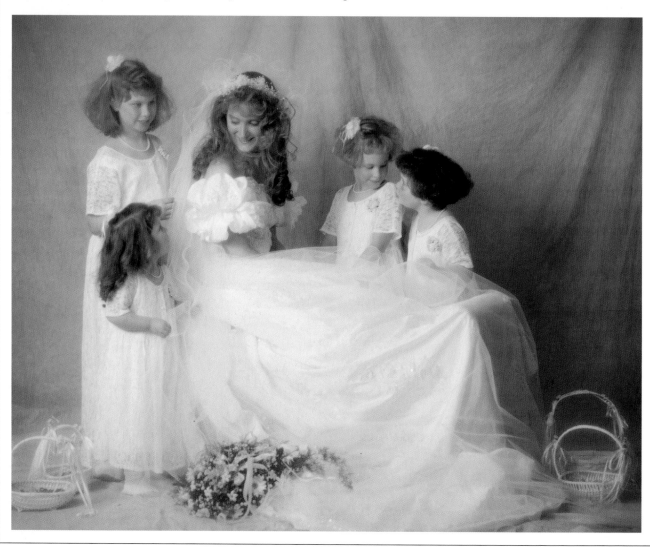

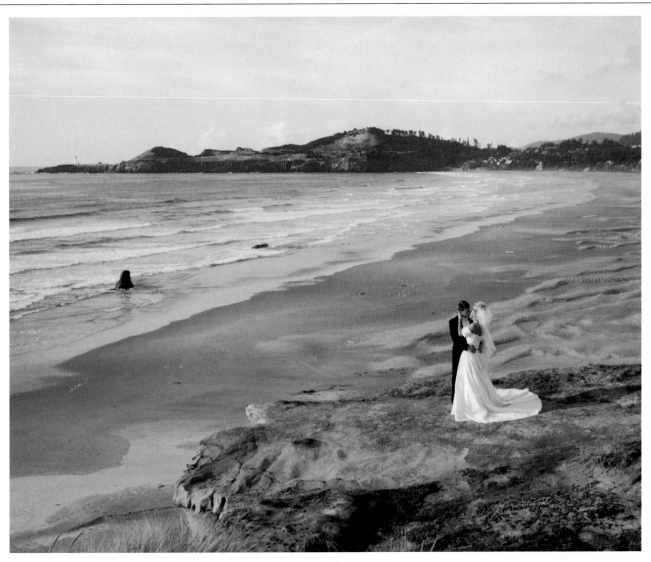

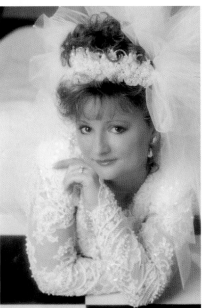

STEWART AND SUSAN POWERS
GAINESVILLE, FLORIDA

Stewart Powers says he began photographing weddings as a means of funding his "art-photography habit." This passion evolved from his experience as a high-school-annual photographer, working for two years with the news bureau during his student days at Davidson College, and finally his study at the University of Florida, where he earned a B.A. in art in 1978 and an M.F.A. in art photography in 1985.

For 10 years, Powers managed a camera shop and did part-time photography, opening a full-time studio in 1987 with his wife, Susan, who earned a B.A. degree in accounting from Columbus College (GA) and a Master's degree in building construction from the University of Florida.

Since 1985, Powers Photography has won more awards from state, regional, and international print competition than any other Florida studio. The awards include the Florida Professional Photographer's Association first-place, wedding-album award for six consecutive years and five Kodak Gallery Awards for wedding albums. Stewart's 1995 album became the first album in Florida's history to earn a perfect score of 100. Susan was the 1994 recipient of the Becker Award, Florida's most prestigious award for creative portraiture.

Both hold the Master Photographic Craftsman degree from Professional Photographers of America (PPA), and they lecture to other professionals throughout the country and instruct classes through PPA's Winona International School of Professional Photography and its affiliated schools.

Early in 1988, Susan took me aside and announced that we were going to make enough money that year to provide for ourselves properly, or we would choose a new career. This caught me by surprise: we had money in the bank, and all the bills were paid. Should I not be thrilled? Susan explained to me that we weren't really in business. We were living on our wedding deposits and, consequently, just treading water financially.

To accomplish "really being in business," we had to change a few concepts about our business and our client's money. We had to include "providing for our future" in the game plan. We began by contemplating what would happen if I broke my arm or leg and couldn't photograph for several months, or worse, several years. How would we pay the bills? What to do about all the deposits on future weddings? Susan and I are the sole support of our family. We have no wealthy parents, nor an inheritance to look forward to. To be "in business," we had to be able to afford disability insurance. This became goal number one.

Our second goal was to stop the practice of spending wedding retainers. A wedding retainer is money you'll earn when you photograph the wedding. It isn't smart to spend money that you haven't earned. We decided we should be able to pay our bills only from money we'd earned. So we opened a money market account and began to save all of our new wedding retainers in it. It was tough at first. Our retainer varies with the collection booked from $350 to $1,000. But steadily, we began to build up this account, and once the wedding actually took place, we would transfer the retainer to the studio's operating account.

Next, we had to make adjustments to our business in order to support the new expenses of disability insurance and retirement investment. We began by raising our expectations for weddings. The changes we made in our photography weren't revolutionary; but significant change often begins with small steps, and each one is important. We focused on adding exciting illustrative and romantic images to our preview set that were distinctive and unique to our area's clientele. We also increased the prices we asked for our top coverage, what some of us call "The Whopper." The new collections ranged from the same entry level at $800 to a new and more "adequate" Whopper at $3,500. Today, our Whopper is $9,000.

In our area, most brides don't expect to spend that amount of money on wedding photography, but there is a benefit when you quote such a "Whopper figure," as it makes the other choices offered appear reasonable. And now, the rare bride with an unlimited budget is no longer compelled to shop at a studio that quotes a top collection as low as $500 to $1,000.

Another area we targeted was improving our family orders and album sales. We added more family-related images and looked for opportunities to create new images important to brothers, sisters, the bridal party, and the parents of the bride and groom. To enhance the album order, we added more romantic portraiture and environmental-illustration images. We learned to use the natural light and outdoor environment for images of the bride and groom. This forced us to optimize our time by learning more effective "flow posing." If you add new images, you have to work very effectively or you run out of time.

So 1988 turned out to be a very significant year for our business. We bought the disability insurance for both Susan and me and began a retirement fund, and our interest-bearing account of our wedding retainers began to grow. Thanks to Susan's ultimatum and the changes that followed it, we stayed in business and prospered.

With prosperity comes knowledge, and here are some of the most important lessons we learned. First, it is good to know what clients you want to attract. We prequalify our clients on the telephone to help us attract those who can afford our level of expertise. You have to say no to some business so that you are available for the business you want.

Also, brides will search first for a wedding photographer who can make her dreams come true. For women, the budget is a secondary matter when compared to objects of the heart. A man shopping for wedding photography is usually money-driven. A woman, however, will allow her heart to overrule her head when it comes to cherished articles. Rarely does she cherish items that are ordinary in nature. She will compare the price of 8 x 10s if you allow that to be her focus. You have the power to control whether a bride perceives wedding photography to be a generic product or something to cherish.

Excellent wedding photography isn't difficult. Excellent service and attitude take great effort. When you make that effort, you'll discover that weddings aren't merely photography opportunities. They are celebrations of the love and commitment between two individuals and, ideally, two families. Isn't it nice that they ask us to take pictures of something so wonderful?

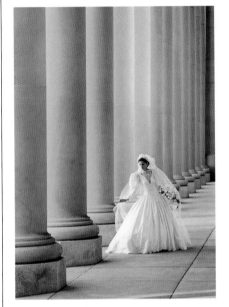

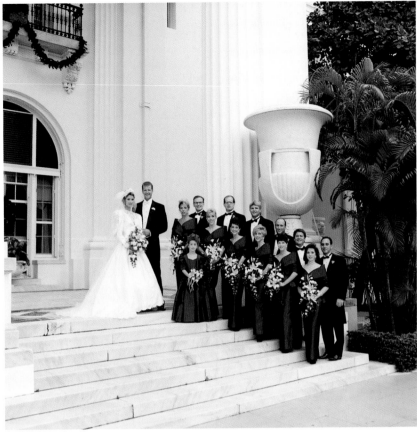

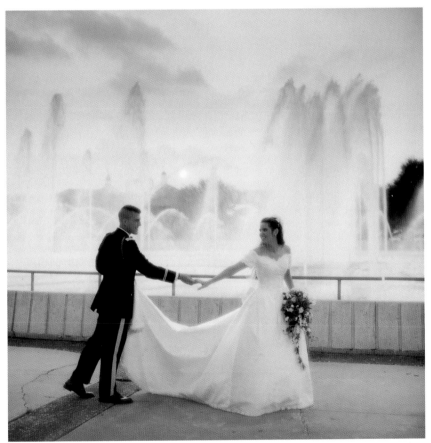

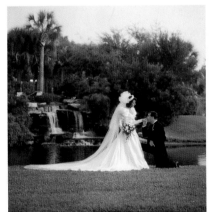

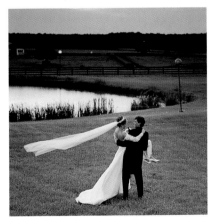

DENIS REGGIE
ATLANTA, GEORGIA

Nationally known as a celebrity- and society-wedding photographer, Denis Reggie is regarded as the pioneer of modern "wedding photojournalism." His client list reads like a "Who's Who of the World of Wealth, Entertainment, and Politics" and includes the late Jacqueline Kennedy Onassis; former New York Governor Mario Cuomo; entertainers Oprah Winfrey, James Taylor, Mariah Carey, and Don Henley of The Eagles; actors Paul Newman, Holly Hunter, and James Garner; sports figures Frank Gifford, Dominique Wilkins, and Pete Rozelle; and media mogul Ted Turner.

Reggie's interest in photography began when he took up sports photography while sidelined with a football injury in high school. After earning a B.S. degree in business administration, he opened his first studio in a 10 x 10-foot rented room in Louisiana in 1976 at the age of 21. In 1986, he moved his business offices and residence to Atlanta. Thanks to his family's interest in politics, he met Ethel Kennedy during a 1980 presidential primary and photographed the first of a long list of Kennedy weddings that June. Something of a "signature photograph" for Reggie is an image that appeared in Life magazine showing the wind catching Maria Shriver's long veil and ensnaring her bridesmaids at her marriage to Arnold Schwarzenegger. Reggie has been profiled in every major bridal and photography magazine in the United States.

Each year, Reggie photographs 52 weddings throughout the country and instructs other professionals through seminars, workshops, and videotapes, many of which major industry corporations, such as Eastman Kodak, Hasselblad, and Canon, sponsor.

I sensed early on that there was a frustrated group of consumers out there—brides who had a definitive interest in wedding photography being something other than what was offered. They seemed to me to be seeking a much more realistic style of wedding photography. I observed that the tolerance for posed pictures diminished as a bride's worldliness, education, and age move upward. As I encountered these college-educated, white-collar brides-to-be, I recognized that they weren't looking for many formal portraits, particularly those posed in front of a painted background, the groom staring at his ring, or any of the other poses they considered to be the clichéd, overdone, melodramatic portraits that had become synonymous with wedding photography.

Through an attempt to achieve success with this somewhat upscale market, this "worldly market," I decided to pursue a more "journalistic" form of wedding photography. By the early 1980s, I'd coined the phrase "wedding photojournalism." By this I meant that my mission as a photographer was to go to the wedding and not create fictional images, but rather document what I saw. In other words, my job was to take pictures and not to make pictures; to find and not to fix; to capture and not to concoct images. In essence, what I wanted my wedding album to be was "nonfiction."

As I articulated this view to potential clients, I found that there was indeed a significant segment of the market looking for the photographer who would be the follower rather than the leader of the action. At that time, most wedding photographers were of a mindset to create primarily "canned" or "prompted" images: bride gazing at bouquet, bride with mother cheek to cheek. Even the shots that one would think of as being more natural, such as dance-floor pictures, were being prompted, adjusted, staged, and enhanced by the photographer barking, "Look here," or "Cheeks together," or "Give me a smile." These types of corrective measures by photographers were seemingly unacceptable to this market.

Nearly 20 years later, I've moved to Atlanta to be near a major airport because I must travel for 80 percent of my weddings, but I also enjoy serving a local clientele. I accept my assignments on a first-come, first-served basis: resumés aren't considered. I am happy to say that I go to these weddings not to make things bigger than life, but to capture the nuances of the event by photographing something as subtle as the grandmother observing as the bride cuts the cake. She may be thinking of when she cut her own cake 60 years ago. I want the eyes, the expression, the moment captured. I don't need to manipulate or adjust the scene. As a sensitive wedding photojournalist, my mission is to observe, to find, and to capture that moment.

I like using natural light whenever possible and operating as things happen. I don't work with a list of bridesmaids, groomsmen, and family trees. I have very little verbal communication with my subjects, and whenever I can, I operate from a distance. I like the subjects to be unaware of my actions because I believe that the best photographs of people are the ones made when they aren't actively aware of the camera. I've based my entire business on this belief.

I often find myself with a longer lens on my camera—perhaps a 200mm lens on my 35mm camera—looking at faces from a hidden location. Perhaps it is the mother, perhaps the flower girl during the ceremony—I quietly capture them on high-speed film when they aren't even aware they're being documented. That is how I come up with images that are really telling.

So the basis of my style is to document the wedding as a journalist—a photojournalist—capturing it as it truly unfolds. I am sure that if a news journalist were to stage a picture to be something it isn't, that journalist would be crossing some ethical barrier. So I've adopted that same mindset: I go to an event not to make the news, but rather simply to report it with a sensitive eye, a warm heart, and a quick hand. It takes a very rapid reaction, and I shoot a lot more film than the wedding traditionalist. I may shoot more than a thousand images to cover a wedding fully. We may use a much smaller number in the finished album, but that is a part of photojournalism. I shoot heavy, make a 20 percent initial edit, then ask the bride to choose her favorites. As part of my service, I design the layout and print sizing for the finished albums.

I photograph 99 percent of my weddings on Kodak Pro 400MC film. I would love to see even faster color films because the more speed I have, the more available light I can use. I also have a strong following of clients who want me to photograph in black and white. I enjoy using 3200 speed Kodak T-Max film for this coverage, as well as good old Tri-X. So I look forward to using more and more natural light, finding a greater percentage of shots that can be done on 35mm, thanks to the improved grain technology of the film manufacturers.

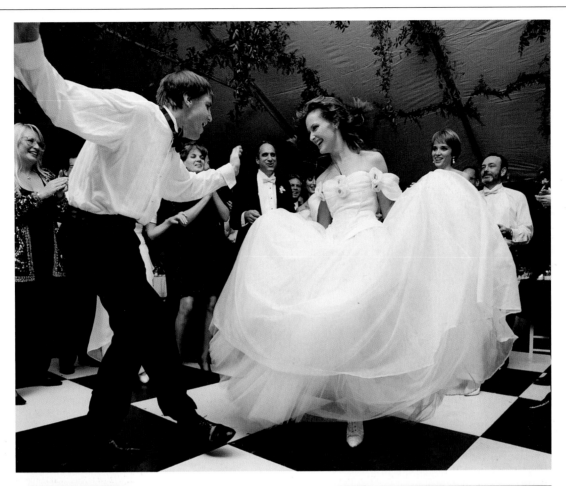

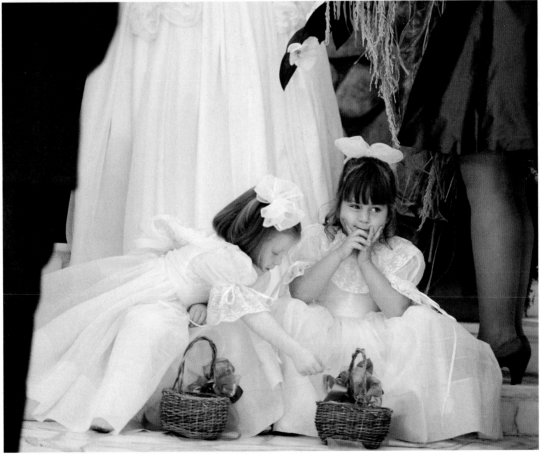

I can't imagine not shooting a wedding on my trusted Hasselblad system with its ultra-accurate TTL flash metering. I've used it happily at the 1,100-plus weddings I've photographed. I consider the 503 cxi to be the ultimate wedding camera on the market.

The freedom I'm obtaining due to evolving technology is wonderful. I can remember only 10 years ago, before the advent of autofocus in 35mm cameras, the challenges associated with a moving target, such as the bride and her father coming down the aisle. Now I can make sure every image is sharp, even with wide-open apertures. And today I can minimize my strobe output, allowing me to operate successfully at $f/5.6$. Through slowing down my shutter speed to 1/30 or 1/15 sec., I can pick up the warmth of the background in a restaurant or a reception hall, incorporating the ambient light, while freezing the subject through the minimal output of the flash burst.

Setting up several thousand watt-seconds of room light is far too artificial for my style of work because it supersedes the ambient light. I would prefer to take the high-tech approach—faster film, minimal flash output, slower shutter speeds, and wider apertures—to produce an image that is far more realistic, even if there is a little motion in the background. If my client is paying for lighting with candles to create a beautiful ambiance, who am I to supersede that ambiance? A painted canvas backdrop would be out of place because it would hide the environment.

I certainly have nothing against portraiture, but I just don't believe that the wedding day is a day for portraiture. I'll pose the bride, the groom, the wedding party, and the families, but this takes only about seven or eight minutes, and it represents about 5 percent of my coverage. It needs to be done, but I keep it to a minimum.

I don't directly market my work; I indirectly market it by making wedding vendors who interact with my potential clients aware of my unique approach. By empowering them with a well-defined message, I've equipped them to convey what I am about to potential clients, and this results in seven or eight telephone inquiries each week. I am able to tell if these inquiries will be a good fit with my wedding philosophy according to the words they use, such as "unposed," or "photojournalism." If they use the words "posed," "portraits," or "fantasy," I might guess they wouldn't be a good fit. Because I am at the upper end of the price spectrum, I also have to make sure that we are a good financial fit.

Wedding photojournalism is really an attitude: an attitude of photographers going to a wedding with the belief that their mandate is to document rather than create. I clearly recognize that my style isn't for everyone. There are many brides who want a photographer to be the leader, the poser, the one who tells her how to be beautiful and who helps fulfill a fantasy. I respect that market, but my market isn't about fantasy-seeking. My market is one where the participants are happy with their station in life. They like their wedding the way it is because they planned it that way. They want the photographer to document it, hopefully with a high degree of artistry and sensitivity to special moments and fine details, according to what it is, not what some photographer thinks it should be.

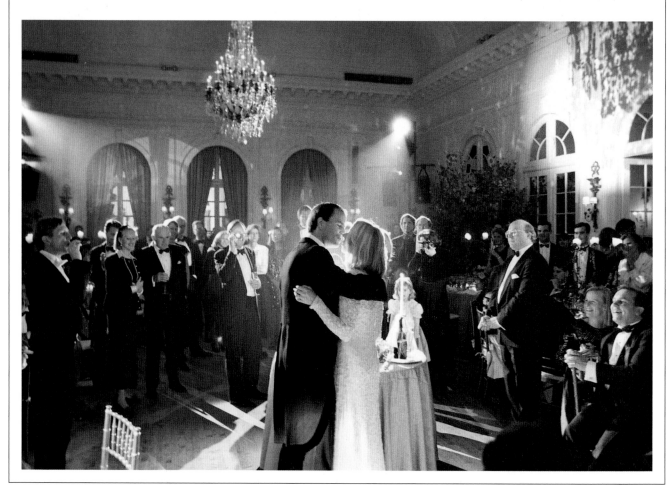

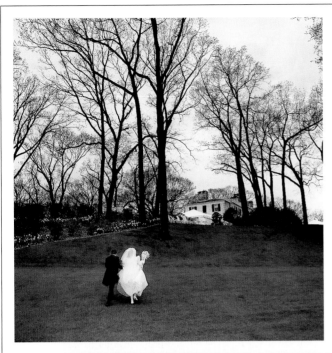

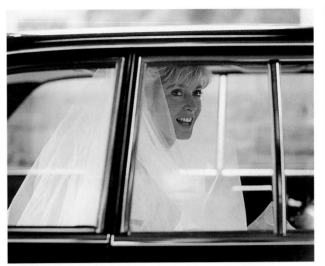

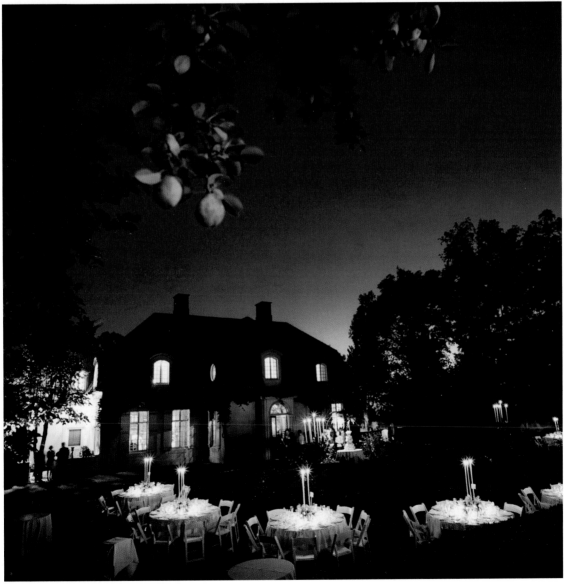

STEPHEN RUDD
TORONTO, ONTARIO, CANADA

Stephen Rudd is credited with having introduced an unstructured, avant-garde style that has transformed the face of wedding photography. He refers to his artistic point of view as "new-wave" photography. He began his photographic career in sales, marketing, and management for a large Toronto studio where he worked for five years. In 1983, Rudd opened his own photography business, Adam and Eve Photographers, in downtown Toronto, an area that has a mix of industrial and business sectors. Toronto is a city of 2 million, with an added population of 1 million in the metropolitan area. At one time, Rudd's studio photographed 350 weddings each year, but now he annually photographs 50 weddings for an exclusive clientele.

Rudd has won countless print-exhibition awards, including having all four of his prints accepted for the Loan Collection and Master's Loan Collection of Professional Photographers of America (PPA) and Professional Photographers of Canada (PPOC). He was named Ontario's "Photographer of the Year" on five occasions and won Wedding Photographers International "Photographer of the Year" in 1986 and 1990.

Rudd holds seven photographic degrees: the Master Photographic Craftsman degree from PPA and PPOC, and Fellowships from the British Institute of Professional Photography, the Royal Photographic Society, and The Professional Photographers of Ontario. Rudd has lectured to other professionals throughout Europe, Canada, and the United States, and is the developer of a line of educational products and accessories for portrait/wedding photographers.

Weddings in Canada are quite different from those in the United States. There are a great many ethnic weddings here because Canada is a country that has welcomed immigrants. In many of these ethnic cultures, the wedding is a big deal, and families spend tens of thousands of dollars for the events. Photography is an essential part of their celebrations.

Toronto has more photographers per capita than any other place else I know. In the studio that I once managed, we did more than 500 weddings each year. When you're dealing with such high volume, you book at a low level of financial commitment and then rely on your ability to "sell up." When I started photographing weddings myself, I went to the same park, the same bridge—all the same illustrative locations. Soon I recognized that if you are to be paid more "upfront," then you had to deliver something more. So I began going to the bride's house earlier. I started doing "fashion stuff" because these are the images brides see in magazines, and I thought that this is the kind of thing they would like to have in their albums if they knew it was available.

Soon it was clear to me that modern brides are looking for truly distinctive photographs of their wedding. In Canada, it is out of the question for the groom to see the bride before the wedding. That is why I urge my clients to participate in "second shoots" after the wedding. Then there is the time needed to create more intriguing photography than can happen amidst the pressures of the wedding day. My clients are brides who recognize photography as an artistic medium, and they're willing to spend the time to make it happen. They pay extra for the "second-shoot" session, which results in a significant increase in sales.

Most clients come to us by way of referrals, but we also attract them through promotional mailings and participation in bridal fairs. Today, I actually make more money photographing 50 weddings each year than I did when the studio photographed 350. What allows us to book the high-end clients is the fact that they understand we're providing them with customized photographs.

It really disturbs me to see photographers who go to great lengths to manipulate, customize, and texturize their prints for competition. Then they turn around and offer raw prints to their clients. Our clients never receive raw prints. They're retouched, enhanced, and customized by such devices as texture screens, watercolor techniques, and so forth.

To create the initial image, I also make use of interpretive tools, such as a range of lenses from the 30mm fisheye to the 350mm telephoto; dramatic lighting; colored gels; soft-focus filters; different kinds of film; different tonal ranges: high key, low key, and window light; and black-and-white film, which sometimes is printed on color paper to achieve a range of tonalities. So these types of images become part of our "artistic contract" with clients. I market my album as a work of art: something that is far more personal, something that originates from an artistic point of view.

What also sets our work apart is that I stick to the square format of the Hasselblad camera instead of cropping the images to a vertical or horizontal format. This not only makes my work look different, but also makes price shopping more difficult because there is nothing to compare. My albums take 10 x 10 images instead of 8 x 10s and parent albums are sold in a 7 x 7 format instead of a 5 x 7. Also, I can sell custom framing because manufactured frames don't come in square formats. In addition to Art Leather albums, we carry a line of Italian import albums, the Acerboni series.

The "love-portrait look" that I created has been a very profitable addition to our business. I originated it because customers hardly ever hung a wedding portrait in their living room. It would go to the den. Yet the couple would go out to a poster shop and buy a James Dean poster, mat, and frame in which they invested $500 or $600. So I decided to create something that could compete with these posters. I take couples to the location of their choice and pose them with my Harley, a '57 Chevy, trains, planes—whatever excites their imagination—then I turn it into a one-of-a-kind poster. The Color Network in Toronto, one of the most advanced labs in North America, creates a 30 x 30 print masked by a litho negative overlay that includes the couple's names and wedding date and my credit line. The print is then step-matted and framed.

The couples display this "designer portrait" at the wedding reception, and this results in good recognition for my studio. It gives me a real kick to arrive at a really big affair, such as a big Italian wedding that costs $100,000, and hear the bandleader say, "I knew you were here because I saw your portraits on display in the lobby." Creativity builds on itself, so couples now bring me off-the-wall ideas they find in fashion magazines and other avant-garde sources, such as European postcards.

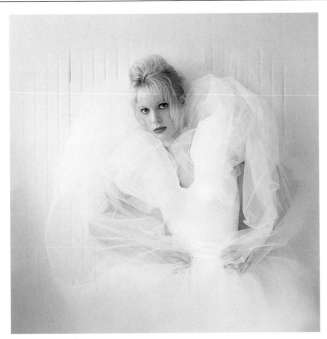

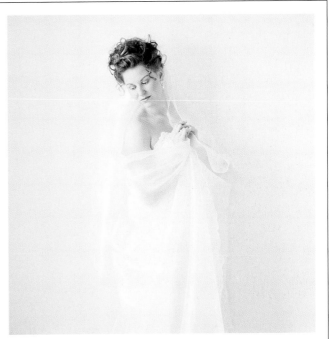

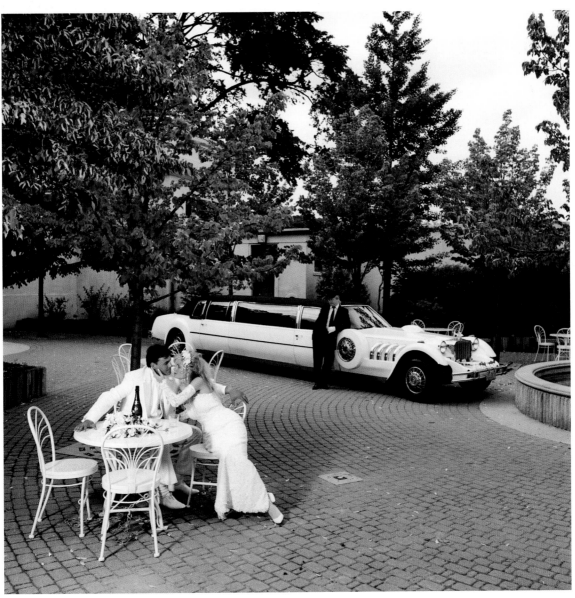

Photographers must realize that what you show to prospective clients is what they'll expect you to produce. You can't show the typical shot of mother pinning on the groom's boutonniere and expect that kind of client to want you to do off-the-wall things. Show what you get excited about, and you'll attract the right kind of client.

It is important to stay excited to avoid burnout. Wedding photography is a field that allows you a great deal of creative freedom. Each wedding has energy that you don't find in other photographic assignments. It is a spectacular time for the bride. There isn't another occasion, except perhaps when she has her first child, that the bride will be so happy and excited. Yet most photographers forsake that energy and freedom by simply copying the work of others.

I believe that everyone is born with a certain amount of creativity. When you go into business, the tendency is to stop exploring your creativity in order to fit into certain professional "conventions." In doing so, you lose about 50 percent of your creativity. And when you elect to become a wedding photographer, you lose another 50 percent of the little creativity you have left because wedding photographers go around copying each other. I created a market for a contemporary style of photography. Everything I've done has been copied so many times that the consumer can't tell the difference between photographers in Toronto.

It is really important for photographers to understand this phenomenon from a business perspective. Camera technology now makes it possible for all the "Uncle Harrys" of the world to come up with good-looking images. All we as professionals have over the amateurs is our creativity. So don't ask the brides what they think you should do. Just go out there, and do what excites you. Be prepared to walk a longer mile. Tap into your resources. Work with composition and design. Manipulate your negatives in the camera, and then go back and manipulate the printing some more to create something that is so unique that it is set apart from what Uncle Harry can do. In the age of computer imagery, it is more important than ever to work with clients from an artistic perspective.

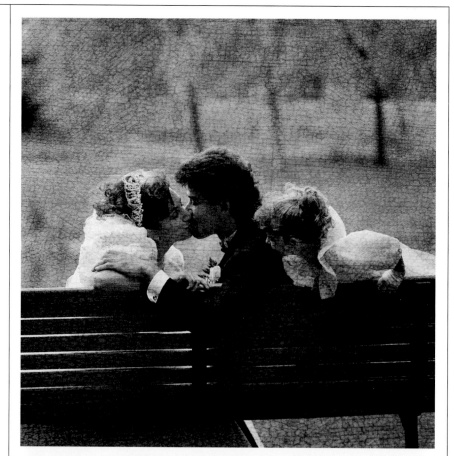

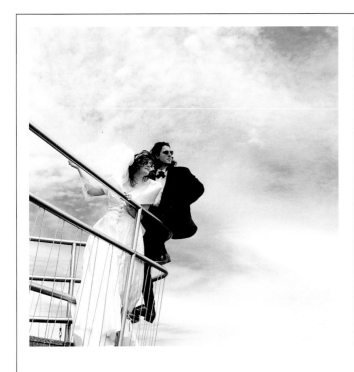

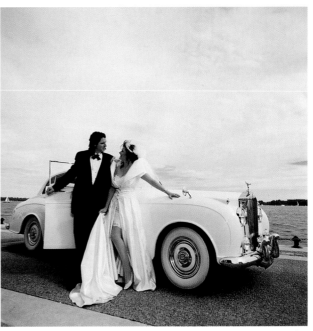

WENDY SAUNDERS

BOULDER, COLORADO;
ST. AUGUSTINE, FLORIDA

Sixteen years ago, shortly after having received a B.F.A. from Virginia Commonwealth University, Wendy Saunders opened Wendy Saunders Graphic Design and Photography in her hometown of Hopewell, Virginia. It was a typical portrait studio with a graphic-design division that later expanded to a second location. Soon she found herself "living to cover the weekend wedding." When a major highway expanded through both locations in 1987, Saunders remedied a long-distance relationship with her future husband by relocating to St. Augustine, where he'd just moved from Seattle.

In 1988, Saunders discovered that her true love was photographing weddings in the photojournalistic style. So she stopped doing general portraiture to concentrate strictly on weddings. By 1991, the Florida studio was set, so in 1992, she and her husband moved to Boulder, Colorado, a community they'd visited many times and come to love. There she opened a second location that today is devoted primarily to weddings and some children's photography. An associate photographer continues to do weddings in St. Augustine, with Saunders supervising album design and production from Colorado and occasionally flying to Florida to personally record special, high-end weddings. Associate photographers also shoot weddings in Colorado.

In addition to presenting seminars sponsored by industry vendors, Saunders hosts private, two-day marketing seminars throughout the United States. She also offers a full line of marketing services, from logo design through the production of color and black-and-white marketing and wedding support materials.

Before I opened my first photography-and-design studio, I worked in a bridal shop, actually delivering the wedding dress and bridesmaids' gowns on the wedding day. I also did window design at the shop. I remember thinking that job would never prepare me for my "art career." Little did I envision that I would soon become a wedding photojournalist! I'd worked retail all through college, even selling suits at a men's clothing store. Today, I recognize that my experience in day-to-day store operation provided the best business training I could have received.

Also during that time, I worked two weddings for the local photography studio. It was typical: shoot your checklist with a limited supply of film. On the second wedding, I brought my own extra film. I returned to the studio having shot twice as much film and feeling as though I'd actually "covered" the wedding day. The owner reviewed my images and exclaimed, "Who would buy these extra images? The bride wouldn't select an 8 x 10 of the church window!" Later, I looked through sample wedding albums from various local photographers and found that all were very traditional, posed images of the wedding day that didn't portray any emotion. At the time, I was hanging around newspaper friends, and apparently I was judging the photography by their journalistic standards.

So I started doing weddings on my own—the way I saw them—selling "combination" albums with a variety of photograph sizes. Couples loved them! I discovered that indeed the bride wouldn't select an 8 x 10 of the church window; however, she would choose a 5 x 7 with two other church images on the same page. I was on to something! So I had couples choose the images and the sizes, thinking they knew what they wanted. Wrong! When couples began telling me they liked my sample album of their wedding better than the one they'd chosen, I took control of the album design.

In 1988, I attended a Denis Reggie seminar, and I sat there amazed. Denis was talking about techniques and approaches that I'd been doing for five years! I just didn't know it was called "wedding photojournalism." I must credit Denis for pushing me off the ledge because in January 1989, my studio changed exclusively to a wedding-photojournalism style: the shoot area and backdrops became history. We doubled our pricing structure to concentrate on building the wedding business. That year we not only doubled our prices, but also doubled the number of weddings. I continued to try to

copy the portrait guys, but I just couldn't stick with it. So I expanded my wedding services to include a "Get-To-Know-You" session prior to the wedding, and introduced black-and-white coverage and handcolored images.

The clients in our Florida and Colorado studios are as diverse as summer and winter. The St. Augustine office doesn't have a physical street location. All production is done in the Boulder office, and final albums are delivered directly to the clients' homes. So instead of an "office," we meet clients in specially selected restaurants, reception sites, in clients' homes, or at an office that is rented by the hour. This works well because our typical client in the Florida office doesn't live in the town. St. Augustine is a kind of "wedding Mecca." Couples come from various parts of the state to experience the ambiance of the town: historic churches, beaches, golf country clubs, and the bay front.

Boulder is experiencing accelerated population growth, and this creates a good wage base. Most of our prime couples are business professionals in their thirties, many of whom own or are starting their own businesses. They tend to place more value on wedding photography. Over 75 percent of our weddings include black-and-white coverage, and infrared images are very popular with this clientele. As a college town (University of Colorado), attitudes are more liberal than those of most Colorado towns.

The mission statement of our businesses is "to provide photography that goes beyond the usual wedding-day images, presenting them in an artistic album essay." Film isn't limited, and it isn't unusual to shoot a thousand images in four to five hours. We strive to live on the leading edge of wedding photography—creating, not cloning. It is my intent for the couple to enjoy the experience of their wedding day, knowing that every fleeting moment is documented. I want to present my clients with artistic wedding coverage, without their having to work at it. As we say to prospects, "When you hire Wendy Saunders, just show up to enjoy your wedding day. The artistic photographs just happen."

Our marketing strategy is simple: Decide whom you want for clients, and run, not walk, after them! About 20 percent of our anticipated income is spent on advertising, with over half of that spent on direct mail because it is effective for both studios and produces our highest response rate, approximately 15 percent. We devote more of the budget to Boulder because it is new, while St. Augustine is established.

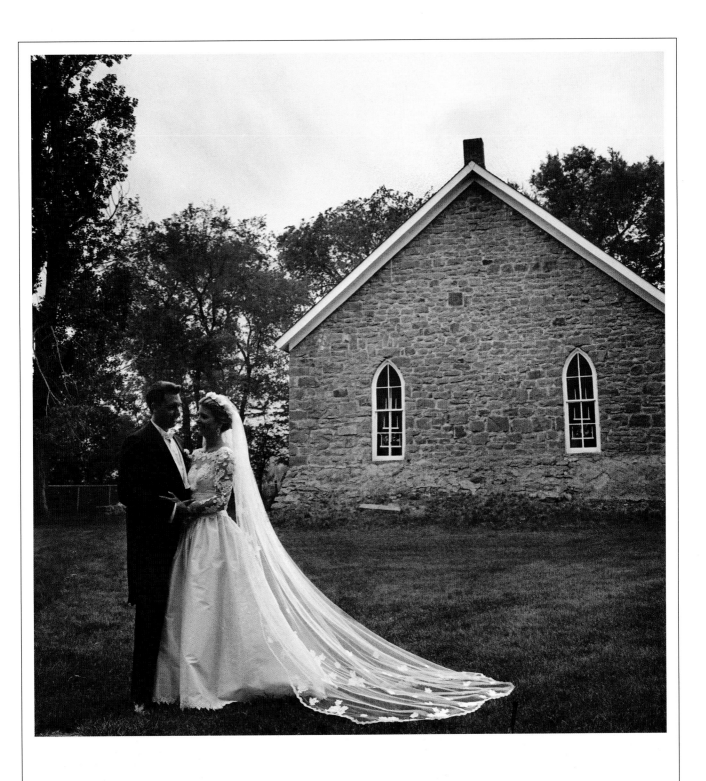

We send a limited number of mailings, usually about 200 each time, and a total of 3,000 "Personal Response Packs" (PR PACs) is distributed throughout the year. These packs contain a wealth of information about our wedding philosophy, as well as examples of my images.

All of our marketing material features black-and-white images, including infrared, as most weddings do include this coverage. We promote the use of two camera formats and the advantages of each. We also market our handcolored images and black-and-white images presented on fiber papers, custom-printed in my darkroom, which have proved to be popular additions to albums. A fisheye lens and dragging the shutter to create movement also add a distinctive look to our photographs. These techniques help to convey to prospective clients that our photographs are unusual. Another important marketing tool is a "wedding-vendor group" that meets twice a month. We learn from each other, exchange mailing lists, and refer our clients to the other members of the group.

Between the two offices, I personally shoot 30 to 40 high-end weddings yearly (yes, I like some weekends free to enjoy the scenic resources of both states!). Associate photographers shoot the rest. In addition to these employees, I have an office manager in Boulder and a part-time person who catalogs prints and compiles finished orders.

When photographing weddings, we use a variety of films. I like Fuji NHG-400 for medium-format work because of its wide latitude and color saturation. It is great for location work because greens are more vivid, and there is greater detail in the shadow areas of sunset situations. I like Kodak PMC for inside flash shots. Most 35mm color photography also is shot with Fuji, the majority being Super G 400, as well as some 800 and 1600 speeds for available-light situations.

My film choice for black and white is Kodak Tri-X 400. I prefer it over T-Max because it provides a more journalistic contrast image. I also push Tri-X to 800, 1600, or 3200 in available light. When shooting infrared, I use Kodak for the 35mm format and Konica in the Hasselblad since Kodak doesn't manufacture medium-format infrared film. I hand-process our black-and-white film, which allows me to control the final negative and image.

Color previews are presented to clients in storybook order, in an Art Leather Prelude Quad album, containing four images on one page. Hasselblad previews are formatted in 5 x 5, and 35mm previews are shown in

4 x 5 size. Black-and-white images are contact-printed and attached to negative cropping cards. Clients make the selection for their album with the black-and-white images printed to the size that will appear in the album.

We use both Leather Craftsmen and Art Leather albums, featuring 5 x 10 (vertical and horizontal) format in the Leather Craftsmen albums. This unusual format looks different, and our clients love it! Because 75 percent of our wedding coverage includes black-and-white photography printed on fiber papers, the Leather Craftsmen albums sell well. Our Art Leather albums are mat-assembled at Art Leather's plant.

Although the couple selects the images, I completely design the albums, including the sizes and page placements.

If I feel they've omitted an image or the flow isn't working with what they've chosen, then I add images, leaving it to the couple to have the final word on what appears in the finished album. Sometimes this necessitates bringing them back to review the album design before the final album production, especially to review the enlarged black-and-white images.

Like most photographers, I never planned on becoming a wedding photographer. It was something I happened into. I'm pleased to say I honestly love my job and can't imagine doing anything else. I believe this love comes through in my photographs. To arrive at a wedding event and create an unlimited number of photographs—to document the day—there is just no greater high!

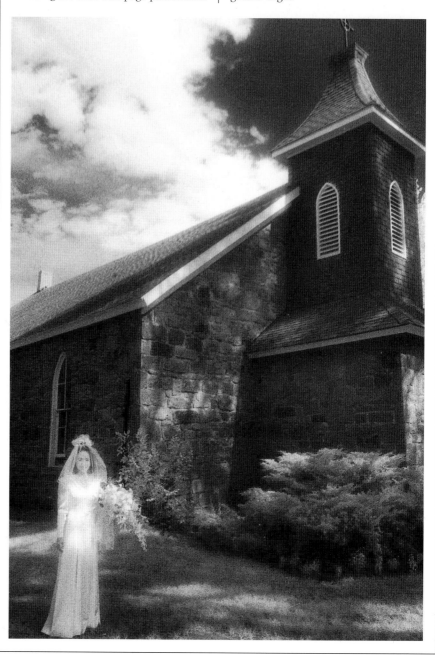

GARY ALAN STRAIN

CONWAY, ARKANSAS

After receiving his Master's degree in physics from the University of Central Arkansas, Gary Alan Strain spent 10 years teaching chemistry, physics, photography, and video at Conway High School. During that time, he began photographing racecars, eventually servicing 13 different racetracks with the help of some of his students and a color lab that he set up at home. After photographing the wedding of a racecar driver in 1969, Strain began doing weddings and portraits from his home, assisted by Nancy, his wife. When their daughter Brandy was born in 1973, Gary says, "We had to get the equipment out of her room." So the business moved to its current location and became a full-time operation.

Today, Gary Alan Strain Photography is truly a family affair. Brandy has joined Gary and Nancy as a full-time studio employee and is following in her father's footsteps by finishing the requirements for the Master's degree from Professional Photographers of America (PPA). Gary holds the PPA Master Photographic Craftsman degree. Daughter Jackie, who is still in high school, also helps out in the studio.

The photographs of both Gary and Brandy hang consistently in state, regional, and international print competition, and the studio has won a total of 22 Kodak Gallery Awards and "Photographer of the Year" honors at the Professional Photographers of Arkansas convention on eight separate occasions.

Although our studio is a high-volume business, we have a total of only four people on staff. I do most of the shooting, bill-paying, financial management, and machine-fixing; Brandy does sales and shooting; and Nancy does all the printing. Two half-time employees do finishing, sorting, and spotting. We have an unusual business mix as compared to the typical portrait/wedding studio. In addition to regular studio portraiture and approximately 50 weddings a year, each year we photograph 10,000 schoolchildren and 800 seniors. The school business adds significantly to our profit picture.

Conway is a small industrial town, located 30 miles northwest of Little Rock, where many of our clients live. Our studio occupies an old home on the edge of the downtown area. We remodeled it from parts that apparently the termites couldn't eat. The grounds are nicely landscaped into settings that are ideal for weddings and other types of portraiture.

At one time, we photographed more than 200 weddings a year, using several "stringers" to cover the weddings I couldn't attend. Although we'd worked out a system in which the stringers' wedding rate was cheaper than mine, and the bride and her family were completely satisfied with this arrangement, the nature of a small town is that we would get negative feedback from folks who attended the wedding as guests. They would wonder what was wrong that I, myself, didn't "show up" at the wedding. It became evident that in a way they held this against me, and that isn't a good thing to happen to a small-town business. So we decided to elevate our marketing, and I now handle all of the weddings personally.

We've also changed our method of handling weddings from the traditional approach of making some photographs before the ceremony and some at the church after the ceremony, to nearly all in which the photography is done prior to the wedding. This greatly eases everyone's stress between the wedding and the reception. We encourage the couples to let us do a portrait session before the day of the wedding or have us photograph their formal portraits several hours before the wedding.

In order to do this pre-wedding photography, we have to educate couples about what we call the "first sighting." Apparently there is something in the genetic makeup of every young woman that causes her to believe that something magic is going to happen when the groom first lays eyes on her as she walks down the aisle. What she doesn't understand, of course, is that

the groom doesn't see anything because he is totally weak-kneed and just trying to keep from doing something antisocial. But when we can bring the couple together days or hours before the wedding, what happens is that we create a very emotional time for the couple that otherwise wouldn't have occurred. We tell the bride that she deserves to have this "special time," and that a bonus is that the wedding will also be a special time for the guests, because the couple and the families can be the first to arrive at the reception and be there to greet the guests, just as they should be.

All of this works to enhance a strategy called "groom activation." The idea is to get the groom as involved in the process as you can. You'll have much better photographs and a much better time when the groom takes an active part in the process. Part of this strategy—one that also serves as an incentive to have the wedding-photography minimum paid at the time of the booking—is a "two-for-the-price-of-one" special on the bridal portrait and the "groomal."

Since the pre-wedding portrait of the bride is called a "bridal," we call a pre-wedding portrait of the groom the "groomal." Because this session takes place before the wedding day, the groom has to arrange to have his tux available then. We book the session as the last appointment of the day (we call it a "prime-time" appointment) because if it runs over, it doesn't make any difference. This allows Brandy or me to do all kinds of lovey-dovey stuff, with no time constraints. Most of our wall-portrait sales come out of this session, and Brandy does some really "radical" stuff with the couples who are less traditional.

Through our marketing, we search for the bride who is looking for something extra, especially in photography, and one who is willing to give the time to acquire it. We don't like bitchy brides and simply become unavailable at the first sign of a problem during the interview. In other words, during the interview, the bride is deciding whether to hire us, but we're also deciding if she is the one who will be worth working for on a weekend—worth it both financially and emotionally. Weekends are too few and too short to deal with stressed-out brides and their mothers.

Our previews are presented numbered, not in an album, so that the bride can sort and arrange them as she pleases. We book by minimum purchase, with no package implied. So this charge doesn't become the "built-in maximum" to be spent on the album.

One of the best ways we've found to build sales is the concept of using

"OPM," or "Other People's Money." There always will be some limit to the amount the bride's family or the bride and groom themselves will spend on photography. But there are plenty of "other people" who are involved in the wedding who have money to spend. This includes members of the wedding party and family members. So before the wedding, we have forms to fill out as to who will be at the reception, and we photograph the ones who would appreciate having a photographic memento of the wedding. When guests at the wedding and reception are handled properly, they can be the best possible source of future clients and instant cash. Otherwise, your only buyers are the bride and groom and the two sets of parents. By the time the wedding takes place, most of the time they're all tapped out.

One other "extra" that has increased sales and also made our albums stand out from the competition is that for the last 20 years, we've been known for our panorama pages. We made the double-page panorama ourselves long before album companies manufactured such pages.

Being in a small town that is only 30 miles away from the largest population center in the state has many advantages. We still have a shot at high-end weddings that are most likely to occur in Little Rock, but we can enjoy the lifestyle advantages of a small town. When I'm photographing the bank president downtown, I'll show up in a sport coat. But most every day I get to come to work in jeans, and nobody minds.

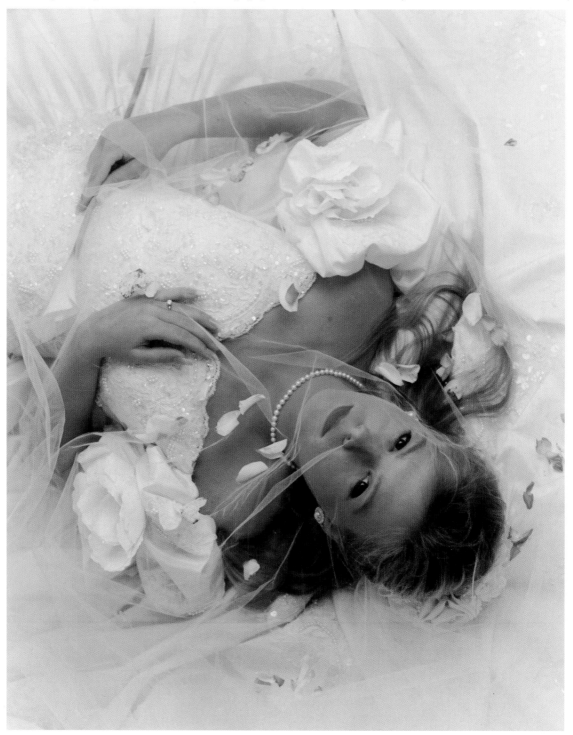

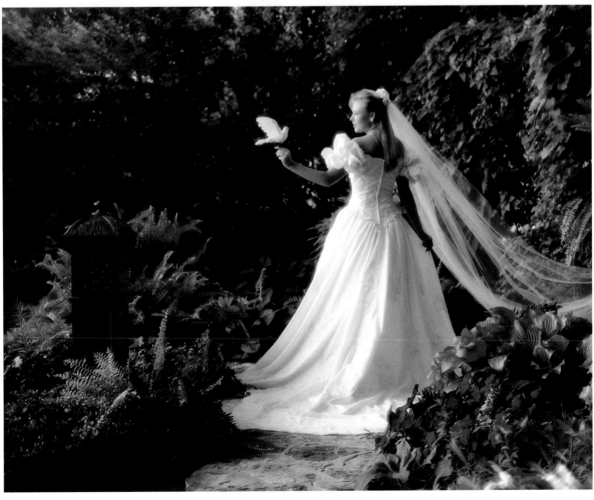

MICHAEL WARSHALL

MELBOURNE, AUSTRALIA

Russian-born Michael Warshall was a young millionaire who had shaped an early fortune from his love of photography by building one of the largest processing labs in Victoria. Unfortunately, the business had grown too big, too fast, and Warshall had no experience in business. So he lost everything.

Warshall then studied business management, traveled overseas, and studied with photographers in the United States. He attended the Winona International School of Professional Photography of Professional Photographers of America (PPA). Today, Warshall is regarded as an international leader in the field of portrait and wedding photography, owns a successful studio and a major lab, and spends much of his time traveling around the world photographing commissioned portraits of prominent business and society figures.

Warshall is a Master Photographer and Fellow of the Australian Institute of Professional Photography, which named him "Photographer of the Year" in 1982 and 1992. He is an Associate in the Royal Photographic Society of Great Britain, the British Institute of Professional Photographers, and the Master Photographers of Great Britain; he is also a Certified member of PPA. He regularly lectures in Australia and New Zealand and was the first Australian Mentor whom Eastman Kodak used to present workshops for professional photographers throughout Australia. He has addressed the PPA International Convention, and in 1988, Wedding Photographers International named him "International Wedding Photographer of the Year."

Over the years, our studio has photographed prominent persons throughout the Southeast Asian region. The grandest affair took place in 1993 in Jakarta, Indonesia: the Royal Wedding of B.R.M. Rahajasa Rahadian Yamin SH, a prince whose grandfather (K.G.P.A.A. Sri Mankunagoro VII) was the King of Solo (now Surakarta) in central Java. There were over 5,000 guests, and the actual ceremony was held over four days with specific Javanese ceremonies taking place throughout the event. The coverage required that I lead a team of photographers. This definitely isn't the type of wedding we're accustomed to in Australia!

Our studio can design a coverage to suit all budgets; however, there is absolutely no possibility of compromise in terms of quality. Every image we produce carries my personal guarantee. Excellence is the commodity upon which I've staked my reputation.

Because of rapid advances in technology and the visual media, I've found it necessary to travel abroad frequently to bring back the latest styles and ideas to serve my Australian and international clients. As a result, our studio facilities reflect these advances and support state-of-the-art equipment, including hi-tech video-production facilities.

Our suburban Elsternwick studio is located on a busy thoroughfare, approximately 10 minutes from the Melbourne central business district, and it serves as our head office. Our "Broadhinton" location is used only for photography and is close by to the Elsternwick location. It is a 100-year-old Victorian mansion that has wonderful backgrounds for portraiture. Once the session is completed at Broadhinton, all transactions take place at the Elsternwick facility.

Our business draws upon a Melbourne area population of approximately 3 million. We once did around 200 weddings per year, but since my personal commitment to the overseas market, the operation in Melbourne has been scaled down. Today, we concentrate more on portraiture, but we still photograph about 60 weddings each year.

Wedding photography appeals to me because it presents the photographer with a unique challenge. You're working without the benefits of studio equipment and without the luxury of time. If you don't get it right first off, there is no second chance. The subjects often are in a heightened emotional state, and so you have to be particularly sensitive to their needs and be able to maintain your professional working standards in what may be a chaotic environment. Wedding photography records one of the most precious moments of a lifetime, and the photographer's challenge is to produce a memento that captures for all time the emotions and magic of the event. These days weddings take all manner of forms, and every one is different. This is also an attraction for me.

Our wedding-photography style is anything the clients want, from the traditional to the candid, spontaneous, unstructured style. Not only do we give the clients exactly what they want, we give them service, service, and more service. In addition to consultations with their photographer, we even do a pre-wedding photography session to determine the style they like best. To reach the market, we advertise in various bridal magazines, place editorial articles in magazines, advertise on television, promote our work through exhibitions and at bridal fairs, and do mailings to existing and potential new clients, with telephone follow-up. This strategy results in word-of-mouth advertising and the fact that Michael Warshall is associated with high-class photography.

At the wedding, our method is to shoot sequentially to tell a story, achieving as much variety as possible. Clients view miniature 3 1/2-inch-square prints in the studio where we help them with album design. Some couples prefer to buy a fixed package, while others prefer an a-la-carte system, so we offer both. Through this latter system, they pay a professional-services fee, with a separate charge for the photographs and the album. Although we have many designs of wedding albums and constantly try new ideas to improve and add variety, the album most popular with our clients is still the 10 x 10 style, using a variety of photographic sizes and mat shapes. Clients usually buy an album of all their previews, and most want at least one wall enlargement.

Staying on top requires dedication and a continual pursuit of excellence, new techniques, and new technology. Therefore, an important part of business is an annual business plan that makes it much easier to keep records of how the business is performing and for making business decisions that will affect the future.

As I complete this interview, my directions are changing once again due to the fact that I just purchased the largest wedding/portrait laboratory in Australia. I've put my Elsternwick studio on the market, and I'll concentrate on my overseas projects and the challenge of the new laboratory. That should keep me busy!

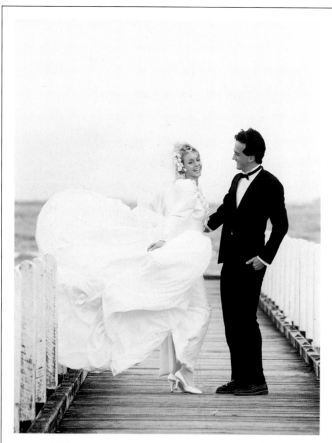

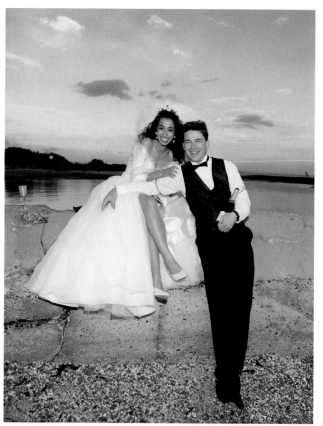

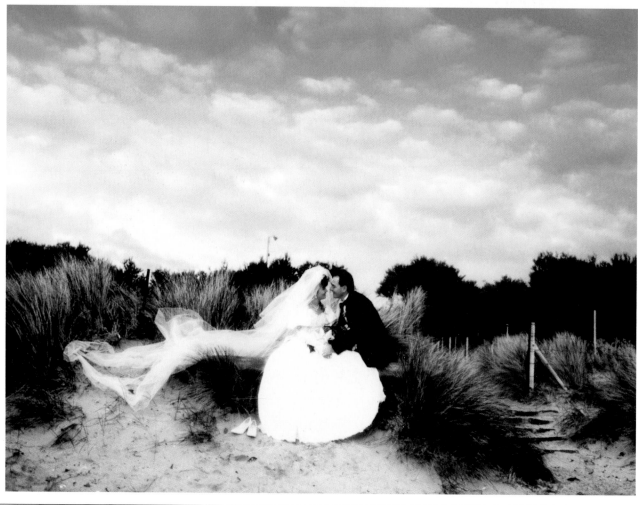

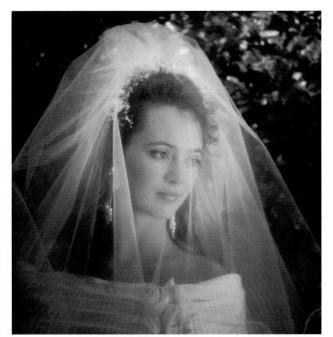

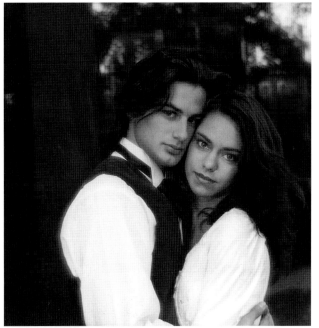

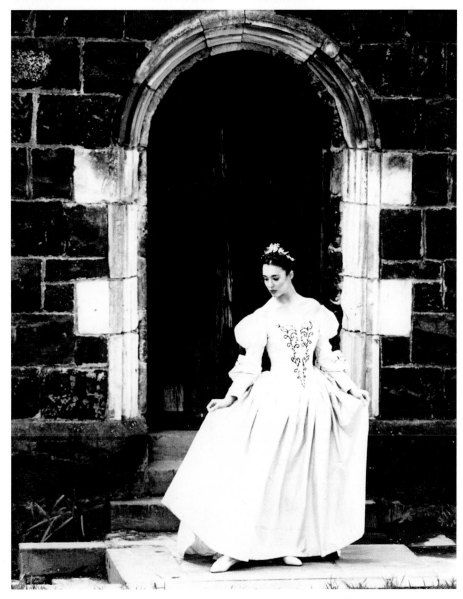

DAVID ZISER

EDGEWOOD, KENTUCKY

Photography was the means by which David Ziser earned tuition and paid his bills while in college. In 1971, he graduated with both a B.A. in physics from Thomas More College in Covington, Kentucky, and a B.S. in industrial engineering from the University of Dayton. After college, he worked as an engineer for private industry and as a self-employed consultant, continuing to photograph weddings on weekends. By 1978, he knew the time had come to decide whether to stay in engineering or to devote himself exclusively to photography. In October of that year, Ziser formally opened a studio in his $150-a-month apartment.

Within a few short years, Ziser's fame as both an innovative photographer and a masterful teacher spread throughout the United States and Canada, and soon thereafter throughout the world. In 1991, he presented seminars for more than 13,000 professionals during a Kodak-sponsored worldwide tour to nine countries. In 1992, he became the first American wedding photographer to make a presentation on behalf of Hasselblad at Photokina in Cologne, Germany, and to address Hasselblad's international sales staff at its annual sales meeting.

In addition to receiving countless awards from national and international print exhibitions, Ziser holds the Master Photographic Craftsman degree of Professional Photographers of America, is a Fellow in the American Society of Photographers, a Fellow in the Master of Photography Association of Great Britain, and a member of the British Institute of Professional Photography.

In my first year of business in a typical "at-home studio," I made a point of offering clients the best photography they could get in Northern Kentucky. I attended seminars and workshops traveling through town, joined my local professional associations and PPA. When I attended my first Professional Photographers of Ohio Convention, I was in awe of the work being displayed, and it made me determined to produce photographs of that quality for my clients.

About this time, the silver crisis hit, which caused the price of film, paper, and chemistry to skyrocket. I went from charging $6 for an 8 x 10 to $12. I went from being the least-expensive photographer in the area to the most expensive. I was too dumb to know any better: If I was going to earn a living at this, I couldn't do it at the price I was being charged for the raw materials.

In addition to my first apartment/studio, I've worked out of a condominium (until my neighbors complained about the traffic); a prestigious office building (an environment that I really didn't care for); and in my present location, which is a large home situated on 1 1/4 acres of land. It is a 75-year-old home with unique architecture, and it is highly visible from the major interstate highway that fronts it and the shopping mall right next to it. The building also is my home, and this arrangement really suits me. I like being able to work at odd hours, and I get feedback from my clients that they enjoy the comfortable atmosphere.

I serve the greater Cincinnati/Northern Kentucky area, a population of around 1.7 million. I am comfortable photographing 35 to 40 events a year, many of which are the largest events in Cincinnati. I can handle this level of business with the help of my studio manager, Shelly, who is in charge of all telephone calls, scheduling, and production.

I consider my style to be a blend of classical portraiture mixed with contemporary design, and an emphasis on the candid style of photography. I do both "coaxed candids" and spontaneous-action candids. I credit Denis Reggie with influencing me to add more candids to my weddings. I definitely see clients wanting to include more of the candid moments. When I started in this business, the portrait background and the bridal pictorial were so new and unusual that everyone wanted to have them. Now many photographers are producing these images, so as a result it seems the brides and grooms are wanting to include the candids in their albums.

When meeting with prospective clients, I cover three issues: my style, letting them know I try to achieve a classical, elegant look to my portraiture; my interest in achieving a nontraditional look, including design elements in the architecture or landscaping; and, finally, the candid photography, capturing the special moments between the bride and her family, the bride and groom, and the groom and his family. In the process, I'm selling myself to them. My presentation is full of enthusiasm and emotion that truly comes from the heart. I think this is why we are so successful at booking our weddings. I don't sit across the table and sell "so many 8 x 10s for so much money." Price usually is the last item covered.

I have a very simple approach to marketing: get to know the people who do business with the people you want to do business with. For example, if I want to photograph the big wedding events that take place in the Hall of Mirrors or the Phoenix or some of the other great venues in the area, I'm going to get to know the people who work at these places. I create partnerships with them and others, such as prominent florists—any business that deals with my ideal clientele. This includes referring their work to my clients and providing them with photographs featuring their work at affairs I cover.

We also try to create an intimate relationship with our clients. Whether I'm visiting clients in their home or Shelly or I am personally delivering a finished album, we want our clients to feel as though they're doing business with a friend, someone they can depend on and trust.

Over the years, I've been fortunate enough to photograph weddings for all kinds of people, from the young woman who works as a cashier at Walgreen's, to the sons and daughters of celebrities and the corporate elite. The common ingredient for them is love, and the best part for me continues to be walking away from an affair knowing that I have some wonderful images of that love in my camera.

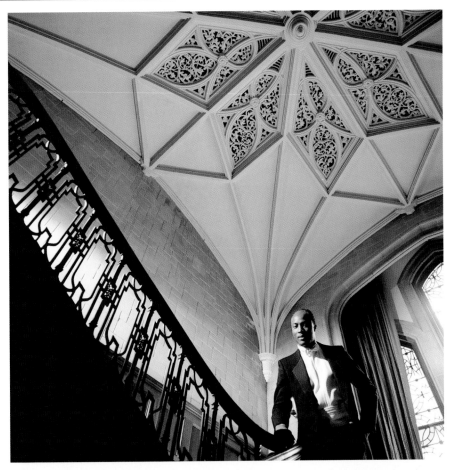

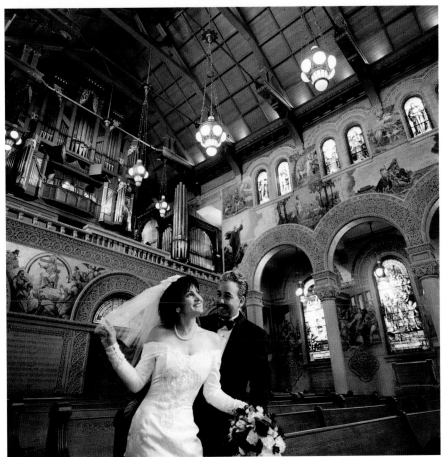

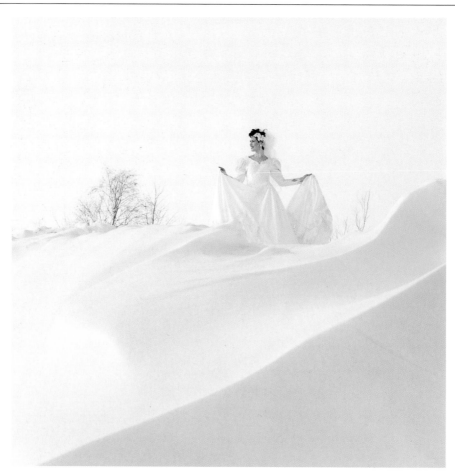

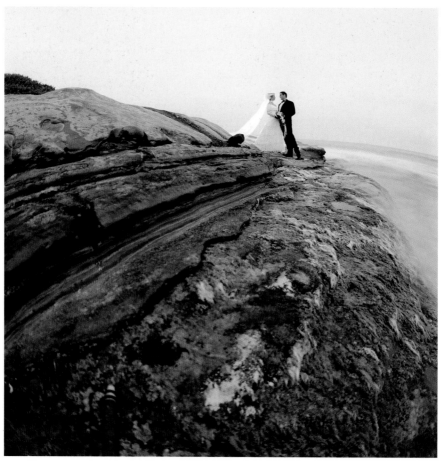

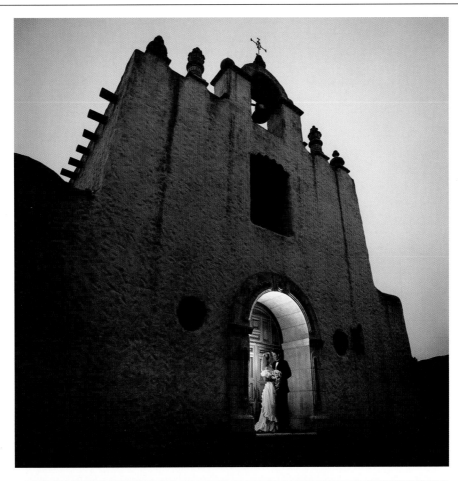

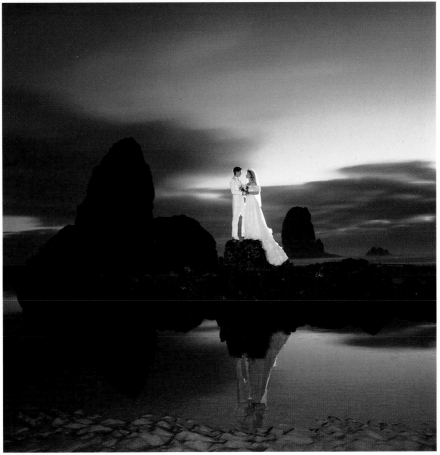

MONTE ZUCKER AND CLAY BLACKMORE

SILVER SPRING, MARYLAND

Monte Zucker's pioneering work in the field of classical, romantic wedding photography has influenced most of today's serious professional wedding photographers. In his nearly 50-year career, he is credited with transforming an industry, and his teaching has influenced several generations of contemporary wedding and portrait photographers. "Monte Magic" is known around the world, and professional associations worldwide have bestowed their highest honors on him.

Zucker holds the Master Photographic Craftsman degree from Professional Photographers of America (PPA), the Fellowship of the American Society of Photographers, and membership in the prestigious Cameracraftsmen of America. He has been honored as a Fellow by several organizations: the Institute of Incorporated Photographers of Great Britain, Professional Photographers of Maryland, Professional Photographers of Australia, and Professional Photographers of New Zealand. His numerous articles have appeared in the industry press around the world, and from 1987 through 1993 he edited The Wedding Photographer's Notebook.

Complementing his artistic prowess, Zucker has demonstrated an uncanny business sense that has served him well. He has exploited marketing and management opportunities in a manner that elevated the business of wedding photography to a level of professionalism, the profitability of which few could have envisioned when he began his photographic career in 1947.

Industry observers credit Zucker's longevity as a visionary at the forefront of his field to his passion for continually improving his craft and to his ability to seek out and embrace new techniques. In 1994, when he purchased a second home in Florida and turned

over the day-to-day operations of the business to Clay Blackmore, his partner and colleague, one of his stated objectives was to keep learning, particularly in the field of digital imaging.

Clay Blackmore's introduction to wedding photography came in 1982 when he was a 20-year-old scholarship student at Sam Houston State University. There, he served as a class assistant for a week-long course Rocky Gunn was teaching at the university for the Texas School of Professional Photography. Blackmore recalls, "Everything about him excited me: his images, his tireless energy, and his enthusiasm. I felt that someday I would like to be in Rocky's shoes, being able to shape the lives of other photographers by being an inspiration to them."

The next year, Blackmore served as class assistant to Monte Zucker, whom he met at the airport while wearing a shirt that said "I was Rocky Gunn's Bullet." Blackmore says, "Here was Monte, the acknowledged leader of the industry. He had to wonder what was going on with this kid who was advertising for Rocky Gunn." But by the end of the week, the "upstart student" so impressed Zucker that he offered Blackmore a job, first as a summer intern, and later as a full-time employee.

After completing his B.S. degree in photography in 1985, Blackmore joined Zucker's firm, which became known as "Monte Clay & Associates," in 1986. Since then, Blackmore has established his own reputation as a premiere photographer and teacher. Since 1985, he has taught his craft throughout the United States, Canada, Europe, Australia, and Asia. His specialty is candid photojournalistic coverage, blended with traditional, romantic portraiture that stresses the classical posing, lighting, and composition he learned from his mentor.

Of his protégé, Zucker observes, "Clay will succeed in elevating wedding photography to even greater heights because he is never satisfied with 'what has always been.' Clay starts with the 'proven' and 'familiar,' but he doesn't quit until he has created images that have never been done before."

Blackmore holds the Master Photographic Craftsman degree from PPA and is a member of the elite Cameracraftsmen of America. He has won first-place honors in PPA's "Bride's Choice" competition, and was honored by the Kennedy Center in Washington, DC; it hung his exhibit of photographs depicting "The Homeless of the Nation's Capital City," a personal project that grew out of his desire to use photography as an instrument of societal change.

The summer that I did my internship with Monte, I covered 10 weddings. In fact, during my second week, I did a complete wedding because the studio had overbooked that weekend. So they put a twin-lens Rolleiflex in my hand, put a dark suit on me, and sent me to this wedding that no one knew much about.

The situation was really strange. The couple had paid only a small deposit, but to our great surprise, it turned out that it was the wedding of Boogie Weinglass, CEO of Merry-Go-Round fashions. It was the "Wedding of the Year" in Baltimore. So while Monte and his other principal photographer were covering two rather small affairs, here I was, a 21-year-old kid with a twin-lens Rollei, running around having a ball. I'd never seen a party like that. The bottom line was that I came back with a great set of pictures. The couple was happy, so Monte said, "If he can handle that wedding, we can send him out every weekend." So I was fortunate not to spend much time as an assistant. It was great to be thrown right in at the beginning of my career.

After I joined the business full-time, Monte began offering several different levels of coverage. I came in at a more moderate rate that was very competitive with our marketplace. But to get both Monte and Clay at a wedding, clients must pay a premium price. I often work the weddings where the couple is looking for more journalistic coverage, the ones that aren't into the painted backgrounds. I am fortunate to have learned classical photographic technique from the master himself. Without this knowledge, my work never would have the impact or consistency that I strive to achieve. At the same time, Monte has encouraged me not to just follow in his footsteps, but to seek my own directions.

What I bring to the business is the ability to be kind of a stylistic "chameleon." I can be the photojournalist, I can be the portrait photographer, I can give the couple exactly what they want. People recommend me because they know they can count on me not to ruffle the feathers of anyone at the wedding. Some photographers come in and want to do it "their way," and this might not be the way of the bride and groom. This can cause friction. What help me book weddings and gain referrals, I believe, are my demeanor at the wedding and my ability to work with people. I keep a smile on my face throughout the event, keep everyone happy, and produce photographs that they love.

At the studio now, there is just Monte and Clay. We don't have a staff

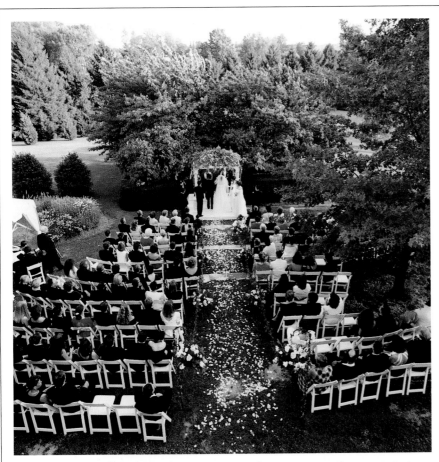

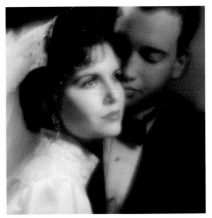

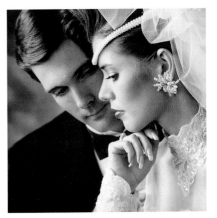

of photographers. Every time we've tried that, we found that it just didn't pay. People found every reason to complain. When we work a wedding together, the client is getting the best of both worlds. Monte is from the school that says make every photograph count. I'm from a school that is more of a journalistic style that says take a lot of pictures to capture the moment—find the moment, not fix the moment. While Monte is doing his pro-active approach —posing his classic things—it creates a lot of "reactive" moments that are great for 35mm photojournalism. Depending on the wedding, we can do as much as half the coverage in 35mm.

As far as the marketing and management side of the business goes, we do a kind of screening process with our telephone inquiries. We ask where the wedding will take place and get the clients' address, so that we can send information to them. These things alone, particularly the zip code, will tell me if they are within our price range. But I never underestimate the buying power of prospective clients. Sometimes a country wedding can produce bigger sales than society affairs. Most of our business comes from referrals and direct contact with allied professionals.

I am sure many photographers would be surprised to know that we rely on "after-selling" to achieve our desired sales levels. Through our teaching of other professionals, we've created a lot of darn good photographers in our marketplace. So we have to book at a moderate level and then take the pictures that sell. If I would tell a prospect that the photography would cost $10,000 for three albums and all the proofs, all they would hear is the $10,000, then turn around and say, "But there's a photographer down the street who charges only $2,500, and he used to work for you." It seems that everyone "has worked for Monte."

What I've decided to do in the future is to become a "fee-based" photographer because I can see where the industry is heading. Every prospect asks me the same question that every other photographer gets: "How much do you charge to shoot a wedding, and can I keep all the proofs?" As a fee-based photographer, I would go to the wedding feeling that I'm being compensated for my time, and then I can include the proofs in a package with three albums.

Another advantage of the fee-based system is you don't have to be paranoid about the proofs leaving the studio. Over the years, we've tried every method of preview presentation: proofs, slides, and electronic presentation. Today, we're working with 5 x 5s because the clients like to hold them and lay them out side by side.

Monte and I are now working on an agreement for me to take ownership of the business. This kind of thing is never easy because there are so many details to work out: the value of the business, the real estate, etc. I must make certain that my overhead isn't so high that I'm stretched so thin that it strangles my creativity. But the real advantage for me to do so is that I've been very fortunate to work with Monte long enough that the clients accept me on almost an equal par with Monte. When I look back and see how far I've come in the 12 years since I first met Monte, I have to give a lot of credit to Monte's drive, always pushing his commitment to excellence.

The fact that I've learned the discipline of lighting, posing, and refining to the point that they are second nature to me has given me the freedom to exploit creative opportunities. It is like a musician working the scales to strengthen the music. Through our teaching, we've done these poses over and over on the stage, so that when I get to a wedding, it is like falling off a log. As I'm moving toward a more journalistic style in my photography, I find that I still must fall back on those elegant portraits time and time again.

Monte is making a transition now, but he'll never retire; he is shifting directions, but not retiring. He is determined to help usher in the digital age to wedding and portrait photography, something I'll be involved with as well. It is really amazing when you think about what Monte has experienced during his career. He began in the age of 4 x 5 black-and-white photography, then went on to roll film, to color, and now he is on the brink of ushering in the digital age. His vision and ability to manage change are extraordinary.

Clearly there are tremendous advantages to having learned from and worked with a "living legend." On the business side, I've picked up his "Psychology 101" when it comes to clients—always giving the clients a little more than they're asking for, pampering the customer, showing pride in your work. All this gives you confidence to ask for a higher dollar and to get it. One of the most important parts of his legacy is that he has led the way in making photography as much a viable business as it is a beautiful art. Monte is a photographic genius. When he gets behind a camera, his ability to bring people together is something no one else possesses. What he has contributed will never be forgotten. I feel fortunate that I've been a part of it.

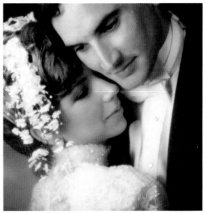

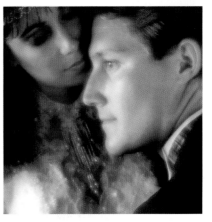

RESOURCES

BUSINESSES AND MANUFACTURERS

Art Leather
45-10 94th Street
Elmhurst, NY 11373
718-699-6300
800-88ALBUM fax
Montage preview presentation software; folio sales literature

Designer Poster Images
The Color Network Lab
131 Hanlan Road
Woodbrige, Ontario, Canada L4L3P5
416-856-4474
800-265-6787
416-861-8040 fax
Designer Poster Images (See Stephen Rudd profile)

EPIX
4861 Royalton Road
Cleveland, OH 44133
216-237-0038
216-237-7545 fax
Preview presentation equipment and software

Alan Feldman
498 Lakewood Drive
Brandon, FL 33510
813-685-4343
813-681-8844 fax
Tamron Fotovix preview presentation systems

Jeff Grann
3976 Chain Bridge Road
Fairfax, VA 22030
703-352-0296
703-352-0537 fax
SuccessWare studio management software

Marathon Press Inc.
P.O. Box 407
1500 Square Turn Boulevard
Norfolk, NE 68701
800-228-0629
Printed cards and brochures; educational books on marketing, management, and photographic techniques for portrait studios

EDUCATIONAL RESOURCES

Carol Andrews
4916 Kelvin, Studio 9
Houston, TX 77005
713-523-4916
713-523-2042 fax
Educational seminars

Michael and Pamela Ayers
1648 North Main Street
Lima, OH 45801
419-22-AYERS
800-PANORAMAS
419-222-7264 fax
PANORAMAS@AOL.COM
Instructional manual on creating and marketing Album Architecture

John and Mary Beavers
7510 Winters Chapel Road
Atlanta, GA 30350
770-393-8355
770-393-0091 fax
Educational seminars

Clay Blackmore
10887 Lockwood Drive
Silver Spring, MD 20901
301-593-3344
301-593-3343 fax
CLAYnCO@AOL.COM
Educational books, videotapes, and related products on photographic techniques, marketing, and management

Gary Fong
5777 West Century Boulevard, #363
Los Angeles, CA 90045
213-823-3589
310-649-3589 fax
Educational seminars and videotapes on photographic techniques and marketing; image sets and marketing/management materials; wedding-photography equipment

Alvin Gee
3300 South Gessner, Suite 120
Houston, TX 77063
713-977-4038
713-977-9995 fax
Instructional videotape on capturing the traditional wedding

Bruce Hudson
16627 Benson Road South
Renton, WA 98055
800-952-6609
206-226-4363 fax
Educational seminars, videotapes, and products on photographic techniques, marketing, and management

Jim Johnson
454 M Street S.W.
Washington, DC 20024
202-554-3896
202-488-7085 fax
Educational seminars on photographic techniques and marketing

Roy and Deborah Madearis
1304 West Abram
Arlington, TX 76013
800-323-6362
817-860-7177 fax
Educational seminars, books, videotapes, and information packets on image-making, marketing, sales, and management

Heidi Mauracher
133 East De La Guerra
Santa Barbara, CA 93101
805-965-6673
Educational seminars on photographic techniques and marketing

Ann K. Monteith
4505 Hill Church Road
Annville, PA 17003
717-867-2278
717-867-4571 fax
MONTEITH@AOL.COM
Educational seminars and books on photographic techniques, marketing, and management; private studio consultant; industry consultant

Stewart and Susan Powers
2001 Northwest 58th Terrace
Gainesville, FL 32605
352-372-9930
352-376-3842 fax
Educational seminars and books; audiotapes and posing guides on photographic techniques, marketing, and sales

Denis Reggie
75 Fourteenth Street, Suite 2120
Atlanta, GA 30309
404-873-8080
800-379-1999
404-873-8088 fax
DREGGIE1@AOL.COM
Educational seminars and videotapes on photographic techniques and business methods

Stephen Rudd
218 Carlton Street
Toronto, Ontario, Canada M5A2L1
416-968-0036
416-968-0038 fax
Educational seminars and videotapes; posing equipment; special-effects devices and negatives

Wendy Saunders
3025 47th Street, Suite D-1
Boulder, CO 80301
303-444-0064
800-933-8380
303-444-8375 fax
WENBOULDER@AOL.COM
Educational seminars and materials on marketing and management; design and printing services; private studio consultant

Gary Alan Strain
P.O. Box 490
Conway, AR 72032
501-329-6455
GAS10@AOL.COM
Educational seminars

Winona International School of
Professional Photography
Professional Photographers of America
(PPA)
57 Forsyth Street, NW, Suite 1600
Atlanta, GA 30303
800-786-6277
Educational classes at PPA's Atlanta Resource Center and through a network of affiliate schools throughout the United States

Monte Zucker
4468 Ascot Circle North
Sarasota, FL 34235
941-355-4392 fax
MZPHOTOG
Educational seminars, books, and videotapes; a broad range of educational products on photographic techniques, marketing, and management

WEDDING ALBUM MANUFACTURERS AND DISTRIBUTORS

Albums, Inc.
P.O. Box 81757
Cleveland, OH 44181
800-662-1000
800-662-3102 fax

Albums Unlimited
3465 Woodward Avenue
Santa Clara, CA 95054
408-982-9294
800-625-2867
408-982-9296 fax

Art Leather
45-10 94th Street
Elmhurst, NY 11373
718-699-6300
800-88ALBUM fax

Berkey Professional
130 Front Street
Hempstead, NY 11550
516-486-3800

Capri Album Company
510 South Fulton Avenue
Mount Vernon, NY 10550
800-666-6653
914-776-6099 fax

Castle Distributing Inc.
1209 Old Highway 8
New Brighton, MN 55112
612-633-4777

Fifth Generation, Inc.
3080 North Washington Boulevard
Sarasota, FL 34234
813-355-5555
800-516-6555

General Products
4045 North Rockwell Street
Chicago, IL 60618
800-888-1934
312-463-3028 fax

Gross-Medick-Barrows
P.O. Box 12727
El Paso, TX 79913
800-777-1565

Jobar Inc.
4909 Bissonnet
Bellaire, TX 77401
713-668-5773

Kambara USA Inc.
P.O. Box 747
Tualatin, OR 97062
503-692-9818

The Levin Co.
P.O. Box 4999
Compton, CA 90220
213-636-1801

Merit Albums Inc.
19438 Business Center Drive
Northridge, CA 91324
818-886-5100

Michael Co.
4662-64 North Pulaski Road
Chicago, IL 60630
800-621-6649

North American Photo
27451 Schoolcraft
Livonia, MI 48150
313-525-7355

Print File Inc.
P.O. Box 607638
Orlando, FL 32860
407-886-3100

Pro Studio Supply
650 Armour Road
P.O. Box 46
Oconomowoc, WI 53066
800-558-0114

Taprell Loomis
2160 Superior Avenue N.E.
Cleveland, OH 44114
800-827-5679

Total Photographics Inc.
4273 Perkins Road
Baton Rouge, LA 70808
504-383-9678

Wooden Nickel Albums, Inc.
US Highway 68
P.O. Box 527
Benton, KY 42025
800-325-5179

INDEX